Images and Ideas
in Seventeenth-Century
Spanish Painting

PRINCETON ESSAYS ON THE ARTS

Images and Ideas in Seventeenth-Century Spanish Painting

JONATHAN BROWN

PRINCETON UNIVERSITY PRESS
Princeton, New Jersey

Published by Princeton University Press, Princeton, New Jersey
In the United Kingdom: Princeton University Press, Oxford

All Rights Reserved

Library of Congress Cataloging in Publication Data will be
found on the last printed page of this book

Publication of this book has been aided by a grant
from The Andrew W. Mellon Foundation

This book has been composed in VIP Palatino

Princeton University Press books are printed on acid-free paper,
and meet the guidelines for permanence and durability
of the Committee on Production Guidelines for Book Longevity
of the Council on Library Resources

Printed in the United States of America

5 7 9 10 8 6

To Sandra

PREFACE

This book has its origins in a doctoral dissertation submitted to the Department of Art and Archaeology, Princeton University, in 1964. When I finished it, I knew that it would require substantial revision to be of interest to a wider audience. But I never imagined that it would take twelve years to complete this revision. The reasons for the delay are too trivial and complex to relate at length. It is enough to say that I allowed my interest to be diverted by other scholarly projects and a five-year term as Director of the Institute of Fine Arts. Nevertheless, I knew all along that I wanted to pursue the lines of thought first laid down in my thesis. This I have at last managed to do, although this text is by no means a simple reworking of the 1964 version.

Part I follows the dissertation to some extent. Its three chapters are an essay in cultural history, with the art of painting as the focal point. I am aware that my excursions into literary history will probably strike scholars of Spanish literature as jejeune and partly misguided. But sooner or later someone had to try to restore the connections that existed between writing and painting in Seville during the late sixteenth and early seventeenth centuries, if only to show the way that other, better equipped students might follow.

The rest of the book is the result of more recent thought and research. As I explain in the Introduction, I believe that the study of Spanish Baroque painting needs to be reinvigorated by the use of newer methods of art historical research. The studies of *Las Meninas* and Zurbarán's painting for the sacristy of Guadalupe are intended to illustrate how these methods can be applied to the subject and will give the reader a chance to judge for himself if they hold any promise of arriving at a deeper understanding of the works of art. Chapter 6, published in 1970 and included here without substantial changes, is in the same vein.

The translations are all my own. As a rule, I have tried to make the texts readable as well as accurate. Hence, a certain license was taken with form, but not, I trust, with content.

The debts of gratitude owed to those who assisted a work so long in progress are bound to be as numerous as they are overdue. I hope that my creditors will be satisfied by this belated but heartfelt acknowledgment of their help. First, I want to thank David R. Coffin and John R. Martin, who advised my doctoral dissertation. Then, I am grateful to Elias Rivers and George Kubler, whose good advice and telling criticism helped me to see that the first revision of my thesis, completed in 1970, was an intermediate, not a final stage of the work. I have gained a clearer and deeper understanding of Spanish history of the period from conversations with John H. Elliott, who also kindly read the manuscript and made suggestions to improve it. An important part was played by some of my students at the Institute of Fine Arts and Princeton University. Steven N. Orso was especially helpful with the work on *Las Meninas*, Edward J. Sullivan, with the work on Guadalupe. Mar-

cus Burke made contributions to both of these studies, too. And Richard Mann was a valuable editorial assistant. Thanks are also due to José Francisco de la Peña and Duncan T. Kinkead, who spent generous amounts of time tracking down photographs in Spain. I also wish to thank the following people for help in ways that are specifically acknowledged in the text: Peter H. von Blanckenhagen, Enriqueta Harris Frankfort, T. James Luce, Alfonso E. Pérez Sánchez and Kathleen Weil-Garris.

For valuable help in preparing the manuscript for publication, I am grateful to Gail Filion, who edited it with care and discretion, and Lynda Gillman, who typed it impeccably.

The College Art Association of America graciously gave permission to republish Chapter 6, which appeared originally in the *Art Bulletin*.

Finally, I thank my wife, Sandra, who has lived with the book and the author for eleven years and has done much to improve them both.

January 1977

[The manuscript of this book was submitted to the publisher in January 1977. At that time, I decided not to incorporate any relevant books or articles that might appear while it was being edited and produced. Every scholar wants his work to be as complete as possible. But completeness, however desirable, is never attainable. Quite apart from the unpredictable and unavoidable element of human error, there is the greatly increased rate of scholarly production that has occurred in the last years, which virtually guarantees that something of interest to an author will appear after his manuscript is in press. This second factor persuaded me to avoid the costly and time-consuming process of making revisions in the proofreading stage. I believe that this course of action was sensible except in one instance where the vicissitudes of book distribution betrayed me. This involves the excellent book by Julián Gállego entitled *El pintor, de artesano a artista*, published in a small edition by the University of Granada in 1976. Gállego's penetrating study of the changing social status of the painter in Spain from the middle ages to the Enlightenment would have strengthened, but not altered, the conclusions of my chapter on *Las Meninas*. But despite its publication date, the book did not come into my hands until after I had dispatched the manuscript. I mention it here not only to explain its omission but also because it should be known by anyone who wishes to pursue research on this important subject.]

CONTENTS

LIST OF ILLUSTRATIONS

PHOTOGRAPH CREDITS

Images and Ideas
in Seventeenth-Century
Spanish Painting

INTRODUCTION

ༀ᷈ᷤᷣᷤᷣ

Observations on the Historiography of Seventeenth-Century Spanish Painting

Historians of Spanish Baroque painting have been remarkably unselfconscious about their field. Guided as if by an unseen hand, they have pursued their investigations in a similar fashion, without sensing a need for periodic evaluation of the aims and results. If their reticence has spared the field its moments of doubt, on the one hand, and sterile egotism, on the other, it has also deprived it of the opportunity to assess its strengths and weaknesses. The moment to pause and reflect on nearly two centuries of scholarly labor has certainly arrived. In seizing this moment, I offer a personal, selective survey of the methods employed in the writing on Spanish painting since 1800, the better to understand the great accomplishments of the past, and to suggest wherein the work of the future may be done.[1]

Within the context of European culture, Spanish Baroque painting has usually been perceived as somewhat apart from the mainstreams of artistic development. Only one painter, Velázquez, is recognized as a universal genius. Ribera, Zurbarán, and Murillo are also accounted major artists, although of more limited scope than Velázquez. All the other Spanish painters appear to be of local or specialized interest. This perception is founded on an oversimplified view of Spanish Baroque painting. Unfortunately, this is what art historians have tended to provide. By limiting themselves to a reduced number of traditional, if essential, conceptions of the discipline of art history, they have minimized the complexity and richness of Spanish painting and neglected its common bonds to art in other European countries. The origins and development of the history of seventeenth-century Spanish painting make it clear how the field came to limit its scope of inquiry.

The modern history of Spanish art was begun by a man who was aware that he was beginning it. Juan Agustín Ceán Bermúdez's monumental work, the *Diccionario histórico de los más ilustres profesores de las bellas artes en España*, was published in 1800, the start of the century in which the history of art would become a full-fledged humanistic discipline.[2] Ceán's book had been

[1] The only critical survey of the history of Spanish painting is by Halldor Soehner, "Die Geschichte der Spanischen Malerei im Spiegel der Forschung," *Zeitschrift für Kunstgeschichte*. In this excellent article, Soehner is concerned with general histories of post-medieval Spanish painting as reflections of changing tastes and philosophies of history.

[2] *Diccionario histórico de los más ilustres profesores de las bellas artes en España*, 6 vols.

preceded by two noble forerunners, Antonio Palomino's theoretical treatise entitled *El museo pictórico y escala óptica*, first published in 1724, and Antonio Ponz's *Viaje de España* of 1772-1794.[3] In the third volume of his work, called *El parnaso español pintoresco laureado*, Palomino had written accounts of the lives of about two hundred and twenty Spanish artists. Ponz's multivolume work, on the other hand, stands squarely in the tradition begun by Herodotus and perfected by Karl Baedeker. It is a diligent, serious guidebook to the artistic sights of Spain. Both of these works are treasure chests of information and will always be indispensable sources for historians of Spanish art, but neither can be considered a "history book." Fundamentally, they lack an historical viewpoint and method.

Ceán perceived the absence of historical method and determined to remedy it. As much as he esteemed Palomino as a source of information, he had no illusions about his reliability, as these lines from the Prologue show.

> Palomino wrote with few [historical] resources. He scarcely did more than gather the traditions current in his day. And even in this he was deficient. In addition to not documenting facts and establishing a chronology, he made the unfortunate error of accepting as true the stories and anecdotes that are freely exchanged by masters and apprentices.[4]

Moreover, Ceán identified Palomino's fundamental weakness with unerring accuracy: "Who has read Palomino and failed to notice the lack of criticism with which he wrote the lives of our painters?"[5]

The critical spirit, this intelligent and probing skepticism basic to historical studies, is what Ceán proposed to bring to his own work. In the Prologue, he spelled out his method in exact detail: "I began by reading and making analytical extracts of all the Spanish, and some foreign, books that directly or tangentially deal with the fine arts, ordering their information by names, dates and professions, in order to establish a chronology and avoid confusion."[6] In a lengthy footnote to this passage, he cites a bibliography of works consulted in three languages. He goes on to explain that he also undertook archival research on rather a large scale, and made a substantial effort to examine works of art at first hand. Every art historian will recognize these procedures as the foundation of the modern discipline. Read what has been written; verify and if possible increase the data by the study of documents; examine and evaluate the original works of art in person—thus, a corpus of reliable knowledge is formed about an artist.

When the time came to commit his research to writing, Ceán chose the time-honored format of the biography. The *Diccionario* is a series of miniature monographs arranged in alphabetical order. The *vida y obras* approach, to give it a name, has continued to be the predominant form of study of the earlier Spanish painters. Ceán deserves full credit for first having applied the

[3] Antonio Palomino, *El museo pictórico y escala óptica*. Antonio Ponz, *Viaje de España*.
[4] *Diccionario histórico*, I, p. iii.
[5] Ibid., I, p. iv.
[6] Ibid., I, p. v.

method to the subject in a serious, critical fashion.[7] However, his historical viewpoint, if such it may be called, is almost nonexistent. Each artist is treated as an autonomous, isolated individual, isolated not only from other Spanish and non-Spanish artists but also from what might be called the broader currents of history. As the title indicates, the book is organized in dictionary fashion, giving the demands of alphabetic progression priority over historical framework. The limitation was deliberate. Having considered the possibilities of using a chronological or geographic framework, Ceán decided finally on the encyclopedic for practical reasons.

> I preferred, then, to use the alphabetic order, arranging all the artists in a list of surnames according to our alphabet, because it was the one most commonly followed in libraries and biographies, and because it has the advantage of allowing the extension or curtailment of the entries according to the merit of each artist, or the amount of information, and finally because of the ease of reference afforded by a dictionary.[8]

Ceán's decision was a logical choice to make for a pioneering work. Yet it is hard not to feel a twinge of unreasonable regret that the foundation of the field was laid with dry masonry. For there is little to distinguish the *Diccionario* from the work of an antiquarian scholar who aims to establish facts but is unconcerned with linking them together to reveal historical concepts and patterns.[9]

The next phase of Spanish art history was produced by a host of non-Spanish writers. Their way to the subject was cleared, first, by Ceán's writings and, second, by a series of political events that, as an unintended consequence, brought foreigners to Spain and Spanish paintings to foreign lands, both in unprecedented numbers. The first event was the Napoleonic occupation of Spain, which lasted from 1808 to 1812. French generals, notably Nicolas Jean de Dieu Soult, who commanded the army in Andalusia, system-

[7] A few of Ceán's contemporaries anticipated his scholarly method as applied to Spanish art although, with one exception, they did not achieve his systematic method. Gaspar Melchor de Jovellanos, the liberal politician, published an historical-critical essay on Spanish art entitled *Elogio de las bellas artes* (Madrid, 1781). His collected writings on art were published by Julio Somoza, *Manuscritos de Jovellanos, inéditos, raros o dispersos* (1913). In Seville, Juan Ignacio de Espinosa y Tello de Guzmán, third count of Aguila, was an ardent collector of art and information about artists, but never published any of his findings. However, he did supply Ponz with much of the data for his volume on Seville; see José M. Carriazo, "Correspondencia de Don Antonio Ponz con el Conde del Aguila," *Archivo Español de Arte y Arqueología*.

Almost exactly at the same time that Ceán was preparing the *Diccionario histórico*, an older contemporary, Eugenio Llaguno y Amirola, was undertaking a similar book on Spanish architects. On his death in 1799, he bequeathed the manuscript to Ceán, who augmented and published it under Llaguno's name as *Noticias de los arquitectos y arquitectura de España desde su restauración*.

[8] *Diccionario histórico*, I, pp. xxx-xxxi.

[9] Later on, Ceán wrote a synthetic history of Spanish painting, dated 1823-1828, which was not published in his lifetime. The manuscript is in the possession of the Academia de Bellas Artes de San Fernando, which published it in installments in *Academia*, 1 (1951), pp. 209-42, and 2 (1953), pp. 25-70.

atically rounded up pictures from churches and monasteries and selected what they wished for their own private collections.[10] The second event, which occurred less than twenty-five years later in 1835, was the Spanish government's decision to disband the religious orders. Almost overnight, the huge monastic and conventual establishments were depopulated. Although the government had intended that their artistic treasures would enter the public domain, a large number of them found their way into private hands. This was the period during which Baron Taylor acquired over four hundred Spanish paintings for Louis-Philippe, which were installed from 1838 to 1848 in the Louvre as the Galerie Espagnole.[11] Spanish collectors were no less avid in their acquisitions, led by such figures as Antonio and Aniceto Bravo, Manuel López Cepero, José de Salamanca, and Alejandro Aguado. In due course, many of these great collections were sold abroad. Hence, starting around 1840, Europe, and especially France and England, was flooded with Spanish paintings and a desire for information about them.

Most of the books that answered this need are little more than pastiches confected from recipes using Palomino and Ceán in varying measures. For example, the precocious book by J. D. Fiorillo, *Geschichte der Mahlerey in Spanien*, published in 1806 as part four of an encyclopedic history of European painting, is Ceán's *Diccionario* put into chronological order.[12] Frédéric Quilliet's *Dictionnaire des peintres espagnols* of 1816 is Ceán's *Diccionario* put into French (and without acknowledgment of its source).[13] So, too, is Louis Viardot's *Notices biographiques sur les principaux peintres de l'Espagne*, published in 1839.[14] Not until 1848 did a worthy successor to Ceán appear.

Sir William Stirling-Maxwell's compendious three-volume work, *Annals of the Artists of Spain*, is extraordinary for its scope and seriousness.[15] The author, a wealthy Scotsman of letters, traveled in Spain in 1843 and became interested in the art of the country. His approach to the subject, like Ceán's, is rooted in the first-hand study of sources, documents, and the works themselves. But, unlike Ceán, Stirling was a well-rounded historian. He did not shy away from qualitative judgments, of which, for example, Velázquez is a beneficiary, and El Greco a victim. More significant, Stirling clearly perceived that the history of painting could not be seen in isolation from political, religious, and social forces. He states this viewpoint in the preface.

[10] A good general account of the dispersion of Spanish paintings in the nineteenth century is found in Juan A. Gaya Nuño, *La pintura española fuera de España*, pp. 16-35. For the collections made by Soult and other French officers, see Illse H. Lipschutz, *Spanish Painting and the French Romantics*, pp. 27-56.

[11] A detailed account of the formation of the Galerie Espagnole is given in Paul Guinard, *Dauzats et Blanchards, peintres de l'Espagne romantique*, pp. 277-91.

[12] J. D. Fiorillo, *Geschichte der Mahlerey in Spanien*.

[13] Frédéric Quilliet, *Dictionnaire des peintres espagnols*. For Quilliet's activities in Spain, see the Marquis del Saltillo, *Mr. Frédéric Quilliet, comisario de Bellas Artes del gobierno instruso en Sevilla el año 1810*.

[14] Louis Viardot, *Notices sur les principaux peintres de l'Espagne*.

[15] William Stirling-Maxwell, *Annals of the Artists of Spain*. A revised edition was published posthumously in London, 1891. For Stirling-Maxwell, see Enriqueta Harris, "Sir William Stirling-Maxwell and the History of Spanish Art," *Apollo*.

I have likewise endeavored to afford some view of the national and social peculiarities of condition in which Spanish artists flourished, and which colored their lives, and directed, or at least strongly influenced, their genius. In pursuance of this object, I have occasionally ventured into the field of history, especially in reviewing the characters of the princes of the Spanish house of Austria, of all royal houses the foremost in the protection and promotion of the fine arts.[16]

In this last sentence, Stirling-Maxwell reveals his understanding of the importance of patronage, especially Hapsburg patronage, another large virtue of his book. This subtle and considered historical perspective still breathes life into a book whose factual basis has largely been superseded by subsequent scholarship. Its panoramic view of the arts in the history of Spain foreshadows a new approach to the field.[17]

Stirling's breadth of vision was equaled by his appreciation of the need for the systematic and detailed study of individual artists. The *Annals* has two appendices, one a catalogue of works by Velázquez, the other of works by Murillo, these painters being the polestars in the firmament of Spanish painting for mid-nineteenth-century taste. These catalogues are what now would be called checklists, giving titles, descriptions of subjects, dimensions, and locations, with a smattering of bibliography. But the systematic arrangement and presentation of these lists, together with their obvious seriousness, entitle them to be considered the first scholarly oeuvre catalogues of Spanish painters. The Velázquez catalogue was enlarged and printed separately in 1855 and seems to have opened a new era in the study of the field.[18] But before considering the advent of the age of the scholarly monograph, we must take note of a remarkable work published in Germany in 1853.

J. D. Passavant's slender volume, *Die Christliche Kunst in Spanien*, was the result of a visit to Spain undertaken in 1852 by this extraordinary connoisseur.[19] Soehner perceptively recognized this book as the originator of a new method of approach to Spanish art.[20] Unlike almost every earlier writer, Passavant eschewed the *vida y obras* approach and relied mostly on his critical faculties to evaluate Spanish art. With his immense knowledge of European, and especially Italian, painting, Passavant was singularly well-equipped to perceive foreign influences on the development of Spanish style. When he encountered the work of a Spanish painter, his mind could draw upon a vast repertory of images to produce a telling comparison to a revelant European

[16] Stirling-Maxwell, *Annals* (1891), I, pp. xxx-xxxi.

[17] Soehner, "Die Geschichte der Spanischen Malerei," p. 294, credits Fiorillo as having been the first to integrate the history of Spain with the history of its art. However, in Fiorillo's book the two are treated in parallel rather than interconnecting fashion. The historical section serves as a preface to the section on artists' lives, which, although organized chronologically, is a potpourri of Ceán and the earlier sources.

[18] William Stirling-Maxwell, *Velázquez and His Works*.

[19] J. D. Passavant, *Die Christliche Kunst in Spanien*.

[20] Soehner, "Die Geschichte der Spanischen Malerei," pp. 282-83.

master or school of painting. This intuitive but informed approach produced a fundamental insight into Spanish painting that would be systematized in the work of later scholars.[21]

The immediate future, however, belonged to the monographists. In the second half of the nineteenth century, the specialized study of a single artist began to take hold. This development is exemplified by two industrious, resourceful works, Charles B. Curtis's *Velázquez and Murillo* of 1883 and Gregorio Cruzada Villaamil's *Anales de la vida y obras de Diego de Silva Velázquez* of 1885.[22] Without too much exaggeration, it may be said that Cruzada was concerned with Velázquez's *vida* and Curtis with his *obras*. Cruzada's book, still an obligatory stopover for those in pursuit of Velázquez, is based on the wealth of important documentation discovered primarily in the archive of the Royal Palace, Madrid. Curtis's approach, on the other hand, combines the talents of a connoisseur and antiquarian. His attempts to trace provenance are truly heroic. Yet despite the differences in emphasis, both books are solidly based on verifiable data; hence their continuing usefulness to scholars. Although Curtis and Cruzada inevitably infuse their personalities, and the tastes of their times, into their studies, the authors are fundamentally concerned with expanding the historical knowledge of the biographies and artistic production of the painters. Neither is much tempted by a wider range of historical questions, such as iconography, patronage, or critical evaluation of style and its origins. During the next thirty years, pioneering monographs were written on virtually every major seventeenth-century Spanish painter except Alonso Cano, all of them taking the same cellular approach to their subjects.[23]

There is one major exception to this trend—Karl Justi's incomparable book, *Velázquez und sein Jahrhundert*, first published in 1888.[24] It is difficult to overestimate the subtlety and richness of this work. The title reveals much about Justi's conception of history. By giving the title of "Velázquez and His Times," as Keane knowingly translated it, Justi demonstrated an awareness of the artist's relation to circumstances beyond the world of the atelier. Justi states his philosophy in a direct way.

> The charm of the old monuments lies in the here embodied special manifestations of spiritual and physical humanity—which being conditioned by certain relations of time, culture and race—can no more recur than can those relations themselves. Hence what we seek and what rivets our attention is a complete representation of

[21] For Passavant's descendants, see ibid., pp. 17-18.

[22] Charles B. Curtis, *Velázquez and Murillo: A Descriptive and Historical Catalogue*; Gregorio Cruzada Villaamil, *Anales de la vida y obras de Diego de Silva Velázquez*.

[23] In addition to Curtis's monograph on Murillo and Cruzada's on Velázquez, the following studies of major artists were published around 1890-1915: Aureliano de Beruete, *Velázquez*; Manuel B. Cossío, *El Greco*; August L. Mayer, *Jusepe de Ribera (Lo Spagnoletto)*; José Cascales y Muñoz, *Francisco de Zurbarán: su época, su vida y sus obras*; José Gestoso y Pérez, *Biografía del pintor sevillano Juan de Valdés Leal*.

[24] (Bonn, 1888). An English edition entitled *Velázquez and His Times*, translated by A. H. Keane and hereafter cited, was published in London, 1889. A Spanish translation, with annotations by J. A. Gaya Nuño, was published in Madrid, 1953.

our common nature, which in each successive epoch is exhibited only in a fragmentary way. . . .

The times of Cervantes and Murillo, when in Spain special forms were created for special material conditions and ways of thought, may also be taken as a special if somewhat limited phase of humanity.[25]

These lines are especially important for an understanding of Justi's approach because of the emphasis on the artistic expression of historical ambiance. Justi is declaring himself to be not a cultural historian, but an art historian who is alive to the influence of cultural developments—specifically, political, social, theological, and literary developments—on the works of art that express or are shaped by these developments. Hence he roams far and wide over seventeenth-century Spain, discussing the people, events, and institutions that form the background to Velázquez's evolution as an artist. Justi sketched his vision of Velázquez's century on a large canvas with broad strokes, leaving it for others to delineate the details. By the breadth of his vision and erudition, he set an example for the study of Spanish Baroque painting that has never been surpassed nor, unfortunately, much imitated.

One other development of the late nineteenth century ought to be noted— the emergence of archival research and publication. The beginning of serious archival research on Spanish art is identified with Valentín Carderera y Solano.[26] Working in the 1830s and 1840s, Carderera, who was a painter, made a copious accumulation of documentary transcriptions from archives in Aragon, Catalonia, and Castile, most of which contained material from the middle ages. Unfortunately, he succeeded in publishing only a small percentage of his discoveries. This task was later undertaken and expanded by the count of la Viñaza, whose work entitled *Adiciones al Diccionario histórico de Ceán Bermúdez* appeared in 1889.[27] The modest title belies the importance of this valuable work, although it does indicate its ancestry. Like the *Diccionario histórico*, the *Adiciones* is ordered alphabetically by artists' names. However, unlike Ceán's dictionary, the emphasis is on documents, not on works of art.

Other important compendia of newly discovered documents were published in the decades that immediately surround 1900. As a rule, investigation was carried out by local archivists and pertained to the city or province where they worked. Outstanding examples of this sort of publication were produced by Zarco del Valle (Castile), Pérez Pastor (Madrid), Ramírez de Arellano (Córdoba), the baron of Alcahalí (Valencia), Martí y Monsó (Valladolid), and Gestoso y Pérez (Seville).[28]

[25] Justi, *Velázquez*, p. 7.

[26] For a résumé of Carderera's life, see the necrology by Pedro de Madrazo, *Boletín de la Real Academia de la Historia*, pp. 5-12 and 105-26.

[27] *Adiciones al Diccionario histórico de los más ilustres profesores de las bellas artes en España de D. Juan Agustín Ceán Bermúdez*.

[28] Manuel Zarco del Valle, *Documentos inéditos para la historia de las bellas artes en España*; Cristóbal Pérez Pastor, *Noticias y documentos relativos a la historia y literatura española*; Rafael Ramírez de Arellano, *Diccionario biográfico de artistas de la provincia de Córdoba*; baron of Alcahalí, *Diccionario biográfico de artistas valencianos*; José Martí y Monó,

In 1914, the Centro de Estudios Históricos initiated a series of documentary publications that lapsed after only two volumes had appeared.[29] But the spirit of this enterprise was revived in two projects concerned with art in Seville and its region. The first was an individual undertaking by Celestino López Martínez, whose four volumes of documents on Sevillian artists are a cornerstone of the field.[30] Even more ambitious was the ten-volume series sponsored by the Laboratorio de Arte of the University of Seville, which involved a number of scholars.[31] Later on, archivists such as Estéban García Chico, the marquis del Saltillo, and María Luisa Caturla contributed significantly to the factual basis of seventeenth-century Spanish painting.[32]

Without pretending to be exhaustive, this brief and selective survey has attempted to show the direction in which studies of seventeenth-century Spanish painting were heading by the end of the nineteenth century. One conclusion is inescapable—the monographic and documentary approaches had carried the day. The differences between Ceán Bermúdez and his nineteenth-century successors are differences of degree, not of kind. Research had become somewhat more sophisticated, but no one, except Justi and, to a lesser extent, Stirling-Maxwell, had been able to perceive a broader range of historical questions that might serve to explore and explain the art of the period. This seeming reluctance to venture beyond the *vida y obras* approach had, of course, a rational explanation. It was difficult, and perhaps even pointless, to generalize about a subject whose specifics were imperfectly known. And in 1900, there were still significant gaps in knowledge about the most important painters, and nothing but gaps where the secondary figures should have been standing.

It is at this juncture that the history of Spanish painting entered its academic and scientific phase. Until the late nineteenth century, most of the research and writing was carried on by amateurs of art. Some were artists themselves, others were collectors or men of letters who developed a passion about the subject, which they expressed in research and writing. But around 1900, the professional scholar, usually trained in a university and often a

Estudios histórico-artísticos relativos principalmente a Valladolid; José Gestoso y Pérez, *Ensayo de un diccionario de los artífices que florecieron en Sevilla desde el siglo XIII al XVII inclusive.*

[29] *Notas del Archivo de la Catedral de Toledo, redactadas sistemáticamente en el siglo XVIII, por el canónigo-obrero Don Francisco Pérez Sedano; Documentos de la Catedral de Toledo, coleccionados por Don Manuel R. Zarco del Valle.*

[30] *Retablos y esculturas de traza sevillana* (Seville, 1928); *Arquitectos, escultores y pintores vecinos de Sevilla* (Seville, 1928); *Desde Jerónimo Hernández hasta Martínez Montañés* (Seville, 1929); *Desde Martínez Montañés hasta Pedro Roldán* (Seville, 1932).

[31] *Documentos para la historia del arte en Andalucía.*

[32] Estéban García Chico, *Documentos para el estudio del arte en Castilla*; and *Nuevos documentos para el estudio del arte en Castilla* (Valladolid, 1959). Marquis del Saltillo, *Artistas y artífices sorianos de los siglos XVI y XVII (1509-1699)*; "Efemérides artísticas madrileñas del siglo XVII," *Boletín de la Academia de la Historia*; "Efemérides artísticas madrileñas (1603-1811)," *Boletín de la Sociedad Española de Excursiones*; and "Artistas madrileños (1592-1850)," *Boletín de la Sociedad Española de Excursiones*.

María Luisa Caturla is best known for her discoveries of important documents pertaining to Zurbarán, the most important of which are listed in Jonathan Brown, *Zurbarán*, pp. 157-58.

university professor or museum curator, made his appearance. This development is personified in Elías Tormo y Monzó (1869-1954), a scholar of astonishing productivity and range.[33] Tormo's bibliography includes over five hundred entries on a great variety of subjects (a certain portion of which comprises occasional pieces for newspapers and popular magazines).[34] His work on seventeenth-century painting is not preponderant in the context of his total production; after 1930 he ceased to write on this subject. But it is unified by a clear historical vision that made his contributions very influential, especially in Spain.

The difference between Tormo's approach and that of the nineteenth-century scholars is substantial, but not complete. Although he often wrote in a mannered prose style, Tormo was committed to a positivistic view of art history. His concern with facts, as furnished and corroborated by primary sources, is everywhere apparent in his best work. The dedication to factualism was accompanied by a no less ardent desire for systematization. In the early years of this century, Tormo and Manuel Gómez-Moreno founded the art history and archaeology section of the Centro de Estudios Históricos, the purpose of which was to create tools for and propagate the methods of a scientific study of art. As the central institute for art history in Spain, this organization, later continued as the Instituto Diego Velázquez, became influential in setting the direction for the field. The centerpiece of the art history section was to be an ambitious "data bank," which Tormo described in 1914.

> The Centro de Estudios Históricos is incorporating this publication [of documents] into the enterprise that is under way to establish, in the form of a card catalogue, using a modern system of reference cards, the "General Corpus of Additions to the Dictionary of Spanish Artists." Included in this catalogue will be not only all the artists cited by Ceán and his precursors (Pacheco, Carducho, Palomino, Ponz, etc.), and his successors in other regions . . . and in various cathedrals, . . . but also the names of the authors of the most difficult-to-find historiographic studies of Spanish art.[35]

In other words, Tormo deliberately set out to perpetuate, and also to expand and refine, Ceán's artistic dictionary. The task was immense, in fact too large for accomplishment. Yet, paradoxically, the ideals set for the field by this apparatus were confined to the ones articulated by the founding father one hundred years earlier—the pursuit and classification of facts about artists and works of art.

Tormo, to be sure, was much more than a stalker after facts. The factual basis of his research was accompanied by a highly developed sense of histori-

[33] I want to emphasize again that this essay is not intended to be a comprehensive survey of scholarship on seventeenth-century Spanish painting, but rather an analysis of the primary methods used by scholars of the field. Hence, for example, the work of the prolific German scholar, August L. Mayer (1885-1944), whose earlier studies are important, is omitted because his approach is fundamentally similar to Tormo's.

[34] For a résumé of Tormo's life and career, and a listing of his major publications, see the necrology by Francisco J. Sánchez Cantón in *Boletín de la Academia de la Historia*.

[35] *Notas del Archivo de la Catedral de Toledo*, 1914, pp. viii-ix.

cal criticism. Tormo characteristically used a fundamental method of modern historical research by formulating hypotheses, which were corroborated or amended according to the evidence at hand. However, he also realized that some questions were unanswerable in the light of available data, and he did not hesitate to leave an open question open.

Furthermore, Tormo possessed a fine conception of what constituted historical inquiry—he knew what questions to ask. This capacity is demonstrated in his study of Antonio Pereda, published between 1910 and 1915.[36] The work is divided into nineteen sections which painstakingly scrutinize and reconstruct the facts of Pereda's life and works. In the first seven sections, Tormo compares and analyzes the main early sources of information—Díaz del Valle, Palomino, Ceán Bermúdez—and establishes an accurate text for the short biography by Díaz del Valle. Section eight is a list of surely dated works. The following two sections discuss in detail the dates of Pereda's two most famous works—the *Relief of Genoa* and the *"Dream of the Knight,"* the date of the latter being referred to as *"archiproblemática."* In subsequent sections, Tormo reconstructs the biographies of two important patrons and treats the reasons for Pereda's failure to succeed at court. Each of these questions is examined with exemplary thoroughness and elucidated, when possible, by newly discovered documents whose implications for the point under discussion are fully explored.

Tormo's passion for the undiscovered made him especially aware that many important seventeenth-century painters had been relatively or entirely neglected by earlier students. Blessed with an insatiable curiosity, the boundless energy to satisfy it, and also by a scholarly discipline, he devoted part of his efforts to the rediscovery and reevaluation of artists such as Zurbarán, Ribalta, Juan Cabezalero, Fray Juan Ricci, and Mateo Cerezo.[37] This passion for discovery coupled with a disciplined scholarly method made Tormo a potent force in the study of art history in Spain. (Of course his was a method whose time had come, as art historians everywhere were stepping across the threshold of specialized studies.) However, as the establishment of the corpus shows, the distance between Tormo and the nineteenth-century writers is not as great as first it may seem. Like his predecessors, Tormo tended to see seventeenth-century painting as a succession of individual artists bound together by little more than the coincidence of time and place, and only minimally responsive to forces outside the world of art. The methodological advance represented by Tormo sharpened the tools used to identify and classify painters and paintings, but added little to the process of interpreting the results. Tormo's dedication to the "objective" approach may be explained by his proper concern for setting the factual record straight before attempting to see how the facts fit together.

[36] Elías Tormo y Monzó, "Un gran pintor vallisoletano: Antonio de Pereda," *Boletín de la Sociedad Castellana de Excursiones*.

[37] *El Monasterio de Guadalupe y los cuadros de Zurbarán;* "Más de Cabezalero, pintor de la escuela de Madrid," *Boletín de la Sociedad Española de Excursiones;* "La educación artística de Ribalta, padre, fué en Castilla," *Revista Crítica Hispanoamericana;* "Mateo Cerezo," *Archivo Español de Arte y Arqueología;* (with Celestino Gusi and Enrique Lafuente Ferrari), *La vida y obra de Fray Juan Ricci.*

In the past fifty years, thanks to the labors of both Spanish and foreign scholars, considerable progress has been made in accomplishing this goal. We now have reliable monographic books and articles on many of the major figures including El Greco, Zurbarán, Cano, Ribalta, and, of course, Velázquez.[38] Research on other important artists such as Carducho, Murillo, Ribera, Valdés Leal, and Herrera the Younger is being actively pursued.[39] Some of the lesser lights, such as Francisco Pacheco, Sebastián de Herrera Barnuevo, Francisco Camilo, Francisco Rizi, Jerónimo Jacinto de Espinosa, and Juan Antonio Escalante, have been restored to their former glow.[40] There are even satisfactory studies of very minor figures, such as Alonso del Arco, Diego Polo, Matías de Torres, and Francisco Solís.[41] Gaps remain in our knowledge, to be sure. The names of Claudio Coello, Antonio Pereda, Jusepe Leonardo, Juan Carreño de Miranda, Juan de las Roelas come immediately to mind as some among the several Baroque painters who need closer study. But even here, there is the promise of progress, especially in the remarkable corpus of Spanish seventeenth-century painting that is being produced by Diego Angulo Iñiguez and Alfonso Pérez Sánchez.[42] This ambitious project, which is the newest branch of a genealogical tree that traces its origins to

[38] For El Greco, see Harold E. Wethey, *El Greco and His School*. For Zurbarán, see Martin S. Soria, *Zurbarán*; and Guinard, *Zurbarán*. For Cano, see Harold E. Wethey, *Alonso Cano. Painter, Sculptor, Architect*. For Ribalta, see Delphine F. Darby, *Francisco Ribalta and His School*, and José Camón Aznar, *Los Ribaltas*. For Velázquez, see José López-Rey, *Velázquez. A Catalogue Raisonné of His Oeuvre*.

[39] For Carducho, see Mary C. Volk, *Vicencio Carducho and Seventeenth Century Castilian Painting*. For Murillo, see Jonathan Brown, *Murillo and His Drawings*, and the soon-to-be-published catalogue raisonné by Diego Angulo. For Ribera, see Elizabeth Trapier, *Ribera*, and Jonathan Brown, *Jusepe de Ribera: Prints and Drawings*; catalogues raisonnés are being prepared by José Milicua and Craig M. Felton ("Jusepe de Ribera: A Catalogue Raisonné," Ph.D. Diss., University of Pittsburgh, 1971). For Valdés Leal, see Elizabeth Trapier, *Valdés Leal*, and Duncan Kinkead, "Juan de Valdés Leal (1622-1690): His Life and Work." For Herrera the Younger, see Jonathan Brown, "Pen Drawings by Herrera the Younger," in *Hortus Imaginum. Essays in Western Art*, ed. Marilyn Stokstad and Robert Enggass, pp. 129-38, and "Drawings by Herrera the Younger and a Follower," *Master Drawings*.

[40] For Pacheco, see Priscilla E. Muller, "Francisco Pacheco as a Painter," *Marsyas*. For Herrera Barnuevo, see Harold E. Wethey, "Sebastián de Herrera Barnuevo," *Anales del Instituto de Arte Americano e Investigaciones Estéticas*. For Camilo, see Diego Angulo Iñiguez, "Francisco Camilo," *Archivo Español de Arte*, 32 (1959), pp. 89-107. For Francisco Rizi, see Diego Angulo Iñiguez, "Francisco Rizi. Su vida. Cuadros religiosos anteriores a 1670," *Archivo Español de Arte*; "Francisco Rizi. Cuadros religiosos posteriores a 1670 y sin fechar," *Archivo Español de Arte*; "Francisco Rizi. Cuadros de tema profano," *Archivo Español de Arte*; "Francisco Rizi. Pinturas murales," *Archivo Español de Arte*. For Jerónimo Espinosa, see Alfonso E. Pérez Sánchez, *Jerónimo Jacinto de Espinosa*. For Escalante, see Enrique Lafuente Ferrari, "Escalante en Navarra y otras notas sobre el pintor," *Príncipe de Viana*, and Jose R. Buendía, "Sobre Escalante," *Archivo Español de Arte*.

[41] For Alonso del Arco, see Natividad Galindo San Miguel, "Alonso del Arco," *Archivo Español de Arte*. For Polo, see Alfonso E. Pérez Sánchez, "Diego Polo," *Archivo Español de Arte*. For Torres, see Alfonso E. Pérez Sánchez, "Don Matías de Torres," *Archivo Español de Arte*. For Solís, see Aurora Miró, "Francisco Solís," *Archivo Español de Arte*.

[42] *Historia de la pintura española. Escuela madrileña del primer tercio del siglo XVII*, and *Historia de la pintura española. Escuela toledana de la primera mitad del siglo XVII*.

Ceán via Tormo, has established the goal of producing succinct catalogues of all seventeenth-century Spanish painters, grouped according to their dates and to the city or region where they worked. In the first two volumes, which cover the first third of the century in Madrid and the first half in Toledo, the work of V. Carducho, E. Cajés, Maino, Sánchez Cotán, Orrente, and Tristán has been brought together with unprecedented thoroughness. When and if the corpus is completed, we will have a formidable accumulation of material from which to construct a more faceted history of Spanish Baroque painting.

If this survey of methods has seemed to place undue emphasis on monographic research, it is because the monograph has been by far the most cultivated approach to Spanish Baroque painting. Yet, necessary though it will continue to be, the monograph, insofar as it focuses exclusively on reconstructing the life and works of an artist, has inherent limitations. Hence, the time seems ripe to expand the frame of reference and methods of the field. The single-minded pursuit of new data has produced invaluable knowledge, but it has also provided a one-dimensional image of Spanish Baroque painting. By concentrating almost exclusively on the artists' lives and their works and by placing discovery above interpretation, art historians have minimized the variety and complexity of this rich period of Spanish art and have produced a picture of the painter isolated from the forces that shaped his work.

The most promising new avenue of approach to the subject seems to be one that seeks to integrate Spanish Baroque painting with the cultural, social, and political institutions that brought it into being. This approach is eclectic in its use of art historical methods now in practice. It draws, in the first place, upon methods of iconographical analysis. The critical study of subject matter in Spanish painting is not very advanced. There have been thematic studies such as those of Manuel Trens, which have traced the changing expressions of representations of important articles of faith, such as the Eucharist and the Virgin Mary, although more in a descriptive than in a analytical fashion.[43] On a more sophisticated plane, Julián Gállego's invaluable book, *Vision et symboles dans la peinture espagnole du siècle d'or*, attempts to describe and analyze the use of a symbolic language in painting of the period.[44] And studies of individual paintings or groups of paintings of El Greco by Harris and Blunt, or Ribera by Darby, of Velázquez by Tolnay and Angulo, and of Murillo by Kubler have demonstrated how much precise and imaginative iconographical studies can tell us about painting as the expression of prevailing currents of thought.[45]

[43] Manuel Trens, *María, iconografía del la Virgen en el arte español*, and *La eucaristía en el arte español*.

[44] Julián Gállego, *Vision et symboles dans la peinture espagnole du siècle d'or*. Also important but overlooked is Giuseppina Ledda, *Contributo allo studio della letteratura emblematica in Spagna (1549-1613)*.

[45] Enriqueta Harris, "A Decorative Scheme by El Greco," *Burlington Magazine*, and Anthony Blunt, "El Greco's 'Dream of Philip II': An Allegory of the Holy League," *Journal of the Warburg and Courtauld Institutes*. Delphine F. Darby, "Ribera and the Blind Men," *Art Bulletin*, and "Ribera and the Wise Men." Charles de Tolnay, "Velázquez' *Las Hilanderas* and *Las Meninas* (An Interpretation)," *Gazette des Beaux-Arts*; Diego Angulo Iñiguez, "Las Hilanderas," *Archivo Español de Arte*, and "La fábula de Vulcano,

Iconography helps to reveal the explicit meaning of a painting, but may leave unanswered the question of why certain visual types were summoned forth by the artist or his patron. Recently, art historians have been inclined to understand motives for artistic creation by what may be called contextual art history. Without examining here the method in detail, it can be said to derive in part from cultural history, as exemplified by such classics as Burckhardt's *Civilization of the Renaissance* or Huizinga's *Waning of the Middle Ages*, in part from the philosophy of *Geistesgeschichte* introduced by Max Dvórak in the 1920s, and in part from the sophisticated methods of symbolic interpretation employed by Fritz Saxl and Erwin Panofsky and their followers. But whereas the cultural historians tend to discuss culture and its artistic manifestations on a general plane, contextual art history operates within narrower confines and seeks to produce more precise results. Millard Meiss's great book, *Painting in Florence and Siena after the Black Death*, is a landmark in the application of this method and lucidly illustrates the process by which the "contextual" art historian describes how works of art respond to specific historical conditions.[46] Contextual art history, then, seeks to place a work of art in the historical-ideological frame of reference in which it was created and to reveal the way in which it expresses ideas in the compressed, charged language of artistic style.

Such an approach, although not uncommon in the study of European art, has seldom been applied to Spanish Baroque painting. And yet Spanish Baroque painting was exceptionally responsive to a myriad of social, religious, and political forces. Although Spain's power declined in the course of the seventeenth century, it was at the center of European history throughout the period. Its complex society shared many interests with other European countries, but also fostered institutions unique unto itself. All of these entities underwent change in this dynamic period of history. The relationship of the arts to certain structural developments of Spanish history has been keenly described by the historian Antonio Domínguez Ortiz. Writing about learning and science, literature and the visual arts in Golden Age Spain, Domínguez Ortiz makes these fundamental points.

All three [fields] are influenced by a series of factors which have to be examined in any attempt to explore the subject in real depth. One of these is the aristocratic character of Spanish society with its universal aspiration after nobility, its cult of valor, honor and personal dignity and its contempt for "low and base" callings. Another is the profound religious ethos which is all-pervasive, including the nonconformist strain, struggling for expression within or beyond the limits of orthodoxy. . . . The economic situation influenced the higher reaches of culture: the irreparable decline after 1640 had a malign effect throughout. Nor can we overlook the enormous dis-

Venus y Marte y 'La Fragua' de Velázquez," *Archivo Español de Arte*. George Kubler, "El 'San Felipe de Heraclea' de Murillo y los cuadros del claustro chico," *Archivo Español de Arte*.

[46] (Princeton, 1951).

crepancies between the progressive areas, where groups of schools of writers and artists sprang up (Seville, Granada, Valencia, Valladolid and later Madrid) and the impoverished rural areas with little cultural activity. Last but not least we must remember that this remote peninsula of Spain was never more united with the rest of Europe than it was in those days, by every kind of contact. There was a constant interchange of men and ideas, which acquired a particular intensity where Italy was concerned.[47]

In other words, the art of painting was at every instant responsive to the organization and institutions of society.

In surveying this vast, uncharted area of study, several fields seem especially promising for cultivation by this method. For instance, it is a truism to say that seventeenth-century Spanish painting is predominately religious in content. But this simple truth veils a complicated reality, because the Spanish Catholic Church was not a monolithic institution. Domínguez Ortiz has elucidated one of several important distinctions in the organization of the church—monastic versus parochial clergy. The religious orders, he observes,

were highly specialized sectors of the church, whether as teachers or ascetics, and were well to the forefront of the struggle against any heterodox tendencies. They had a zest for combat which the secular clergy had lost, living as they did like laymen and in close dependence on the state.[48]

Hence, we might expect to find significant differences between paintings done for parish churches and those for monastic churches and cloisters, and indeed differences do exist. Moreover, perceptible distinctions are found even from order to order, as for example a cloistered order such as the Carthusians as against a worldly order such as the Society of Jesus. Within the sphere of the secular clergy, it can be important to distinguish between a work done for a cathedral at the behest of a cardinal or archbishop, and one done for a parish church on commission from the parish priest or a private donor. Finally, the lay confraternity, an important social and religious institution in the seventeenth century, had its own set of requirements for an artistic enterprise.[49] Only a detailed analysis of the history, goals, and personality of these institutions, coupled with a consideration of local conditions that might include the director of the project or a specifically motivated desire for self-assertion, can produce an understanding of why a work of art came into being and what its purpose was meant to be.

A second major area for exploration is art at the court. The monarchy was by far the most important secular institution, but its impact on the art of the time has been neglected, despite the fact that the Spanish Hapsburgs seem to have been exceptionally aware of the value of art as a means of expressing their imperial aspirations. As the studies by Taylor, Rosenthal, and Tanner have shown, an imperial iconography, partly dynastic, partly personal, was

[47] Antonio Domínguez Ortiz, *The Golden Age of Spain 1516-1659*, p. 230.
[48] Ibid., p. 200. [49] For example, see Chapter 6, below.

developed in the sixteenth century by Charles V and Philip II.[50] What of its fate in the seventeenth century? Both Philip III and Philip IV built or redecorated royal palaces, including El Pardo, the Alcázar of Madrid, and the Buen Retiro, usually employing the leading artists of the time. None of these major works has been critically examined.[51] In his later years, Velázquez assisted Philip IV in the redecoration of certain state rooms in the Alcázar; did the sovereign and his *pintor de cámara* have a plan in mind when they carried out the work? The answer will not be known until these royal commissions have been studied with the requisite care to determine how they express the institution of an empire that was transformed in the course of the century. The study of ephemeral festival decorations begun by J. E. Varey has indicated another fruitful area of investigation that will help us to understand art in the service of monarchy.[52] The results of these lines of approach may also provide some insights into the relationship of Spanish imperial symbolism and the European vocabulary of monarchical expression.

The seventeenth century in Spain was also an amazingly rich period for art collecting. Philip IV was one of the most ambitious collectors of his time, yet almost nothing has been written about his taste in art or the means by which he enlarged his collection.[53] Furthermore, a host of avid, discriminating collectors existed among the Spanish nobility. The count of Monterrey, the marquis of Leganés, the marquis del Carpio, and other aristocrats made fabulous collections of Italian art about which very little is known.[54] The subject is not only inherently interesting but also full of implications for the development of style in Spanish painters.

Knowledge of these extrinsic factors is the necessary prerequisite to understanding the forms in which they were incorporated. However, the study of subject, even in the broadest sense, is not a substitute for understanding style. Stylistic development has a logic of its own, which is motivated in part by purely artistic factors. The evolution of style in Spanish painting during the seventeenth century has much to do with the impact of innovative non-

[50] René Taylor, "Architecture and Magic: Consideration of the Idea of the Escorial," in *Essays in the History of Architecture Presented to Rudolf Wittkower*, eds. Douglas Fraser, Howard Hibbard, and Milton J. Lewine (London, 1967), pp. 81-109; Earl Rosenthal, "The Invention of the Columnar Device of Emperor Charles V at the Court of Burgundy in Flanders in 1516," *Journal of the Warburg and Courtauld Institutes*, and *"Plus Oultre*: The *Idea Imperial* of Charles V in his Columnar Device on the Alhambra," in *Hortus Imaginum*, pp. 85-93; Marie Tanner, "Titian: the *'Poesie'* for Philip II."

[51] The only exception is the Torre de la Parada, the subject of an excellent monograph by Svetlana Alpers, *The Decoration of the Torre de la Parada*, Corpus Rubenianum Ludwig Burchard, vol. 9.

[52] See, for example, Varey, "Calderón, Cosmé Lotti, Velázquez and the Madrid Festivities of 1636-37," *Renaissance Drama*; "L'Auditoire du Salón Dorado de l'Alcázar de Madrid au XVIIe siècle," in *Dramaturgie et Société. Rapports entre l'oeuvre théâtrale, son interprétation et son publique aux XVIe et XVIIe siècles*; and "Motifs artistiques dans l'entrée de Marianne d'Autriche a Madrid en 1649," in *La Fête théâtrale et les sources de l'opera. Actes de la 4e session des Journées Internationales d'Etude du Baroque*.

[53] See Pedro Beroquí, *El Museo del Prado (Notas para su historia)* (Madrid, 1933), for a brief introduction to the subject.

[54] See Alfonso E. Pérez Sánchez, *Pintura italiana del s. XVII en España*, pp. 63-72, for a short discussion and further bibliography.

Spanish artists, notably Caravaggio and Rubens. Recent studies by A. E. Pérez Sánchez have done much to clarify the Italian origins of Spanish painting in the early seventeenth century.[55] When comparable work has been accomplished on the influence of Rubens after 1640, we will be able to comprehend how Spanish painters evolved the more dynamic style of the later part of the century. The study of compositional sources, an allied field, is more advanced and has a certain amount to contribute to understanding stylistic evolution, if only prudence and common sense can restrain the impulse to adduce improbable antecedents for paintings.[56]

Finally, the artistic theory of the period needs attention in order to determine the attitudes held by painters to their art.[57] There is no modern edition of Carducho's important *Diálogos de la pintura*, not to mention a thorough study of its aesthetic philosophy or its relation to the art of its time. In short, the method of contextual art history, as applied to Spanish Baroque painting, needs to take full account of the processes by which painters converted the wishes of their patrons into works of art. This organic process seems to offer the best hope for restoring some of the variety and substance that Spanish Baroque painting originally possessed.

Methods can only be judged in their applications. The four studies this book comprises offer not only new information about their subjects but also an opportunity to substantiate, reject, or alter the claims made here for this method of approach to Spanish painting. Part I, the longest section of the book, examines the literary-artistic academy of Francisco Pacheco and its interaction with the humanistic and theological currents of the time. It also attempts to show how this academy helped to shape some of the attitudes and practices of painting in Seville during the first third of the seventeenth century. Part II consists of three individual studies of a work or group of works by major painters. The essay on *Las Meninas*, that most-written-about of paintings, delineates a prevalent social attitude and demonstrates how the greatest painter of the time created his greatest painting in response to it. The other two studies treat commissions from two types of religious organizations, the monastic order and the lay confraternity, and aim to reveal not only the specific circumstances that brought the paintings into being but also the diversity of patronage within the Catholic Church and its implications for artistic creation.

Obviously, it would be desirable to extract some general principles about seventeenth-century Spanish painting from these specific examples. But it is premature to advance this kind of synthetic view with so much work still to be done. It will suffice if this book can draw attention to the needs of the field and offer a few examples of how they might be met.

[55] "La crisis de la pintura española en torno a 1600," in *España en las crisis del arte europeo*, pp. 167-77; "Carlo Saraceni á la Cathedrale de Toledo," in *Actes du XXII^{eme} Congrès International d'Histoire de l'Art*, pp. 25-32; *Caravaggio y el naturalismo español*.

[56] The systematic study of compositional sources effectively begins with two publications: Diego Angulo Iñiguez, *Velázquez, como compuso sus cuadros principales*, and Martin S. Soria, "Some Flemish Sources of Baroque Painting in Spain," *Art Bulletin*.

[57] The study of Spanish art theory by Marcelino Menéndez Pelayo, *Historia de las ideas estéticas en España*, IV, pp. 7-153, although out of date, has yet to be superseded.

PART I

THEORY AND ART IN THE ACADEMY OF FRANCISCO PACHECO

1

A Community of Scholars

The academy of Francisco Pacheco is famous in the history of Spanish art; scarcely a handbook fails to mention the organization that was the breeding ground for the young Velázquez, who became Pacheco's apprentice in 1611. Yet for all its renown, we know very little of the academy. Most writers have been content to quote or paraphrase a line from Palomino's 1724 biography of Velázquez: "The house of Pacheco was a gilded cage of art, the academy and school of the greatest minds of Seville."[1] Palomino adds nothing more about the academy, nor, with one exception, do any of the earlier sources. In his unfinished book on famous literati, *Varones insignes en letras*, Rodrigo Caro, who was a member of the academy, devotes a line to it. Speaking of the poet Fernando de Herrera, Caro writes: "While he lived, his poetry was never published. This was done by Francisco Pacheco, celebrated painter of this city, whose studio was an academy frequented by the most learned spirits of Seville and elsewhere."[2] Caro is a valuable eyewitness to the academy, but unfortunately he never described its activities or membership. Hence, unanswered questions remain. Who were the members? What were their interests? How did the academy come into being? and What was its influence on the art of its time? The answers are important not only because they illuminate the beginnings of Velázquez, but also because they provide information about a unique interaction of the arts and letters in seventeenth-century Spain. The absence of an organized record may in part be overcome by analyzing certain developments in Seville's intellectual life as described in the writings of its leading figures, especially those of Pacheco.

Pacheco's academy originated in one of the several academies that came into existence in Seville during the sixteenth century.[3] These academies were

[1] Palomino, *El museo pictórico*, p. 892.

[2] Rodrigo Caro, *Varones insignes en letras*, p. 60. Caro began this encyclopedia in the last year of his life, 1647, and died before finishing it.

[3] For literary academies in Seville during the sixteenth and seventeenth centuries, see the list compiled by the nineteenth-century historian Gómez Azeves, as transcribed by Federico Sánchez y Escribano, *Juan de Mal Lara*, p. 78, note 1. (The original list is preserved in an unpublished manuscript in the Biblioteca Económica de Amigos del País de Sevilla, Seville.) A fundamental work is Joaquín Hazañas y La Rua, *Noticia de las academias literarias, artísticas y científicas de los siglos XVII y XVIII*. More recently, the academies in Seville have been discussed briefly within the wider context of Spanish academies by José Sánchez, *Academias literarias en el siglo XVII*, pp. 194-219, and Willard King, *Prosa novelística y academias literarias en siglo XVII*, pp. 25-27. Gómez Azeves and Sánchez, and King to a lesser extent, unnecessarily multiply the number of academies by counting each academic meeting place as a separate academy. Although these informal academies had no fixed membership, it is possible at times to discern a nucleus

essentially imitations of the Italian literary academy, itself a descendant of the Neo-Platonic academy organized in the fifteenth century by Marsilio Ficino in his villa outside Florence.[4] In these academies, scholars and humanists met informally to discuss matters of mutual interest and to criticize and assist works in progress. Their ultimate aim was not to achieve specific, formulated objectives, but rather to create a congenial atmosphere wherein ideas might be conceived and tested. This model was clearly in the mind of Juan de Mal Lara when he suggested the creation of academies in Seville:

> Although it is not done in Spain, in other countries it is a laudable custom for all learned men to assist someone who is writing, and even to have the authors read their work in the academies formed for this purpose, and for everyone to give their opinions and to say notable things and, with a certain modesty, to give it all to the author without publishing the fact that they did him favors.[5]

This kind of academy came into being whenever a group of men—scholars, poets, amateurs of letters—decided to meet at irregular and unspecified intervals to pursue a common interest. Enlightened members of the nobility were also included, for reasons of convenience as well as merit, because they were likely to have a commodious library or study that could serve as a meeting place. Friendship and camaraderie were the mortar of an academy's structure, and it is possible that a person who was disliked by a majority of the members could not have gained admittance into the circle, no matter what his credentials.

The origins of Seville's academies are difficult to trace because of their informal organization. No minutes were kept of the meetings, the only records being the literary and artistic production of its members, to which we must look to judge the nature of a specific group. One of the most important academies was formed under the aegis of the scholar-poet Juan de Mal Lara.[6] Two generations later, this academy would become the academy of Francisco Pacheco. Mal Lara was born in Seville in 1524. He began his humanistic education at the University of Salamanca and continued his studies in Barcelona (1540-1547). After spending another year in Salamanca he returned to his native city in 1548, where he opened a small school, called the *estudio*, which was devoted to instructing young boys in humanistic letters, emphasizing Greek and Latin grammar and the ancient classics. Several fine humanists

of a few men who, in the fashion of a bridge club, took turns playing host to each other. They can be thought of as belonging to a single academy.

[4] A brief description of the Florentine Neo-Platonic academy is found in André Chastel, *Marsile Ficin et l'art*, pp. 7-15.

[5] *La philosophía vulgar*, "A los lectores," sig. avi verso.

[6] The basic biographies of Mal Lara are Federico Sánchez y Escribano, *Juan de Mal Lara*, and Daniel Pineda Novo, "Juan de Mal Lara, poeta, historiador y humanista del siglo XVI," *Archivo Hispalense*. Also the introductory chapter in Juan de Mal Lara, *Filosophía vulgar*, ed. Antonio Vilanova, vol. I, pp. 9-45. King, *Prosa novelística*, pp. 25-26, pointing to the lack of an explicit reference to Mal Lara's academy, hesitates to accept its existence. However, given the academy's deliberate informality, the absence of such particular evidence is not surprising. As will be shown below, its existence can safely be inferred.

were educated in Mal Lara's school, the best of whom was Francisco de Medina, a vital link in the succession of the academy from Mal Lara to Pacheco. The exact date of the formation of the academy, which was distinct from the *estudio*, is unknown, because it began and developed coevally with Mal Lara's friendships. A brief description written in 1612 partially lists its participants, together with the academic nicknames assigned to each member.[7] After 1565, meetings were occasionally held in the city palace and the country villa of Alvaro Colón y Portugal, the second count of Gelves (1534-1581), who was the academy's noble patron. His connection with the academy is documented by a book (*In Aphtonii Progymnasmata*) that Mal Lara dedicated to him in 1567.[8]

The interests of the academy were to a large extent determined by Mal Lara, whose thorough education had given him an impressive command of humanistic letters. By example and by personal influence, he created the distinctive pattern that characterized the academy during and after his tenure as its leader. Like many humanists of the day, the cornerstone of his activity was an encyclopedic curiosity that is most evident in his best known work, *La philosophía vulgar*, published in Seville in 1568. The *Philosophía* is an imitation of Erasmus's *Collectanea Adagiorum*, and, like this work, it is a collection of a thousand common proverbs (*refranes*) accompanied by scholarly explanations.[9] Mal Lara's premise, borrowed from Erasmus, was that these adages embodied remnants of divine wisdom imparted by God to Adam at the moment of Creation, which then were passed down from father to son in the familiar epigrammatic form. In the explanatory passages, or glosses, Mal Lara brings to bear the full weight of his humanistic erudition, which included ancient authors and their scholiasts as well as an ample store of patristic texts and biblical commentaries.

One of the more ambitious glosses demonstrates Mal Lara's scholarly procedure. In his discussion of the proverb *"Yra de hermanos yra de diablos,"* which can be translated "Fraternal anger is the anger of devils," Mal Lara writes a history of fraternal relationships from Cain and Abel to Romulus and Remus. After an initial explanation of the proverb's obvious meaning, he undertakes a two-part treatise on the causes, effects, and kinds of brotherly animosity. The first part is dedicated to incidents drawn from Greek and Roman history, although at one point he cites an example from Inca history as described by

[7] Luis Pacheco de Navaez, *Compendio de la filosofía y destreza de las armas de Gerónimo Carranza* (Madrid, 1612). Cited by Sánchez y Escribano, *Juan de Mal Lara*, pp. 76-77.

[8] Also, Sánchez y Escribano, *Juan de Mal Lara*, p. 76, cites a poem by Juan de la Cueva that, in spite of its chronological confusion (Mal Lara had been dead for fifteen years in 1585), links the count of Gelves with the academy.

En Hispalis catorze de Febrero
del ano del Señor ochenta i cinco
a los Academistas remitida
del Museo del ínclito Malara
Presente el ilustrísimo de Gelves.

[9] This work has been the subject of a penetrating study by Américo Castro, "Juan de Mal Lara y su Filosofía Vulgar," in *Homenaje a Menéndez Pidal*, III, pp. 563-92. The debt of Mal Lara to Erasmus is further elaborated by Federico Sánchez y Escribano, *Los "Adagia" de Erasmo en "La Philosophía Vulgar" de Juan de Mal Lara* (New York, 1944).

Ravisius Textor. The story of Ariamenes and Xerxes as told by Herodotus is used to show how quarrels between brothers can be forestalled by generosity, while Ovid's account of Romulus and Remus illustrates the unfortunate consequences of fraternal hatred. In the second part of the explanation, which is more didactic, Mal Lara relies on selections from the Old and New Testaments and the Church Fathers. Such authorities as Amos, Ezekiel, Micah, St. Paul, and St. Ambrose are cited as warnings against this evil. Thus the simple proverb has become the pretext and vehicle for the expression of Mal Lara's learning and moral values. The display of erudition is impressive and influenced Seville's humanistic pursuits up to the moment of their decline.[10]

Needless to say, similar works by both Spanish and non-Spanish authors were known in Seville before Mal Lara. But Mal Lara assured a great impact for his methods by inviting his friends to help in the writing: "It was my desire from the very beginning that many might work on this book. And thus searching for those who might know what to do, I found a friend who made glosses of seventy [proverbs], which are spread throughout the entire work."[11] By inviting scholarly cooperation on his book, Mal Lara made his dream of an academy a reality.

In addition to his interest in the literary arts, there is some indication that Mal Lara was sympathetic to the visual arts, an affinity that he owed perhaps to his father, who had been a painter. In 1566, he was summoned to Madrid by Philip II to compose Latin verses that were added to six paintings ascribed to Titian.[12] There is also one interesting trace of a close friendship with a painter. In February 1561, Mal Lara was taken prisoner by the Inquisition on suspicion of having written heretical poetry. He remained in jail for five months until he was absolved and released. Before he went to prison, he entrusted his money and the key to his *estudio* to Pedro Villegas Marmolejo, a painter of Seville, who seems to have been a man of some culture.[13] With nothing more to guide our knowledge of this relationship, the incident indicates only that Mal Lara's academy may have been hospitable to the art of painting from the beginning.

This abbreviated survey of Mal Lara is hardly sufficient to reveal the importance of his accomplishments, but perhaps it will indicate the road he opened for his associates. The tradition he established was based on the ideals of Renaissance scholarship, whose methods entailed exhaustive research, espe-

[10] An equally impressive display of Mal Lara's erudition is the *Descripción de la Galera Real del Sermo. Sr. Don Juan de Austria*, written in 1570, but not published until 1876 by the Sociedad de Bibliófilos Andaluces, Seville. The Royal Galley, which was commanded by Juan de Austria at the Battle of Lepanto, was extensively decorated with emblems and mottoes—a sort of "Alciati flotante," which gave Mal Lara the chance to show his skill at the emblematic game. Mal Lara's interest in emblems is discussed by Karl L. Selig, "The Commentary of Juan de Mal Lara to Alciato's *Emblemata*," *Hispanic Review*.

[11] *Philosophía*, sig. biii, verso.

[12] Mal Lara mentions the commission in *Descripción de la Galera Real*, p. 133.

[13] The document was published by López Martínez, *Desde Jerónimo Martínez hasta Martínez Montañés*, p. 204. For further discussion of Villegas Marmolejo, see below, Ch. 3, note 1.

cially about antiquity and religion. If on occasion the closely woven nets were cast too wide, the process was fascinating to the scholar and his patient readers. Credit must be given to Mal Lara for inspiring his fellow humanists through word and deed. When he died prematurely in 1571, his colleagues received his legacy and enriched it. Leadership of the academy thence passed into the hands of three outstanding figures of Seville's golden age of letters, the poet Fernando de Herrera; the humanist scholar and pupil of Mal Lara, Francisco de Medina; and the canon of the Cathedral, Francisco Pacheco, uncle of the painter. For this stage of the academy's history, information about its members and activities is more abundant, and a more detailed picture of its character can be drawn.[14]

Fernando de Herrera (ca. 1534-1597) is best known as a poet.[15] He was also a man with scholarly ambitions that achieved their fullest expression in his *Obras de Garcilaso de la Vega con anotaciones*, published in Seville in 1580.[16] This compendious work is, among other things, the summation of the academy's development up to the year of publication. In the preface, Herrera specifically acknowledged the encouragement that Mal Lara had given him, thus establishing the relationship between the two men and the continuity of their endeavors: "Juan de Mal Lara, by whose death the world of letters lost a great part of its valor and nobility, was one of those who most persuaded me to push forward with this task."[17] The assistance of his co-academicians is also apparent in the prefatory material. Canon Pacheco contributed a Latin ode and Medina wrote an essay on the Spanish language that is often considered to be the manifesto of the Sevillian school of poetry. Other members of the academy such as Diego Girón and Cristóbal Mósquera de Figueroa also contributed translations of Latin poetry. The *Anotaciones*, as the book is called, thus demonstrates the interests and methods of the academy.

The *Anotaciones* is a complex and formidable work.[18] Although its main intention was to provide purified texts of Garcilaso's poetry together with a study of his sources, the book ranges over the entire field of lyric poetry past and present. Herrera's approach, as he noted himself, was modeled on

[14] Mal Lara's circle of friends obviously extended beyond these three men. Other important members included the dramatist Juan de la Cueva, the poet and lexicographer Cristóbal de las Casas, and the poet Diego Girón. I have omitted them from my discussion because their importance for the formation of the painter Pacheco, as judged from his own writings, seems minimal.

For the participants in Seville's intellectual life in the late sixteenth-early seventeenth century, see the following: Francisco Rodríguez Marín, *Luis Barahona de Soto, estudio biográfico, bibliográfico y crítico*; Mario Méndez Bejarano, *Diccionario de escritores, maestros y oradores naturales de Sevilla y su actual provincia*; Fermín Arana de Varflora, *Hijos de Sevilla ilustres en santidad, letras, armas, artes o dignidad*, and its supplement by Justino Matute y Gavaria, *Adiciones y correciones a los hijos de Sevilla . . . de I. Fermín Arana de Varflora*.

[15] The basic work on Herrera's life is still Adolphe Coster, *Fernando de Herrera (el Divino)*.

[16] Hereafter cited as *Anotaciones*.

[17] Ibid., p. 80.

[18] For a thorough analysis of this work, see Antonio Vilanova, "Preceptistas españoles de las siglos XVI y XVII," in *Historia General de las Literaturas Hispánicas*, pp. 574-84.

Scaliger's commentaries on Greco-Latin literature.[19] This procedure afforded him the opportunity to display his impressive knowledge of ancient authors and their commentators. For example, Herrera's annotations to Garcilaso's *Canción Quinta* (*"Si de mi baja lira"*) (pp. 266-75) discuss the origins of the lyre, the etymology of the word *palestra*, and the physiology of blood according to Aristotle and Galen. But at the same time, he turns his attention to the continuing question of poetic diction in his explanation of the word *alimañas* which he considers "old-fashioned and crude, and thus not suitable for a learned and elegant writer."[20] The commentaries to the longer and more difficult poems, especially the *Eclogues*, become veritable fugues of poetic theory, the history of classical literature, literary criticism, and linguistic erudition.

At one point, Herrera considered the art of painting.[21] The phrase "many-hued colors" (*colores matizadas*), which appears in Garcilaso's Third Eclogue, is the starting place for a discussion of color and perspective. Herrera's discourse on color, which utilitizes the writings of Alberti and Pliny, is confusing because he is really thinking about the interrelated questions of *rilievo* and *imitazione*. His two principal points are: "Light and shadow are the vocabulary of painting," and "All the strength of painting consists in representing things corporeal and visible on a flat surface so that they appear to the eye with the same effectiveness and reality, form and figure, as they are found in nature itself."[22] These ideas do not stray far from Alberti's theory, although Herrera subsequently shows a good understanding of perspective constructions. They are important not for their contribution to the humanistic theory of art, but rather because they indicate that painting was already considered a legitimate part of the humanistic tradition in Seville.

The second important successor to Mal Lara was the master's most accomplished pupil, Francisco de Medina, a poet, scholar, and teacher. Little is known about Medina in spite of his central place in the intellectual and artistic life in Seville during the last quarter of the sixteenth century.[23] He was

[19] Robert M. Beach, *Was Fernando de Herrera a Greek Scholar?*, attempts to prove that Herrera knew Greek sources only from Latin translations, in spite of his use of quotations in Greek. Beach also notes that, following a common practice of the time, some of Herrera's annotations are unacknowledged quotations from Scaliger and other scholars.

[20] Herrera, *Anotaciones*, pp. 266-75.

[21] Ibid., pp. 674-76. On at least one other occasion Herrera wrote about art. Pacheco, in *El arte de la pintura*, ed. Francisco J. Sánchez Cantón (Madrid, 1956), I, pp. 257-58, quotes from a passage on the divisions of painting that he found among Herrera's papers.

[22] Herrera, *Anotaciones*, pp. 674-76.

[23] The most important source for Medina's life is Francisco Pacheco's *Libro de descripción de verdaderos retratos de ilustres y memorables varones*, ed. José M. Asensio, hereafter cited as *Libro de retratos*. The pages of this edition are unnumbered. For the account of its rediscovery, cf. José M. Asensio, *Francisco Pacheco. Sus obras artísticas y literarias*, pp. 39-59. The manuscript is in the Museo Lázaro Galdiano, Madrid, which has promised its annotated publication. Although Pacheco dated the manuscript in 1599, he continued to work on it in later years, as witnessed by the inclusion of some biographies whose subjects were children at this date. As late as 1637 he was soliciting information

born in Seville in 1544 and appears to have been a prodigy in Greek and Latin because he had obtained the Latin chair at Jerez de la Frontera by 1564, when he was only twenty. In that same year, he traveled to Italy, where he remained until 1570. Upon his return, he took the degree of *licenciado en artes* at the University of Osuna (August 14-18, 1570) and by 1572 had become *catedrático* there. Shortly afterwards he was appointed tutor to the son of the second duke of Alcalá, who had replaced the count of Gelves as the academy's noble patron. Unfortunately, his pupil, the precocious Fernando Enríquez de Ribera, died prematurely in 1590, an event which affected Medina greatly. Pacheco describes the impact on Medina in this way: "The death of the Marquis of Tarifa [the young man's title] caused this prudent man to retire to a quiet life in the remotest outskirts of the city, where he had a rich museum of rare books, and unusual things from antiquity and our own times."[24] Subsequently, he accepted an offer to become the secretary to the archbishop of Seville, Rodrigo de Castro, a position he held until the archbishop's death in 1600. During the last fifteen years of his life, Medina lived in active retirement, continuing to write and to participate in the life of the academy.

Almost none of Medina's work has been rescued from oblivion. He is principally known as the author of the preface to Herrera's *Anotaciones*, which has been sufficient to earn him a place in the history of Spanish literature. According to Pacheco, who knew him well, he wrote mostly poetry and Latin inscriptions, including his own epitaph, which he composed nine years before his death. In addition to diverse literary activities, Medina seems to have been a scholarly consultant to the academy. Herrera cited his authority several times in the *Anotaciones* and also incorporated several of Medina's translations from Latin in the text. Pacheco also had great respect for Medina's knowledge of painting and frequently quoted his opinions in his famous treatise, *El arte de la pintura*, beginning with Medina's *Definition of Painting* in chapter one. As Pacheco writes in his biography of Medina, "This singular man had a wide understanding of the fields he knew. . . . He spoke and knew about painting as if he had been a skilled painter (to which I, who often spoke with him, can testify), surpassing many [painters] whom I have known." According to Pacheco, Medina was also an art collector. "[When he died] he left many interesting prints, and writings about the phenomena of his times, and original paintings, and ancient money in all metals."[25] Thus Medina supplies yet another indication of the academy's interest in the visual arts. And his long life, which spanned two generations of academicians, enabled him to impart a measure of continuity to the academy's history.

The colleague of Herrera and Medina, Canon Pacheco, is a figure whose greatness, if apparent to his contemporaries, has escaped the notice of pos-

for a biography of Alonso Berruguete (see José Martín y Monsó, "Dos cartas de Francisco Pacheco," *Estudios histórico-artísticos*, p. 38). For Medina, see also Coster, *Fernando de Herrera*, pp. 27-31, and Angel Lasso de la Vega y Argüelles, *Historia y juicio crítico de la escuela poética sevillana en los siglos XVI y XVII*, pp. 269-675. Important documents of his life were published by Francisco Rodríguez Marín, *Nuevos datos para la biografía de cien escritores de los siglos XVI y XVII*.

[24] Pacheco, *Libro de retratos*, s.v. "Francisco Medina." [25] Ibid.

terity.[26] He was born in Jerez de la Frontera in 1535, where he lived until the age of twenty-four. Then he moved permanently to Seville and followed a course of study in philosophy and scholastic theology at the Colegio de Santa María de Jesús (Colegio de Maese Rodrigo) at the University of Seville. By 1570, when he received the degree of Bachelor of Theology, he had already taken holy orders, and for the next thirty years he ascended the ecclesiastical hierarchy, becoming in turn a canon of the Cathedral of Seville, chaplain of the Royal Chapel, member of the Inquisition, and finally administrator of the Hospital of San Hermenegildo.[27] This skeletal biography contains nearly the complete account of his public life, and from all appearances it was a quiet and uneventful one. If his contemporaries are to be believed, the canon was a major force in the city's intellectual life. It is difficult to discover this fact without their assistance because the canon wrote little and published less. Yet the most informed men of the age unanimously praised his erudition in words that recall Wilde's description of the priest in *The Importance of Being Earnest*: "Dr. Chasuble is a most learned man. He has never written a single book, so you can imagine how much he knows."

In his book on the scholars of Seville, Juan de Robles, a student of Francisco de Medina, confirms Pacheco's habit of leaving his scholarship undone.

> And thus although there have been many notable scholars [in Seville], they have not written, and if they have begun they have not finished, such as the illustrious *licenciado* Francisco Pacheco, canon of this Cathedral, among whose papers were found several books he was trying to complete, in particular a dictionary of the most difficult or unusual names that are found in the [ancient] authors.[28]

In answer to the question of whether any trace of his literary activity might then (1631) be found, the response takes the form of a catalogue of the canon's literary corpus:

> Of a major work, none: only hints of his skill and erudition; the prayer of the saints of Seville, the epigrams of the antechamber of the chapter room in the Cathedral and the verses dedicated to St. Christopher that are near the door [of the Cathedral] that opens on the Lonja, and the inscriptions that are at the foot of the tower of San Hermenegildo, and the epigrams for the tomb of Philip II. . . . In which things, in the opinion of the most learned men, he ac-

[26] There is no modern biography of Canon Pacheco. Most of the information about his life comes from the biography of Porrás de la Cámara, a Sevillian writer who was a generation younger than Pacheco, entitled *Elogio del Licenciado Francisco Pacheco, canónigo de Sevilla*, which was published by B. José Gallardo, *El Criticón* (Madrid, 1835), pp. 19ff. Coster, *Fernando de Herrera*, pp. 32-37, and Rodríguez Marín, *Luis Barahona de Soto*, p. 136, are the best résumés of his life. A newspaper article by Celestino López Martínez, "El licenciado Francisco Pacheco," *El Liberal* (Seville), Nov. 23, 1934, p. 1, is short but informative.

[27] Rodríguez Marín, *Luis Barahona de Soto*, p. 137, footnote 1, publishes an important document of 1570 in which Pacheco, as part of the process for obtaining his Bachelor of Theology, gives a short *curriculum vitae*. Additional documentary evidence appeared in Rodríguez Marín's *Nuevos datos*, pp. 393-400.

[28] Juan de Robles, *Primera parte del culto sevillano*, pp. 28-29.

complished greater things than all the eminent writers of antiquity, and left far behind the Pindars, Horaces, Ausoniuses and Martials, and all the other lyric poets and epigrammists.[29]

This exalted opinion should be given some credence because other qualified experts recognized Pacheco's talents. In 1644, Rodrigo Caro, an accomplished student of classical languages, sent to a fellow scholar a collection of prayers that Canon Pacheco had written, with this recommendation:

And in it you will see very lovely hymns, so lovely that, to the learned men who were then in Rome, they seemed very good, and thus you will judge them. They were written by a canon of this Cathedral called Francisco Pacheco, who was the author of the inscription on the main tower that I put in the *Antigüedad de Sevilla* [a book Caro had written in 1634] and of many epigrams that today can be seen in the antechamber of the chapter room in the Cathedral and in other parts. It seems to me that they can compete with any one of the ancient poets of Rome.[30]

Another witness to Pacheco's talents was Lope de Vega, who sought to establish the distinction of Francisco de Rioja, a later member of the academy, by comparing him to three men whom he considered preeminent humanists: Herrera, Medina, and Pacheco.[31] Others joined in the praise of Pacheco, and these voices must be heeded, because Canon Pacheco is little more published now than he was in his lifetime.

Some idea of Pacheco's work can be extracted from the testimony of admirers. All agree that he was a distinguished Latinist, particularly skilled in Latin verse. Besides the epigrams he wrote for the cathedral, Pacheco composed verses for the funeral monument the city of Seville erected in observance of the death of Philip II. This composition, and another that accompanied the huge painting of *St. Christopher* by Matteo Pérez da Lecce, in the cathedral, were translated into Spanish by Francisco de Rioja.[32] In addition Canon Pacheco wrote a long Latin ode that Herrera used as a preface to the *Anotaciones*, a fact that further testifies to their friendship.

His devotion both to poetry and Herrera is proved by a satirical poem Pacheco directed against the poetasters he found to be overrunning Seville when he arrived from Jerez.[33] Against this talentless horde Canon Pacheco

[29] Robles, *Primera parte*, p. 29. In another work, the *Diálogo entre dos sacerdotes . . . en razón del uso de la barba de los eclesiásticos*, Robles suggests that only envy in the court prevented Canon Pacheco from becoming the tutor of Philip III.

[30] Extract from a letter of Rodrigo Caro to Dr. Juan Francisco Andrés, May 23, 1644, published by Montoto in his edition of Caro's *Varones insignes*, p. 121. The prayers composed by Pacheco were published under the title *Officia propria Sanctorum hispalensis ecclesiae et diocesis* (Seville, 1590).

[31] Lope de Vega, *El Laurel de Apolo*, Epístola a Micael de Solís Ovando, 1628.

[32] See Cayetano Alberto de la Barrera, *Francisco de Rioja*, pp. 270-71, 276-77, which has both Pacheco's Latin and Rioja's Castilian translation.

[33] The poem has been published with comments by Francisco Rodríguez Marín, "Una sátira sevillana del licenciado Francisco Pacheco," *Revista de Archivos, Bibliotecas y Museos*. According to Marín, the poem was written around 1569.

fired a burst of poetry that bristles with vituperation, written in a language by turns coarse and clever, and spiced with pungent slang. Herrera is elevated as an exemplary poet whose skill and sensitivity might be emulated by the poetic butchers who in fact ignore him. The satire is the most personal record left by the canon; it reveals a sharp and witty man, sufficiently dedicated to the cause of good art to fight in the open for it.

Canon Pacheco conceived the program for the large monstrance made by Juan de Arfe for the Cathedral of Seville between 1580-1587. Details of the technical procedures and a brief description of Pacheco's program are related in a small pamphlet written by Arfe upon its completion in 1587.[34]

> [Because] the monstrance is the largest and best work in silver of its kind, I wanted to let its shape and design be known to all, and to describe its most beautiful ornament which, by order of Your Excellency [the archbishop of Seville], was devised by the *licenciado* Francisco Pacheco. In order that it might be proper and decent and significant, I made it conform to the plans of the Catholic Church, distributing among its parts the stories, figures and hieroglyphs that would fulfill this intent, and particularly the one pertaining to the mystery of the Holy Sacrament.[35]

Although the program has never been studied, this short description indicates that it is based on some sort of theological and emblematic erudition.[36] Pacheco's collaboration on this artistic project provides another example of the academy's relationship with the visual arts. Thus it is not surprising that the academic coterie soon admitted to its circle a painter of fine intellectual, if ordinary artistic endowments, Pablo de Céspedes.

Céspedes's life and art are still largely unstudied. He was born in Córdoba, probably around 1548.[37] According to his friend, the painter Francisco Pacheco, he attended the University of Alcalá, where he studied Greek, Latin, and Hebrew, and acquired a humanistic education that made him a truly learned artist. Céspedes maintained his interests in literature and

[34] Juan de Arfe y Villafañe, *Descripción de la traza y ornata de la custodia de plata de la Santa iglesia de Sevilla*. The text is partially reprinted by José Cascales y Muñoz, *Las bellas artes plásticas en Sevilla*, pp. 13-16.

[35] Cascales Muñoz, *Las bellas artes plásticas*, p. 14.

[36] The most thorough study to date of the *custodia* and its maker is by Francisco J. Sánchez Cantón, *Los Arfe*.

[37] Francisco Pacheco, whose *vida* of Céspedes in the *Libro de retratos* is the basic source, claims Céspedes was sixty years old when he died in 1608; hence he would have been born around 1548. Subsequent writers, beginning with Ceán Bermúdez, *Diccionario histórico*, I, p. 316, have advanced his birth date ten years on the basis of his still-undocumented matriculation at the University of Alcalá in 1556. Pacheco knew Céspedes well and, until explicit reason for doubting the accuracy of his chronology is forthcoming, is entitled to belief. The other literature on Céspedes includes two unsatisfactory nineteenth-century books—Francisco Tubino, *Pablo de Céspedes*, and Ramón Cobo Sampedro, *Pablo de Céspedes, apuntes biográficos*—and a number of later summary articles that only recapitulate the early sources. An exception is Rafael Ramírez de Arellano, "Artistas exhumados: Pablo de Céspedes, pintor, escultor, arquitecto, literato insigne y ¿músico?" *Boletín de la Sociedad Española de Excursiones*, which publishes the inventory of Céspedes's possessions made after his death.

scholarship throughout his life, as we shall later see. Nothing has been discovered about his artistic training, although he practiced both painting and small-scale sculpture in wax. The first notice of his work as an artist comes from Rome, where, Pacheco states, he spent seven years. The dates of his stay can only be approximately determined.[38] Giovanni Baglione mentions that Céspedes was working in Rome during the pontificate of Gregory XIII, which began in 1572. On September 7, 1577, he was documented in Córdoba, where he took possession of a prebend in the Cathedral. If Pacheco's dates are reliable, Céspedes then would have arrived in Rome around 1570, a date that fits reasonably well into our reconstruction of his career. If he was born around 1548, then he would have entered the University of Alcalá around 1564, when he was sixteen. And if he stayed at Alcalá for four years, which would not have been an unusually long time, he would have gone to Rome around 1568-1569.

Baglione's account, in addition to Céspedes's own writings, gives some idea of his life and work in Rome.[39] He became particularly friendly with the painter Cesare Arbasia, who returned with him to Spain, and also came to know Federico Zuccaro. As a painter, he mastered fresco technique, a skill rarely found among Spanish painters, and he applied it to several commissions. For instance, he painted the frescoes in a chapel of Santa Trinità de Monte and also decorated the façades of residential buildings in the manner of Polidoro da Caravaggio. Some time was spent in the study of ancient and modern Italian art, a good knowledge of which Céspedes demonstrated in his writings.

After his return to Córdoba, he continued to live his dual life as artist-humanist. As a scholar, he assisted his former teacher Ambrosio de Morales to prepare the third volume of his *Crónica general* and initiated a correspondance with the historian Fernández Franco, discussing, among other matters, the identity (early Christian or Roman) of the ancient temple that they assumed was buried under the cathedral.[40] A few years later, however, he returned to Rome, where from late 1580 to 1582 he helped to investigate the Christian bloodline (*limpieza de sangre*) of a fellow prebendary who was attached to the papal court.

[38] Tubino, *Pablo de Céspedes*, p. 32 cited evidence that Céspedes was forced to flee Spain in 1559 because of his association with Bartolomé Carranza, archbishop of Toledo, who was persecuted by the Inquisition. In fact, a certain "Licenciado Céspedes" was connected with Carranza, but he was not the painter. According to testimony this "pseudo-Céspedes" gave in Toledo on December 12, 1559, he had known the archbishop for about fifty years and had acted as his agent in Rome. Hence, he obviously was too old to be the artist. The fact that he normally lived in Rome, where Céspedes the artist was later to go, may have caused the confusion. For Céspedes's testimony, see José I. Tellechea Idigoras, *Fray Bartolomé Carranza. Documentos históricos I. Recusación del Inquisidor General Valdés (Tomo XII del Proceso)*, p. 211.

[39] Giovanni Baglione, *Le vite de' pittori, scultori et architetti*, ed. Valerio Mariana, p. 31. For the frescoes in Santa Trinità, see Diego Angulo Iñiguez, "Los frescos de Céspedes en la iglesia de la Trinidad de los montes," *Archivo Español de Arte*.

[40] The extent of Céspedes's humanistic interests can be measured in the inventory of books made upon his death, published by Ramírez de Arellano, "Artistas exhumados," pp. 35-37.

In 1585, Céspedes made the first of several trips to Seville, a city whose thriving humanistic culture would have attracted a man of his background. He arrived there in August 1585 and did not return to Córdoba until January 1587. Soon after, he traveled to Guadalupe, where he painted several pictures for the chapel of Santa Ana and renewed his acquaintance with Federico Zuccaro, who visited the famous monastery in September of 1587.[41] As the result of his visits to Seville, he became acquainted with members of the Seville academy in which he eventually occupied a prestigious position because of his scholarly attainments and his artistic experience. Céspedes's relations with the academy are amply documented by references in Pacheco's *El arte de la pintura* as well as by the sympathetic ode that Céspedes wrote to commemorate Herrera's death. Pacheco also refers to Céspedes in his life of Herrera, calling him "an intimate friend" of the poet. In his later years, Céspedes periodically returned to Seville for shorter visits, and at least on one occasion was a guest in Pacheco's house.[42] He also befriended the archbishop of Seville, Rodrigo de Castro, who became his protector. His last trip to Seville took place in 1603, five years before his death in 1608.

The most important aspect of Céspedes's association with the academy was his interest in the theory of art. With his scholarly background and exposure to theoretical currents in Italy, Céspedes became interested in the philosophy of his profession. Time, unfortunately, has been unkind to his writings. His most substantial work, the *Poema de la pintura*, survives only in the fragments scattered throughout Pacheco's treatise, *El arte de la pintura*. His other extant theoretical works include a discourse addressed to Pedro de Valencia in 1604 on the comparison of ancient and modern painting and sculpture, a short tract on the origin of painting, and a letter to Pacheco on some technical questions, which is also included in the *Arte*.[43] The importance of these works, which must be regarded as vestiges of his thought on artistic questions, is immense for Pacheco's academy. They seem to have inspired several imitations and thus expanded the scope of the academy's humanistic interests. Yet Céspedes's example alone would not have generated the great interest in art had he not found a willing disciple who was to assume an important role in the future history of the academy. This person was the nephew and namesake of Canon Pacheco, the painter Francisco Pacheco.

Pacheco was baptized on November 3, 1564, in the foreport of Seville, Sanlúcar de Barrameda.[44] Both his parents died while he and his three brothers

[41] The documentation of Céspedes's stay at Guadalupe was published by Detlev Heikamp, "Vicende de Federico Zuccaro," *Rivista d'arte*, p. 228. The paintings are discussed and reproduced by Alfonso E. Pérez Sánchez, "Céspedes en Guadalupe," *Archivo Español de Arte*, pp. 338-41.

[42] Cf. Pacheco, *Libro de retratos*, s.v. "Pablo de Céspedes," where he says, "During one of these visits, when he was my guest, I did his portrait and wrote a sonnet in his honor which I include at the end of these words of praise."

[43] The poem is printed without the interruptions of Pacheco's text by Ceán Bermúdez, *Diccionario histórico*, V, pp. 324-43, and in "Conmemoración del nacimiento de Pablo de Céspedes-MDXXXVIII-y de la muerte de Vicente Carducho," *Anales de la Real Academia de Bellas Artes de San Fernando*, pp. 56-77. Its significance is discussed below on pp. 44-45.

[44] No satisfactory modern study of Pacheco has been published, although Muller,

were still young, and their care was assumed by Canon Pacheco. The uncle selected Francisco as the brightest of the brothers and apprenticed him to a painter. He also gave him entry to his learned and cultivated society of friends. As a result, Pacheco's career became entwined with the Seville academy founded by Juan de Mal Lara. After the death of Herrera in 1597 and of his uncle two years later, Pacheco inherited, as it were, their academy. This circumstance puts Pacheco's famed academy in its true historical place as another stage, although an important one, in the growth of an intellectual movement that had been evolving for nearly fifty years before he joined it. Patterns of thought and a set of scholarly procedures had achieved maturity by the time Pacheco became an "academician." Given his training and temperament, he adopted them as the guiding ideology of his life. Being a man of great energy, he was able to consolidate the gains of the past and to strike out into new territory; but his activities are always understandable in terms of their continuity with the past.

Pacheco's phase of the academy begins around 1600, when he took the place of Herrera and his uncle. For the next twenty-five years he was a mainstay of a new group of poets, scholars, and artists who slowly replaced the earlier members as they died. A sense of orderly evolution is conveyed by the fact that some of the older men continued as academy members even as the younger men entered the group. Francisco de Medina, who lived until 1615, was Pacheco's close friend and iconographical adviser. Pablo de Céspedes made his last trip to Seville in 1603, but maintained contact with his fellow academicians, as witnessed by the *"doctíssima carta de pintura"* that he wrote to Pacheco during the last year of his life, 1608.

The constituency and activities of Pacheco's academy are known principally from the painter's own treatise, *El arte de la pintura*. Because of the circumstances of its composition, the *Arte* is a chronicle of the Seville academy as well as a theoretical tract. Its pages offer a look behind the scenes of the intellectual activity that flourished within the association for over fifty years. There are two reasons why the book became a chronicle as well as a treatise. First of all, Pacheco assiduously sought the opinions and guidance of his friends and incorporated their advice into the text. Second, because it was written over a forty-year span, the *Arte* inevitably recorded a substantial period of the academy's history.[45]

"Francisco Pacheco," makes a good beginning. Manuel Barbadilla, *Pacheco, su tierra y su tiempo* (Jerez de la Frontera, 1964), offers an enthusiastic but uncritical appreciation of Pacheco. Older monographs are by José M. Asensio, *Francisco Pacheco*, and by Francisco Rodríguez Marín, *Francisco Pacheco, maestro de Velázquez*, which republishes and discusses several important documents of the painter's life first brought to light in his *Nuevos datos*, pp. 457-72. The short but comprehensive introduction of Sánchez Cantón to his two-volume edition of Pacheco's *Arte* (Madrid, 1956), viii-xlvi (hereafter cited as *Arte*, followed by the volume number and page), contains a chronological table with all the known facts of his life, except the date of his death, which was discovered by Antonio Gallego Burín and published in *Varia Velazqueña* (Madrid, 1960), II, p. 256.

[45] The most important discussions of *El arte de la pintura* are the following: Menéndez y Pelayo, *Historia de las ideas estéticas*, II, pp. 620-32; Enrique Lafuente Ferrari and Max Friedlander, *El realismo en la pintura del siglo XVII. Paises Bajos y España*, pp. 73-76; Antonio Sancho Corbacho, "Francisco Pacheco, tratadista de arte," *Archivo Hispalense*, pp.

Pacheco started to work on his treatise around 1600-1604, according to a letter he wrote in late February 1634, and the idea for it may have occurred even earlier.[46] It evidently was composed at irregular intervals, for in the same letter he mentions that in 1619 he had published as a small pamphlet what is now the last chapter (12) of Book II. There is no way to know whether by that date he had actually reached the end of the second book, although given his methodical mind it is entirely possible. In any case, even when he was not actively writing the treatise, he continued to compile material that was later incorporated into the text.[47] As Pacheco noted in the manuscript itself, the entire manuscript was finished on January 24, 1638. It was ready for press as early as 1641, the year a license to publish was obtained, but the publication unaccountably did not occur until 1649, five years after his death. For about forty years Pacheco had worked at his book, on and off during the early part, steadily as he reached an advanced age, continually adding new material that revealed fresh areas of the academy's activities.

Because Pacheco possessed a keen awareness of his intellectual and artistic heritage, he alludes in the *Arte* to the earlier members of the academy and their achievements, which increases its value as an historical document of this association. Furthermore, Pacheco saw fit to commemorate his forebears in a special volume, which is another indispensable record of his academy, the *Libro de descripción de verdaderos retratos y memorables varones*.[48] The *Libro de retratos* contains portrait drawings of Spanish, primarily Sevillian, poets, scholars, theologians, and artists, accompanied by short biographies and poetic eulogies. Mal Lara, Herrera, Francisco de Medina, and Pablo de Cés-

121-46; José de las Cuevas, "Francisco Pacheco y *El arte de la pintura*," *Archivo Hispalense*, 23 (1955), pp. 9-65; Sánchez Cantón, Introduction to *El arte de la pintura*, pp. viii-xxxvi, and F. Delgado, "El Padre Jerónimo Nadal y la pintura sevillana del siglo XVII," *Archivium Historium Societatis Iesu*.

[46] The letter was published by Martí y Monsó, "Dos cartas," p. 38. Pacheco's words read: "This book of portraits would have been finished if I had not desired to write the book on painting, on which I have been working for more than thirty years." In the *Arte* itself (II, p. 194) Pacheco mentions the year 1605 in connection with his book: "I now find myself rich in notes and observations that have been seen and approved by the most learned men since 1605." It is not entirely clear whether he is referring to the date when he first commenced work on the treatise or to the year when he began to seek experts' opinions.

[47] A manuscript volume in the Biblioteca Nacional, Madrid (signature 1713), entitled "Tratados de erudición de varios autores. Año 1631," is a file of the material Pacheco collected over the years. In its 290 folios are various treatises written between 1603-1629 by Pacheco and his friends, mostly about matters pertaining to art and iconography. In 1631, Pacheco bound and organized the book, identifying the passages and authors. A majority of the texts found their way into print, mostly in *El arte de la pintura*. All the texts for the discussion of whether Christ was crucified with three or four nails are there; so are the *"aprobaciones"* of Pacheco's *Last Judgment*. In addition, the volume contains the manuscripts of other works by Pacheco; the defense of St. Theresa against Quevedo, the *Apacible conversación . . . acerca del misterio de la purissima Concepcion de Nuestra Señora* and the attack against Martínez Montañés, *A los profesores del arte de la pintura*. The existence of the manuscript was first noted by Cayetano Alberto de la Barrera, *Poesías de D. Francisco de Rioja*, pp. 156-63. For additional discussion, see below, pp. 59-60.

[48] For the history of the *Libro de retratos*, see above, note 23.

pedes are among the earlier academy members whose lives are recorded. From its pages and those of the *Arte*, we can reconstruct the history of Pacheco's predecessors and his contemporaries, and thence discover their interests, accomplishments, and influence on Pacheco himself as author and artist.

The continuity of interests from one generation to the next was manifested first of all by the cultivation of studies of the ancient world. The new academicians, however, complemented their literary endeavors by the study and collection of antiquities, an activity that is epitomized in the work of Pacheco's friend, Rodrigo Caro. Caro, born in 1573, was from Utrera, a small town near Seville.[49] He was educated at the University of Osuna, becoming *licenciado* in 1596, after which he took holy orders. Subsequently he established a law practice in Utrera, which he maintained until 1620, when he moved to Seville to serve a succession of archbishops in several capacities. Once in Seville, he soon won the friendship and admiration of Pacheco, who wrote in a letter dated October 1625: "I received a letter from Rodrigo Caro, whom I greatly esteem. I take infinite delight in his good memory and correspondence; would that all one's friends were like him."[50]

A few years later, Pacheco recommended Caro to his friend Francisco de Rioja, by then a high court official, in the hope of abetting Caro's nomination to the royal chaplaincy of the Seville Cathedral. Rioja, however, was unwilling to help, and the appointment never was made.[51] Nevertheless, the incident confirms the friendship of Caro and Pacheco and also shows that Pacheco had inherited an appreciation of classical studies, which were Caro's specialty.

Caro's initial contact with classical antiquity seems to have occurred during his student days. In 1595, he visited the ruins of Itálica, an important Roman town near Seville and the birthplace of Trajan and Hadrian. He recorded the enormous impact of this visit, his first glimpse of antiquity, in a poem, *Itálica*. This poetic response to the ancient world furnishes a key to Caro's scholarship, which was motivated by emotion however cerebral its expression. Caro was principally interested in the remains of the Roman colonies in southern Spain, which, quite simply, he loved. His life's work was a brilliant and passionate attempt to revive the echoes of the Roman legions that once marched on his native soil.[52]

One of the by-products of this passion was a curious chauvinism that influenced Caro's scholarship and sometimes marred its accuracy although it adds to his interest as a human being. Because his vision of antiquity was so in-

[49] Caro has been the subject of two sympathetic studies. Marcelino Menéndez y Pelayo dedicated some choice lines to Caro's career and writing in the preface of his edition of the *Memorial de la Villa de Utrera*. More recent is M. Morales, *Rodrigo Caro, bosquejo de una biografía íntima*. A third fine assessment of Caro's career is by Santiago Montoto in his introductory study of *Varones insignes en letras*.

[50] Morales, *Rodrigo Caro*, p. 264.

[51] Rioja's rebuff of Caro, as told in Rioja's letters, is recounted in ibid., pp. 263-67.

[52] A full account of Caro's achievements as an archaeologist is given by Antonio García y Bellido, "Rodrigo Caro, semblanza de un arqueólogo renacentista," *Archivo Español de Arqueología*, pp. 5-22.

tense, he eagerly sought any trace of its presence, which enhanced whatever it touched. It became important to him to prove that his native town, Utrera, had been a Roman settlement named Utricula. The authority for this claim was a chronicle written by a certain Flavius Lucius Dextrus of Barcelona, which was "discovered" in a monastery at Fulda in 1618.[53] Caro's excitement at the discovery of the manuscript, which contained much new information about Roman Spain, was shared by many leading scholars of the day, including Quevedo, Juan de Pineda, and Rioja. But an equal number of skeptics suspected that the chronicle was a forgery. Ultimately it was shown to be the work of a Toledan Jesuit named Jerónimo Román de la Higuera, who had written the chronicle to corroborate the legend of St. James Major's trip to Spain, an event then at issue. Rioja and Quevedo both acknowledged their mistake, but Caro not only incorporated material from the work into three of his books, including the important Antigüedad y principado de Sevilla (1634), but even published a separate work in defense of Dextrus in 1627.[54] But despite this flaw, the Antigüedad is generally recognized as the first serious scholarly history of Seville and its province, containing material both original and accurate, especially in the identification of the sites of Roman towns.[55] It is not written that Caro ever renounced his belief in Dextrus, although a friend reported that at the end of his life he confessed that the text was full of impurities and additions. When pressed further on the authenticity of the chronicle, Caro answered with silence.

If the accuracy of the works influenced by Dextrus is compromised, there are others that are untainted by this unfortunate error and that place Caro's best qualities in high relief. An early work, written before the discovery of Dextrus, is the Memorial de Utrera, first published in 1604.[56] Here Caro reconstructs the history of Utrera from its earliest days as a Roman city, through the period when it served as an important border town in the fight against the Moors, and finally into the sixteenth century. As a piece of sober, thorough, and fair-minded local history (he refutes the claim that Utrera was the ancient Itálica), it is outstanding, and in addition is written in lucid prose that makes it readable despite its limited appeal.

Caro's masterpiece, as Menéndez y Pelayo asserted, is the book entitled Días geniales o lúdicros, which was dedicated to the duke of Alcalá in 1626, but not published until the nineteenth century.[57] The book is cast in the antique

[53] The full story of Caro and the Dextrus chronicle is related by Menéndez y Pelayo in Memorial, pp. xxv-xxx; Morales, Rodrigo Caro, pp. 81-92; and José Godoy Alcántara, Historia crítica de los falsos cronicones, pp. 16-34.

[54] Caro's Antigüedad y principado de la ilustrísima ciudad de Sevilla was published in Seville in 1634. The defense of Dextrus is entitled Flavii Lucii Dextri Omnimodae Historiae quae extant Fragmenta . . . (Seville, 1627).

[55] The Antigüedad served as a literary source of Ribera's now fragmentary Teoxenia. See Delphine F. Darby, "In the Train of a Vagrant Silenus," Art in America, pp. 140-48.

[56] See above, note 49.

[57] Rodrigo Caro, Días geniales o lúdicros. According to Menéndez y Pelayo, the name is based on a lost treatise on the same subject by Suetonius entitled Ludicra Historia, which was mentioned by St. Isidore from whose writings Caro learned of it. See also A.

form of a symposium. In a country villa outside of Utrera are gathered the owner, Don Fernando, and two friends, Don Pedro and Don Diego, plus a servant, Melchor. They have come to discuss the nature of games and sports both ancient and modern. Following the form of the didactic conversation, one figure takes the lead and gives long and involved answers to his companions' questions. Don Fernando plays the spokesman and through him Caro funnels his own vast knowledge of the references to the subject found in ancient literature. The range of the book is wide; it begins with the history and description of Greek and Roman games, including the Olympics, and concludes, after passing through an amazing variety of diversions, with the amusements, superstitions and songs of small children. At times Caro displays a thoroughly modern concern with the games children play. In another part of the book, he engages in fascinating mythographic discourses, as for example when he observes how celebrations of the feast of the Holy Innocents incorporate certain aspects of the Saturnalia. In many ways, *Días geniales* is the most appealing and sophisticated scholarship produced by the Sevillian school during the seventeenth century.

Caro's passionate attachment to antiquity—"sacred antiquity" as he called it—led him to collect mementos that helped to revivify this lost world. As he says in *Días geniales*, "there is no part of sacred antiquity, however small it may be, that does not deserve study and admiration." With his indefatigable curiosity, he became an avid collector of ancient artifacts. His duties as inspector of churches in the diocese of Seville enabled him to visit numerous Roman sites and to enlarge his collection as he went. His reports to the archbishop frequently mention the nature and quantity of ancient objects he found along his route.[58] Roman coins and medals composed a large part of his collection, but he also was able to acquire a sizable number of lapidary inscriptions and statues.[59] The devotion to his collection helps to complete the outline of a man whose intellect reconstructed antiquity and whose spirit made it live.

A final facet of Caro's interests unfortunately remains a mystery. At one point he wrote a treatise on painting, entitled "Diálogo de la pintura." Although it was never published, the manuscript survived until 1839, when it was stolen from the library of the Seville Cathedral.[60] The loss is lamentable not only because of the manuscript's inherent interest but also for the light it might have shed on the place of art theory in the academy.

del Campo, "Ocios literarios y vida retirada en Rodrigo Caro," in *Studia Philólogica. Homenaje ofrecido a Dámaso Alonso*, pp. 269-75.

[58] Caro was named "Visitador general de las parroquias y de los monasterios de fuera de Sevilla" by Seville's archbishop, Pedro Vaca de Castro, in late 1620 or early 1621. Caro's duties entailed the inspection of churches and monasteries in the diocese. Some of the written reports to the archbishop have been published by Montoto, *Varones insignes*, pp. 81-108.

[59] Morales, *Rodrigo Caro*, pp. 193-213, has collected the numerous references made by Caro to antique remnants in his possession, thus providing a partial catalogue of his holdings.

[60] Rodrigo Caro, *Memorial de la Villa de Utrera*, p. xvi.

Another member of the academy who cultivated a taste for ancient art and modern painting was Fernando Enríquez Afán de Ribera, the third duke of Alcalá.[61] The family's interest in art was first manifested by the duke's great-great-uncle, who completed the construction of the famous palace in Seville, the Casa de Pilatos. His nephew and successor, the first duke of Alcalá, furnished the palace with a great collection of Roman antiquities that he exported from Naples.[62] The significance of the collection is suggested by two pieces of sculpture that are still in the palace and that were once called Pallas Athena. Recent scholarship has identified them as the most important copies of a lost work by Phidias, the *Minerva Lemnia*.[63] These two capital works were surrounded by quantities of lesser pieces. Rodrigo Caro's description of the collection implies that it was almost beyond counting. There are in the ducal house, he wrote, "many marble effigies of princes and ancient men of note and two colossal statues of the goddess Pallas and another multitude of statues and remains of antiquity.[64] An inventory of the collection compiled in 1751, when the property had fallen into neglect, and after much pillaging had occurred, lists hundreds of antique works, all of which had been collected by the dukes of Alcalá.[65]

This extensive group of ancient sculpture formed only a part of the duke's cultural patrimony. His father, who had died while a young man, had been a poet of promise and the favorite pupil of Francisco de Medina. He had also participated in the academy of Herrera, Canon Pacheco, and Medina, occasionally entertaining the group in his villa at Huerta del Rey. In 1582, Herrera dedicated a book of his poems to the young duke, who responded with a sonnet of his own. Thus it was almost inevitable that his son, the third duke, who was born in 1583, became, in the words of a contemporary, "so enamoured of letters that there was not a single moment in which he was not occupied in public affairs that he did not employ in reading and study, not only of literature, but also the other sciences."[66] To facilitate his studies, he amassed a great library, one of the largest in Spain at the time, which according to Caro had "so many volumes of all sciences and humanistic letters, manuscripts and ancient medals that it competes with the most illustrious in the world."[67] This extraordinary collection was housed in a library built espe-

[61] The duke of Alcalá's biography has been reconstructed by Joaquín González Moreno, *Don Fernando Enríquez de Ribera tercer Duque de Alcalá de los Gazules (1583-1637)*.

[62] The collection and the history of its formation is described by José Gestoso y Pérez in "Coleccionistas antiguos" in *Curiosidades antiguas sevillanas*, pp. 237-67.

[63] A description of the Casa de Pilatos and a concise history of its construction is in José Guerrero Lovillo's *Sevilla*, Guías artísticas de España, pp. 140-43.

[64] Cited by Gestoso y Pérez, "Coleccionistas antiguas," p. 244.

[65] "Relación de las alhajas, pinturas, estatuas y demás que al presente existen en el palacio del duque mi señor a la parroquía de San Estéban de esta ciudad remitida a su excelencia en el mismo día 4 de agosto de 1751," in ibid., pp. 245-65. The duke also possessed a copy of the famous ancient mural painting now known as the "Aldobrandini Wedding," which he had made when he was ambassador in Rome in 1525. Later, he sent it to Seville, together with a short explanation of its subject, which Pacheco includes in his *Arte* (I, p. 25).

[66] Ignacio Góngora, "Claros varones en letras," Biblioteca Colombina, Seville; cited by Gestoso y Pérez, "Coleccionistas antiguas," pp. 241-42.

[67] Cited by Gestoso y Pérez, "Coleccionistas antiguas," p. 244.

cially for the purpose that was to be decorated with a ceiling painting by the duke's good friend, Francisco Pacheco.[68]

In addition to his own pursuit of the humanistic arts, the duke was also a notable patron. Following his father's example, he opened his library to his learned friends. Several writers acknowledged his patronage, or sought it, by dedicating books to him. These include, to mention those works written by academy members, Juan de Jáuregui's translation of Tasso's *Aminta*, 1607, and Rodrigo Caro's *Relación de las inscripciones y antigüedad de la Villa de Utera*, 1622. Lope de Vega also dedicated two of his *comedias* to the duke.[69]

The pages of *El arte de la pintura* reveal the duke's active participation in Pacheco's academy. The duke, it appears, was an amateur painter, which may have drawn him to Pacheco's circle. Pacheco testifies to his artistic work in the chapter on "nobles and saints who have practised painting": ". . . our Duke of Alcalá (is one who) has joined to the exercise of letters and arms that of painting, as a thing befitting to such a great prince."[70]

In another chapter Pacheco, in a characteristic and revealing digression, tells a fascinating story that occurred as a result of the duke's interest in painting.[71] In 1605, the duke purchased a painting of the *Crucifixion* attributed to the sixteenth-century Sevillian master Pedro de Campaña and took it to Pacheco for restoration. Shortly after Pacheco had repaired it, the duke brought him another painting, the exact duplicate of his own, which belonged to someone who had inherited it from his grandfather. Confronted by a touchy problem of connoisseurship, Pacheco arrived at an unorthodox and imaginative solution. In the interests of honesty, he was forced to conclude that the duke's picture was a copy, but a copy that, in his opinion, surpassed the original in quality. Thus he requested the duke's permission to affix Campaña's signature to his painting, which was given and done.

If we discount the element of sycophancy, this incident demonstrates not only the friendship of Alcalá and Pacheco but also a typical moment in the life of the academy. The friendship of scholars, artists, and patrons was promoted by informal visits occasioned by the desire to exchange information and ideas. The duke of Alcalá felt at liberty to call at Pacheco's studio to ask advice about the art of painting, which was Pacheco's specialty. The notion of special areas of competence emerges several times in the *Arte*. Indeed, the anecdote about Campaña's painting appears in the context of a warning from Pacheco to his learned friends to recognize the limits of their knowledge, and not to confuse expertise in one subject with another. To prove the point, he quotes passages from writers, including Herrera himself, in which they demonstrate incompetence when they attempt to pronounce on artistic matters.[72] The warning seems to have been heeded; limitations of knowledge appear to have been recognized and information was shared in an admirable spirit of give-and-take.

[68] See below, pp. 77-80 for discussion of this commission.

[69] Later, while he was viceroy of Naples (1629-31), he became an important patron of Jusepe de Ribera. See the articles by Delphine F. Darby, "Ribera and the Blind Men," and "Ribera and the Wise Men."

[70] *Arte*, I, p. 171. [71] Ibid., II, pp. 175-76. [72] Ibid., II, pp. 167-68.

In addition to the duke of Alcalá, another man of means participated in the academy. This was Juan de Arguijo (ca. 1565-1623), whose achievements as a poet and patron have been overshadowed by his spectacular profligacy.[73] In ten years, Arguijo managed to squander most of the enormous fortune that he had inherited from his father and father-in-law in 1597. A large part of it, according to his contemporaries, was spent on a single day's entertainment. On October 12, 1599, the duchess of Lerma, wife of the king's favorite, visited Seville and spent an afternoon and evening at Arguijo's villa at Tablantes, where he honored her with an extraordinarily lavish reception. When she departed, so it is said, Arguijo was no longer a rich man. Actually his bankruptcy was the result of continued financial irresponsibility, of which the reception was the most spectacular single act. By 1606, he was so seriously in debt that he had to sell his palace to satisfy creditors. In 1608, he took refuge with the Jesuits and remained a virtual recluse until 1616, when it was safe to return to society. Nevertheless, during the fourteen-year period between 1594-1608, when Arguijo's fortune was intact, he was a princely patron of the arts. He rebuilt his family home, adorning the patio with ancient and modern statuary brought from Italy, and decorated the library with a ceiling painting that was finished in 1601.[74] According to a contemporary biographer, this palace served as a meeting place for Seville's artistic community. "Arguijo decided to form an academy and gather poets, musicians and men of wit in his house. Thus he was known by all those in the realm who practiced these arts."[75]

There are several reasons to believe that this academy included members of Pacheco's group of friends. Arguijo was in contact with Francisco de Medina, who carefully edited a manuscript of Arguijo's poems.[76] Pacheco's acquaintance with the poet is proved by the fact that he included one of Arguijo's poems in the Arte. There are also indications that Arguijo was a friend of Francisco de Rioja, who later became one of Pacheco's principal iconographical counselors. However, Arguijo does not play as prominent a role in the Arte as does the duke of Alcalá, and thus may not have been in Pacheco's inner circle.

The worldly interests of Caro, Alcalá, and Arguijo were balanced by Pacheco's ecclesiastical friends. Although Pacheco's uncle had been a priest, theology was relatively inconspicuous in the earlier activities of the academy. This changed considerably in Pacheco's time, principally because of his increasing concern with orthodoxy in religious painting. He came to close terms with local clergymen, many of whom were Jesuit scholars. The pages of the

[73] The most concise and useful biography of Arguijo is found in the introduction to his Obras poéticas, ed. Stanko B. Vranich. The previous bibliography is given there.

[74] Arguijo's house and its decoration are described in detail by José Gestoso y Pérez, "La casa de D. Juan de Arguijo," Bética, and Diego Angulo Iñiguez, Pintura del Renacimento, pp. 314 and 317. Among the statues he possessed was a Venus and Cupid by Giovanni Bandini, which became the subject of a sonnet by Lope de Vega.

[75] From an anonymous manuscript entitled Memorias sevillanas, cited by José M. Asensio, Don Juan de Arguijo, estudio biográfico, p. 29.

[76] See Jáuregui, Obras poéticas, ed. Vranich, p. 27.

Arte are filled with their names and their opinions, which greatly influenced the painter's views on art.

Pacheco's most prominent Jesuit friend was Juan de Pineda (1558-1637), a prolific and important theological scholar. Their acquaintance is recorded in the *Arte* (II, p. 92), where Pacheco mentions two paintings on stone that he did in 1620 for Padre Pineda.[77] Although Pineda was active as an ecclesiastical administrator, his major activity was scholarship. He published nineteen books, and six more remained in manuscript at his death. According to Pacheco, only death itself could stay his hand. "Even at death's door he was still dictating, and although his hands could not hold a book, he made them read to him, to supply information for a work he was not able to finish."[78] His writings cover a wide range of subjects, including a commentary on the Book of Job (Madrid, 1597-1601), a study of the life and times of Solomon (Lyon, 1619), a commentary on Book I of Ecclesiastes (Seville, 1619), plus several sermons, among them one on Christ's wounds that Pacheco cites in his discussion of the number of nails used in the Crucifixion. He was also responsible for compiling the *Index expurgatorius librorum* of 1612 for the Spanish Inquisition.

Pineda's book on Solomon is a dense jungle of erudition.[79] Its eight sections, which fill 780 pages, reveal his formidable command of relevant ancient source material. Solomon's life and works often serve as a pretext to wander down many a scholarly byroad. For example, several chapters of Book IV are dedicated to the geography of the ancient world and the etymology of place names. The reconstruction of Solomon's temple, a favorite pastime of the day, is accompanied by discourses on geology, chemistry and alchemy, architecture and court protocol, to mention but a few.

Luis de Alcázar (1554-1613) is another Jesuit who appears in Pacheco's *Arte* as part of his circle of friends.[80] Like Pineda he was a theological scholar of distinction, although his production was substantially smaller. His only major work is entitled *Vestigatio arcani sensus in Apocalypsi*, first published in Antwerp in 1614. The book is a paraphrase and extended commentary on Revelation (the text, exclusive of the appendix, is over a thousand pages long), into which Alcázar poured a lifetime's learning. Accompanying the text is a series of twenty-one engravings designed by Juan de Jáuregui, who was also Pacheco's friend. The assumption that Alcázar was in direct contact with the academy is borne out in the *Arte*. Pacheco cites Alcázar's *Vestigatio* several times to corroborate his iconographical expositions. More direct evidence of their association comes from a Latin poem Alcázar wrote in 1604 to accompany Pacheco's painting of *Christ Gathering His Garments after the Flagellation*.[81]

[77] For Pineda's life, see Pacheco, *Libro de retratos*, s.v. "Pineda"; Nicolás Antonio, *Biblioteca Hispana*, I, p. 583; and Juan E. Nieremberg, *Varones ilustres de la Compañía de Jesús*, VII, p. 195.

[78] Pacheco, *Libro de retratos*, s.v. "Pineda."

[79] *Comentarios Salomon praevivus, id est, de rebus Salomonis Regis, libro octi*, Lyon, 1609.

[80] For Alcázar's life, see Pacheco, *Libro de retratos*, s.v. "Alcázar." Antonio, *Biblioteca Hispana*, II, p. 14 and Arana de Varflora, *Hijos de Sevilla*, III, pp. 83-84.

[81] *Arte*, I, pp. 291-95.

Pineda and Alcázar were the most learned and renowned ecclesiastical friends of Pacheco, although he had many more. However, by virtue of their superior learning they exemplify the strong religious influence that entered the academy after Pacheco became its leader. Pacheco acknowledges the role of his Jesuit friends at the beginning of the section entitled *Additions to Some Images* (*Arte*, II, p. 194): "My advice, which comes from a seventy-year old man, will serve as wholesome counsel. And the best and most fitting of it will be owed in the main to the holy religion of the Society of Jesus, which has perfected it."[82]

Although Pacheco was the only professional painter in the academy, some of his friends, such as the duke of Alcalá, did paintings as a pastime. In addition, there were at least two other academicians who are known to have been serious amateur painters. Juan de Fonseca y Figueroa was one; but his association with the Seville academy was transitory because he moved to Madrid in 1609.[83] The other amateur painter, Juan de Jáuregui, who also eventually emigrated to Madrid, exerted an important influence in Seville by means of his continuous friendship and correspondence with Pacheco.[84] Although no painting by Jáuregui survives, his skill as an artist can be judged through a series of twenty-one engravings he designed to illustrate Alcázar's *Vestigatio Sensus Apocalypsi*. Although the medium unavoidably distorts Jáuregui's style, the quality of the engravings is certainly acceptable, if at times characterized by a sense of stiffness. Two separate portrait engravings designed by Jáuregui (*Lorenzo Ramírez de Prado*, 1612, and *Alfonso de Carranza*, 1628) differ significantly in quality and thus demonstrate how much Jáuregui's talent is at the engraver's mercy.[85] In any case, painting was merely an avocation for Jáuregui, whose main interest was poetry and poetic theory. He also took a literary approach to art and exercised considerable influence on an important concern of the Seville academy—the theory of art.

Given the humanistic and scholarly background of the academy, it is not surprising that its concern for painting should come to include art theory.

[82] For the influence of the Jesuits on Pacheco, see F. Delgado, "El Padre Jerónimo Nadal."

[83] The life of this little-known humanist and court official is briefly recounted by Alberto de la Barrera, *Francisco de Rioja*, pp. 292 (note VIII)-319. For his additional connections with Pacheco, Velázquez, and the academy, see below, p. 61, note 52, and José López Navío, "Velázquez tasa los cuadros de su protector, D. Juan de Fonseca," *Archivo Español de Arte*.

[84] The principal biography and critical study of Jáuregui's life is José Jordán de Urries y Azara, *Biografía y estudio crítico de Jáuregui*. See also Juan de Jáuregui, *Obras*, ed. Inmaculada Ferrer de Alba, pp. vii-lxxi.

[85] The engravings were published by Miguel Herrero, "Jáuregui como dibujante," *Arte Español*. For some time a well-known portrait thought to represent Cervantes (Real Academia de la Historia, Madrid) was attributed to him, but this is now generally doubted. See José Gómez-Menor, "En torno a algunos retratos del Greco," *Boletín de Arte Toledano*. The literary testimony of his painting, including tributes from some great writers of the day, has been collected by Jordán de Urries y Azara, *Biografía*, pp. 10-15, and Herrero, "Jauregui como dibujante," pp. 8-11. Juan de Arguijo was among Jáuregui's admirers.

Jáuregui figures in Spanish literary history as the author of two famous attacks on the poet Luis de Góngora: the *Antídoto contra las Soledades* and the *Discurso Poético*.

This pursuit naturally was influenced by the rich tradition of Italian theoretical writing. However, it also evinced a distinctive local flavor that resulted from the scholarly interests and procedures of Pacheco's academy. A close reading of Pacheco's treatise, *El arte de la pintura*, reveals its debt not only to Italian writers but, more important, to his forebears and friends within his academy.

2

El Arte de la Pintura
as an Academic Document

Pacheco's *El arte de la pintura* has long been regarded as a centerpiece in the history of Spanish art theory. In the seventeenth century, it is rivaled only by Carducho's *Diálogos de la pintura* as a source of knowledge of contemporary artistic thought and life. The prestige of the *Arte* has also been heightened by virtue of Pacheco's connection with Velázquez, the most important artist of the age. But perhaps the very scarcity of theoretical works in the seventeenth century has magnified and even distorted Pacheco's significance as a spokesman for his period. *El arte de la pintura*, for all its references to artists and events outside Seville, is deeply rooted in that city. The debt to Seville is evident not only in the preponderance of Sevillian artists who figure in the text but also by its very method of composition. The *Arte*, to a large extent, is a collaborative work, and deliberately so. Pacheco appears to have emulated the examples of Mal Lara and Herrera, both of whom used their academy to formulate and develop their ideas. And like his academic forerunners, Pacheco also invited his associates to contribute to his work. Throughout the treatise, Pacheco cites the authority of his friends and often quotes their opinions at length. Hence, although the *Arte* is unmistakably indebted to the broad tradition of writing on art, and while it also reveals certain general conditions of artistic life in seventeenth-century Spain, it is fully understandable only by reference to intellectual and artistic conditions that prevailed in Seville, and particularly in the academy. To some extent, the very origins of the practice of art theory in Seville are traceable to this group, specifically to Pablo de Céspedes. It is with his fragmentary writings that the study of Pacheco's art theory logically begins.

Céspedes's most substantial theoretical work is the so-called *Poema de la pintura*, a theory of art in poetic form.[1] The *Poema* was never published in Céspedes's lifetime and has since been lost. Luckily, however, Pacheco quoted parts of the poem in his own treatise when they seemed relevant. Although this procedure precluded a complete transcript of the text, it is doubt-

[1] For Céspedes's theory of art, see Menéndez y Pelayo, *Historia de las ideas estéticas en España*, II, pp. 596-605, and Jonathan Brown, "La teoría del arte de Pablo de Céspedes," *Revista de Ideas Estéticas*. All the surviving fragments of Céspedes's theoretical writings are collected in Ceán Bermúdez, *Diccionario histórico*, V, pp. 273-352. The *Poema* appears in Guillermo Díaz-Plaja, *Antología mayor de la literatura española* (Barcelona, 1958), II, pp. 282-90. The following discussion is indebted to Rensselaer W. Lee's "Ut Pictura Poesis: The Humanistic Theory of Painting," *Art Bulletin*.

ful that Pacheco ever owned the complete text. Before the first quotation of the *Poema*, Pacheco announces his intention to include "some of [Céspedes's] famous stanzas [that] came into my hands after he passed to a better life."[2] This statement may be interpreted to mean that he had access only to part of the poem. However that may be, Céspedes's *Poema* as we know it is a fragmentary work and accordingly must be dealt with cautiously. In fact, almost all of the dozen or so passages quoted by Pacheco deal with matters of secondary importance. One group of stanzas explains a simplified method for achieving technical proficiency in painting that is merely a poetic restatement of the adage "practice makes perfect." Another is an extended description of the function and use of the cuadriculum; while a third is a ringing description of a horse's anatomy. When the unessential is subtracted, there remain only three or four significant passages. But even these must be treated with care, as the following example demonstrates.

The poem opens by posing the much-debated question, Which is more important for achieving greatness in painting, color or design? This is followed by six stanzas in praise of color. Céspedes allegorically describes the Creation as wrought by the "Painter of the World." Then he relates the creation of man by borrowing an image from Leonardo's *Paragone*: man was formed by sculpture and enlivened by painting. His evocation of the skin tones seems to suggest a heightened sensitivity to color as this prose translation demonstrates:

> He dressed him [man] in a well made and measured garment of a beautiful color in which pink was mixed into white. The color appeared as if someone had placed a rose among a bunch of lilies, in splendid confusion; or like Indian ivory when it polishes and paints clear skin with a Sidonian hue.[3]

From these passages it might be inferred that Céspedes assigned priority to color over drawing as the most important part of painting, whatever the contradictory evidence of his own art. His discussion of the value of design is limited to half a stanza that poses a rhetorical question, "What principle is suitable to the noble art (of painting)?" The answer: "Drawing, which alone represents whatever lives on the air, on land or sea!" Then follows a lengthy description of Michelangelo's *Last Judgment*, which, although admiring, is intended to establish a standard of good drawing rather than of good art. Yet however much the evidence of the poem suggests an interpretation of Céspedes as a colorist, his true sympathies were with *disegno*. The poem's fragmentary state makes it impossible to draw definite conclusions from it. Whenever possible, Céspedes's convictions may be corroborated by another of his theoretical works, the *Discurso de la comparación de la antigua y moderna pintura y escultura*.

The *Discurso* is an extensive letter that Céspedes wrote in 1604 to Pedro de Valencia, a fellow Andalusian humanist.[4] Here he clarifies his position on the

[2] *Arte*, I, p. 8. [3] Ibid., I, p. 29.

[4] This text is included in Ceán Bermúdez's *Diccionario histórico*, V, pp. 273-315. The full title is *Discurso de la comparación de la antigua y moderna pintura y escultura, donde se*

relative importance of drawing and color: "How could the sculptor make a worthy thing if he were not assisted first by drawing, which is the principal and greatest part of painting?"[5] Upon reflection, this statement of values is appropriate to a painter who spent seven years of his life in Rome, the stronghold of the *disegno* camp. And the evidence of his paintings points in the same direction. It also places his admiration of Michelangelo in the proper framework and permits a proper reading of the implications of his praise of the *Last Judgment*.

But if Céspedes adheres to the Roman school on this matter, he departs from it on another question of equal importance, that of the *idea della bellezza*. When one considers his friendship with Federico Zuccaro, a Neo-Platonic *idea* might reasonably be anticipated. But in this regard Céspedes's aesthetic tenets are unexpected because he merely counsels his fellow painters to study nature with the utmost attention, selecting from it the best formed parts (for nature is not without flaws) which, when judiciously combined, yield a perfect work of art.

> Look at nature and, if you know how to look, you will find what you are seeking. Never cease looking at it, and preserve in drawings what you see there. When you need them you will be delighted at the profit you will find there; and bring to life with color the life that the paint brush and your genius have imitated.
>
> I dare neither to say nor to promise that you will find all the necessary beautiful parts united in a single object, even when nature, the most beautiful of all, creates things that are flawless. You must choose the ideal and from perfect parts make a perfect whole.[6]

This theoretical position adheres to the pragmatic Renaissance idea of producing a "perfected" nature by choosing and combining her best parts without, however, the guidance of a coherent and dominating ideal. In fact, the resemblance of these passages of the *Poema* to Alberti's definition of ideal beauty is striking, so striking that the language of the poem could be virtually a paraphrase of *Della pittura*.

> For this reason it is useful to take from every beautiful body each one of the praised parts and always strive by your diligence and study to understand and express great loveliness. This is very difficult, because complete beauties are never found in a single body, but are rare and dispersed in many bodies. Therefore we ought to give our every care to discovering and learning beauty.[7]

Seen from an absolute viewpoint, this *idea* is less than ideal because there is no external standard of perfection, leaving the painter to his own judgment and experience to make the right choices as he works. Céspedes's failure to incorporate the Neo-Platonic ideal of beauty into his theory at the time it was

trata de la excelencia de las obras de los antiguos, y si se aventajaba a la de los modernos. Dirigido a Pedro de Valencia y escrito a instancias suyas año de 1604." Hereafter cited as *Discurso*.

[5] Céspedes, *Discurso*, p. 277. [6] Ibid., p. 342.

[7] Leon Battista Alberti, *On Painting*, trans. John R. Spencer, pp. 92-93.

in vogue is important for an understanding of not only his own ideology but also that of other writers on art in Seville. Neo-Platonic theorists such as Lomazzo and Zuccaro were read there, as Pacheco's numerous references to them prove, but their ideas made only a superficial impression on artistic thought. No one was better situated to introduce Neo-Platonism into Seville than Céspedes, and his failure to do so may have been decisive for the other writers on art there.

Céspedes also rejected the other possible standard of excellence sometimes used by sixteenth-century theorists—the art of classical antiquity. The *Discurso* is explicitly based on Céspedes's belief that the artists of antiquity were in no way superior to the great masters of the sixteenth century. The treatise is essentially a series of comparisons between ancient and modern artists designed to prove the point. Céspedes begins by quoting a passage from Pliny in praise of a famous ancient artist; below that, he places the modern counterpart who would, he contends, surpass his predecessor. For example, he rebuts the famous story of how Zeuxis fooled the birds with his painting of grapes by citing the effect of Titian's portrait of the duke of Ferrara. When the portrait was placed in a window of his palace, all the Ferrarese paid their respects to it and spoke to it, believing that it was the duke in person.[8] More important, however, is the revelation of Céspedes's tastes in Italian painting from 1400 to his day, which he expresses both here and in a later section of the treatise where he supplies a short history of painting from the Middle Ages through its rebirth in the art of Cimabue, Giotto, and Masaccio, to its final perfection in the works of Michelangelo and Raphael. His concept of the history of art is obviously inspired by Vasari and as such is not important. But the section does reveal his artistic preferences, which are significant. Céspedes returned from Italy with the tastes of a mid-sixteenth century Roman painter. He communicated his opinions to the members of the Seville academy, especially to Pacheco who, although he never visited Italy, often speaks of works in that country as if he had seen them. Clearly he was merely repeating what he had heard in conversations with Céspedes.

An example of a jointly held opinion is found in their respective evaluations of Polidoro da Caravaggio, an artist whose works and fame were confined largely to Italy. Céspedes was a great admirer of Polidoro and probably learned the technique of façade painting from one of the master's disciples. He speaks of him in the *Discurso*, saying, "He painted many houses in black and white with such artifice and imitation of ancient works that his painting is a school for painters. When Titian came to Rome and looked at some of his works, he stopped and said, 'Let us look at the work of this master.' "[9]

In a discussion of great draftsmen in the *Arte*, Pacheco places Polidoro in the exalted company of Raphael, Andrea del Sarto, and Parmigianino, adding parenthetically that Polidoro "never wanted to paint with colors, only in black and white, it seeming to him that the art of painting consisted of the chiaroscuro of drawing."[10] Pacheco had never visited Rome, nor possibly had ever seen a single painting by the Roman master, yet values the artist in the

[8] Céspedes, *Discurso*, p. 282. [9] Ibid., p. 280. [10] *Arte*, I, p. 362.

highest terms and speaks of the man and his style as if familiar with them. It would seem that he was merely recasting the opinion of Céspedes, which he respected sufficiently to advance as if it were his own. Further evidence of Pacheco's reliance on Céspedes for opinions and information can be found in his discussion of Polidoro's cartoon technique.[11] This procedure would have been known only to someone who had intimate knowledge of the process and its practitioner, such as Céspedes.

Thus, through conversation as well as his writings Céspedes exercised an important influence on the aesthetic life of the Seville academy as it began to broaden its interest in painting in the early seventeenth century. Céspedes's work set the style for subsequent essays in humanistic art theory. His essentially empirical theory of art was almost wholly appropriated by Pacheco, and his judgment of the relative worth of color and drawing, as the paintings of the period show, was not questioned for a long time. Céspedes even pointed the way to a major preoccupation of Seville's art theorists, the learned painter. In his obscure and fanciful treatise on the origin of painting, he attempted to trace its beginnings to the painting done in imitation of palm trees on the wooden supports in the famous temple of Solomon, a theory that also efficiently accounts for the invention of the Corinthian order.[12] On the basis of his theoretical legacy Céspedes may be nominated as the father of Sevillian art theory. His influence was felt strongly by Pacheco, who viewed himself as Céspedes's literary heir and executor.

Another important figure in the history of art theory in Pacheco's academy was the poet-artist Juan de Jáuregui. Like Céspedes, he had also emigrated to Rome, departing around the year 1606 to undertake the study of painting, poetry, and classical antiquity. He ultimately concentrated on poetry, although he maintained an interest in the other two fields. Jáuregui returned to Seville around January 1610, when he took part in a poetry contest. His arrival was preceded by the reputation he had gained for his translation of Tasso's *Aminta*, generally esteemed as a masterpiece of this difficult literary art.[13] For the next nine years he remained in Seville, and then moved to Madrid, where he lived for most of the rest of his life. During this Sevillian period, Jáuregui became fully integrated into the circle of literati and painters in Pacheco's academy. His friendship with Pacheco was almost inevitable, given their common interests. One sign of their friendship is the laudatory poem that Pacheco composed for the introduction of Jáuregui's book of poetry, *Rimas*, which was published in Seville in 1618. In his dry and pompous style, Pacheco acclaims Jáuregui's accomplishments in painting and poetry.

> The mute poetry and the eloquent painting, copies [of nature] which sometimes surpass nature in their beauty, flourish mightily in your

[11] Ibid., II, p. 4.

[12] *Discurso sobre el templo de Salomon. Acerca del origen de la pintura*, ed. Ceán Bermúdez, *Diccionario*, V, pp. 316-23.

[13] In *Don Quixote*, Cervantes writes of the difficulties of translation (Part II, chapter 62), comparing a translation to a Flemish tapestry seen from behind—"although you see the figures they are full of threads that obscure them"—and cites two works that overcome the enormous problems of the art. One is Jáuregui's version of *Aminta*, "which felicitously puts in doubt which is the translation and which the original."

work, Jáuregui. Now the learned lyre, now the valiant paintbrush show the greatness of your genius, which Fame spreads throughout the world with joyful rapidity.[14]

Jáuregui combined these two interests in a poem that is his first essay of art theory.

The *Diálogo entre la naturaleza y los dos artes pintura y escultura* has been largely neglected in spite of its evident charm and interest.[15] As the title announces, the treatise, if such it may be called, is a versified dispute on the superiority of painting and sculpture, with nature acting as judge. Because Jáuregui was a painter, the outcome of the debate is predictable, but the reasoning that leads to the conclusion is important within the context of Sevillian art theory. The dialogue opens with a round of mutual accusations, as sculpture alleges that painting is based on illusion and vanity. Painting retorts by accusing sculpture of baseness because of its reliance on manual labor. Sculpture, now placed on the defensive, introduces the question of genealogy, and for a moment the debate deserts the issues and becomes personal.

Sculpture: Your humble genealogy should make you silent.
Painting: Well, yours is not astonishing either.
Sculpture: You began in shadow.
Painting: And you, in idolatry.

Here Nature makes the first appearance as arbitrator, reminding the disputants that the honor acquired by later generations elevates the ancestry. After expressing contrition, both parties return to substantial matters. Sculpture lays claim to superiority on its substance, charging that painting is deceitful illusion and only appears to exist, while sculpture is tangible and corporeal. Painting now seizes the opportunity to gain the upper hand and never again relinquishes it. Both painting and sculpture, it contends, are merely imitations of real objects, but the power of verisimilitude given to painting by color affords it an inestimable advantage over sculpture. This argument temporarily silences Sculpture, which however soon returns with the argument that the durability of the medium assures the survival of statues and their creators. To this Painting cleverly replies that, even though not a single work by the famous ancient masters of the art survives, the flame of their glory burns no less brightly than that of Phidias and Praxiteles. At length, Nature intervenes to resolve the quarrel in favor of Painting. Her arguments include the greater range of subjects open to painting and a reiteration of the important advantage of color. Then she adduces Leonardo da Vinci's point about the fatiguing physical labor involved in sculpture; if sculpture is to be honored with the title "Liberal Art," then any mechanical and base work must be so called. On this note, the discussion closes with Painting triumphant.

[14] Juan de Jáuregui, *Obras*, ed. Ferrer de Alba, I, pp. 12-13.
[15] Juan de Jáuregui, "Diálogo entre la naturaleza y las dos artes pintura y escultura, de cuya preeminencia se disputa y juzga," *Rimas*, pp. 174-85. The text is reprinted in Jáuregui, *Obras*, I, pp. 97-103. See Menéndez y Pelayo, *Historia de las ideas estéticas*, II, pp. 580-83, and *Obras*, pp. lviii-lxiii, for short discussions of the work.

Jáuregui's poem is of course a poetic paraphrase of the *paragone*, first made by Leonardo and a matter of dispute in sixteenth-century Italian theory. Theorists such as Paolo Pino (*Dialogo della pittura*, 1548), Antonio Francesco Doni (*Dialogo del disegno*, 1549), Lodovico Dolce (*Dialogo della pittura*, 1557), and Raffaele Borghini (*Il Riposo*, 1584) debated the superiority of the two arts. These treatises, which were known in Seville (Pacheco quotes passages from them in the *Arte*), obviously inspired Jáuregui's *Diálogo*. But in spite of its reliance on these sources, the *Diálogo* is important for two reasons; first it enlarges our conception of the extent to which art theory was practiced in Seville, and second, it confirms the derivative nature that characterizes most of Sevillian art theory.

The lack of originality did not deny the poem an impact; Jáuregui's ingenious *Diálogo* supplied ideas that would be used in 1622 by his friend Pacheco in a context involving more than a witty play of words. Pacheco wrote a short work called *A los profesores del arte de la pintura*, which was a polemic directed against the sculptor Juan Martínez Montañés.[16] This quarrel between Seville's leading painter and sculptor occurred because of an infringement of the rules governing the production of polychrome statuary. The painting of these statues could be undertaken only by artists who had been licensed by the painters' guild. Thus it was not unusual for easel painters to engage in the work. Pacheco and Montañés had in fact been collaborators before their dispute, which came about in the following way.

The convent of the Santa Clara had contracted for an altarpiece with Montañés alone, contrary to the usual practice of assigning separate parts of the work—sculpture, polychromy, gilding—to certified masters. This contract effectively gave Montañés control over the painting, an art he was not licensed to practice. Montañés compounded the crime by dividing unequally the payment of six thousand ducats, allowing his painter only fifteen hundred and keeping the rest. For the community of painters, his action had serious implications, both philosophically and financially. It implied that sculpture took precedence over painting, that the division between the arts in polychrome statuary was meaningless, and that a sculptor's work was literally more valuable than a painter's. The painters would not allow this breach of law and custom to go unchallenged and therefore brought suit against Montañés before the local tribunal. Pacheco, as the most respected painter in Seville, became a leading spokesman against the sculptor. The arguments he used in his brief bear a close resemblance to Jáuregui's opinions as expressed in the *Diálogo*.

Following Jáuregui, Pacheco's main point was the greater flexibility and power conferred on painting by its use of color. After claiming that the paintings of the Emperor Charles V conveyed a truer idea of his appearance than sculpture, he generalized: "And thus with all other images of which one can bring many examples. Because the colors demonstrate the passions and feel-

[16] Francisco Pacheco, *A los profesores del arte de la pintura* (Seville, 1622); ed. cited Francisco J. Sánchez Cantón, *Fuentes literarias para la historia del arte español*, pp. 267-74. The history of the dispute is briefly recounted by Beatrice Proske, *Juan Martínez Montañés, Sevillian Sculptor*, pp. 103-104.

ing of the soul with greater vividness."[17] This can be compared with Jáuregui's poem, where he says "It is clear how also in man colors excel in externalizing the internal passions."[18]

Pacheco's tract proceeds to deal with practical points of administrative detail; for example, that sculptors should not be allowed to paint without passing a standard painter's examination. But in the theoretical realm, the similarity of his ideas to Jáuregui's is unmistakable. This by no means implies that Pacheco was blindly following Jáuregui's example and did not, for instance, consult the Italian sources himself. It would be wrong to characterize Pacheco as an intellectual tape recorder, playing back what others spoke in his ear. The coincidence of views rather must be taken as the result of two like-minded men who worked together to resolve a problem of mutual interest. This example of consultation and cooperation demonstrates the processes of the Seville academy when its gears were meshing. And, more specifically, it hints at a collaboration between two of its members that was to bear the ripest fruit of the academy's endeavors in the field of art theory, Pacheco's *El arte de la pintura*.

The *Arte* is a heterogeneous work, organized confusingly. Pacheco divided the treatise into three books, as he called them, and added a lengthy appendix to Book Three. Book One is supposedly devoted to the theme of the "antiquity and grandeurs" of painting. Under this rubric, he discusses not only the announced subject but also the superiority of painting versus sculpture, the Christian aims of painting, and finally the definition of three levels of painterly skill. Book Two is concerned with the theory and parts of painting, and generally stays to the point. The third book is also reasonably self-contained, except for its appendix, and covers the practice of painting. However, at the end of Book Three, Pacheco added a lengthy appendix entitled "Additions to Some Images," which deals with religious iconography and constitutes a book in itself. The jumbled contents of the *Arte* may become clearer if we revise its divisions in this way: Books One and Two can be combined into a single book and entitled "The Theory of Painting." The title of Book Three is accurate as it stands—"The Practice of Painting and the Ways to Employ It." But its appendix is really a separate book that might be called "The Catholic Painter's Guide to Orthodox Iconography." The following discussion is based on this reorganized table of contents and considers only the theoretical sections of the *Arte*, that is to say, Books One and Two and the Appendix to Book Three.

The theoretical sections of the *Arte* are confusing because of Pacheco's heavy reliance on earlier writers. Time and patience are needed to sift through the borrowed material and the verbose, often imprecise prose style

[17] Pacheco, *A los profesores del arte de la pintura*, p. 270.

[18] Jáuregui returned to the comparison of painting and sculpture when he defended painting as a liberal art against the Royal Treasury, which sought to impose a tax called the *alcabala* on the sale of works by living painters. Jáuregui's was one of a number of contributions offered in the painters' defense by such figures as Lope de Vega and Alonso de Butrón. They first appeared in a small pamphlet in 1629, and were then reprinted as an appendix to Vicente Carducho's *Diálogos de la pintura*, pp. 371-518.

to discover Pacheco's aesthetic philosophy. It is hardly an exaggeration to say that, were the *Arte* the sole surviving book of art theory from before 1650, we would be able to reconstruct from it a fairly detailed record and sample of the lost writers and writing. Up to a point, Pacheco acts as an anthologist of art theory. A typical example of his approach to the philosophical problems of art theory is found in the description of the nature of color, which occupies two lengthy chapters of Book Two (chapters nine and ten). In the first paragraph, he announces his intention to "make a rich cloth" of what the great writers of the past have said on the subject, and then proceeds to unroll a string of lengthy quotations about the nature and role of color in painting. In chapter ten, he expounds on the importance of color for obtaining *rilievo* by quoting from Alberti, Leonardo (one of whose manuscripts he appears to have owned), and Dolce. After the last citation he states that "to add to what is so learnedly explained (by those writers) would be presumptuous." It goes without saying that this attitude precludes much original thinking on the author's part. At one crucial point after another, Pacheco offers little more than a pretext for a florilegium of theoretical writing.

The path to understanding his own views of artistic creation is littered with false clues. Sometimes he sounds like a Mannerist theorist (particularly Federico Zuccaro), as for example when he writes:

> Painting is not done by accident, but by the selection and art of the master. In order to move his hand to execution, an example or interior idea is needed. This resides in his imagination and understanding, and is drawn from the exterior and objective example that he perceives with his eyes. . . . To explain this more clearly, what the philosophers call the exemplar, the theologians call the idea (the originator of this name was Plato, if we believe Tullius and Seneca). The exemplar or idea is either external or internal, or, to call it by another name, objective or formal. The external is the image, sign, or word that appears to the eyes. God spoke of this when he said to Moses: "See and work according to the example that you saw on the mountain." The internal is the image made by the imagination, and the concept that the intelligence forms. Both things guide the artist when he sets out to imitate, with pencil or brush, what is in his imagination or an external figure.[19]

This Platonic trend of thought covers several more pages and then virtually disappears from the book.[20] Most of the time Pacheco espouses pragmatic ideas that can be traced through Céspedes to Raphael's "Letter to Castiglione" and ultimately to Alberti.

The reliance on these earlier writers is clearly expressed in the closing lines of Book One, at the end of a chapter in which Pacheco attempts to define the levels of skill that a painter must achieve to become a master. As paragons of

[19] *Arte*, I, p. 259.
[20] Erwin Panofsky, *Idea. A Concept in Art Theory*, trans. J.J.S. Peake, p. 64; p. 217, note 67; p. 219, note 74 and p. 225, note 28, keenly analyzes some of Pacheco's aesthetic ideas. See above, chapter 1, note 45 for a selective bibliography on the *Arte*.

artistic achievement, he nominates Raphael and Michelangelo and describes their conceptual process as a recommendation to aspiring painters.

> . . . it will be suitable to do what Raphael, Michelangelo and other artists of their stature did and to follow surely in the footsteps of such guides, so that the invention of figures and histories approaches and reaches perfection by the imitation of the best things in nature. Because this model [nature] should never be lost sight of. And this is the place where we promised to speak of this point. All the weight of our study [of other artists] does not eliminate the need to study this original model [nature], because with precepts and good and beautiful art comes the ability to judge the most beautiful works of God and nature. And it is here that the valuable thoughts of the painter must be measured and corrected. When this [nature] is lacking, or when the necessary beauty cannot be found, then it works admirably to make use of the ideas of beauty that the worthy artist has acquired [from other sources].[21]

In other words, artistic perfection is imagined as the result of an organic but unstructured relationship between the study of nature and the study of great artists. Nature is the primary source, but in order to select her best qualities the painter's mind must be schooled in the works of the masters. When beauty cannot be found in nature, then the painter is free to fall back upon what he has learned in his studies of other artists.

This aesthetic is a paraphrase of the ideas found in Raphael's famous letter to Castiglione, which Pacheco quotes in the immediately following sentences, and after which he summarizes as follows:

> Hence, perfection consists in passing from ideas to nature and from nature to ideas, always seeking the best, the surest and the perfect. Raphael's own master, Leonardo da Vinci, did this as well, following the example of the ancients. When he had to invent a history, he first investigated all the appropriate and natural gestures of the figure, in accordance with his idea. Then he made several sketches. Afterwards he went to where he knew people of the sort he was painting were accustomed to congregate and observed their faces, costumes and the movements of their bodies. Whenever he found something that pleased him, he sketched it in his sketch-pad, which he always carried with him, and in this way he finished his works marvelously.[22]

These ideas are miles away from Platonic thought because they rely on the artist's continuing perception of nature to achieve perfection. The reciprocal relationship between things and things as perceived by the painter is deemed sufficient to define an idea, and no immanent force or external ideal is necessary. Pacheco's empirical approach can be interpreted as either old-fashioned or modern. Its origins, as we have seen, are found in the writings of Alberti,

[21] *Arte*, I, p. 250. [22] Ibid., p. 251.

Leonardo, and Raphael. Yet, by placing the painter's own judgment and experience of nature at the center of artistic creation, this loosely structured aesthetic is refreshingly tolerant and undogmatic. It is this quality of mind that must have led Pacheco to appreciate the stylistic innovations of his pupil Velázquez. But it would be a mistake to construe Pacheco as the spokesman for what we now call naturalist painting. His theory is too general, his tastes too eclectic, his arguments at times too self-contradictory to regard him as anything but a literate, experienced painter. The *Arte* provides comfort and support for almost every point of view current in European painting at the turn of the seventeenth century, excepting only the most extreme forms of the *maniera*. It is this very quality that makes the *Arte* a true, if somewhat belated, reflection of this complex moment in the history of painting, when the differences between Carracci and Caravaggio seemed far less striking than they were to seem by the end of the century. In any case, aesthetics were not the subject dearest to Pacheco's heart. His real love was the formulation of iconography, especially religious iconography.[23]

This penchant can be seen by the manner in which every important theoretical discussion edges imperceptibly but inevitably to a consideration of iconographical accuracy, which Pacheco misnames "decorum." For example, immediately after he has written on the "idea" of beauty, which requires about five pages of the chapter entitled "Of the Division of Painting and Its Parts," he carries the discussion to the necessity that a painter be well-versed in humanistic letters.[24] Significantly, he regards this as the second part of painting, following only after beauty, which, because he hardly discusses it, seems more like an afterthought. From the insistence on decorum and its requirement of knowledge, it is but a short step to a discussion of whether Andromeda was white or black, which is offered as an illustration of a typical preoccupation of the learned painter. This excursus is justifiable to explain why in the interests of accuracy a painter might wish to undertake research. But Pacheco belabors the point by offering another lengthy example in the form of a letter from a Jesuit friend discussing the alternatives for painting the decapitation of St. Paul. Time and again in the first two books, ideas are displaced by erudite iconographical discourses.

But the most convincing evidence of his true interests is found in the transformation of Book Three. Originally, the *Arte* was to have been divided into three books, each consisting of twelve approximately equal chapters. The first two books adhere to this scheme, but in the third a significant alteration occurs. Chapter ten closes with lines that indicate that the work at one time ended here, two chapters short of the intended twelve.[25] In its current state, however, the book continues for six more chapters, whose total length is al-

[23] Sánchez Cantón, in his edition of *Arte de la pintura*, p. xix, also has suggested that it was Pacheco's interest in religious iconography that led him to prepare and publish his *Arte*.

[24] *Arte*, I, pp. 255-75.

[25] The crucial lines read: "But the great Raphael, who, more than any other painter imparted divine simplicity and incomparable majesty to his images, should furnish us with the only example we need, and me with a glorious conclusion for my work." Ibid., II, p. 191.

most twice as long as the first ten chapters of Book Three. The first two chapters of this appendix are structurally part of Book Three, but the remaining four are entitled *"Adiciones a algunas imágenes."* Because of their unified content, however, all six chapters should be considered under the single title of *Adiciones*. The *Adiciones* are essays on how a painter should represent scenes from the New Testament and lives of saints. Here, for example, is the famous discussion of whether Christ was crucified with three of four nails (chapters fifteen and sixteen), which sets the tone for the entire section. Pacheco combines his own researches with the investigations made by fellow scholars, mostly Jesuits and academy members. This appendix, however, is not merely a postlude; it is the heart of the author's original contribution to the *Arte*.

The similarity of the *Adiciones* to certain treatises inspired by the Council of Trent is apparent and logical, given the date when Pacheco began to write the *Arte*.[26] The similarity is particularly evident in the militant insistence on textual fidelity when a painter is representing sacred stories. Pacheco takes the concept of decorum, merely a general rule of suitability, and distorts it by his oversensitive Catholic orthodoxy. He echoes the repeated cry for accuracy that occurs in post-Tridentine works such as Borghini's *Il Riposo*, Paleotti's *De imaginibus sacri*, Molanus's *De picturis et imaginbus sacrus*, and Gilio da Fabriano's *Degli errori de' pittori* in his *Due dialoghi*, all but the last of which are often cited in the *Arte*. When Gilio worries lest the number of Pharisees with Christ in the temple be too many or too few, he is speaking the same language as Pacheco. The Council of Trent, however, is not the only source of Pacheco's obsessive fear of heterodoxy and heresy; he was also greatly influenced by the program of ideological suppression conducted by the Spanish Inquisition in the sixteenth century.

The Inquisition, which was refounded in 1480, had initially been concerned with punishing Jews and Moors who were suspected of practicing their religions after ostensible conversion to Catholicism. With the rise of the Protestant revolt during the sixteenth century, the Inquisition gradually turned its attention to doctrinal matters and hence to the realm of ideas. Its impact on intellectual life was ultimately profound; ideas fell victim to the tribunals as surely as did people.[27] Historians of Spanish thought have pointed to the years between 1556-1563 as the moment when the process of ideological repression came to a head. The movement away from the liberal humanism of the early 1500s began with the persecution of the Spanish followers of Erasmus. The history and fate of Erasmus's thought in Spain has been reconstructed in Bataillon's *Erasme et L'Espagne*, which identifies its extinction by the Inquisition as a symbol of the demise of Renaissance humanism in Spain.[28] In the 1550s a comprehensive plan was developed to save Spain from the Lutheran heresy by cutting its intellectual ties with the rest of

[26] Fermín de Urmeneta, "Directrices teológicas ante el arte sagrado y las teorías de Pacheco," *Revista de Ideas Estéticas*, analyzes Pacheco's theology in some detail.

[27] This account of the Inquisition is based on Henry Kamen, *The Spanish Inquisition*, esp. pp. 67-103, and José L. González Novalín, *El inquisidor general Fernando de Valdés (1483-1568). Su vida y obra*.

[28] Marcel Bataillon, *Erasmo y España*, trans. A. Alatorre.

Europe. This program simultaneously strangled the nascent liberalism that was taught in certain Spanish universities, notably the University of Alcalá. In 1547, the first *Index* of prohibited books was published, which duplicated the one compiled at the University of Louvain in the preceding year. Four years later, another edition of the *Index* was published with an appendix of Spanish works. Only one book by Erasmus was included in this list. However in the more extensive *Index* of 1559, sixteen of Erasmus's works were condemned, and the list of Spanish authors was greatly expanded. The *Index* threatened authors as well as books by providing the Inquisition with grounds for imprisoning or executing condemned writers. Another potent measure against intellectual freedom was enacted on September 7, 1558, when the regent Doña Juana issued an edict in the name of her brother, Philip II, which banned the importation of foreign books in Spanish translation. On November 22, 1559, Philip further abetted the movement by ordering the return of all but a handful of Spanish students from foreign universities. The students came back to universities that were scrutinized by censors whose watchfulness culminated in the arrests of professors including such illustrious scholars as Luis de León and Francisco Sánchez, "el Broncese."

The campaign against suspected Lutherans reached a climax in these same few years with the discovery of two alleged Protestant cells, one in Valladolid, the other in Seville. The Seville group was supposedly led by a canon of the cathedral, Dr. Constantino Ponce de la Fuente, whose followers included monks and nuns from the Hieronymite order.[29] They were executed in a series of *autos de fe* held on September 24, 1558, December 22, 1560, and April 26 and October 28, 1562; altogether 218 persons appeared at the *autos*, of whom 51 were burned at the stake. It was during this persecution, in 1561, that Juan de Mal Lara was briefly taken prisoner by the Inquisition, an experience that made him a cautious scholar for the rest of his life.

Pacheco was born on the threshold of this age, an age that accepted the restriction of thought in the name of orthodoxy. He was an immediate descendant of the Council of Trent, having been born one year after the final session. More specifically, he was influenced by the Inquisition, which had imposed its will in Seville in the years before he arrived there. His acceptance of inquisitorial ideals is confirmed by his appointment in 1618 as the inspector of paintings for the Seville tribunal. His friendship with the Jesuit Juan de Pineda is also significant in view of the fact that Pineda was responsible for the *Index* of 1612, in which, for the first time, Erasmus appeared among the *auctores damnati*. Pacheco's concern for orthodoxy pervaded his thinking and his friendships, and during his tenure as an academy member, as we have seen, he partly diverted the academy's scholarly interests to its service.

The alliance of scholarship and orthodox theology is evident in Pacheco's explanation of the ideal of the learned painter, which follows from his conception of the religious function of art.[30] In chapter eleven of Book One, he deals with the question of "the aim of painting and of the images and of the

[29] Kamen, *The Spanish Inquisition*, pp. 78-81.

[30] For the term "learned painter" and its definition, see Lee, "Ut Pictura Poesis," pp. 235-42.

fruit [they bear] and the authority that they have in the Catholic Church." In a series of forthright statements, he makes the duty of painting explicit. "The most principal aim [of painting] will be to achieve a state of grace."[31] On another page he writes, "Their [Christian images'] principal end will be to induce men to piety and bring them to God."[32] And again, "It [painting] aspires to the supreme end, seeking eternal glory, and attempts to dissuade man from vice and to lead him to the cult of God Our Lord."[33] This evangelical definition of painting confers great responsibility on the painter because it endows him with the power to move men to good or evil and hence to salvation or damnation. Such a grave burden imposes a strict duty to be accurate and orthodox in representations of sacred themes, and Pacheco frankly values these qualities above aesthetic ones.

> And although I may seem to have strayed from my intention to deal with the matter of sacred images, I want it known that if they are not the sole application of painting, they are nonetheless the most illustrious and majestic part and that which gives it greater glory and splendor, being used for sacred histories and divine mysteries that teach the faith, the works of Christ and His Most Holy Mother, the lives and deaths of the holy martyrs, confessors and virgins, and all that pertains to this; and it is the most difficult part of this noble art because of the strong obligation it owes to faith, propriety and decorum which so few achieve, however great they may be as painters.[34]

In passages such as these, Pacheco is virtually paraphrasing the decree of the Council of Trent on religious art.

> And the bishops shall carefully teach this: that by means of the histories of the mysteries of our Redemption, depicted by paintings or other representations, the people are instructed, and strengthened in remembering, and continually reflecting on the articles of faith; as also that great profit is derived from all sacred images, not only because the people are thereby admonished of the benefits and gifts bestowed upon them by Christ, but also because the miracles of God through the means of the saints, and their salutary examples, are set before the eyes of the faithful; that so for those things they may give God thanks; may order their own life and manners in imitation of the saints, may be excited to adore and love God, and to cultivate piety.[35]

To achieve the requisite level of accuracy and fidelity, the painter must become a man of learning. Therefore Pacheco advises his colleagues to acquire a knowledge of humanistic letters.

[31] *Arte*, I, p. 213. [32] Ibid., p. 219.
[33] Ibid., p. 214. [34] Ibid., p. 236.
[35] *The Canons and Decrees of the Council of Trent*, trans. T. A. Buckley, p. 214.

It is convenient that artists know, and not superficially, humanis-
tic letters, and even divine ones, to ascertain the manner in which
they must paint the things that are offered to them. . . . Thus it is
very proper or even necessary to join the study of painting to that of
letters, in order to profit from the historians and poets and of all the
faculties in infinite cases.[36]

Echoes of an Italian theorist such as Lodovico Dolce resound in passages like
this one. It is not surprising that in the chapter on decorum Pacheco quotes
extensively from his writings.

While he believed that the painter was obliged to delve deeply into the
fields of learning that might be applicable to his subjects, Pacheco realized
that universal knowledge was impossible. Thus, again following the lead of
the Italian theorists, he urged the consultation of scholars, especially in the
representation of sacred subjects.[37] He writes:

But since not all who apply themselves to the faculty [painting] are
learned in these matters, much can be gained by good judgment and
extensive communication with scholars in all fields. . . . For it is a
great fault in good painters that they do not follow the authority of
books and the judgment of the studious and well-informed who can
give them good information about the fables, histories or mysteries
which occur and many other matters.[38]

The distinction that Pacheco consistently draws between iconographically
accurate versus beautifully executed paintings is perhaps the most striking
proof of his commitment to Counter-Reformation ideals. This position is
most clearly manifested in his support of Lodovico Dolce's critique of the ico-
nography of Michelangelo's *Last Judgment*, which he quotes extensively.[39] It
is remarkable because Pacheco greatly admired Michelangelo and his art—an
admiration that had earlier led him to devote an irrelevant chapter (Book
One, chapter seven) to a long description of the master's exequies and
sepulcher. However, his conviction that the fresco contained serious dog-
matic errors was so firm that he disregarded the advice of two close and re-
spected friends, Céspedes and Jáuregui, to mitigate Dolce's attack. Pacheco
refused by saying, "but having more respect for the truth, in my opinion
Dolce accuses him with much reason, as far as this part of decency is con-
cerned, and it is not proper for us to defend or to follow him in it."[40] This is
another case of the line Pacheco unhesitatingly draws between "truth" and
beauty. We find the same distinction, couched in similar words, in the writ-
ings of Gilio da Fabriano. But Gilio was a cleric, not a painter. "I find greater

[36] *Arte*, I, p. 264.

[37] Lodovico Dolce, *Dialogo della pittura intitolato l'Aretino*, p. 154f. Cited by Lee, "Ut
Pictura Poesis," p. 237.

[38] *Arte*, I, p. 264. The similarity of Pacheco's counsel to another of his sources,
Lomazzo, can be seen by comparing this statement to Lomazzo's ideas as summarized
by Lee, "Ut Pictura Poesis," p. 238.

[39] *Arte*, I, pp. 344-48. [40] *Arte*, I, pp. 348-49.

genius in artists who adapt their art to fit the truth of the subject rather than those who distort the purity of the subject for the beauty of art."[41]

Pacheco's deep commitment to the doctrine of the learned painter may be understood as the result of his urge to Catholic orthodoxy and his involvement with the academy. The former made him exceptionally sensitive to doctrinal errors, the latter gave him the means to detect and amend them. With access to the best scholars in Seville, Pacheco was able to realize the ideal of the Catholic *peintre-savant*. Artists had often been advised to consult experts to make their paintings accurate and faithful to the text, but in practice they seldom did so. Pacheco, however, took the advice seriously. His dedication to this idea is lucidly illustrated by his relationship with the poet Francisco de Rioja.

Rioja (1583-1659) was born in Seville and received a humanistic education and a degree in theology at the University.[42] By 1598, he had taken holy orders and had been appointed as a chaplain in the church of Omnium Sanctorum. At about this time, he met Pacheco, with whom he commenced a lifelong friendship. Rioja, in fact, was a witness to the marriage of Pacheco's daughter to Velázquez in 1618.[43] After the death of Francisco de Medina, Rioja became Pacheco's principal iconographical adviser. The fruit of their labors is evident in the *Arte*, where Rioja's learned commentaries are cited or quoted four times, including the lengthy discourse that Pacheco used as justification for painting the Crucifixion with four instead of three nails.[44] In addition, Rioja supplied two translations of Latin poetry and an original poem on the difficulties encountered by a painter wishing to paint the story of Apollo and Daphne.[45]

However, the *Arte* contains only a fraction of the scholarship that Rioja made available to Pacheco. A larger quantity is preserved in Pacheco's unpublished compilation of scholarly opinions, "Tratados de erudición," in which Rioja emerges as the leading authority.[46] The earliest entry by Rioja dates from 1603 and is a commentary on a Latin inscription from Carmona. Most of his other contributions concern religious subjects: there is advice on how to be a good preacher (March 13, 1616; fols. 11-21); a defense of some Latin verses by Herrera that had been criticized by Rodrigo Caro (June 22, 1619; fol. 134r); a discourse in defense of priests wearing beards (undated; fols. 2-10); and the defense of an inscription for the *titulus* of the Cross that

[41] G. A. Gilio da Fabriano, *Due dialoghe*, p. 80. On the criticism of Michelangelo's *Last Judgment* by Gilio and Dolce, see Lee, "Ut Pictura Poesis," pp. 231-34.

[42] For the much-neglected Rioja, see Alberto de la Barrera, *Poesías de D. Francisco de Rioja*; Alberto Sánchez, *Poesía sevillana en la edad de oro*, pp. 385-406; Santiago Montoto, "Las capellanías del poeta Francisco de Rioja," *Boletín de la Academia Española*, and Jean Coste, *Francisco de Rioja, racionero entero de la Santa Iglesia de Sevilla*.

[43] See the document published by Asensio, *Francisco Pacheco*, p. 26.

[44] *Arte*, II, pp. 362-78.

[45] Ibid., I, p. 498.

[46] For Pacheco's "Tratados de erudición," see above, p. 34, note 47. According to José Amador de los Ríos, in his notes to S. de Sismondi, *Historia de la literatura española*, II, p. 174, the library of the Seville Cathedral formerly possessed a volume of correspondence between Rioja and Pacheco. It disappeared in 1839, the same year that Rodrigo Caro's *Diálogo de la pintura* was also found to be missing from the collection.

was criticized by the duke of Alcalá (April 20, 1619; fols. 28-33r).[47] The last two opinions involved other members of Pacheco's circle and clearly demonstrate the corporate nature of its intellectual activity. One of the discourses (fols. 39-46) begins with a phrase that explicitly documents the reunions: "On the day that you [Dr. Sebastián de Acosta] and I met in the house of our good friend Francisco Pacheco, the subject of tradition in the church came up, among others." Rioja and Pacheco maintained their friendship after Rioja was called to Madrid in 1621 by the count-duke of Olivares. In 1629 Pacheco sent him two inscriptions for an altarpiece, one in Spanish, the other in Latin, asking his approval of their propriety and linguistic correctness (fols. 227-28).

In such ways, Pacheco fulfilled his obligations as a learned painter. By recording many of the opinions he received, he made his treatise reflect the process of intellectual life in his circle and its influence on the evolution of his thought and the practice of his art.

One other instance of the inner workings of Pacheco's academy may help to clarify the interests and interactions of the members. This is the controversy over the wording of the *titulus* of the Cross. The controversy is not recorded in the *Arte*, perhaps because its bitterness dissolved the academy's usual amicability. The participants regarded it seriously enough to publish their views in a series of pamphlets.[48] The first of these, written by the duke of Alcalá, sets the scene. One day the duke was visiting Pacheco's studio when he noticed a *Crucifixion* painted by his friend, "as excellently as all his works. And there came to my eyes some defects that the titulus (of the Cross) suffered."[49] When he confronted Pacheco with these putative errors, to what horror we can only imagine, Pacheco produced the sources of his inscription which was prefaced with these words: "This titulus is the best of all: Padre Luis del Alcázar gave it; Francisco de Rioja approved it." In spite of his respect for the authority of these two scholars, and his friendship with Rioja, the duke wrote a six-page attack on the accuracy of the titulus, concentrating on two basic points: the validity of the word *hic* in the Latin titulus, *Hic est Jesus Nazarenus Rex IVD*, and the correctness of the entire Hebrew titulus, for which he suggested a new one.

The challenge was accepted by Rioja. His rebuttal begins with formulaic praise for the Duke's discourse—"The discourse is marvelous, and it is written extremely well, in a beautiful mode, with well-chosen words and close reasoning. The arguments are in excellent taste, well-disposed, based on good sources, full of erudition, and finally the titulus is written in excellent Hebrew."[50] Except, he is painfully obliged to add, it is mistaken. Rioja's discussion centers on the Hebrew titulus and raises the basic question of whether it could even have been written in that language because the vulgar

[47] See below for the history of this controversy.

[48] All the material of this controversy, which amounts to four separate discussions (one by the duke, one by his anonymous spokesman, and replies to each by Rioja), is collected in a single volume in the collection of the Hispanic Society of America.

[49] The polemic opened in 1619 with the duke's treatise entitled *Del título de la Cruz de Christo Señor Nuestro*, which is in the form of a letter to Pacheco, dated April 1, 1619.

[50] Rioja's reply, the second half of the first round of the dispute, was addressed to Pacheco as well and dated April 20, 1619.

tongue in Jerusalem at the time, if one considers the evidence, was Syrian. As for the imputations against the accuracy of the Latin, Rioja supplies a long list of patristic authors who had used this inscription.

This explanation did not end the controversy. The rebuttal was not written by the duke, but by an anonymous scholar who directed a long and abusive screed against Rioja.[51] Rioja, who by this time had shed his air of patronizing magnanimity, published a counterattack that was financed by his friend the count-duke of Olivares, and there the matter rested. It is not known whose side Pacheco took, because he tactfully omitted the dispute from the *Arte*. In any case, the controversy is interesting because, when the animosity is stripped away, it exposes the academy's working methods as they may have unfolded in the privacy of Pacheco's studio or the duke's library. It also demonstrates that one did not paint pictures thoughtlessly if one aspired to be considered a learned painter by the members of Pacheco's academy.

This reconstruction of the activity and thought of Pacheco's academy indicates how the patterns established by its founder, Juan de Mal Lara, in the sixteenth century were continued. However, the more liberal humanism of the early days was altered by a passionate concern for doctrinal orthodoxy. With the advent of Pacheco as an influential figure, the academy became increasingly interested in painting, an interest encouraged by the artist's strong belief in the ideal of the learned painter.[52] Pacheco's *Arte* is an important document and product of the academy and sheds considerable light on its members, their interests, and procedures. It may not be unfair to characterize Pacheco's contribution to the book as that of an overseer, organizer, and coordinator of material consisting of the writings of previous authors, the researches of his fellow academicians, and the results of his own experiences, above all in the practice of painting. But even in his role as compiler he sought the advice of his friend Juan de Jáuregui. Throughout the manuscript Pacheco wrote marginal notes that leave no doubt that Jáuregui read many of its sections and suggested changes or approved parts as they stood. Pacheco did not always follow Jáuregui's counsels, as the note scribbled at the beginning of chapter five in Book One indicates: "This chapter was not eliminated al-

[51] This rebuttal may possibly have been written by the duke himself. Alberto de la Barrera, *Poesías de Rioja*, p. 30, 322-24, considers it so. Rioja himself refused to believe it was the duke because of the abusive tone. The mysteriously authored attack, entitled *Advertencias a la carta de Francisco de Rioja*, was published three times; once in Seville, once in Barcelona and once in an unknown place. These publications included the duke's original letter and Rioja's response, and one of the editions, the undated one, forms the first part of the Hispanic Society copy. Rioja published his second reply (see below) in 1621, dedicated to the count-duke of Olivares: *Respuesta de Francisco de Rioja a las advertencias contra su carta.*

[52] It may come as a surprise to learn that eleven separate treatises on painting were written by six different writers connected in some way with the Seville academy. Besides the two by Pacheco, the two by Jáuregui and the four by Céspedes mentioned above, there are also the following: (a) Francisco de Medina, "Definition of Painting," quoted in *Arte*, I, pp. 12-13. (b) Juan de Fonseca y Figueroa, *De Veteri Pictura*, a lost treatise mentioned by J. A González de Salas's commentaries on Petronius's *Satyricon*, Frankfort, 1629; cited by Alberto de la Barrera, *Poesías de Rioja*, pp. 309-10. (c) Rodrigo Caro, *Diálogo de la pintura.*

though Don Juan de Jáuregui wanted to take it out, and with his consent it was abbreviated by eleven pages." Sánchez Cantón has even hypothesized that some of the marginalia in the manuscript may have been written by Jáuregui.[53] This close collaboration exemplifies Pacheco's compositional method and demonstrates his belief in the concept of the learned painter and in the consultative process by which it was to be realized. According to this belief, the painter was to be as much a scholar as an artist, and painting became, by extension, a branch of erudition. The implications of this doctrine for the art of painting in Seville, both in the academy and out, remain to be seen.

[53] Sánchez Cantón, his edition of the *Arte*, I, pp. 95 (note 1), 267 (note 1), 344 (note 8), 345 (note 4).

3

Theory into Practice: The Arts and the Academy

The image of Pacheco's academy projected in these pages is of a casual but cohesive association of poets, scholars, and painters united by their respect for the aims and methods of humanistic scholarship in the fields of classical antiquity and Catholic theology. The members, following the example of the academy's founder, Juan de Mal Lara, sought to attain their goals by individual efforts within a framework of collective encouragement and participation. Authors used the academy as a source of ideas and constructive criticism, in addition to the more concrete contributions they made to one another's labors. Mal Lara's *Philosophía vulgar*, Herrera's *Anotaciones*, and Pacheco's *Arte* were the most notable academic collaborations and provide the clearest examples of the academy's processes and methods. In each case, the authors sought to supplement and enrich their works by drawing on the expertise of their learned friends. The academy's interests were not, however, limited to humanistic scholarship, even if it set the prevailing tone. Some of its members were also artists, chiefly poets and painters, a circumstance that raises questions about the arts and the academy. How were the painters of Seville affected by the academy? To what extent did it influence prevailing practices, and to what extent did it reflect them? The scope of these questions makes a complete answer difficult; hence, the succeeding discussion will focus primarily on the art of painting and, within this area, on matters of content more than style.

The academy's interest in Catholic theology naturally made the strongest mark on the art of Francisco Pacheco. But if we attempt to use his example as a standard for other artists of the period, we will be misled. The *Arte*, as we have seen, often reveals Pacheco in the process of consulting his learned friends about religious subject matter. The success of the method depended on close relationships between painters and scholars, and such relationships were virtually nonexistent in Seville outside of Pacheco's academy.

In fact, working arrangements between men of learning and men of art were rare in seventeenth-century Spain, however much theoreticians may have urged them.[1] While numerous social and professional forces served to

[1] The most famous example is El Greco, who had a longtime association with a circle of distinguished scholars and theologians in Toledo. See Wethey, *El Greco*, I, pp. 12-14. Very little is known of the influence of these men on the painter. A second case is Antonio Mohedano, a painter who spent his later years in Antequera, where he became a close friend of the poet Pedro Espinosa. Espinosa published two of Mohedano's poems

keep the two groups apart, perhaps the most important reason they seldom made contact was because the consultative process did not correspond to the realities of artistic commissions. In practice, painters were rarely entrusted with iconographical formulation. This right was reserved for the patron, who would supply detailed instructions for a commissioned work and oblige the painter to submit a preliminary drawing to insure satisfaction. The contract for a painting of the *Assumption of the Virgin* signed by Antonio Mohedano and Fr. Mateo de Recalde, a Franciscan, on April 19, 1605, is typical.

> I, Antonio Mohedano, will paint a canvas . . . of the Assumption of Our Lady the Holy Virgin Mary in accordance with a memorandum and set of instructions signed by the said father.[2]

Ecclesiastical patrons, who were very alert to the dangers of heresy, could be expected to undertake complete responsibility for iconographical formulation. The contract between Zurbarán and the Merced Calzada, signed on August 29, 1628, assigns the painter a completely subservient role.

> I, Francisco de Zurbarán Salazar, master painter, recognize that I have agreed and contracted with Father Juan de Herrera, prior of the Convento Grande de la Merced . . . to make twenty-two paintings of the story of St. Peter Nolasco to adorn the second cloister where the refectory is, putting in each one the figures and other things that the prior orders me to do, be they few or many.[3]

The content and tone of the document, repeated in contract after contract, offered the painter little opportunity to initiate consultations with learned authorities about iconographical details. These were supplied by the patron, who was exercising his traditional rights of control over the product he was paying for.

The most demanding patrons were the Jesuits, who, as leaders in the Counter-Reformation, were watchdogs of orthodoxy. Painters in their employ not only received iconographical programs but also instructions about how to execute them. The contract for an altarpiece between the Jesuit College in Marchena and Alonso Vázquez, dated October 14, 1599, epitomizes the concern for accuracy and decorum. The paintings were to include St. John the Baptist in the Desert, the Decapitation of St. John, St. Joseph holding the Christ Child by the hand, and the Dream of St. Joseph.

in his anthology, *Flores de poetas ilustres de España*, fols. 62 and 92. See Francisco Rodríguez Marín, *Pedro Espinosa*, pp. 66-68, and José M. Fernández, "El pintor Antonio Mohedano de la Gutierra," *Archivo Español de Arte*.

A sixteenth-century Sevillian painter, Pedro de Villegas Marmolejo (ca. 1520-96), was also acquainted with humanists. He was a close friend of Arias Montano (see B. Rekers, *Benito Arias Montano* and Juan de Mal Lara (see above, p. 24 and López Martínez, *Desde Jerónimo Hernández hasta Martínez Montañés*, p. 204).

Finally, several literati, including Lope de Vega and Juan de Jáuregui, rallied to support Vicente Carducho and Eugenio Cajés in their lawsuit against the Royal Treasury in 1629. Again, it is not known whether the painters and writers had been associated before this event and, if so, how the relationship affected those involved.

[2] José Hernández Díaz, *Documentos para la historia del arte en Andalucía*, II, p. 163.

[3] López Martínez, *Desde Martínez Montañés hasta Pedro Roldán*, pp. 221-22.

All the figures that are to go in these paintings, besides representing the truth of the story, should represent it in such a way that it provokes devotion. Every figure should be shown with the appearance and attitude that their saintliness demands. And the manner and disposition in which said picture represents them (should conform) to the conditions and particulars already stated.[4]

The similarity of the tone of this document to passages in *El arte de la pintura* is unmistakable, a coincidence that stems from Pacheco's continued reliance on Jesuits for ideas and iconographical formulas.

Other Jesuit commissions are sufficiently complicated as to suggest that the painter was given an explicit plan to follow, even when documents are lacking. An example is the central picture in the bottom story of the altarpiece in the Society's Church in Seville, painted around 1606 by Juan de las Roelas (fig. 1).[5] The subject of the painting is the circumcision of Christ, but several alterations have been made that remove it from the realm of narrative painting. A sequential pattern is established by the figure of Simeon on the left, who is wiping the blade of a knife. This action indicates that it is the moment just following Christ's circumcision,when his name is being given. As he is christened, the Jesuit monogram miraculously appears above, surrounded by a group of adoring angels, seraphim, and putti. Beneath, St. Jerome and St. Ignatius take notice of the vision by pointing toward it. The episode is converted to an allegory in order to glorify the Society of Jesus. As Emile Mâle has noted, the Circumcision held special significance for the Jesuits, whose name was derived from the one given Christ during this ceremony.[6] Thus the scene was often depicted over the high altar in Jesuit churches.This type of programmatic painting was almost always prescribed by the patron; the painter's role being confined to translating verbal concepts into visual images. In this case, Roelas has done the translation skillfully. The marked physical reactions to the miracle displayed by the saints and angels are precocious manifestations of a Baroque style that would not be fully realized in Seville until the middle of the century.

These few examples are sufficient to show that a painter often did not need

[4] Hernández Díaz, *Documentos para la historia del arte en Andalucía*, II, pp. 155-56.

[5] The history of this important altarpiece is not yet completely known. On July 1, 1604, the Casa Profesa made a contract with the Italian painter Gerolamo Lucente da Correggio to paint the six subjects that comprise the present altarpiece (ibid., pp. 159-61). On March 18, 1605, Gaspar Ragis was hired to gild the altarpiece, which supplies a *terminus ante quem* for the architecture, though the paintings need not have been finished by this date. According to Gestoso y Pérez, *Curiosidades antiguas sevillanas*, p. 204, the altarpiece was completed on March 25, 1606. Although he does not cite a source for the information, this date seems reasonable. At some point, the responsibility for the paintings was transferred from Lucente da Correggio to a group of local artists. The division of labor between them is still not clear. According to Pacheco's testimony, the *Annunciation* (fig. 2) is the work of Mohedano, and the *Nativity*, of Roelas (*Arte*, II, p. 243). The *Circumcision* has usually been assigned to Roelas as well for reasons of style. The attributions of the remaining three paintings remain open to question. Francisco Varela has often been named as the author of the *Adoration of the Magi*. *St. John the Evangelist* and *St. John the Baptist* have tentatively been given to Pablo Legote by Wethey, *Alonso Cano*, p. 188, who properly rejects a previous attribution to Cano.

[6] Emile Mâle, *L'Art religieux après le Concile de Trente*, pp. 431-43.

to worry about consulting authorities on his own, especially when he was employed by a religious organization. The patron was prepared to tell him exactly what was wanted and to make him demonstrate his intentions in advance. Pacheco concedes the point in the *Arte*, although he presses the ideal of the learned painter with determination. His experience had shown him the realities of artistic conception, which he tacitly acknowledges by the assumptions that support the *Adiciones a algunas imágenes*. This lengthy section is addressed to the artistic rank and file with two purposes in mind: first, to show artists the ideal way to confect religious iconography and, second, to give them the authoritative information they might not otherwise have had, lacking the resources for consultation that Pacheco commanded. The second purpose constituted a de facto recognition of his unique situation and demonstrates that Pacheco's freedom to devise iconography, when granted, was exceptional. Under these circumstances, there was little profit to be gained from the investment required to become a learned painter.

If the ideal of the learned Catholic painter belongs exclusively to the realm of the academy, the attendant insistence on orthodoxy accurately reflects a universal preoccupation of patrons and painters, which is manifested by the way Pacheco's contemporaries adopted and conserved iconographical schemes once they had been approved. An example of this concern is the evolution of the Annunciation in Sevillian painting during the first half of the seventeenth century. The basic composition depends on a formulation supplied by the Jesuits. Two paintings of the Annunciation done within a half-dozen years of each other for Jesuit churches indicate this common source. The first was painted by Antonio Mohedano around 1606 for the Casa Profesa in Seville (fig. 2); the second, by Juan de las Roelas, around 1608 for the Jesuit College in Marchena (fig. 3).[7] The Jesuit source is further confirmed because both paintings follow the prescription for the scene given by Pacheco in *Adiciones a algunas imágenes* where he acknowledges the advice of the Jesuit priest Juan Jerónimo. Although Pacheco was not the first painter to employ the composition, his description (*Arte*, II, pp. 231-34) indicates its special features, most of which are present in Mohedano's picture. According to this scheme, the Virgin was to be shown kneeling at a writing table on which an open book lies. She is young (fourteen years and four months old, as Pacheco scrupulously notes) and has long hair covered with a veil. Either her hands are clasped or her arms crossed. On the table, an oil lamp burns to indicate both the Virgin's poverty and the fact that it is night. Gabriel appears kneeling on the ground before the Virgin in a reverent attitude holding a lily in his left hand. He is not to be shown under any circumstances as making a flying entrance, which would be indecorous. Finally, there is to be an upper zone in which appear God the Father, accompanied by seraphim and angels, and the Holy Dove. This formula acquired great authority among the painters of Seville, who usually followed its outline faithfully, although they often altered details. Their obedience to the scheme has important stylistic implications as well, because it bound the painters to an anti-Baroque composition.

[7] For the documentation of these two commissions, see A. Rodríguez G. de Ceballos, "Alonso Matías, precursor de Cano," in *Centenario de Alonso Cano en Granada. Estudios*.

As Emile Mâle has pointed out, the typical Baroque interpretation of the Annunciation is characterized by its extraterrestrial setting, as opposed to the late medieval and Renaissance formula, which showed the scene set in a mundane environment.[8] By removing the encounter from earth, the Baroque artist converted the prosy intimacy of the Virgin's small room into a foyer of heaven and so glorified the event. Pacheco's prescription for the scene compromises this aim by demanding a number of literal details, which impose stylistic restrictions leading the painter into non-Baroque avenues of expression. The most obvious of these requirements is the call for a night scene with illumination supplied by an oil lamp on the Virgin's *prie-dieu*. Any painter who followed this instruction committed himself to a system of lighting that would make him a Spanish Georges de la Tour. The requirement that Gabriel kneel on the ground is again anti-Baroque. As Mâle says, the essential characteristic of the Baroque Annunciation is the entrance of Gabriel resting on a cloud. This permitted the painter to dramatize the encounter by making the angel the centerpiece of an active, theatrical composition. The painters of Seville found it difficult to resolve the conflict between the requirements of orthodoxy and art, and often adopted a solution that shows Gabriel kneeling close to earth on a cloud-like cushion. As these two prescriptions suggest, the demands for iconographical accuracy, if observed, had formal implications. The resulting tension between fidelity to orthodox iconography and effective artistic presentation is manifested in the paintings of the Annunciation in Seville.

Mohedano's *Annunciation* (fig. 2) is the most literal translation of the iconography. It departs from Pacheco's text only in the few details that have unavoidable and undesirable formal consequences. Hence, the oil lamp is omitted as the source of illumination in favor of a beam of light emanating from the heavens. Instead of restraining her hands, the Virgin gestures with them to suggest a response to Gabriel's greeting. And Gabriel does not bear the lilies in his left hand; they are placed in a vase at the lower right, following a traditional way of displaying this symbol. Otherwise Mohedano faithfully obeys the prescription, including its most conservative condition that requires the scene to take place in a plausible earthly setting. Thus the composition is divided into two parts—earth below, heaven above. This anti-Baroque duality became a dominant feature of the scene in Sevillian painting for the next fifty years.

Zurbarán's *Annunciation* for the altarpiece in the Cartuja of Jerez de la Frontera (fig. 4), painted in 1638-1639, is clearly in the line of succession. Here, as in Mohedano's picture, the dichotomy between the two zones is maintained. Below, the Virgin sits in a room that opens on a small town square, a device that firmly asserts the worldly setting. Although Zurbarán attempts to indicate Gabriel's heavenly origins by showing him as he kneels on a cushion-like cloud, the motif is betrayed by the weighty corporeality and sober monumentality of the angel. The heavens are again confined to the upper zone and do not penetrate below. God the Father has been omitted

[8] Mâle, *L'Art religieux après le Concile de Trente*, pp. 239-42.

above, but this is a minor change within the conservative composition that Zurbarán follows. In many ways, this work typifies Zurbarán's transitional place in the history of Sevillian painting.[9]

A break with tradition occurs in Alonso Cano's *Annunciation*, painted in 1645 for the altarpiece of the Church of La Magdelena in Getafe (fig. 5). Although Cano had by this time been absent from Seville for seven years, the painting has some points of contact with the "Seville" formula; Cano, after all, had been Pacheco's pupil. But he also has begun to de-emphasize the separation between the upper and lower zones, primarily by reducing the paraphernalia of the setting to the bare minimum necessary for clarity. And although the clouds remain confined above the two figures, the larger angels have disappeared, and with them the sense of the heavens weighing heavily upon the scene below. Consequently, the unification of the composition is closer at hand. Gabriel, too, now rests on a feathery cloud that comes closer to rejecting Pacheco's demand that he kneel upon the ground.

With Murillo, the composition that had influenced fifty years of Sevillian painters was finally abandoned. In this instance, the departure from tradition occurs progressively within the artist's own development. The Prado *Annunciation* of ca. 1650-1655 (fig. 6), a relatively early work, is a partial expression of a new ideal. The most significant difference is the interpenetration of heaven and earth. Misty clouds, populated by playful putti, seem to envelop the room, making it difficult to determine where one leaves off and the other begins. Only a chair and sewing basket, barely perceptible in the background, supply a descriptive touch to the picture. The setting has been changed from the solid to the ethereal, and even the traditional motif of Gabriel kneeling directly on the ground cannot defeat the impact of innovation.

The *Annunciation* painted around 1668 (fig. 7) shows the new composition in its final form. Here the encounter takes place in the midst of an amorphous bank of clouds that invades the entire space, denying any suggestion of illusionistic depth. The removal of the Annunciation from earth is so complete that the cloud upon which Gabriel kneels seems to have been found at hand, rather than brought for the purpose. In this cloud-veiled atmosphere, the meeting of the angel and the Virgin becomes a quiet drama, its intensity magnified by the celestial setting, which is free from the distractions of earth (except for the sewing basket that lies unobtrusively upon the ground). Murillo's power to concentrate the emotional essence of a sacred text finally expresses the spiritual qualities of the Annunciation.

The evolution of this composition indicates how the forces of conservatism and orthodoxy, for which Pacheco spoke, influenced painting in Seville. Until the 1640s, artists accepted the prevailing Tridentine ideals, caring little to devise a new iconography or composition even if free to do so. If a patron did not dictate, then tradition did. This observation further indicates the remoteness of Pacheco's learned artist from reality. Pacheco of course recognized how painters really worked and that his ideal painter-scholar was at

[9] For a more extended definition of Zurbarán's style, see Brown, *Zurbarán*.

best a remote possibility. He continued, however, to insist that the ideal was the highest goal to which an artist could aspire and installed those who attained it as on the loftiest of his three levels (*estados*) of painters.

> We will not speak here of those who know only how to copy and have to follow good or bad originals, be they prints, drawings or paintings. They belong to the first level, as we have seen (Book I, Chapter 12). Those of the second level can still make use of these sources and join them together at the end and thus take better advantage of them. These painters, when the opportunity is offered to them to paint a figure or a history, can choose from among prints, drawings or paintings, a head from one, a half-figure from another, another figure or two from someplace else, plus arms, legs, draperies, buildings and landscapes and join them altogether. In this way, they are at least responsible for the composition and for the many other things that make a unified picture.
>
> It is a certainty that the ability to make sketches, drawings and cartoons straight away belongs to those painters who occupy the third and final level of painting; because they are the most obligated to make new things. . . . And thus when they are asked to do a figure or history be it old or new, they try to discover how it should be painted, either by asking scholars or reading books, and in their mind they construct unified ideas. [10]

Pacheco understood common working procedures, but his elitist ideals blunted his sympathy for the methods. He was, however, realistic enough to accept the status quo and to attempt to steer less intellectually inclined colleagues clear of heterodoxy or worse. And, on the whole, they seemed happy enough to follow the formulas until they failed to respond to changing stylistic needs.

As a reflection, then, of prevailing practices and precepts, the academy is only partially accurate. The desire for orthodoxy was current, but the ideal of the artist-scholar as the means to achieve it was realized only by Pacheco. Hence, the question may be asked, did the academy exert any influence at all over Pacheco's contemporaries and immediate followers? The history of the Annunciation appears at first to establish Pacheco as an important source for the other painters of Seville. But a closer reading of the evolution of the theme indicates that Pacheco's description postdates the pictures of Roelas and Mohedano, which in turn respond to the dictates of their Jesuit patrons. Pacheco's place in the evolution is not at the beginning, but somewhere in the middle, and it is safe to assume that the iconography of the Annunciation would have followed its path without his intervention. Furthermore, Pacheco's treatise, the distillation of his academic experience, was not published until 1649, just at the moment when painters were beginning to explore a dynamic Baroque style that was incompatible with the *Arte*'s explicit, detailed prescriptions. It would almost be possible to dismiss Pacheco's rele-

[10] *Arte*, II, pp. 2-3.

vance on chronological grounds if it could be shown that his ideas were un-known and unknowable before the *Arte* was published. But other avenues of communication allowed these ideas to reach painters and affect their art. The diffusion of Pacheco's most renowned iconographical innovation illustrates this process.

Pacheco seems to have become interested in the iconography of the Crucifixion in 1597 when the silversmith Juan Bautista Franconio returned from Rome with a bronze *Crucifixion* attributed to Michelangelo.[11] In this im-age, Christ's feet were crossed and each foot was secured by a nail. The use of four nails instead of three intrigued Pacheco, who had a number of copies of the statue made for distribution to his friends (*Arte*, II, p. 387). A few years later, Juan Martínez Montañés adapted the motif in his famous *Christ of Clem-ency* (Seville, Cathedral), executed between 1603-1606. This became one of the first works to employ the four-nailed Crucifixion in Seville.[12] Pacheco himself painted a *Crucifixion* with four nails in 1614 (fig. 8).[13] However, it dif-fers in two significant respects from the earlier sculptures; Christ's feet are no longer crossed, and he appears to stand on the supedaneum. The reason for this change is implied by Francisco de Rioja in a letter he sent to Pacheco in 1619 which fully documents the validity and priority of the four-nailed Crucifixion. The letter is included in the lengthy section of the *Adiciones a algunas imágenes* devoted to the question.

> Francisco Pacheco . . . has been the first that, in these days, has re-stored the practice found in some images of Christ by painting it with four nails, thus following in every respect what the ancient writers say. This is because he paints the cross with four arms and with the supedaneum on which the feet are nailed side by side. You can see the figure planted on it as if He were standing up; the face with majesty and decorum, without ugly twisting or discomposure, as is suitable to the sovereign greatness of Christ our Lord.[14]

Pacheco apparently placed the figure in a standing position in order to elimi-nate the curve of the body that, in his view, lessened the dignity of the image. His example was followed by many painters in Seville.

Pacheco's pupils were, of course, taught to use this composition. Veláz-quez's moving picture in the Prado (fig. 9), painted around 1631-1632, cap-tures the sober, commanding dignity that epitomizes the image. Another pupil, Alonso Cano, faithfully adhered to the prescription in the *Crucifixion* painted around 1646 (fig. 10). Beyond his immediate followers, we know that Antonio Mohedano used the four-nailed Christ for a version of the theme he painted in Antequera (*Arte*, II, p. 388). Mohedano must have learned of the

[11] For the history of this copy, now attributed to Jacopo del Duca, see Proske, *Mar-tínez Montañés*, p. 41, p. 149, note 159.

[12] Ibid., pp. 39-43.

[13] A later *Crucifixion* by Pacheco in the same format was published by Matías Díaz Padrón, "Un nuevo 'Cristo crucificado' de Pacheco," *Archivo Español de Arte*, pp. 128-30.

[14] *Arte*, II, p. 337.

new iconography when he worked in Seville between 1605-1610 and was be-
friended by Pacheco. Zurbarán based many, though not all, of his *Crucifixions*
on Pacheco's prescription. The superb painting in the Art Institute, Chicago,
dated 1627 (fig. 11), is a dramatic yet faithful conception of the four-nailed,
standing Crucifixion, while a slightly later work in the Seville Museum (ca.
1630; fig. 12) follows Montañés' *Christ of Clemency* by showing a dying, rather
than a dead Christ. Only toward the middle of the century do painters begin
to ignore this tradition, as they did many others. A *Crucifixion* by Cano (fig.
13), probably done in 1643 for the Dominican Convent of Loeches, reverts to
the three-nailed Crucifixion. Murillo also uses this type in a number of his
versions of the theme. A late painting in the Prado (fig. 14) clearly rejects the
remoteness of Pacheco's Christ and seeks to impress the viewer with the
pathos of the event. The three-nailed Crucifixion, which allows the body to
curve gently, was probably adopted by Murillo to abet his quest for a more
expressive and engaging religious art.

The history of the iconography of the four-nailed Crucifixion indicates how
the academy's influence made itself felt in Seville. Apparently this was ac-
complished by Pacheco's personal contacts among fellow artists and by the
example of his paintings that incorporated the academy's researches into
iconographical problems. The *Arte*, which relates the process of diffusion, is
essentially a retrospective document, more useful as a record now than it was
as a stimulus then. Pacheco promoted his ideas by deeds rather than by
words. For a long period of time, he was a ubiquitous figure in Seville's world
of art. The *Arte* is full of references to the artists he met and knew, and the list
of their names is an impressive testimony to his professional contacts. As he
made the rounds over the years, his opinions on the art of painting were cir-
culated to his colleagues. His ideal of the artist-scholar may have been re-
jected for practical reasons, but his belief that painting was the servant of
Catholic orthodoxy surely strengthened a concept that was generally held.
His prestige and power in the artistic community, buttressed by the authority
of his learned friends, insured that his specific iconographical recommenda-
tions were listened to with care.

Although the *Arte* faithfully records the academy's concern for sacred ico-
nography, it almost entirely neglects the other area of interest to the
academy—classical antiquity. Yet this field of study was the academy's initial
raison d'être. It was cultivated by the founder, Juan de Mal Lara, and then by
the line of his successors—Herrera, Céspedes, the duke of Alcalá, and Caro,
to name the most outstanding. The impact of their interest in classical an-
tiquity on the arts in the academy was great, although it was felt unequally in
different art forms. By any measure, poetry was significantly stimulated by
classical sources, both in form and content. The so-called Seville school of
poetry, many of whose leading members were associates of the academy, is
usually characterized by its interest in classical poetry. Painting, on the other
hand, proved resistant to the lure of antiquity, a fact accurately reflected by
the scant attention paid to it in the *Arte*. This resistance, it must be said, was
not unique to the academy or even to Seville.

It has often been observed that Spanish Baroque artists, except those em-

ployed by the king and certain noblemen, rarely depicted subjects drawn
from classical history or mythology.[15] The obvious reason for the scarcity of
antique themes in painting was the overwhelming role played by the Catholic
Church in artistic patronage. However, the Church's influence was not lim-
ited to works commissioned by its member organizations; its negative view of
classical subject matter held sway over secular patrons as well. In this respect,
the Spanish Church exceeded the strictness of the Tridentine decrees, which
objected to pagan religious and philosophical systems but permitted the de-
piction of classical mythology. The reasons for the rejection of classical
themes are entwined with the Church's attitude on the depiction of nudes.
We know from the history of the various repaintings of the nudes in
Michelangelo's *Last Judgment* that the unclad human body was not to be toler-
ated in religious paintings for reasons of propriety and respect. Although
classical figures would not be encumbered with these restrictions, they pre-
sented a problem of a different sort: namely, their possible inspiration to im-
moral behavior. The Inquisition, after all, punished those who professed to
believe that fornication was not sinful while at the same time it sought to cur-
tail the practice of solicitation in the confessional. Although it was not difficult
to find episodes from classical mythology in which the figures could be de-
cently clothed, patrons and artists were not encouraged to look for them; the
moral were damned by the immoral, the clothed by the naked, and all were
banished from the artist's repertoire. Pacheco presents this viewpoint on an-
cient themes in the section on the proportions of the female figure. After be-
stowing his approval on the representations of female nudes who appear in
Old Testament stories, such as Eve or Susanna, provided they are executed
with *honestidad y decoro*, he attacks the famous painters who had gone to licen-
tious extremes in their paintings of antique themes.

> And they have specialized in making them with great vividness or
> lasciviousness by means of drawing and color. Their paintings (as
> we can see) occupy the salons and chambers of the great men and
> princes of the world. And these artists not only achieve great re-
> wards, but also greater fame and renown. I, however, if I may be
> permitted to speak thus, do not in the least envy such honor and
> advantage.[16]

The confusion of ancient "fables" and sexually provocative nudes is com-
plete. Pacheco goes on to state that his scorn for artists who agreed to paint
these subjects is founded on the belief that they harmed both their own and
the viewer's soul by inciting sensual thoughts, if not behavior, in the same
way that holy pictures provoked virtue and piety.

It is not surprising, thus, that Seville, where there was almost no counter-
weight to the Church's predominance as an artistic patron, was inhospitable
to depictions of the ancient gods. However, the very rarity of these subjects
in painting makes the exceptions stand out. During the first years of the

[15] An excellent discussion of mythological painting in Spain is found in Gállego,
Vision et symboles, pp. 41-72.
[16] *Arte*, I, p. 412.

seventeenth century, two major works were commissioned that incorporated antique subject material. The patrons were both men of means, Juan de Arguijo and the duke of Alcalá. But more important, they were both associates of the academy, a fact that helps to explain these ventures into the ancient world. These two commissions offer the opportunity to observe the collaboration of art and the academy in the secular field that was so important to it. Besides their academic origin, the two commissions have other things in common; both were ceiling paintings that adorned the libraries where, we may suppose, academic meetings were held from time to time. The similarities go beyond the incidental, however, because both cycles are iconographically akin.

The first group of paintings formed part of Juan de Arguijo's last act of prodigality. In 1600, Arguijo began the extensive redecoration of his palace and furnished it with paintings and statuary, some of which he imported from Italy.[17] The project came to a halt in December 1606, when Arguijo discovered that he could no longer afford to live in his splendid dwelling and was forced to sell it. One of the most ambitious decorations of the palace was the ceiling painting in his library, which, according to an inscription it bears, was dedicated in 1601 (fig. 15).[18] The artist is unknown, although the names of Antonio Mohedano and Pacheco have been casually attached to it.[19] The paintings on canvas are set in a rectangle divided into a complex geometrical arrangement. A border of *grutescos* frames the entire ensemble. The paintings consist of five compositions, including a large central panel and four smaller panels, one in each corner. Between one pair of small panels is Arguijo's coat of arms, and between the other pair is the dedicatory inscription: GENIO ET MUSIS DICATUM AS MDCI (Dedicated to Genuis and the Muses. Year of the Savior 1601). Flanking the central panel on the long axis are two sections of decorative painting, also with *grutescos*. In the interstices that make up the remaining space, these decorative motifs are repeated.

The identification of the numerous scenes and figures in the ceiling poses few problems.[20] The central group is an assembly of the ancient gods. Jupiter,

[17] The house and its history are described by Gestoso y Pérez, "La casa de D. Juan de Arguijo," *Bética*.

[18] The whereabouts of the ceiling paintings are unknown to me. When Gestoso y Pérez wrote his article (1914), they had long since been removed from the house and were then in the possession of D. Javier Sánchez-Dalp. The ceiling is briefly discussed by Angulo Iñiguez, *Pintura del Renacimiento*, pp. 314-17.

[19] Another possible candidate is the little-known Italian artist Gerolamo Lucente da Correggio, who was active in Seville in the first twenty years of the seventeenth century. The earliest record of Lucente in Seville is dated July 1, 1604, when he signed a contract to execute the paintings for the main altarpiece of the Casa Profesa (Hernández Díaz, *Documentos para la historia del arte en Andalucía*, II, pp. 159-61). As mentioned above on p. 65, the commission was ultimately executed by other artists. Obviously, Lucente had arrived in Seville at an earlier date, although whether he was there by 1601 is unknown. However, the style of Arguijo's ceiling is clearly Italianate and the quality is notably better than what Mohedano and Pacheco could accomplish. Until more is known of Lucente's work, the attribution is entirely hypothetical.

[20] Gestoso y Pérez, "La casa de D. Juan de Arguijo," identifies most of the figures correctly. Diego Angulo Iñiguez, *La mitología y el arte español del renacimiento*, pp. 139-46, concurs with Gestoso in all but two cases, Justice and Envy. See note 21 for a discussion of Angulo's interpretation.

the most prominent figure, sits at one end holding a scepter in his left hand. His foot rests on a bolt of lightning, alongside which is an eagle, another of the god's traditional attributes. To his right, ranged along the left side of the panel, are Saturn, Mars, Diana, and Neptune, each denoted by conventional symbols. On the opposite side, on Jupiter's left, we see Apollo, Mercury, Venus, and Cupid. On the other short end is Juno flanked by two figures half submerged in darkness. The one to Juno's left holds a plow and thus can be identified as Ceres. The figure at her right is nearly invisible but, given his dark complexion and proximity to Venus, is probably Vulcan. The single figures in the four smaller panels are also quickly recognizable. On the left side of the dedicatory inscription is Phaëthon and his chariot tumbling out of the skies. On the right is the *Rape of Ganymede*, drawn after Michelangelo's model. The other panels show personifications of *Justice*, holding a sword and a balance, and *Envy*, an ugly harridan who holds a torch in one hand, symbol of the vice that consumes itself, while she tears snakes from her hair with the other hand.

If the identification of the figures is a routine matter, the collective meaning of the pictures is considerably more challenging.[21] A closer scrutiny of certain details in the ensemble suggests its general intention, although some parts still defy specific interpretation. Beginning with the assembly of the gods, which is predominant by virtue of its size and location, it is clear that Jupiter is meant to be seen as the central figure. He sits alone on one edge of the painting, his majesty emphasized by the light that glows about him. Besides the attributes of eagle, lightning, and scepter, two more objects accompany him: two urns, one in light at Jupiter's right, the other in darkness at his left. According to a tradition that can be traced back to Homer, these urns stand at the Gates of Jupiter and symbolize good and evil, which the god dispenses to human beings as he determines their moral constitution.[22] In this instance, however, Jupiter does not act solely as giver but also as judge of good and

[21] The only attempt to interpret the meaning of the ensemble has been made by Angulo, *La mitología*. Essentially, Angulo understands the ceiling to be an allegory of the judgment of quality in poetry. The key to his interpretation is the identification of the figure holding the sword and balance as Astrea. In this picture, Astrea is seen to be fleeing from earth, where she has found envy but not justice, and is returning to Olympia and the reign of her mother, Themis, who is symbolized by the scale in the center of Olympus. For his interpretation of Phaëthon and Ganymede, Angulo turns to the sonnets that Arguijo wrote about them. In the sonnet on Phaëthon, Arguijo draws the conclusion that Phaëthon symbolizes the glory of having made an attempt rather than man's presumption to rise above his mortal station. Arguijo derived this unusual interpretation to the myth from Fernando de Herrera's sonnet "Tan alto esforçó el buelo mi esperança," a poem that comments on the unhappy conclusion of a love affair. In the context of the ceiling, where Phaëthon is paired with Ganymede, this idiosyncratic reading destroys the obvious contrast between a successful and unsuccessful ascent to the heavens. Angulo, in fact, infers this contrast when, citing the dedicatory inscription, he concludes that the (poetic) genius will gain Olympia while his envious enemies will, like Phaëthon, be cast down. Although this interpretation would certainly be suitable for a poet's library, it depends on the questionable analysis of several symbols, which will be commented on below.

[22] The symbolism of the urns is explained by Dora and Erwin Panofsky, *Pandora's Box. The Changing Aspects of a Mythical Symbol*, pp. 48-54.

evil, a fact indicated by the scepter he holds in his left hand. The scepter is surmounted by an open eye, an emblem that, according to Valeriano, signifies justice.[23] The preeminent role of justice in the ceiling is confirmed by another motif in the central panel. In the heavens, above the assembled gods, a band of light appears. At its center, which is also the center of the ceiling, there is a scale.[24] This motif suggests that a judgment is being executed by Jupiter; but what is being judged?

The answer is found in the stories of Ganymede and Phaëthon, whose fates were decided by Jupiter. Ganymede was carried to the heavens by Jupiter in the guise of an eagle, while Phaëthon was struck down by a bolt of lightning from the god during his attempted ascent. (These two agents of the god's will rest at his feet in the central panel.) Besides symbolizing the favor and disfavor of Jupiter, Ganymede and Phaëthon also had long been interpreted allegorically. In the sixteenth century, Phaëthon was usually understood to symbolize the dire fate that would befall mortals who attempted to defy human limitations. The most influential interpretation of Ganymede was supplied by the Neo-Platonists, who converted him into the personification of the *mens humana* which, freed from the body, contemplated heaven ceaselessly.[25] These readings could be accommodated to fit Arguijo's ceiling. However, another source seems to provide a more exact and plausible basis for interpretation.

In 1585, sixteen years before the ceiling was dedicated, Juan Pérez de Moya published his book *Philosophía secreta*, a work that became the most popular Spanish guide to ancient mythology.[26] Pérez de Moya's interest in the subject is not simply descriptive; almost like a medieval scholar, he utilizes the myths as a basis for moral exegesis. Thus each myth is not only recounted but also is given a threefold *declaración* that includes an historical, physical, and moral lesson. The moral description of Ganymede begins conventionally by characterizing Ganymede as the prudent man: "By means of this fable scholars wish to paint the picture of a prudent man. Ganymede was loved by Jupiter. This

[23] Pietro Valeriano, *Hieroglyphica*, p. xxxiii, s.v. "Justicia." According to Valeriano, a scepter surmounted by an eye is also an attribute of Apollo, an interpretation that is clearly inapplicable in this case. In Cesare Ripa, *Iconologia*, II, p. 59, s.v. "Modestia," this motif symbolizes moderation, which seems opposite to the Ganymede-Phaëthon dichotomy. However, this symbol does not appear in the earlier editions.

[24] In Angulo's interpretation, the balance is a symbol of Themis, the goddess of justice, who awaits to welcome the ascending Astrea. There is, however, no compelling reason to personalize the abstract symbol. The spectrum of light naturally brings the zodiac to mind, especially because the balance is also an astrological symbol. In the absence of the other eleven signs, or even one of them, there seems no reason to think the band serves any purpose other than to highlight the balance. Arguijo was born on September 9, 1566. The sun does not enter the sign of Libra until September 22, thus eliminating any obvious astrological significance of the motif.

[25] See Erwin Panofsky, "The Neoplatonic Movement and Michelangelo," *Studies in Iconology*, pp. 212-22.

[26] Juan Pérez de Moya, *Philosophía secreta*. Pérez de Moya's significance as a mythographer is discussed by Jean Seznec, *The Survival of the Pagan Gods*, pp. 317-18, and by Gállego, *Vision et symboles*, pp. 67-68. It is interesting to note that Velázquez possessed a copy of Moya in his library.

means that the prudent man is beloved by God." Continuing his description, Moya takes an unexpected turn that equates Ganymede not merely with prudence, but also with learning as a means to attain God: "And it is he alone who arrives by means of learning to God, because if God is learning, the scholar imitates him by being virtuous."[27]

Moya's interpretation of Phaëthon provides a counterfoil to the meaning of Ganymede. He begins conventionally by describing Phaëthon as vainglorious and arrogant. But as he continues, Phaëthon too acquires another dimension of meaning. "[Phaëthon,] presuming to be learned without really being so, sowed much confusion and many false doctrines among the simple folk." Moya cites Phaëthon as a warning to those who "know little and misuse the sciences. Great empires and administrations and republics should not be entrusted to youths nor to men of little learning, but rather to the wise and experienced."[28]

Ganymede and Phaëthon, then, represent two aspects of the pursuit of knowledge: knowledge attained by prudent study and vain pretension to knowledge. Those in the first category pass through the Gates of Jupiter, while those in the second category are cast down and not permitted to take their place among the assembled gods of antiquity. Thus are the good and evil that Jupiter, symbol of divine wisdom, judges, with the results we see in the panels of Ganymede and Phaëthon. In the context of a library, a center of learning, the message is relevant both as an encouragement and admonition to those who labored within.

In the personifications of Justice and Envy on the other side of the ceiling, we sense in a general way the same opposition of the ascent of good versus the descent of evil. Justice, of course, is a cardinal virtue while envy is a deadly sin.[29] But beyond this broad interpretation of the two symbols, the reasons for contrasting these two particular figures are difficult to define. There may be a suggestion that justice is found only in heaven, where it is symbolized by the balance, whereas envy rules on earth. Angulo, in fact, hypothesized that Arguijo, as an amateur poet, might have wished to comment on the critics of his art by subtly attacking their powers of artistic judgment, at the same time indicating where the only possibility for true judgment lay. In the absence of any more precise interpretation, the two figures may be understood in a general way simply as personifications of two aspects of good and evil. Thus, they would relate to the other symbols of this polarity represented in the ceiling, especially the twin urns of Jupiter. If this were the

[27] Pérez de Moya, *Philosophía secreta*, f. 201v. See also Antonio Gallego Morell, *El mito de Faetón en la literatura española*.

[28] Pérez de Moya, *Philosophía secreta*, f. 85v.

[29] The sword and balance held by this figure are the traditional attributes of Justice, a point upon which almost all the mythographers agree. Angulo's attempt to identify her as the more complex character Astrea is not warranted in this context. The association of Envy with snakes is found in Ovid, *Metamorphoses*, II, verses 768-70, and became standard in Renaissance art. See Guy de Tervarent, *Attributs et symboles dans l'art profane 1450-1600*, cols. 405-406, s.v. "vipere." The bared left breast of Envy would appear to follow Ripa's description of the figure; *Iconologia*, p. 241.

case, then the cryptic meaning of the dedicatory inscription may become apparent.

Initially, the dedication of the ceiling to "genius and the muses" seems irrelevant to the content of the pictures as described above. "Genius," however, in this context means something distinct from its modern definition, which became current during the eighteenth century. In the sixteenth century, the word still retained much of its Latin significance, which defined "genius" as the deity or spirit that kept watch over every person and determined his fate, in other words a guiding force. A somewhat altered definition of the word is supplied by an academic colleague of Arguijo, Fernando de Herrera. In the *Anotaciones*, he defines genius as follows: "the specific virtue or particular property of all living beings."[30] By employing the word "virtue," Herrera adds a moral dimension that accords both with the underlying significance of the ceiling and with certain specific symbols. Most directly related are the Jovian urns of good and evil. According to the passage from Homer's *Iliad*, where the imagery first appeared, Jupiter determines an individual's make-up by mixing good and evil from the contents of the urns.[31] In other words, he confects what might be called an individual's "genius." The ceiling paintings present the concept in the extreme forms of good and evil, whereas generally the mixture was more in balance.

The ceiling, however, is not merely dedicated to "genius," or to good and evil. The co-nominees are the muses, the goddesses of the arts, literature, and science as they were described by the mythographers. Pérez de Moya follows this conventional description, but then expands upon it in a way that bears on Arguijo's paintings.

> The Muses were daughters of Heaven or of Jupiter, because Jupiter was held by the gentiles to be the greatest of the gods and also to be the [source of] knowledge denoted by these muses. This knowledge cannot come to man except from God denoted as Jupiter.[32]

Hence the dedication is directed by inference to Jupiter as the source of art and knowledge and of good and evil. In the paintings, he is depicted in this way, although he supplements his role by acting as judge of these qualities as well. In its broadest sense, Arguijo's ceiling is an allegory of the creation and judgment of knowledge and virtue. The virtuous possessor of true knowledge attained by prudent study achieves the Olympian heights, while the vain and evil pretender to knowledge rises briefly, only to fall.

The relationship of Arguijo's ceiling to the academy is established not only by dint of his known association with the group but also because it served as a model for the decoration of another academician's library. Two years after Arguijo's library was decorated, a second, almost identical work was commissioned by the duke of Alcalá for his study in the Casa de Pilatos, where it

[30] For the etymology of the word, see Juan Corominas, *Diccionario crítico etimológico de la lengua castellana*, II, pp. 722-23, s.v. "genio."

[31] Homer, *Iliad*, XXIV, 527, trans. Richmond Lattimore (Chicago, 1952), p. 489.

[32] Pérez de Moya, *Philosophía secreta*, fol. 179r.

is still installed.[33] The author of the work was Pacheco, who described the genesis in Book Three of the *Arte*.

In his account, Pacheco mentions that he received the commission in 1603 and executed the *Fall of Icarus* as a trial piece.[34] Pacheco acknowledges the assistance of two fellow academicians. Pablo de Céspedes, who was in Seville at the time, offered his advice and approval on technical matters. Francisco de Medina is given credit as the iconographical adviser. Medina's intervention in the scheme suggests that he was also the author of the program of Arguijo's ceiling. Arguijo and Medina were well-acquainted. As we have seen, the scholar had corrected the poet's manuscripts. Medina is also a logical candidate because he possessed the kind of erudition that informs the ceiling painting. Of course, it is possible that the program of the decoration of Arguijo's study was devised by someone else, perhaps Arguijo himself, and then elaborated by Medina. However that may be, the two ceiling paintings demonstrate the interaction of scholars and painters in the academy.

Curiously, Pacheco has nothing to say about the meaning and purpose of the work. The silence is puzzling in one so devoted to iconographical disquisitions. Perhaps he later came to regret his participation in a work with a pagan subject. Whatever the explanation, the decoration can be explained only by reference to Arguijo's ceiling and an analysis of additional elements in Pacheco's paintings.

The ceiling of the duke's study, which is dated 1604 on a titulus on the central panel, is a somewhat more ambitious undertaking than its model.[35] All five of the subjects in the Arguijo ceiling are repeated; that is, the *Assembly of the Gods*, *Phaëthon*, *Ganymede*, *Justice*, and *Envy* (figs. 16-17, 19, 21-22). There are two additional scenes; the *Fall of Icarus* and *Perseus astride Pegasus* (figs. 18 and 20). However, the disposition of the panels is different. The *Assembly of the Gods* remains the centerpiece, but immediately flanking it are *Phaëthon* and *Icarus*, while *Perseus* and *Envy* fill two of the corners and *Justice* and *Ganymede* the other two. And, finally, the meaning and emphasis of the pictures have been altered to express the requirements of the new patron.[36]

The change is immediately apparent in the large central scene, which shows the assembled gods of antiquity (fig. 16). In the place of a balance in

[33] The copies of *Phaëthon* and *Icarus* that are located in the south porch of the upper story were made by motion picture studio artists during the filming of *Lawrence of Arabia* to reduce background glare.

[34] The advanced state of deterioration of this picture indicates that Pacheco had not yet mastered the technique of tempera painting he describes in this section of the *Arte*.

[35] The inscription reads *Franc. Paccius, Hispalens. Superis. labori. adspirantib. Pingeb. A. M. DC. IV*. The play on the word *Superis*, referring to the gods and their position vis-à-vis the viewer, is probably Medina's idea as well. A preparatory drawing for the *Assembly of the Gods* is preserved in the collection of the Real Academia de San Fernando, Madrid. It bears two inscriptions in Pacheco's hand. One reads "en 9 de abril de 1604"; the other, "acabó se de pintar ese cuadro en 19 de Agosto de 1604," which dates the picture precisely. Another preliminary study, showing Phaëthon, is in the Gómez-Moreno collection, Madrid.

[36] Previous interpretations of the ceiling include those of Angulo, *La mitología*, pp. 123-38, and George Kunoth, "Francisco Pacheco's *Apotheosis of Hercules*," *Journal of the Warburg and Courtauld Institutes*, pp. 335-37.

the center there is the figure of Hercules seated and seen from behind.[37] Hercules's presence among the gods changes the meaning of the central scene and, indeed, of the entire group of pictures. The thematic purpose he serves is explained on an inscribed tablet held by Jupiter's eagle and by another short inscription that arches over Hercules himself. The first inscription reads: D. FERD. HENRICO A. RIBERA. DUCI. ALCALAE. III HEROICA. VIRTUTE. ARDUUM. AD. GLORIAM. ITER. PARANTI. EXEMPLAR. PROPOSITUM. Freely translated, it reads "This example is presented to Duke Fernando Enríquez de Ribera, third duke of Alcalá, who is preparing with heroic virtue for the hard road to glory."[38] The inscription implies that the duke is about to begin an important undertaking, which, if he follows the advice as painted above, will lead him to glory. This enterprise is nothing less than his life's work. In 1604, when the ceiling was finished, the duke of Alcalá turned twenty years and crossed the threshold of manhood. As the heir to a great noble house, he would have aspired to perpetuate its glory. The path to success is indicated in the central motif. Hercules, a mortal, sits apotheosized among the gods, accompanied by an inscription that underlines his significance: PETITUR HAC CAELUM VIA ("Heaven is sought by this road"). The laborious road chosen by Hercules is the way to glory. As Kunoth has noted, Hercules was selected as the example of glory because the Ribera Alcalá family claimed descent from him (as did the kings of Spain) and incorporated him into the family emblem in the fifteenth century. Thus the central panel is a didactic allegory exhorting the young aristocrat to follow the path of glory blazed by his heroic ancestor. The subsidiary scenes offer more explicit guidance by pointing out the virtues the young man must adopt and the vices he must avoid to attain his goal.[39]

Immediately flanking the main group, the stories of *Phaëthon* and *Dedalus and Icarus* (figs. 17 and 18) are shown as admonitions against vice. Phaëthon, as we have seen, was a common symbol of vainglory and pretension. According to Pérez de Moya, he was particularly relevant to these vices in the field of learning. The symbolism of Dedalus and Icarus is closely related. Pérez de Moya pictures the father and son as the incarnations of prudence versus imprudence and in terms that are relevant to the ceiling.

> Moreover, we are given to understand that when ambition and the
> desire for high things are restrained by reason, and prudence stays

[37] As Kunoth points out, the motif of Hercules seen from the rear follows the custom of celestial maps. He also suggests that Pacheco's Hercules is a composite formed of the *Farnese Hercules* (via Goltzius's engraving) and a figure in Michelangelo's *Last Judgment* (his fig. 416).

[38] James T. Luce, Professor of Classics, Princeton University, kindly assisted in the translation of the Latin inscriptions and offered fruitful suggestions about their application to the paintings.

[39] Kunoth, "Pacheco's Apotheosis of Hercules," interprets the significance of Hercules somewhat differently. He writes, "The reward won by his [the duke's] ancestor for his heroic virtue is clearly being promised to the Duke." I would add that the inscription indicates that the promise is extended but its fulfillment is not guaranteed. In order to realize it, the duke must demonstrate the virtues and avoid the vices depicted in the remaining six pictures. By omitting these pictures from his discussion, Kunoth misplaces the emphasis of Hercules's symbolic function.

within bounds, not elevating itself above what its merits are worth, then, after life has run its course, man arrives at his desired end, as Dedalus did. But those, who like Icarus, wish to raise themselves higher than they should, transported by an uncontrolled desire, end by falling into the miseries of the world, symbolized by the waves of the sea, with dishonor and irreparable harm.[40]

The young nobleman is thus advised to be modest, reasonable and prudent.

Other qualities needed for the long journey to glory are represented by *Ganymede* and *Perseus* (figs. 19 and 20). As in Arguijo's ceiling, Ganymede symbolizes prudence applied specifically to learning. Perseus astride Pegasus furnishes an example of a more worldly virtue needed by the aspirant to glory. Pérez de Moya describes him as the representative of physical strength. "Perseus conquered these three sisters [the Gorgons] because Perseus is understood as the virtue of strength."[41] And Pegasus, the winged horse who sprung from the Gorgon's blood, may be interpreted as courage or, more conventionally, as fame.

The remaining two personifications, *Justice* and *Envy* (figs. 21-22) are also holdovers from Arguijo's ceiling.[42] Here the grounds for interpreting them simply as chosen representatives of vice and virtue are more compelling, though it is hard to know why justice and envy have been singled out.

The decoration of the duke's private study, then, was meant to inspire the young man to a life of virtuous achievement that would ultimately be rewarded by elevation to the sempiternal glory of Olympia. In another sense, it is also a blessing bestowed by a faithful friend and servant of the family. *Maestro* Medina had been the devoted tutor of the duke's father, a patron of the arts and amateur poet, whom death had claimed at an early age. In his son, Medina may have glimpsed the hope for redemption of a promise unkept.

These two commissions represent the only significant traces of classical themes in Sevillian painting.[43] Not surprisingly, the impetus for both of the decorations can be traced directly to Pacheco's academy, where classical studies were actively pursued. But, on closer scrutiny, the academy's influence on mythological painting is less impressive than it might seem. There is a huge disparity between the literary and scholarly interest in antiquity and its reflection in painting. And the difference is not merely quantitative, because the paintings, unlike the poetry, carefully filter out the pagan elements of antiquity. As examples of mythological art, the ceiling paintings are clearly circumscribed by their allegorical intentions. In both ensembles, the ancient gods and heroes are used symbolically to express moral ideas. They are consequently more intelligible as examples of Renaissance emblematic mythography than as vital expressions of a classical past. In devising the programs,

[40] Pérez de Moya, *Philosophía secreta*, f. 205r. [41] Ibid., f. 211v.

[42] Envy is somewhat differently represented here than in Arguijo's ceiling. She is shown holding her heart in her hand, a motif probably derived from Andrea Alciati, *Emblemata*, Emblem 71, where Envy is described as devouring her own heart.

[43] There is another small mythological ceiling in another room of the Casa de Pilatos. See Angulo, *La mitología*, pp. 143-46.

Francisco de Medina relied on Cartari, Valeriano, and Pérez de Moya, not Ovid, although of course he knew the classical author. His preference was to clothe the ancient characters in the modern guise of allegory and symbol. Ganymede became a symbol of prudence, not the object of Zeus's uncontrollable passion. This approach to antiquity conformed to a well-established tradition that reaches back at least to the *Moralised Ovid*. By employing, so to speak, expurgated texts, a safe balance was struck between the lure of an attractive past and the requirements of the restrictive present. Before entering Seville, the antique gods had to pass through the customshouse of Catholic orthodoxy where their paganism was confiscated. Mythological painting in Seville was limited not only in number but in scope, and an unexpected community was found between religious and secular art. Only in the case of one artist did the academy's interest in antiquity find a unified expression, and that was Diego de Velázquez.

The pictorial sources of Velázquez's art have been studied with some care, but equally important to his formation is the intellectual legacy he acquired as Pacheco's apprentice.[44] Velázquez entered Pacheco's household as a boy of twelve and spent the crucial years of adolescence and early maturity in an environment where scholars may have outnumbered artists. Velázquez can be considered as the finest product of the union of art and learning, the realization of the academy's ideal learned painter who, unlike Pacheco, could synthesize erudition and art. Nowhere is this quality more apparent than in his paintings of antique themes, in which he subtly and brilliantly effected a unique renovation of the antique spirit.

Velázquez's mythological paintings are challenging works. From the first major painting, *Los Borrachos*, to the late *Mercury and Argus*, a common but elusive spirit pervades Velázquez's interpretation of antique sources. Not that his approach is uniform; there are mythological allegories (the *Fable of Arachne*) and straightforward narratives alike (the *Forge of Vulcan, Mercury and Argus*) and a number of works that still escape precise categorization (*Venus at the Mirror, Mars*, and *Los Borrachos*). But even when the intent is clear, the paintings ultimately escape our grasp because they are unique realizations of their conceptions. To know that *Los Borrachos* may be a *teoxenia*, based on an engraving of a Hellenistic relief, does not account for its enduring fascination.[45] When *Las Hilanderas* was shown to be the *Fable of Arachne*, its mystery was deepened, not clarified. Perhaps it is the uncanny modernity that makes

[44] The principal external evidence of Velázquez's humanistic interests comes to us from the inventory of his library, made after his death in 1660; see Francisco J. Sánchez Cantón, "La librería de Velázquez," in *Homenaje a Menéndez Pidal*, III, pp. 379-406, and "Los libros españoles que poseyó Velázquez," in *Varia Velazquena*, I, pp. 640-48. Kurt Gerstenberg, *Diego Velázquez* (Munich and Berlin, 1957), pp. 215-39, has a useful chapter on Velázquez and humanism; see also Kurt Gerstenberg, "Velázquez als Humanist," in *Varia Velazqueña*, I, pp. 207-216.

[45] The suggestion that *Los Borrachos* may represent a *teoxenia*, or visitation of a god to men, was briefly made by Delphine F. Darby, "In the Train of a Vagrant Silenus," *Art in America*, pp. 140-48, esp. p. 145. A copy of the Greco-Roman relief that inspired Ribera was in the collection of the Duke of Alcalá and thus almost certainly was known to Velázquez.

these pictures such fugitive artistic experiences. Velázquez is an anti-archaeological painter. Although he is hardly the first to tell the ancient myths in realistic terms, he is one of the few painters to make a convincing translation from antiquity into naturalism. He developed his approach to antiquity throughout his life. The early paintings, such as *Los Borrachos* and the *Forge of Vulcan*, still make concessions to the conventions of mythological painting, as in the idealized figures of Bacchus and Apollo. But later on, the duality is resolved by telescoping mythology into genre. Mars is wittily depicted as the unhappily surprised lover of Venus, not as the truculent god of war.[46]

This unconventional and original interpretation of a Greco-Roman source is typical of Velázquez's mythological paintings. Velázquez not only read the ancient texts, he also interpreted them. But his literary intelligence was always dominated by his artistic sensibilities, and this is why his paintings are great works of art. In his union of art and learning, Velázquez was able to capture in pictures what the Sevillian humanists and poets had put into words—a sense of the continuing relevance of the antique heritage and a deep feeling of attachment to a tradition that, although formed in the distant past, was made of the very stuff of mankind.

The process through which Velázquez arrived at his personal understanding of classical mythology still awaits re-creation, but surely his experience in Pacheco's academy played an important part. Velázquez represented the highest expression of the association between painting and letters that the academy fostered during the late sixteenth and early seventeenth century. He also represented its final expression. By 1622, he must have felt the need for a grander arena. Seville, which as Spain's richest city could once offer wealth and honor, had begun to experience a decline that soon would reduce it to the status of a provincial capital.[47] Men with worldy ambitions now went to Madrid, particularly men from Seville who often found favor with their powerful fellow-citizen, the count-duke of Olivares. When Velázquez moved permanently to the capital in 1623, Pacheco's academy was on the point of dissolution. In 1617, Rioja had left for Madrid to serve as Olivares's librarian. Two years later, Jáuregui, too, moved to Madrid, and the duke of Alcalá went to Barcelona to become viceroy of Catalonia. By 1644, the year of Pacheco's death, Seville's humanistic tradition was all but extinguished. In that year, one of the survivors of the golden age, Rodrigo Caro, wrote to a fellow scholar, lamenting the pitiful state of humanistic studies in a city that had been their proud center.

> Have pity, Sir, on those of us who live in Seville in these days, that
> being the mother in every age of such illustrious minds, she now
> finds herself in this unhappy time so prostrated that, in this great

[46] For this interpretation of *Mars*, see Madlyn M. Kahr, *Velázquez: The Art of Painting*, pp. 91-92.

[47] The decline of Seville in the seventeenth century is reconstructed by Antonio Domínguez Ortiz, *Orto y ocaso de Sevilla. Estudio sobre la decadencia de la ciudad durante los siglos XVI y XVII*.

city, I doubt that three men will be found who treat of these studies. And if someone is undertaking them, it is either with vain ostentation and without public profit, or with ignorance of the true principles by which one should study the glorious dust of antiquity.[48]

Pacheco survived to see the demise of his academy, but he kept its memory alive by finishing the book that would chronicle the unique association to which his art, and much of contemporary art in Seville, is inextricably bound.

[48] Caro, *Varones insignes*, p. 121.

PART II
PAINTERS AND PROGRAMS

4

On the Meaning of
*Las Meninas**

A painting as rich in ambiguity as it is in subtlety, *Las Meninas* (fig. 23) has long been recognized as a masterpiece of Western art, a pictorial tour de force rarely equalled and never surpassed. But when we attempt to explain its greatness, we soon realize how it seems to evade the grasp both of intuitive and rational understanding. The reason for this apparent mystique lies primarily in the contradiction between form and subject. By its very size and overwhelming virtuosity, *Las Meninas* claims attention as a masterpiece. And yet the subject could not be less prepossessing—an informal group portrait in an artist's studio. Fritz Saxl expressed the paradox well when he wrote, "We are bewildered because we feel that this, a subject for a snapshot, has suddenly been turned by Velázquez into a representative court picture."[1] This tension between form and content has been an important reason for its irresistible fascination to writers of every stripe and inclination. Critics, scholars, poets, playwrights, and philosophers all have tried to reach its essence, to provide a truly definitive explanation of its meaning, only to find that the picture has eluded the elaborate intellectual traps that they have set for it. In the face of these circumstances, and in the absence of any conclusive documentation, it must be admitted that no single interpretation will ever satisfy every point of view. *Las Meninas*, like every great work of art, is renewed, not depleted, by time and thus remains forever alive. By the same token, every generation has an obligation to accept the challenge of interpretation as part of this process of perpetual revitalization. In this spirit the following lines were conceived and written.

* The ideas in this study were initially presented in a public lecture given at the Institute of Fine Arts, New York University, on October 16, 1973. Subsequently, they were restated in shortened form in a paper given at the Annual Meeting of the College Art Association of America in January 1974.

In June 1975, Madlyn Kahr published an article entitled "Velázquez and *Las Meninas*," *Art Bulletin*. This article has two parts. The first is an attempt to identify the visual sources of *Las Meninas* in Flemish gallery pictures. This suggestion was first proposed by Matthias Winner, "Gemalte Kunstheorie. Zu Gustave Courbet's 'Alégorie réelle' und der Tradition," *Jahrbuch der Berliner Museen*, whose work is not cited by Kahr. The second part, an analysis of the reasons that impelled the creation of the picture, duplicates the content of my public lectures, also without acknowledgment. I believe that the priority of my lectures relieves me of the responsibility to acknowledge Kahr's arguments where they follow mine. Kahr has subsequently restated the arguments, with some amplification, in *Velázquez*, pp. 128-202.

[1] Fritz Saxl, "Velázquez and Philip IV," *Lectures*, pp. 311-24.

The characters in *Las Meninas* have long been known. In 1724, Antonio Palomino was able to identify virtually every person in the picture.[2] In the center foreground is the young Infanta Margarita María attended by two maids of honor, or *meninas*. At the left is María Agustina Sarmiento, who offers a drink of water in an earthenware cup to the princess. The other *menina* is Isabel de Velasco. In the right corner are the dwarfs Mari Bárbola and Nicolas Pertusato. The middleground is occupied by a chaperone, Marcela de Ulloa, who is accompanied by an unidentified bodyguard, and behind them, in the open door, is José de Nieto, the *aposentador* of the Queen's household. The left side is dominated by a large canvas, before which the painter stands. Finally, on the rear wall, a mirror reflects the images of the king and queen, Philip IV and Mariana of Austria. Palomino informs us that the scene is set in the *galería del cuarto bajo del Príncipe*, also called the *pieza principal* because it had been the main room in the second floor apartment once occupied by Prince Baltasar Carlos.[3]

Once we leave the realm of description, the road to understanding becomes lost in a thicket of speculation. There is, in fact, no substantial agreement about what the figures are doing or why they have been brought together. The earliest references to the painting provide no clues.[4] In the palace inventory of 1666, the picture is called "Her Highness the Empress with her ladies and a dwarf." By 1734, it was referred to as the "Family of King Philip IV." Both of these titles are typical of the casual descriptions used by the court officials entrusted with compiling royal inventories and cannot be relied upon for purposes of identification except in a general way. The name of *Las Meninas* was not given to the picture until 1843, when it was so listed in the Prado catalogue by Pedro de Madrazo. The elevation of the servants above their masters may have sprung unconsciously from the republican sentiments that swept nineteenth-century Europe, but the new title is no more revealing than its predecessors.

The first significant interpretation of the painting emerged in the late nineteenth century, when it came to be understood as a genre painting of unrivaled spontaneity and verisimilitude. The "Impressionist" reading is epitomized in Karl Justi's description in his classic work, *Velazquez und sein Jahrhundert*.[5] For Justi and his contemporaries, *Las Meninas* was a slice of palace life preserved with pluperfect fidelity by a master of objective observation. It was, up to a point, comparable with a snapshot in its power to reproduce without distortion a casual event devoid of transcendent meaning. This understanding of *Las Meninas* as a faithful counterfeit of reality survives to this day, expecially in the minds of writers who expect the painting to obey natural laws and who consequently reject the license taken by artists to alter

[2] Palomino, *El museo pictórico*, pp. 920-22.

[3] For a detailed discussion of the identification of this room, see below, pp. 99-101.

[4] These have been compiled in the useful book by Francisco J. Sánchez Cantón, *Las Meninas y sus personajes*.

[5] Justi, *Velázquez and His Times*, pp. 416-22. The following review of the literature on *Las Meninas* aims to summarize the main currents of thought about the work, not to be complete.

nature for expressive purposes. By placing the painting under an objective imperative, something Justi himself did not do, they minimize the imagination of its creator.

A fresh interpretation was not advanced until sixty years later. In 1949, Charles de Tolnay published his important article in which he "read" *Las Meninas* as an allegory of artistic creation.[6] The painting, he wrote, "is one of the earliest self-portraits of an artist where the subjective spiritual process of creation is emphasized rather than the objective material execution which, however, is not hidden." In a certain sense, the importance of Tolnay's method of approach transcended the conclusions he drew from it. By breaking with the prevailing interpretation, he revealed the possibility of *Las Meninas* as an intellectual as well as technical masterpiece. This approach was not without its hazards, however, as the article by J. A. Emmens illustrates.[7] Despite the careful scholarship and ingenious hypotheses, it is no easier to accept Emmens's view of the painting as an illusionistic *emblema* than it is to share Justi's belief that it showed a moment in the life of the royal family.

A third approach unhappily combined the excesses of the first two. Its inception can be traced to an article by a Spanish architect, Ramiro de Moya, that appeared in 1960.[8] Moya set himself the apparently limited and uncomplicated task of tracing the perspective of the room and then reconstructing the setting and position of the figures as they actually were to be seen on the day the picture was painted. Fundamental to Moya's thought was the nineteenth-century belief that the picture was totally bound to reality and that, furthermore, this reality could be accurately measured by the rules of perspective. Two of his results indicate a direction he set for a number of writers, all of them Spanish. First he concluded that the mirror on the rear wall reflected the image that Velázquez was painting on the large canvas, not the persons of the king and queen, which, according to his diagram, would have been blocked by the canvas. Second, he deduced that Velázquez used either a stand-in or a mannequin for himself, while he painted the picture from a point outside the scene. It is immediately apparent that Moya took for granted the idea that Velázquez must have been reproducing a scene that was taking place before his eyes, with the intention of making it indistinguishable from what he was actually seeing. Furthermore, he also believed that human vision and perspective construction were subject to the same rules. The first of these assumptions is historically inconsistent, the second is simply untrue. And, more interesting still, it soon became apparent that the perspective of the picture could be drawn in several ways. In the following issues of *Arquitectura*, other architects and engineers criticized Moya's and each other's drawings until the validity of the entire procedure was seriously called into

[6] Charles de Tolnay, "Velázquez' *Las Hilanderas* and *Las Meninas* (An Interpretation)," pp. 21-38.

[7] J. A. Emmens, "Les Menines de Velázquez. Miroir des Princes pour Philippe IV," *Nederlands Kunsthistorisch Jaarboek*.

[8] Ramiro de Moya, "El trazado regulador y la perspectiva en *Las Meninas*," *Arquitectura*.

question.[9] Nevertheless, Moya's followers among art historians and men of letters were not disillusioned, and continued to seek the meaning of the picture in the differences between reality as revealed by perspective and as interpreted by Velázquez. Their explanations are at best *jeux d'esprit;* at worst, examples of reason carried to unreasonable lengths.[10]

The last line of thought depends fundamentally on Tolnay's interpretation of *Las Meninas* as an ideological statement, although this time concerning the social status of the art of painting. This hypothesis was first alluded to by Martin Soria and subsequently developed in a short essay by Arturo del Hoyo and in excellent articles by Halldor Soehner and George Kubler.[11] As will be seen later, this idea is clearly embodied in *Las Meninas.* Yet neither this approach nor any other by itself has been sufficient to explain the overwhelming impact of this stupendous painting.

Whatever the disagreements between the partisans in this· debate, there always has been agreement on one point—*Las Meninas* is not only a great picture, it is also Velázquez's masterpiece. Such unanimity about the production of a major artist is rare indeed, and perhaps it occurs because the painting was intended from the outset to be extraordinary. One can almost sense an intention to dazzle the viewer that makes the picture unique in the artist's oeuvre. The size, the complex composition, the unrivaled technique all mark it as a deliberate showpiece. If this is so, then we have identified the most important question about *Las Meninas*—what did Velázquez hope to show by this prodigious display of his talents?

Before exploring aspects of the painting that may help us to find an answer, it is important to resolve a fundamental problem—what is going on in the painting? Several explanations have been put forth, but the most plausible and coherent answer has been offered by Soehner, although it requires certain amendments.[12] This analysis of the "plot" departs from one of the most striking qualities of the picture—the sense of arrested motion that is con-

[9] See especially Carlos de Inza, "Prosiguen las pesquisas," *Arquitectura.*

[10] As examples, the following may be cited: Antonio Buero Vallejo, "El espejo de *Las Meninas,*" *Revista de Occidente,* and Bartolomé Mestre Fiol, "El 'espejo referencial' en la pintura de Velázquez," *Traza y Baza,* no. 2 (1973), pp. 15-36; no. 3 (1973), pp. 75-100. Both articles attach disproportionate importance to the mirror as an aid in the execution of the painting.

[11] George Kubler and Martin Soria, *Art and Architecture in Spain and Portugal and their American Dominions,* p. 268. Arturo del Hoyo, "El conceptismo de Velázquez (ante *Las Meninas),*" *Insula,* is partly seduced by the "mirror" hypothesis, but his grasp of the implications of the presence of the king and queen is sure. Halldor Soehner's "*Las Meninas,*" *Münchner Jahrbuch der Bildenden Kunst,* undertakes a lengthy "affective" analysis of the painting, but also clearly situates the picture in its historical setting. George Kubler, "Three Remarks on the *Meninas,*" *Art Bulletin,* offers concise and telling insights into the painting which, like the others mentioned here, anticipate some of the ideas in this chapter. Kubler also advanced a visual source for the painting, a late sixteenth-century miniature by Hans Mielich illustrating Orlando di Lasso's *Psalmi poenitentiales.* The question of visual sources is vexing and will probably never be conclusively answered because of the synthetic nature of the painting.

[12] Soehner, "*Las Meninas,*" p. 149. Soehner acknowledges that the germ of this idea was first put forth by Gerstenberg, *Diego Velázquez,* pp. 190-98.

veyed by the poses and glances of the actors.[13] This quality, as much as the uncanny rendering of space and atmosphere, must have suggested the analogy of a photograph to the countless writers who have used it, and also contributes to the undeniably "modern" flavor that is responsible for the painting's popularity in our time. One other peculiar aspect of the painting should also be noted before attempting to reconstruct the action, and that is the outward glance of three of the figures. These two observations indicate the underlying structure of the event depicted in *Las Meninas*. A group of people is engaged in an activity that is being interrupted by something that occurs outside the picture frame. If we accept this analysis of the pictorial moment, and integrate it with the specific action of the figures, then the following playlet unfolds.

The infanta has come to see the artist at work. Some moments before the "curtain" has risen, she has asked for a drink of water, which is now being proffered by the kneeling attendant at the left. Just as she hands a small pitcher to the princess, the king and queen enter the room and can be seen reflected in the mirror at the rear. One by one, although not simultaneously, the assembled persons begin to acknowledge the royal presence. The maid of honor at the right, who has seen them first, starts to curtsey. Velázquez has also noticed the intrusion and stopped in the midst of his work; be begins to lower his brush and palette. Mari Bárbola, like Velázquez, has just perceived the entrance of the king and queen, but has not yet had time to react. The princess has been watching little Nicolas Pertusato tease the dog, but suddenly glances to the left toward her parents, although her head remains turned in the direction of the dwarf. Hence the peculiar dislocation between her glance and the position of her head. Finally, Isabel de Velasco, intent on serving water to the princess, has yet to notice the monarchs, as has the chaperone, momentarily involved in a conversation with the bodyguard, who himself has just noticed Philip and Mariana.

This description of the action not only explains the effect of instantaneity and clarifies the poses of the figures, it also confirms the fact that the mirror on the rear wall reflects the persons of the king and queen. They are physically present in the room, a fact that Velázquez has underlined by making them the catalysts of the action. All eyes, so to speak, are focusing, or are about to focus, on Philip and his queen. The costume and action of the *aposentador de la reina* further corroborate the royal presence. According to court etiquette, the *aposentador* had to "be in attendance to Her Majesty, wearing a cape but not a sword or hat, in order to open doors as he is ordered to do."[14]

[13] The device of "frozen action" was used by Velázquez in other multifigure compositions (i.e. the *Surrender of Breda* and the *Fable of Arachne*) as it is here, to heighten the verisimilitude of the event depicted. It is exactly analogous to the technique employed by Rembrandt in such famous paintings as the *"Night Watch"* and the *Syndics*.

[14] "Etiquetas generales de la Casa Real del Rey Nuestro Senor para el uso y exercicio de los ofizios de sus criados," Biblioteca Nacional, Madrid, sig. 10.666, p. 126. See below, pp. 95-96, for additional discussion of the "Etiquetas" and the duties of the *aposentadores*.

Although José de Nieto is little more than a sketchy figure (fig. 24), the hat he holds in his left hand and the cape he wears around his shoulders are easily legible as he stands in the door that he has opened a few moments before and through which the king and queen will shortly pass. Hence, Velázquez has supplied numerous, though subtle, clues to the central event of the painting—the royal epiphany.

The significance of this fact emerges when we realize that an extraordinary and perhaps unprecedented event is being shown to us. It is difficult to recall an earlier painting in which a living monarch and a painter at work are represented together.[15] To be sure, Velázquez has shown the king and queen indirectly, out of deference to their exalted station, although the infanta, also a royal personage, is fully in view. Also for reasons of decorum, Velázquez has not set the scene in the room he used as a studio, but rather in a larger, grander space that was located nearby. By virtue of the presence of the easel, this room has been converted temporarily into the artist's atelier, although it was not the place where he customarily painted.[16] But the implication of these concessions to the king's station is only slightly diminished because Velázquez has stopped the action of the painting exactly at the moment when

The king and queen had separate households that were organized in parallel structures. See Damilo de la Valgoma y Díaz-Varela, *Norma y ceremonia de las reinas de la Casa de Austria*. The fact that Velázquez, the *aposentador del rey*, and thus Nieto's counterpart in the king's household, should be allowed to paint while Nieto performs official duties may be a subtle way to indicate that his status as a painter gave him a higher place in the court. *Las Meninas* as related to the social position of painters in seventeenth-century Spain is further discussed below.

[15] The only earlier representation of a king in a painter's studio known to me is Han Burgkmair's woodcut in the *Weisskunig* (ca. 1514-1519), reproduced in Michael Levey, *Painters at Court*, fig. 96. In this work, commissioned by Maximilian I, the purpose is to glorify the king as an art patron, not the painter as an artist worthy of kings.

[16] There has been considerable confusion about the identification of this room despite the fact that Palomino, who is universally regarded as a reliable source of information about the picture, gives its name as the *galería del cuarto del Príncipe*. The confusion has risen because the studio of the *pintor de cámara* was moved after 1646.

According to the plans of the Alcázar drawn by Juan Gómez de Mora in 1626 (see below, p. 99), the workshop was located in the *galería del cierzo* in the northern part of the palace. Also, a document of December 3, 1632, mentions that Velázquez's workshop was still in that place (José M. de Azcárate, "Noticias sobre Velázquez en la corte," *Archivo Español de Arte*, pp. 363-64). Thus, Francisco Iñiguez Almech, *Casas reales y jardines de Felipe II*, p. 98, identified the setting of *Las Meninas* with this room.

However, according to the palace inventory of 1686 the workshop had been moved into the quarters formerly occupied by Prince Baltasar Carlos, the so-called *cuarto* or *cuarto bajo del Príncipe*. This apartment consisted of a suite of rooms on the second floor, the largest of which was the *galería*, a long, hall-like space with windows on the south. The prince died in 1646, after which it would have been possible to assign the rooms to other purposes. Both Francisco J. Sánchez Cánton, *Las Meninas y sus personajes*, p. 14, and Yves Bottineau, "L'Alcázar de Madrid et l'inventaire de 1686," *Bulletin Hispanique*, pp. 450-51, identify the *galería* or *pieza principal* with the painter's workshop and the setting of *Las Meninas*. Only the second of these points is correct, as will be discussed below. The 1686 inventory (Bottineau, "L'Alcázar de Madrid," p 454) makes it clear that the *obrador de los pintores de cámara* was in another room in the prince's apartment.

the king and queen appear in his workroom. It is in this circumstance that the basic meaning of the painting can be found.[17]

The presence of the monarch in a painter's studio is a time-honored image of art theory. Its ancestry can be traced back to the most important source of knowledge on ancient art, Pliny's *Natural History*. In Book 35, Pliny describes the relationship between Alexander the Great and Apelles, with specific incidents that became grist for the theorists' mill—the frequent visits to the artist's studio, the exclusive right to paint the emperor's portrait, even the gift of a mistress by Alexander to his favorite painter. Pliny recorded these anecdotes as matters of curiosity and wonderment. But many centuries later, they were used to argue a major theoretical issue with transcendent social implications—the condition of painting as a liberal, noble art and thus of painters as artists entitled to enjoy the privileges of high social status.

The struggle for acceptance of painting as a liberal art, as is well known, began in Italy during the fifteenth century.[18] As a weapon in the fight, theorists often turned to the famous relationship between Alexander and Apelles and constructed the following argument: an art that was patronized by kings was, *ipso facto*, a noble art, because a king would honor with his presence and favors only an activity appropriate to his own exalted station. Therefore, the presence of the sovereign ennobled the art. In Italy, the tide began to turn in favor of painters during the sixteenth century. A milestone was reached in 1533, when Titian was made a Knight of the Golden Spur and Count Palatine by Charles V. In the letters patent, the analogy to Alexander and Apelles was explicitly invoked. "Your gifts as an artist and your genius for painting persons from life appear to us so great that you deserve to be called the Apelles of this age. Following the example of our forerunners, Alexander the Great and Octavianus Augustus, of whom one would only be painted by Apelles, the other only by the finest masters, we have had ourselves painted by you, and have so well proved your skill and success that it seemed good to us to distinguish you with imperial honors as a mark of our opinion of you, and as a record of the same for posterity."[19] By 1600, the battle had largely been won, and painters nicknamed "Apelles" were everywhere to be found.[20] Furthermore, as Francis Haskell has noted, the granting of noble titles to artists had become almost commonplace.[21]

These events would have been familiar to Velázquez, who had traveled in Italy and who owned a copy of Pliny as well as a number of the Italian treatises that espoused the cause of painting.[22] Moreover, he had been

[17] Soehner, "*Las Meninas*," p. 158, and Kubler, "Three Remarks," p. 213, both recognized this point.

[18] The history of these events is summarized by Anthony Blunt, *Artistic Theory in Italy 1450-1600*, pp. 48-57.

[19] Translation from Georg Gronau, *Titian*, pp. 105-106.

[20] For a wider discussion of this phenomenon, see Ernst Kris and Otto Kurz, *Die Legende von Kunstler. Ein Geschichtlicher Versuch*, pp. 47-50, and Levey, *Painters at Court*, pp. 118-21.

[21] Francis Haskell, *Patrons and Painters, A Study in the Relations between Italian Art and Society in the Age of the Baroque*, p. 19.

[22] See the inventory of Velázquez's library compiled after his death, as published by Sánchez Cantón, "La librería de Velázquez," pp. 388-405.

trained in the workshop of a leading Spanish exponent of the dignity of painting, his father-in-law Francisco Pacheco. Pacheco's treatise, *El arte de la pintura*, although not published until 1649, was begun in the early years of the seventeenth century, and Velázquez must have heard the well-worn arguments from an early age. Several passages in the book are devoted to establishing the nobility of painting as a liberal art, and in them Pacheco resorts to the tried and true image of the monarch visiting his favorite painter. In chapter six of Book I, entitled "Of the honors that famous painters have received from the great princes and monarchs of the world," Pacheco revives the Alexander and Apelles legend, citing the incident of the studio visitation. "(Apelles)," he writes, "was an agreeable conversationalist and very pleasing to Alexander the Great, who often came to his studio as a form of entertainment."[23] Moving through time, he cites the example of the first modern counterparts of Apelles and Alexander, namely Titian and Charles V. This emperor not only paid the painter handsomely, but also "never permitted anyone else to paint his portrait, as Alexander did with Apelles."

The defense of painting as a noble art is concluded in chapter seven of the *Arte*, entitled "Of other famous painters of our times, who have been favored with special honors for painting." Here Pacheco furnishes examples of modern artists who have enjoyed the favor of princes and kings. One artist he chooses to illustrate his point is Velázquez himself, thus implicitly bracketing him with the great painters of the past who had attracted a monarch's patronage and friendship. "One can hardly believe the liberality and kindness with which he is treated by such a great monarch [Philip IV]. He has a studio in one of the king's galleries, to which His Majesty has a key. [In it, there is] a chair where he can sit and watch him paint at his leisure, which he does almost every day."[24] The passage is important, first, because it proves that Philip IV often visited Velázquez at work, just as he is doing in *Las Meninas*. Second, it not only attests to the remarkable friendship between king and painter, which is known from other sources as well, but it also implies that the nobility of Velázquez's art, like that of Apelles and Titian before him, was guaranteed by the regal visitation to the atelier.

These references furnish a broad context for the interpretation of *Las Meninas*. In the painting, Velázquez is playing Apelles to Philip's Alexander, and perhaps just such a cryptic reference was intended.[25] The parallel is further extended because Velázquez, like Apelles, was given the exclusive right to paint his sovereign, which he did, like his antique forerunner, innumerable times. Thus, *Las Meninas* would appear fundamentally to be the record of a unique relationship between Velázquez and Philip IV, a relationship that guaranteed the noble status of the painter's art.

One small but important detail supports this idea. This is the key that

[23] Pacheco, *Arte*, I, p. 103. As Pacheco notes, the source of this information is Pliny, *Natural History*, book 35, chapter 10.

[24] Pacheco, *Arte*, I, p. 161.

[25] The currency of the image in the royal court is confirmed by its use in Calderón's play, *Darlo todo y no dar nada* (1657). See Angel Valbuena Prat, "Velázquez y la evasión del espejo mágico," in *Varia Velazqueña*, I, p. 176.

hangs from Velázquez's waist, of which now only the double-looped top is visible.[26] It has often been pointed out that this is the symbol of his office as *aposentador* of the Royal Palace, but its significance has not been fully explored. In the complex organization of the Spanish Hapsburg household, the *aposentador* was an administrative officer in charge of the section called the *furriera*, which primarily was charged with the upkeep of the furniture and the cleanliness of the palace.[27] Other important duties included supplying fuel for fires in the winter and arranging for lodgings for the royal household when the king traveled.

If the duties were somewhat onerous, the rewards, powers, and perquisites were considerable. In addition to lodgings in the palace, the *aposentador* received a salary of 600,225 *maravedís* per year, which put him in the middle of the pay scale for palace officials. He was also allowed to control the leasing of the shops located in the *patio del rey* in the palace. His powers included the right to assign rooms in the palace after consulting with the *mayordomo mayor*, the chief household official. These two officers also decided on seating arrangements for public festivals. More important were the ceremonial duties, because they were exercised in public. The king's public appearances were governed by a complicated protocol, which assigned a place to every member of the court. The main ceremonial duty of the *aposentador* was to hold the king's chair, a task that put him at the center of attention (although as a servant, not a peer).

But the highest of all his signs of favor was his passkey. Although in principle a necessity for one entrusted with the maintenance of the palace, a key that opened every door, including the one to the king's chamber, conferred great prestige on its owner. Besides the *aposentador*, only the *mayordomo mayor* and certain favored grandees were permitted to have a passkey. This singular sign of favor and trust is specifically mentioned in the "Etiquetas," which prescribe how the key must be worn, and how Velázquez wears it in *Las Meninas*.

[26] Although the top of the key is visible, it is hard to see the position of the stem, owing to the dark tones and the accumulation of dirt and discolored varnish. The illegibility may also be the result of restorations made by Juan García de Miranda after the painting was damaged in the palace fire of 1734. A close examination of the surface with the aid of artificial light, kindly arranged by Dr. A. E. Pérez Sánchez, suggested that the key is positioned at an angle, with the stem pointing outward. This foreshortening tends to blur the spatial relationship of the key to the *bolsa* worn further back on the waist. When the picture receives the cleaning it so urgently needs, the key may become more visible.

[27] The duties and perquisites of royal servants, including the *aposentador*, were defined in the "Etiquetas generales de la Casa Real del Rey," which served as the basis of court protocol. The "Etiquetas" were periodically revised, and an important reform occurred between 1647-1651. A copy of this document in the Biblioteca Nacional, Madrid, sig. 10.666, has served as a basis for the following discussion. Antonio Rodríguez Villa, *Etiquetas de la Casa Real de Austria*, summarizes the main points of the 1647-1651 etiquette. See also J. E. Varey, "L'Auditoire du Salon Dorado de l'Alcázar de Madrid," pp. 81-83. In addition, Varey's article, "Velázquez y Heliche en los festejos madrileños de 1657-58," *Boletín de la Real Academia de la Historia*, presents interesting documentation of Velázquez's defense of the perquisites of his office against the influential marquis of Heliche.

"He is entitled to wear in his sash a double key that opens all the doors of the palace."[28]

The access to the king's chamber enjoyed by the *aposentador* may account for Philip's dramatic intervention in the selection of Velázquez for that office. The post became vacant in 1652, and as usual the *Bureo*, an executive committee for palace governance, was asked to nominate a successor. Although it proposed Gaspar de Fuensalida as its first choice by a vote of five to one, and although Velázquez was not chosen first on anyone's ballot, the king's verdict was returned in a terse, monarchical sentence: "Nombro a Velázquez."[29] The key worn by Velázquez even as he paints is thus not only a badge of high office but also the token of the special relationship between the painter and king. It also reemphasizes, although discreetly, the elevated status enjoyed by a painter in a royal court, and in terms that would have been understood by every member of the court.

If the half-hidden key and the shadowy mirror image of the rulers are tributes to Velázquez's modesty and sense of decorum, the size and complexity of the composition cannot be considered self-effacing. *Las Meninas* is one of the largest pictures known to have been painted by Velázquez, measuring ten and a half feet high by nine feet wide. Hence the figures are approximately life-size. In addition, the picture is cast in the form of a superb illusion of reality, one unequalled in his work. The choice of this large format and exceptional spatial construction is essential to interpreting the painting and indeed helps to clarify and enrich its significance.

In the early days of the struggle to improve the status of painting, writers emphasized aspects of the art that could be identified with the traditional liberal arts. Both Alberti and Leonardo made an association between painting and mathematics, basing their claims on the "science" of perspective, which they regarded as a branch of mathematics.[30] Considered as such, painting became a form of knowledge, instructing man about the natural world. Leonardo carried the argument one step further and explicitly placed the burden of proof upon the shoulders of perspective. "Practice must always be founded on the sound theory, and to this perspective is the guide and gateway; and without this nothing can be done well in the matter of painting." More explicit still, he speaks of the equation of perspective to mathematics in these words: "Among all the studies of natural causes and reasons light chiefly delights the beholders; and among the great features of mathematics the certainty of its demonstrations is what pre-eminently tends to elevate the mind of the investigator. Perspective therefore must be preferred to all the discourses and systems of human learning."[31] Perspective, in short, became

[28] "Etiquetas," f. 125. The symbolic importance of the key as a sign of royal favor is clearly seen in Velázquez's *Portrait of Olivares* (São Paulo, Museu de Arte), where it is worn ostentatiously at the waist.

[29] This documentation is reproduced in the useful compendium of Velázquez documentation compiled by Gallego Burín, *Varia Velazqueña*, II, pp. 279-80. Gallego Burín cites the initial publication of each document, and thus this information will not be given here.

[30] See Blunt, *Artistic Theory*, pp. 49-51, for a summary of the role played by perspective in establishing painting as a liberal art.

[31] J. P. Richter, *The Literary Works of Leonardo da Vinci*, I, section 19 and section 13.

a guarantor of painting as a liberal art, and that may be why Velázquez cast his manifesto in the form of one of the most brilliant perspective compositions ever conceived. However, by the mid-seventeenth century, perspective had outlived its didactic function. Instead, it was being used, especially in Italy, to create a world of illusion that aimed to confuse the boundaries between art and reality. Many of the greatest works of Baroque illusionism had been created by that time, and there is reason to believe that Velázquez had seen them and mastered their techniques.

Velázquez's knowledge of Baroque illusionism was primarily a result of his employment as an architect and decorator, a facet of his career that has been too-little appreciated. Although all his architectural work was destroyed when the Alcázar was demolished after the fire of 1734, abundant documentary evidence reveals its extent and importance.[32] His architectural career began officially on June 6, 1643, when he succeeded Francisco de Praves as superintendent of the king's special projects (*obras particulares*). (The appointment was made over the objections of the Junta de Obras y Bosques and is another instance of Philip's favoritism.) In this capacity, Velázquez became involved with the reconstruction and remodeling of certain state rooms on the main floor of the Royal Palace. The principal part of the commission involved the creation of two magnificent chambers—the Octagonal Room (*Pieza Ochavada*) and the Hall of Mirrors (*Salón de los Espejos*). In the early months of 1647, he was appointed as overseer and accountant (*veedor y contador*) of the Octagonal Room, and by 1648, the structural reforms had been completed there and in the Hall of Mirrors.[33] Documents show that during the 1650s, Velázquez was more occupied with architecture than he was with painting. The appointment as *aposentador* was made partly in recognition of this fact because the duties of this office required architectural skills.[34] In 1655-1656, he directed the renovation of certain parts of the palace, including the Galería del Oriente, the patio de la Tapicería, and the Garden of the Emperors. Finally, in 1659-1660, Velázquez planned and directed the construction of the pavillion on the Isle of Pheasants, where Philip IV and Louis XIV met to arrange the marriage of Philip's daughter to the French king.

Velázquez, as a painter-architect, took a deep interest in the theory and technique of architectural design and construction, to which the contents of his library attests. In addition, he also studied the related fields of mathe-

[32] Velázquez's career as architect and decorator is discussed by Antonio Bonet Correa, "Velázquez, arquitecto y decorador," *Archivo Español de Arte*, and more precisely by Francisco Iñiguez Almech, "La casa del Tesoro, Velázquez y las obras reales," in *Varia Velazqueña*, I, pp. 649-82. Important documentation was published by Azcárate, "Noticias sobre Velázquez," pp. 357-85. These articles have served as the basis for the following discussion.

[33] The appearance of the Hall of Mirrors is well-known through the numerous portraits of Charles II and Queen Mariana by Juan Carreño de Miranda, which used the room as a setting (i.e., the *Portrait of Charles II*, Berlin). The *Pieza Ochavada* is known only in the partial view in Mazo's *Portrait of Queen Mariana* (London, National Gallery), which is analyzed by Yves Bottineau, "A Portrait of Queen Mariana in the National Gallery," *Burlington Magazine*, pp. 114-16.

[34] Other architects who had held this office prior to Velázquez were Juan de Herrera, the architectural consultant of Philip II, and Francisco Gómez de Mora, the court architect of Philip III.

matics, geometry, and perspective. Hence, the splendid illusion in *Las Meninas* was the result of many years of interest and preparation (and, in addition, fully justified Leonardo's faith in perspective as the expression of a form of knowledge).

His architectural commissions also led him to a first-hand acquaintance with Italian Baroque illusionistic projects. After the remodeling of the Octagonal Room and the Hall of Mirrors had been completed, Velázquez and the king began to plan its lavish adornment, which was to include ceiling frescoes. There being no Spanish artist versed in the art of illusionistic fresco decorations, Velázquez was sent to Italy in November 1648 to find a frescoist and also to obtain paintings, sculpture, and furnishings for the rooms.[35] Philip IV instructed Velázquez to engage the services of Pietro da Cortona or a master of equal stature. Cortona was invited, but did not accept. At length, Velázquez persuaded Michele Angelo Colonna and Agostino Mitelli to come to Spain. They did not finally arrive until 1658, when they painted the frescoes in the Hall of Mirrors (destroyed in the palace fire of 1734), and numerous commissions that substantially influenced the style of painting in Madrid during the later seventeenth century. In addition to meeting these painters, Velázquez also became acquainted with a wide circle of artists in Rome. By January 1650, he had entered the Academy of St. Luke; one month later he joined the Virtuosi al Pantheon.[36] More to the point, he almost certainly met the greatest living master of illusionism, Gian Lorenzo Bernini, at least if we are to believe Palomino. There is also a shred of concrete evidence to suggest an encounter between these two giants of the age. The artist who was commissioned by Velázquez to cast the bronze lions used as table supports in the Hall of Mirrors was Matteo Bonarelli, a long-time assistant to Bernini.[37]

Against this background, it is reasonable to interpret *Las Meninas* in the specific context of Baroque illusionism. By carefully re-creating the appearance of a room on a large scale, and enlivening it through the subtle control of light and shadow, Velázquez sought to build a bridge between art and reality. The method he used was based on the fundamental ideas of Italian Baroque illusionism, but was modified in an original way to suit his different purpose. In many illusionistic works of the period, the aim was to unite the world of reality with the sphere of art in order to make the artistic re-creation of an event as believable as possible. There were diverse ways of achieving this effect, but all of them depended on confounding the barriers of space and matter in order to allow the real and the artificial to intermingle. This process is used in *Las Meninas* to accomplish a special purpose—to make the implied presence of the king and queen as real as possible. For ideological reasons, Velázquez wanted to emphasize that Philip and Mariana were standing in his space, but decorum prevented him from representing their persons alongside his own. He resolved the problem by a number of means. First, he focused

[35] The fullest discussion of this trip is by Enriqueta Harris, "La misión de Velázquez en Italia," *Archivo Español de Arte*.

[36] *Varia Velazqueña*, II, p. 268.

[37] The discovery of Bonarelli's signature on one of the surviving lions was published by Jacob Hess in his edition of Giovanni Passeri, *Vite de Pittori*, p. 256, note 2.

the attention of the figures in the picture around the entrance of the royal pair. Next, he revealed the monarchs' presence indirectly by the mirror reflection. This method had often been used in earlier art; Velázquez himself knew it from Jan van Eyck's *Arnolfini Wedding Portrait*, which belonged to Philip IV and hung in the Royal Palace. Finally, Velázquez grasped the possibility of strengthening the implied existence of the king and queen by projecting an imaginary space in front of the canvas that was seemingly inhabited by beings more corporeal than the figures in a painting. By choosing a large format for his picture, he could use a lifesize scale of people and architecture, thus opening wide the door for implying an actual royal presence. The effect of this presence is considerably strengthened by the fact that the extension of space in front of the picture plane coincides with the part of the room that is not shown in the painting.

It has sometimes been suggested that the setting of *Las Meninas* was created from the artist's imagination.[38] However, Velázquez made a considerable effort to reproduce accurately this palace room, the *galería* or *pieza principal del cuarto del Príncipe*. In 1626, the court architect, Juan Gómez de Mora, made detailed groundplans of the Alcázar.[39] On the plan of the *cuarto del Príncipe*, the *pieza principal* is visible in the long gallery-like room in the lower left, or southwest, corner (fig. 25). When Gómez de Mora drew the plan, the *pieza principal* was divided into two parts, numbered 25 and 12. However, from 1645 to 1649 two rooms on the floor above the *pieza principal*, the Hall of Mirrors and the Octagonal Room, were remodeled under Velázquez's direction. A year after the project began, Baltasar Carlos died, and this may have been the moment when it was decided to carry out certain minor alterations in the *pieza principal*. Presumably this was when the thin partition wall was removed and a second door was opened immediately to the east, to join the new staircase that was being constructed in the space cleared by the demolition of a medieval tower. The remodeled room bears a strong resemblance to the room we see in *Las Meninas*. The *pieza principal* had seven windows on its south wall and two doors at the east. In *Las Meninas*, we see the doors and five of the windows. The remaining two bays are contained in the space in front of the picture plane.

Additional and even more satisfactory evidence that *Las Meninas* is taking place in the *pieza principal del cuarto del Príncipe* is given by the paintings hanging on the walls. The inventory of 1686 lists all the pictures in the room, many of which can be identified in *Las Meninas*.[40] Most easily recognizable are the

[38] See, for example, Kahr, "Velázquez and *Las Meninas*," p. 229, who believes that the setting is imaginary. The fact that the picture is a reasonably accurate "portrait" of a specific room has implications for Winner's and Kahr's suggestion of Flemish gallery pictures as a visual source for the painting. Because the room looked much as it appears in *Las Meninas*, the resemblance between it and the gallery pictures would seem merely to be a coincidence.

Using a different line of reasoning than mine, Angel del Campo, "El Alcázar de *Las Meninas*," *Villa de Madrid*, also correctly identified the setting with room number 25 on Gómez de Mora's plan of 1626.

[39] The plans, which are in the Vatican Library, Barb. Lat. 4372, were first published by Iñiguez Almech, *Casas reales*, figs. 14-15.

[40] The complete correspondence of the paintings in *Las Meninas* to the ones that were

copies by Juan Bautista del Mazo of Rubens's *Pallas and Arachne* and the *Judgment of Midas* that hang in shadow on the east wall, where in fact they were placed in the actual room. But Velázquez took equal care to depict the paintings on the south wall with fidelity. A close examination of this part of the room as depicted in *Las Meninas* shows the following arrangement. At the bottom are tall, narrow pictures, separated from a second row by a narrow space. Immediately above the second row is a third row of paintings that runs just below the ceiling and is separated from the pictures beneath by the thinnest of margins. These small paintings are flanked by rectangular pictures that hang over the windows.

These pictures correspond completely in number, relative size, and subject to those described in the 1686 inventory. The inventory was made from ceiling to floor, thus making it reliable for the reconstruction of the arrangement as well as the individual pictures. Numbers 905-911 are "seven pictures above the windows measuring three *varas* wide by three *quartas* high, with various birds, animals and landscapes, which are copies of Rubens by the hand of Mazo, in black frames."[41] In *Las Meninas*, these landscapes are represented as murky compositions in muted green and brown colors and hang in black frames, as described, above the windows. Numbers 912-916 are "five small paintings measuring half a *vara* wide and three *quartas* high in the spaces between the paintings over the windows, with black frames, showing a wild boar and some small dogs, painted by the hand of Juan Bautista del Mazo." These small, nearly square canvases complete the "cornice" of pictures that runs just below the ceiling and are especially visible in the first two pillars of the room as depicted in *Las Meninas*. Numbers 917-922 are listed as "six small paintings, measuring half a *vara* wide and two *tercias* high in the space between the windows, with the Labors of Hercules by the same hand [Mazo], and are copies of Rubens, in black frames." Once again the number, position, and relative size are echoed in *Las Meninas*. Finally, numbers 923-928 are described as "another six paintings, measuring one and a half *varas* high and two *tercias* wide, also in the space between the windows, in black frames. Two of them show the philosophers Heraclitus and Democritus; one, Hercules slaying the seven-headed Hydra, and the remaining three, Mercury, Saturn, and Diana, all copies of Rubens by the hand of Juan Bautista del Mazo." The correspondence of this group of tall, thin paintings in *Las Meninas* is reinforced by the nearest painting, which obliquely shows a single figure in conformity to the description in the inventory.

Naturally, the number of pictures listed in the inventory does not tally exactly with the number of pictures shown in *Las Meninas* because two bays of

hanging in the *pieza principal del cuarto bajo* was pointed out to me by Steven N. Orso. Mr. Orso intends to discuss the further implications of this important observation in his doctoral dissertation, now in progress.

The inventory of 1686 is published by Bottineau, "L'Alcázar de Madrid et l'inventaire de 1686," with the listing of the pictures in the *pieza principal* on pp. 450-53 of volume 60 (1958).

[41] The measurements cited in the inventory have the following approximate metric equivalents: *vara* = 83.5 cm.; *quarta* = 20.8 cm.; *tercia* = 27.5 cm.

the room have been omitted. These "missing" bays are the ones that lie in front of the picture and where the imagined figures of the king and queen are standing. By accurately reproducing the main features of this room in *Las Meninas* on this scale, Velázquez made it possible for the real space in front of the picture plane to meld with the illusionistic space represented as being within it. The resulting projected space was created for Philip and Mariana, whose implied presence thus acquired an added dimension.[42] If the illusion of their presence is accepted, then another traditional point was scored in favor of painting—its power to confer immortality. The unending reincarnation of Philip and Mariana gives them an existence that is safe from the reach of time. More important for Velázquez's purposes, it also secures the presence of the monarchs as perpetual witnesses to an art that is worthy of kings precisely because they are there. Finally, the faithful reproduction of the appearance of the *pieza principal* emphasizes the fact that the monarchs have come to visit Velázquez in an actual room in the palace. By this device, Velázquez dramatically realized the significance of the event depicted in the canvas.

The canvas that stands before Velázquez, though a passive element, insistently asserts its presence in the form of a difficult question—what is the artist painting? Over the years, three answers have emerged. The first, advanced by Palomino and followed by recent writers in Spain, is that Velázquez is working on a portrait of the king and queen. The second answer claims that Velázquez is portraying the Infanta and the figures who accompany her. The third hypothesis, first suggested in the Prado catalogue of 1819, is that Velázquez is painting *Las Meninas* itself. The truth of the matter will never be conclusively discovered because the picture surface cannot be seen. If an answer exists at all, perhaps it can be found by collating the motif with the intent of the picture. To proceed on this basis, we can see that the picture is a large one and has proportions that resemble those of *Las Meninas*. We also know that Velázquez took pains to represent the other pictures in the room accurately. Moreover, it is very possible that *Las Meninas* is, to some extent, a metaphor, and that therefore the canvas may have been intended to play a part in constructing the meaning. It is the last observation that may be the most telling, because if the painting before Velázquez were *Las Meninas*, then a superb *concetto* would take shape and deepen the meaning of the picture: the king and queen would be witnessing the creation of the very work that proclaimed the nobility they confer upon the art of painting. Velázquez, in other words, seems to have wanted it to be known that his declaration of the nobility of his art was specifically endorsed by the king. As we shall see at the conclusion of this study, other points help to confirm this idea.

[42] In this interpretation of the space of *Las Meninas*, the viewer is not meant to inhabit the same areas as the king and queen, which would have been a breach of court protocol. Instead, he occupies a space outside the illusion, as indeed he would have to do in order to see the large canvas at a glance. Hence, three levels of reality are brought into play. In addition, this arrangement of the space frees the painting from being bound to any particular real architectural setting.

The location of *Las Meninas* in the palace is unknown until 1666, when it hung in the *despacho de verano* and where it was also recorded in 1686 and 1700.

Regardless of whether the large canvas is *Las Meninas* itself, it does seem likely that the picture was meant to strike a blow for the nobility of painting and painters. To students of Italian art, this idea will seem anachronistic. By 1656, the probable date of *Las Meninas*, no cultured person in Italy would have classified painting as a craft. But in Spain, the issue was still very much alive because the Royal Treasury continued to regard painting as a manual trade, and to levy a tax on payments to painters for their works. The infamous tax was called the *alcabala* and was collected on manufactured goods such as clothing, shoes, and barrels. Painters were insulted and degraded by the classification with tailors, shoemakers, and coopers, and since the early seventeenth century had repeatedly gone to court to win exemption.[43] It is significant that the legal battle was often fought by painters who had lived in Italy. The initial skirmish was fought around 1607 by El Greco, who sued to rescind the *alcabala* on the payment collected from the Brotherhood of Charity at Illescas. Although the judge absolved him of paying the tax, the Treasury did not abandon the principle. In 1628, two court painters of Italian descent, Vicente Carducho and Eugenio Cajés, again brought the matter to trial and emerged victorious in a decision handed down on January 11, 1633. The details of this suit are well-known because Carducho published the depositions of his witnesses as an appendix to his treatise, *Diálogos de la pintura* (Madrid, 1633). But only five years later, the tax collectors were again brought to court and again by an Italian painter, Angelo Nardi. On August 14, 1638, the tribunal once more found for the art of painting and exempted it from the tax. Incredibly, the issue went to trial three more times—in 1640, 1671, and 1676—before the government was willing to accept the principle that painting was an art and not a craft.

The official prejudice against painters would naturally have been known by Velázquez, but one might anticipate that he would have been shielded from its abuses because of his position as the king's painter. This was not the case. As late as 1637, Velázquez was being asked to pay the *alcabala* on works he had painted.[44] For a painter who had already achieved status in the royal household—he had been appointed as *ayuda de guardarropa* on July 28, 1636— this would have been demeaning. For a painter who was also an ambitious courtier, it would have been intolerable.

Velázquez's ascendancy in the royal household is well-documented.[45] But

[43] The earliest writer to take up the cause in Spain was Gaspar Gutíerrez de los Rios, *Noticia general para la estimación de las artes y de la manera en que conocen las liberales de las que son mecánicas y serviles* . . . (Madrid, 1600). A copy was owned by Velázquez.

The legal history was first summarized by Palomino, *El museo pictórico*, pp. 161-63, on the basis of documents in the Archivo Histórico de Protocolos, Madrid. A more recent and extended account is by Enrique Lafuente Ferrari, "Borrascas de la pintura y triunfo de su excelencia. Nuevos datos para la historia del pleito de la ingenuidad del arte de la pintura," *Archivo Español de Arte*.

Kubler, "Three Remarks," p. 213, recognized the association of *Las Meninas* with the campaign against the *alcabala*.

[44] See the document referred to by Julián Gállego, "Datos sobre la calificación profesional de Velázquez," *Ponencias y comunicaciones. XXIII Congreso Internacional de Historia de Arte*, p. 161.

[45] All the documentation referred to below is published in chronological order in *Varia Velazqueña*, II, pp. 222-80.

the time, energy, and care he invested in the process need to be emphasized. Velázquez's courtly honors were not simply the by-products of his excellence as a painter; he worked hard to rise as high as he did. He was also willing to fight to defend his status in a court where disputes over rank and privilege were rife among the members of the household. It might even be said that his vocation as a courtier was second only to his vocation as an artist.

His first court appointment was of course as painter to the king, which occurred on October 6, 1623. On March 7, 1627, he became *ugier de cámara*, a minor officer of the king's apartments. In the following year, he became the chief court painter with his nomination as *pintor de cámara*. After a lapse of some years without further honors, he was granted by the king on May 8, 1633, the favor of the *paso de la vara de Alguacil de Casa y Corte*, which permitted him to sell the office of a constable and retain the proceeds. In order to be effective, this favor had to be approved by the *Cortes* of Castile. The initial vote, taken on September 9, 1633, was negative. But Velázquez persisted and succeeded in obtaining a positive decision on July 10, 1634. Two years later, on July 28, 1636, he was given a new appointment as *ayuda de guardarropa*, and thus rose to a slightly higher position among the servants in the king's chamber. A significant promotion occurred on January 6, 1643, with his nomination as *ayuda de cámara*. An *ayuda de cámara* served in the private rooms of the king's apartment, and thus enjoyed the favor of proximity to the royal person. In Velázquez's case, the appointment was honorific (*sin ejercicio*), meaning that he did not have to perform the duties of the office to enjoy its emoluments. During the 1640s, Velázquez's fortunes continued to improve owing to his work as architect. Only one minor setback occurred in 1646 when a fellow *ayuda de cámara* named Salinas challenged Velázquez's seniority in the position. Velázquez's petition is interesting to read not so much for its substance as for its knowlege of the complex rules for determining seniority.[46] In the end, he was unsuccessful, because Philip decided against the painter. Nevertheless, Velázquez's career as courtier reached a successful conclusion with the appointment as *aposentador de palacio* in 1652. Velázquez now held four offices simultaneously—*pintor de cámara, ayuda de cámara, aposentador de palacio* and *superintendente de obras particulares*—and had become a wealthy man as a consequence of their salaries plus his daily living allowance. There remained only one further ambition to achieve—a knighthood.

Although it was nowhere recorded, we can be certain that this was a long-standing goal of Velázquez. López-Rey suggests that it took shape not later than the first trip to Italy (1629-1630) and cites a revealing anecdote from Pacheco, dated 1632.[47] Pacheco relates that his son-in-law had told him that the king of France had bestowed a prestigious order on Cavaliere d'Arpino when he learned of the painter's dissatisfaction with the low status of his original knighthood. By 1636, Velázquez's aspirations to a knighthood were an open secret. According to an anonymous letter dated July 28 of that year, Velázquez's recent appointment as *ayuda de guardarropa* was commonly understood as a sign of his ambition to become *ayuda de cámara* and "to wear the

[46] Ibid., pp. 258-59.
[47] José López-Rey, *Velázquez' Work and World*, pp. 139-40.

habit of a military order, as Titian had done."[48] At about this time, another
sign of Velázquez's hopes surfaced when he began to use regularly the aris-
tocratic form of his name, Diego de Silva Velázquez, instead of the simple
form, Diego Velázquez.[49] By 1650, he had already petitioned the king for a
knighthood and was publicly campaigning to achieve it. On December 17,
1650, the papal secretary of state, Cardinal Pamphili, wrote to the nuncio in
Madrid, asking him to make known the pope's support of Velázquez's peti-
tion.[50] Evidently Velázquez was using his newly formed friendship with In-
nocent X to reinforce his claim to a knighthood.

Perhaps the inception of Velázquez's ambition can be traced even more
specifically to the knighthood granted on August 30, 1631, to his friend and
fellow painter, Peter Paul Rubens. It may even be that the paintings shown
on the rear and side walls of the workshop in *Las Meninas*, which are mostly
copies by Mazo after Rubens's paintings, were intended to cite an important
precedent and to pay tribute to a man whose life, though curiously not his
art, was so influential for Velázquez.[51] Furthermore, the fact that the original
paintings were designed but not executed by Rubens provided fuel for the
argument of painting as a liberal art. Their glory resided in the conception,
not in the execution. In any case, Rubens's career as a courtier would have
been a proximate and shining inspiration to Velázquez. But if we pry beneath

[48] *Varia Velazqueña*, II, p. 242.
[49] The earliest instance of this form that I have found is a receipt dated July 6, 1634,
published by María Luisa Caturla, "Cartas de pago de los doce cuadros de batallas para
el Salón de Reinos del Buen Retiro," *Archivo Español de Arte*, pp. 343-44. The changing
forms of Velázquez's name are traced by José López-Rey, "Nombres y nombradía de
Velázquez," *Goya*, pp. 4-5, who places the earliest use of the aristocratic form in 1647.
[50] This was first published by Ludwig von Pastor, *Geschichte der Päpste*, XIV, p. 1169.
In the English translation by E. Graf (St. Louis, 1950, XXX, p. 413), the text was con-
fused by the transposition of certain lines. Martin Soria, "Una carta poca conocida
sobre Velázquez," *Archivo Español de Arte*, pp. 135-36, published the incorrect version.
The mistake was corrected by Enriqueta Harris, "Velázquez en Roma," *Archivo Español
de Arte*, p. 186.
[51] Tolnay, "Velázquez' *Las Hilanderas*," p. 36, ingeniously interpreted the paintings
on the rear wall as symbols of the "victory of divine art over human craftsmanship."
Although this reading would strengthen the argument presented here, caution should
be employed in accepting it. First, as Emmens pointed out, Tolnay (and Kahr) incor-
rectly identified the subject of the right-hand painting as *Apollo and Marsyas*. It actually
shows the *Judgment of Midas*, which was most often interpreted by mythographers as
an allegory of false critical judgment. Furthermore, as Emmens also noted, the subject
of the other painting, *Minerva Punishing Arachne*, was universally taken as representing
the sin of false pride. In this connection, it is worth mentioning that, according to Ovid,
the tapestry-weaving contest ended in a tie. Arachne was punished for her presump-
tion, not for her failure as a weaver. Hence, she was equal to the goddess as an artist.
Tolnay did not cite any textual source for his interpretation.
More recently, Kahr, basing her ideas on Tolnay, thought the pictures were inserted
by Velázquez as a precaution against charges of presumption. In her words, they are "a
commentary that stemmed from guilty feelings that the artist might not have been able
to acknowledge, even to himself." The post-Freudian view of the painting is anach-
ronistic and inconsistent with a work of art that was so consciously planned. In any
case, all future attempts to assign meaning to the paintings within the painting will
have to take into account the fact that all of the pictures in the room actually were there.

the surface of Rubens's honors, we will learn, as Velázquez must have learned, that the prejudice against painters was deeply rooted in the minds of the Spanish ruling class.

In the case of Rubens, the prejudice is first encountered in a letter from the prime minister, the count-duke of Olivares, to Isabella Clara Eugenia, ruler of the Netherlands. The infanta had written to recommend that Rubens, her trusted friend and ambassador, be assigned the task of preliminary negotiations to arrange a peace between Spain and England. On June 15, 1627, Olivares rejected the suggestion, stating that Rubens was only a painter and that therefore "the reputation of this monarch will necessarily suffer if a man of so little importance must be approached by ambassadors."[52] This attitude is difficult to explain even on grounds of social status, because Philip IV had conferred a patent of nobility on Rubens in 1624. Nevertheless, Rubens soon was to establish important contacts with representatives of the English crown and had to be summoned to Madrid for consultations with the king and Olivares. He arrived at the Spanish court in September 1628 and stayed until April 1629, when he was sent to England to prepare the way for an exchange of ambassadors.

During this nine-month period, Philip (and Velázquez) came to know and respect Rubens, both as an artist and a man, and often visited Rubens in his studio.[53] Just before his departure to England, the king appointed him to the Privy Council of Flanders. Yet the king's appreciation of Rubens had no effect on other members of the government, who continued to regard him as a painter and thus unworthy of important diplomatic assignments. In a memorandum of the Council of State dated December 21, 1630, which records the deliberations on the nomination of an ambassador to England, the prejudice surfaces once again. The final choice, the count of Oñate, was unable to leave immediately and therefore an interim representative, called the "resident," had to take his place. Three men were nominated, Rubens among them. Despite his special qualifications for the post, he was not selected. The reasons for the rejection are explicitly stated in the report to the king. "Peter Paul Rubens would have been very appropriate for the post because of the fame and acquaintance he enjoys in that court. But because he practices a craft that in the end is base and done by hand, it would seem to present difficulties if Your Majesty were to give him the title of one of your ministers."[54] The document is all the more astonishing because by then Rubens had not only proven his skill as a representative of Spanish interest, but also had been knighted by Charles (March 3, 1630).

[52] The letter is transcribed in the fundamental work of Gregorio Cruzada Villaamil, *Rubens, diplomático español*, pp. 117-19.

[53] In a letter to his friend Peiresc, dated December 2, 1628, Rubens wrote, "The King takes great delight in painting and in my opinion is a very gifted prince; this I know from personal contact with him, for I am living in a suite of apartments in the palace and he comes to see me nearly every day." Max Rooses and Charles Ruelens, *Correspondance de Rubens et documents epistolaires*, IV, p. 10.

[54] Ibid., IV, pp. 351-53.

When at last the Spanish knighthood was proposed for Rubens, the petition had to come from the State Council of Flanders. The document, dated July 16, 1631, implicitly recognized the low regard in which painters were held in Spain.

> Her Serene Highness the Infanta [Isabella Clara Eugenia] writes to Your Majesty recommending this request, noting the services of the nominee, and begging Your Majesty to grant him the honor she requests. Your Majesty knows him and his good qualities, and knows how rare he is in his profession. In consideration of this and for his services in important matters, and as he has served as·Your Majesty's secretary, this will not have the consequence of encouraging others of his profession to seek a similar favor. The Emperor Charles V made Titian a Knight of Santiago. And thus it seems wise for Your Majesty to honor the nominee with the knighthood he pretends to.[55]

The petition is noteworthy on two counts. First are the assurances to the king that a knighthood for Rubens need not be regarded as setting an undesirable precedent for other painters. That is why the claim was based primarily on Rubens's services as a diplomat and royal servant. The second interesting point is the mention of Titian's knighthood, which appears to have become a famous event in Spain. The knighthood of these two painters would have further inflamed Velázquez's ambitions for the honor, and perhaps provided an aesthetic as well as social logic to his hopes. For Titian, Rubens, and Velázquez were not only the most favored painters of the Spanish Hapsburgs, they were also three of the greatest masters of the painterly style. Hence, there was every reason for Velázquez to see himself as qualified to enjoy the honors bestowed on these two illustrious painters.[56]

The Council's petition is also interesting because it makes a common mistake about Titian's knighthood. Titian was of course knighted by Charles V, but he was made a Knight of the Golden Spur, not a Knight of Santiago. The difference is crucial and substantial because the Order of Santiago was one of the most elite aristocratic military orders of Spain. It had been founded in the twelfth century as a lay religious order dedicated to reconquering Spain from the Moslems. Although it had ceased to function as a military organization in the late fifteenth century, it had remained at the very pinnacle of Spanish society, counting among its members the grandest of Spain's grandees. Titian, as a lowborn painter, would have been in no way qualified to join its ranks, although the legend of his membership indicates how highly his esteem had

[55] Ibid., V, p. 392.

[56] Velázquez reinforced his claim to equality with Titian and Rubens in his choice of paintings that were hung in the Hall of Mirrors. This room, remodeled and redesigned by Velázquez in the late 1640s and early 1650s, was intended not only as a state chamber but also as a picture gallery for some of the prize works of the royal collection. The selection reveals a pronounced taste for the great masters of the Venetian coloristic tradition. It included eight works by Rubens, six by Titian, four by Tintoretto, three by Veronese, two by Ribera, and one by Bassano. Velázquez also selected four of his own paintings, thus inviting the viewer to compare him with the other artists represented in the room.

risen in the minds of the ruling family.[57] Yet it was to this very order that Velázquez was to request membership when, in 1658, Philip offered to nominate him to one of the three most prestigious military orders (Alcántara and Calatrava were the other two).

Against the background of aristocratic prejudice against artists, it is easy to see that Velázquez's ultimate courtly ambition was a formidable one. The qualifications for membership were in every way stringent.[58] A candidate had to prove, first, that he was the legitimate son of a noble line that stemmed at least from both the maternal and paternal grandparents. Then he had to establish that he had no trace of any but Christian blood, which excluded those of Jewish, Moorish, or converted Christian ancestry. A related condition was to prove that no one in the family for the past four generations had been condemned by the Inquisition as a heretic. A final important condition, and one that was to prove critical for Velázquez, read as follows: "The habit shall not be given to those who themselves, or whose parents or grandparents, have practiced any of the manual or base occupations here described. . . . By manual or base occupation is meant silversmith or painter, if he paints for a living, embroiderer, stonecutter, mason, innkeeper, scribe, except for secretaries of the king." The grouping of painters with stonecutters, masons, and innkeepers is in itself revealing. However, in 1653, a rule was made to consider painters who had not accepted payment for their works. Clearly Velázquez hoped to fit into that category, despite the fact that he had been a member of the Guild of St. Luke and that his paintings had always been paid for individually by the king and other patrons. All the conditions were subject to proof by an investigation (*probanza*) conducted by the Council of Military Orders. As the artist stood on the bottom rung of the ladder leading to his knighthood and looked up, the climb must have seemed steep indeed, and so it was.

On June 6, 1658, Philip IV nominated Velázquez for membership in the Order of Santiago, and three weeks later he gave the command to begin the investigation.[59] However, it was not until November that a team of two investigators started to interview persons who might have known Velázquez's parents and grandparents. From November 1 to November 28, they took depositions from witnesses in northwestern Spain, where Velázquez's paternal grandparents had been born. (Because of the war with Portugal, the investigators could not visit Oporto, where Velázquez's grandfather had lived.) They stopped at the villages of Monterrey and Verín, the hamlet of Pazos, the

[57] I know of only two artists who had been accepted previously by the order, Baccio Bandinelli (1536) and Giovanni Battista Crescenzi (1626). Crescenzi, however, was a member of an Italian aristocratic family. Bandinelli's acceptance was the result of the sponsorship of Charles V. Even so, his application was beset by obstacles at every step of the way, much as Velázquez's was to be in 1658.

I am grateful to Kathleen Weil-Garris for having brought Bandinelli's knighthood to my attention and discussing its implications with me.

[58] The requirements are stated in *Reglas y establecimientos de la Orden y Cavallería del Glorioso Apostol Santiago, Patrón de Las Spañas, con la historia del origen y principio della*, pp. 56-59. A copy was in Velázquez's library.

[59] The documents of the *probanza* are reproduced in *Varia Velazqueña*, II, pp. 301-377.

cities of Tuy and Vigo. Then they returned to Madrid to conduct further interviews.

On December 22, the investigators began to direct the inquiry at a vulnerable place—whether Velázquez, before entering the king's service, had ever practiced his art as a trade under the rules of the guild. During the succeeding days, seventeen witnesses chose not to tell the truth about the matter. They included fellow artists (Cano, Carreño, Zurbarán, Herrera Barnuevo, Nardi, and Burgos Mantilla), who had a stake in improving the social position of a colleague. But Knights of Santiago and members of the king's household were also questioned. The results of their testimony will be seen shortly.

After completing their work in Madrid, the investigators went to Seville to uncover the history of Velázquez's mother's family. On February 14, 1659, they examined the 148th and final witness, after which they submitted their report. Two weeks later the Council of Orders rendered its verdict— Velázquez was eligible in all but one respect. The Council rejected the claim to nobility on the part of his paternal grandmother and both maternal grandparents, and thus excluded him from the order. The results of the meeting, although not publicly announced until April 2, were soon known to Velázquez, who was shocked by the decision. The attempt to enhance his prestige had dealt it a humiliating blow. However, he decided to fight on and, in March, he submitted further proof of his claim, a notarized copy of a record that indicated that his mother's family had been exempted from paying a meat tax, an exemption granted in Seville only to *hidalgos* or nobility. This proof, in addition to the evidence collected during the investigation, should have been convincing. The historian Damilo de la Valgoma y Díaz-Varela has reviewed the extensive documentation of the *probanza* and shown that Velázquez's claim to nobility was in order and was conclusively proven by the investigation.[60] Why, then, was it rejected? In the view of Valgoma y Díaz-

[60] Damilo de la Valgoma y Díaz-Varela, "Una injusticia con Velázquez. Sus probanzas de ingreso en la orden de Santiago," *Archivo Español de Arte*, pp. 191-214.
 Subsequently, Julián Gállego, *Velázquez en Sevilla*, pp. 15-26, has presented arguments against Velázquez's claim to nobility, although without acknowledging the arguments put forth by Valgoma. Gállego casts doubt on the veracity of the witnesses, some of whom did in fact lie about the living Velázquez made as a painter. As Gállego points out, witnesses in *probanzas* were often bribed to conceal negative information about applicants. Then he mentions the fact that Pacheco, although often boastful of Velázquez's achievements, never mentions his noble origins. Gállego also asserts that Velázquez's father, if a nobleman, would never have permitted his son to have become a painter. Finally, he notes the absence of noblemen at the baptisms of Velázquez and his six brothers and sisters, and questions whether the family moved in the circle of Seville's minor nobility. In short, Gállego marshals circumstantial evidence that indicates the lack of Velázquez's nobility.
 However, Valgoma's argument is buttressed by additional documentary material on Velázquez's parents and grandparents that was produced while they were still alive, hence antedating the *probanza*. This evidence seems to establish the claim to a low order of nobility on both sides of the family. For the present, it remains a mystery why the family did not choose to emphasize their status until Velázquez decided to capitalize on it.
 As an aside, it might be noted that subsequent descendants have added powerful substantiation to the nobility of the Rodriguez de Silva y Velázquez family. A. de Mes-

Varela, the only reason was his profession as a painter. As he expressively puts it, "the powerful marquis of Távera (president of the Council) and his colleagues on the Council would not resign themselves to seeing a painter proudly wear the venerated cross of Santiago and to accepting him as a brother."

On April 3, the Council advised the king that, according to the rules of the order, only a papal dispensation could excuse the unproven nobility. Philip secured the necessary documentation from Pope Alexander VII and communicated it to the Council on July 29, together with the command to invest Velázquez with the habit. But on August 3, the king received the incredible news that the Council had found yet another fault in Velázquez's genealogy. This time it rejected what it had previously accepted, the noble lineage of his father's family. No more striking proof can be offered of the determination to exclude Velázquez from the order. But in the end, he prevailed. Another papal dispensation was obtained for this alleged defect and on November 28, 1659, ten years after his initial petition, Velázquez was admitted to the order and redundantly but necessarily ennobled.

These extraordinary circumstances furnish, I believe, the immediate raison d'être of *Las Meninas*. Although it was probably painted two years before Velázquez formally sought his knighthood, the painting clearly responds to social conditions and personal ambitions that had long been in force. *Las Meninas* is not only an abstract claim for the nobility of painting, it is also a personal claim for the nobility of Velázquez himself. This explains why he lavished the last ounce of his genius upon it. By depicting his message in a monumental, dazzling tour de force of thought and technique, he meant to demonstrate once and for all that painting was a liberal and noble art that did not merely copy, but could re-create and even surpass nature. Painting was a legitimate form of knowledge, forever beyond the reach of craft, and therefore was a liberal art. Its lofty status was proved conclusively by the monarchs who visited the atelier to watch the painter work his special magic, and who remained there as perpetual guarantors of his claims. This explains why Velázquez represented himself in a pensive attitude and not actually daubing paint on canvas. And also why he chose not to conceal his palette and brushes, as many artists before had done in their self-portraits. With a brilliant stroke of daring, Velázquez invited the viewer to consider the painter as worthy because, not in spite, of his art.

One last point deserves consideration. Velázquez must have obtained Philip's consent to depict him, even indirectly, in the studio. To do so would otherwise have been an unforgivable breach of decorum. Hence, the purpose of the picture would have been known to the king, who perhaps recorded this knowledge in *Las Meninas* itself. According to Palomino, shortly after Velázquez's death Philip ordered the cross of Santiago to be added to the painter's self-portrait. This is the kind of story that might well have survived

tas, "Descendencia regia de un pintor de reyes," *Hidalguía*, has demonstrated that Velázquez is an ancestor of Franz Joseph II, prince of Liechtenstein, Prince Bernhard of Holland, and King Baudouin of Belgium.

the twenty years between Velázquez's death and Palomino's arrival in Madrid. The usual interpretation of the king's command to add the cross is as a tribute to their long-standing friendship. But if *Las Meninas* was indeed an affirmation of the nobility of painter and painting, the gesture was also the king's clever way of acknowledging and, in a profound sense, completing its meaning. Philip's personal conviction of the nobility and liberality of the art of painting is apparent from his record as a patron and collector. Moreover, he is known to have been an amateur painter himself, having studied the art under the tutelage of Fray Juan Bautista Maino. Direct evidence of his belief on this subject is contained in Carducho's *Diálogos de la pintura*, where the painter records the following conversation between himself and the king. "Listen to what I heard His Majesty say about this matter. I said, 'Sir, every monarch and every age has considered the art of painting to be noble and liberal.' And as I was preparing to continue my discourse in order to prove the point, His Majesty cut me off and said, 'It is true.' "[61]

[61] Vicente Carducho, *Diálogos de la pintura*, p. 362.

5

Zurbarán's Paintings in the Sacristy of the Monastery of Guadalupe

During the seventeenth century, the religious orders were virtually unrivaled in Spain as artistic patrons. Every major painter, with the single exception of Velázquez, produced at least one example of the episodic commissions that depict the history and illustrious members of these groups. The rise of religious communities as patrons is fundamentally connected to the expansion of monasteries and convents in the second half of the sixteenth century.[1] During this period, numerous mendicant reform orders originated in Spain, such as the Observant Augustinians, the Discalced Carmelites, the Trinitarians, and the Mercedarians, while others were imported from abroad such as the Alcantarine and Capuchin branches of the order of St. Francis. By 1600, the orders had largely supplanted the parish churches as spiritual centers for the populace as a whole. Additional impetus to the movement was supplied by the extraordinary number of newly canonized Spanish saints—Theresa, Ignatius Loyola, Bruno, and Peter Nolasco—who were identified with the orders. Yet for all their importance in the history of Spanish art of the period, the pictorial ensembles commissioned by the religious orders have usually been studied only in the context of the artists who produced them.[2] The monographic approach has been invaluable but limited because it has excluded the study of a class of patron who conceived and monitored the work at every step in order to assure that the intended message had its desired effect. This omission has distorted the historical record in two ways. First, it has given undue importance in these commissions to the painters, thus destroying the balance between style and content achieved in these works. And, second, it has obliterated the significant differences between this type of religious art and others, thus making Spanish Baroque religious art seem much more homogeneous than it really is.

The study of monastic commissions as a unique collaboration between patron and artist is hindered because much of the original material has been lost or destroyed. For example, the directives from patron to painter, often re-

[1] The phenomenon is concisely described by Domínguez Ortiz, *The Golden Age of Spain*, pp. 124-26.

[2] Guinard, *Zurbarán*, pp. 14-28, devotes a few pages to the question of monastic painting in Spain, but is concerned with stylistic analysis and the history of the dispersion of the cycles in the nineteenth century, not with subject matter.

ferred to in contracts, have virtually all been lost. Presentation drawings and sketches that the artists furnished for criticism and approval have also failed to survive in great quantities. But most important, almost all of the series have been removed from their original sites, thus destroying the legibility of this most narrative form of art. In fact, only one significant cycle is still intact and *in situ*. Luckily it is a major work by a major painter for a major client— Zurbarán's paintings for the sacristy of the Hieronymite monastic church at Guadalupe, executed in 1638-1639.[3] By taking advantage of this unique and precious accident of survival, we can begin to formulate an appreciation and an approach to this central form of Spanish artistic expression.

The monastery of Guadalupe is one of the most impressive sights in Spain (fig. 26). Its massive masonry walls dominate the small village and in turn are dominated by the surrounding hills. It is also one of the most remote sites in Spain. The nearest cities are Cáceres and Toledo, respectively 125 kilometers and 185 kilometers distant over hilly, rugged terrain. The monastery owes its unusual situation to a miracle that occurred at Guadalupe early in the fourteenth century.[4] Around 1320, a herdsman from Cáceres named Gil discovered a calf that had died in the terrain where his cattle were grazing. Deciding to skin the animal, he made a cross-shaped cut in its breast, whereupon the calf sprang back to life, and simultaneously the Virgin appeared. She told Gil to report the miracle to the priests in Cáceres, and to have them dig in the ground where she had appeared. When at length the priests were persuaded to come and excavate, they discovered a perfectly preserved image of the Virgin (supposedly carved by St. Luke), which became the famous Virgin of Guadalupe. A small, crude hermitage church was constructed on the site, and priests were assigned to establish and maintain its cult.

About ten years after the foundation, the king of Castile, Alfonso XI, visited the shrine and became devoted to the Virgin of Guadalupe. Impressed by the number of pilgrams who were worshipping at the shrine, he donated money to rebuild the church, a project completed in 1337. Three years later, Alfonso's devotion to the Virgin of Guadalupe acquired new dimensions of fervor and conviction. On October 29, Alfonso fought a major battle against the Moors at Salado. On the eve of the encounter, he commended his fortunes to the Virgin of Guadalupe. When his troops won a stunning victory, he vowed to enrich her shrine. Almost immediately afterwards, he asked the

[3] The literature on Zurbarán's paintings for Guadalupe, although extensive, is largely descriptive. The fundamental work on the sacristy is Elías Tormo, "El Monasterio de Guadalupe y los cuadros de Zurbarán," in *Pintura, escultura y arquitectura en España. Estudios dispersos de Elías Tormo y Monzó*, pp. 45-87. Two more recent studies of importance are César Pemán, "Zurbaranistas gaditanos en Guadalupe," *Boletín de la Sociedad Española de Excursiones*, pp. 155-87, and Guinard, *Zurbarán*, pp. 107-15.

[4] This account of the history of Guadalupe and its shrine is based on the following sources: Germán Rubio, *Historia de Nuestra Señora de Guadalupe*, and Arturo Alvarez, *Guadalupe. Arte, historia y devoción mariana*. Both of these works are based on documents in the monastery's archives, which now reside partly at Guadalupe and partly at the Archivo Histórico Nacional (AHN), Madrid. A detailed catalogue of the holdings in the AHN was published by Luis de la Cuadra, *Catálogo-inventario de los documentos del Monasterio de Guadalupe*. A large number of documents were lost in the 1830s when part of the archive was removed to Madrid.

Archbishop of Toledo to grant him and his descendants the *jus patronatus* of the church. On January 6, 1341, Cardinal Gil de Albornoz granted the patronage, and, from that date, Guadalupe became intertwined with the crown of Castile, which promoted the Virgin as a patroness and the monastery as a national shrine. From 1340 to about 1500, Guadalupe was the hub of Spanish religious life. Its preeminence was based not only on the royal patronage but, as a consequence, on its identification as the spiritual center of the greatest political and religious enterprise of the time, the *Reconquista*. The unique amalgamation of church and state represented by this long crusade against the Moslems was incorporated in Guadalupe, making it a pilgrimage site of unsurpassed popularity. The rulers of Castile were frequent visitors, as were titled nobility, high-ranking ecclesiastics, powerful generals and thousands upon thousands of common people who came to pray and redeem their vows. Also among the supplicants were the explorers of the New World, who had prayed to the Virgin of Guadalupe to deliver them from danger, and who conquered and colonized America in her name. Columbus and Cortés both came to Guadalupe and gave their thanks.

The ascendancy of Guadalupe had an additional cause—the brilliant leadership of the Hieronymite order, which was installed there in 1389. Initially, the church and shrine were administered by secular clergy. However, during the reign of Juan I, the Hieronymites were invited to take charge of the site. The Hieronymite order was an unusual choice because it had been founded only a few years earlier and had not been confirmed until 1373. The Hieronymites were a reform order, comprising originally noblemen who had wearied both of court life and of the abuses then rampant in Spanish monasticism.[5] Juan I must have been impressed by their zeal, their noble blood, and, in all probability, by their Castilian origins. It would have seemed appropriate to him that this Castilian shrine be administered by an order that was itself rooted in the soil of the kingdom. The choice was momentous for the order, which remained intimately identified with Spanish rulers until 1600. Charles V retired to the Hieronymite monastery at Yuste in 1558, and his son, Philip II, entrusted the monastery at El Escorial to Hieronymite monks in 1561.

On October 22, 1389, the Hieronymites took possession of Guadalupe under the priorate of Fray Fernando Yáñez de Figueroa. Immediately a building program was initiated that involved the reconstruction and amplification of the church and the addition of the splendid *mudéjar* cloister. The inauguration of the new works in 1402 was attended by Enrique III, who often visited Guadalupe. The king became so impressed by Yáñez that in 1406 he asked him to become the archbishop of Toledo and primate of Spain. Although Yáñez refused the offer, the friendship between prior and king set another important precedent for future rulers of Castile, who often sought the advice of Guadalupe's priors on political as well as religious matters. María de Aragón, the wife of Juan II, selected Fray Pedro Cabañuelas as her confessor, and

[5] The classic history of the Hieronymite order is by José de Sigüenza, *Historia de la Orden de los Jerónimos*.

came to rely on his spiritual guidance so heavily that she requested and received burial next to his remains. More impressive still were the achievements of Cabañuelas's successor, Bishop Gonzalo de Illescas. After the execution of the prime minister, Count Alvaro de Luna, in 1453, Juan II selected Illescas as one of his two state councillors and also as his confessor.

The next king of Castile, Enrique IV, continued and even intensified the devotion of the crown to Guadalupe. It was he who saved Guadalupe from destruction at the hands of his brother, the infante Alonso, who with other grandees attempted to appropriate the shrine for one of the military orders so that its lands and riches could be confiscated. Enrique IV also chose Guadalupe as the stage for a major event in Spanish history, the attempt to arrange the marriage of his half-sister, Isabella, to Alfonso V of Portugal. In 1464, the two kings met at Guadalupe with high hopes, only to be frustrated by the refusal of the young princess to agree to the match. Had she complied, she would not have become the wife of Ferdinand of Aragon, with whom she unified the kingdoms of Spain and founded the Spanish Empire.

Isabella herself became the most fervent adherent to the Virgin of Guadalupe, and the most generous patron of her shrine. Both Ferdinand and Isabella frequently visited Guadalupe to thank the Virgin for the military and political successes of their reign.[6] In January 1479, they journeyed to the monastery to give thanks for having restored peace in the kingdom and to sign the important peace treaty with France (January 10). On April 21, 1486, Ferdinand signed the *sentencia de Guadalupe*, a decree that was the first attempt to mitigate the abuses of the feudal land system in Catalonia. In the following year, the king and queen ordered the construction of a royal hospice, which was completed in 1491 on the designs of their architect, Juan Guas. After the reconquest of Granada on January 1, 1492, they again made a votive trip to Guadalupe, during which time (June 20) they ordered three small ships to be placed under the orders of Christopher Columbus. The ties between rulers and monastery were so close that on May 11, 1477, Isabella was made what we would today call an "honorary member" of the Hieronymite order. Four months later, on August 31, Ferdinand was likewise honored.[7]

The victory over the Moslems at Granada and the consequent end of the *Reconquista* deprived the monastery of the cause it had come to symbolize. Its mission and importance were further diminished by the start of a new phase of Spanish history, the involvement with the empire in Europe and America founded by the indefatigable Ferdinand and Isabella. Their successor was an emperor, Charles V, who was not a Spaniard by birth and whose titles included king of Castile as one of many. These changes inevitably weakened

[6] The visits of Ferdinand and Isabella to Guadalupe have been documented by Antonio Rumeu de Armas, *Itinerario de los Reyes Católicos 1474-1516*, which includes complete maps of the routes followed to Guadalupe by the monarchs from other parts of the peninsula.

[7] The documents, which are in the Archivo General de Simancas, are referred to by Luis Súarez Fernández and Juan de Mata Carriazo Arroquia, *La España de los Reyes Católicos (1474-1516)*, Historia de España, ed. Ramón Menéndez Pidal, XVII, t. 1, pp. 265-66, 291, n. 105.

the traditional relationship between the crown and the monastery. Although Charles V in time bestowed his favor on the Hieronymite order, which had spread throughout the land, his imperial responsibilities allowed him time for only a single visit to Guadalupe (1525). When he abdicated the throne in 1558, he retired not to Guadalupe but to the sister monastery at Yuste.

Charles's son and successor, Philip II, has an ambivalent place in the history of Guadalupe. He made several benefactions to the monastery and twice visited it. But these favors were more than offset by his creation of a temple that rivaled and finally eclipsed the importance of Guadalupe—El Escorial. The rivalry occurred not merely because El Escorial was bigger and newer, but because Philip installed the Hieronymite order there in 1561. The Hieronymites he chose were the prior of Guadalupe and twenty of his monks. Whatever pride was felt at Guadalupe must soon have turned to disappointment, especially when it became known that Philip had decided to create a royal pantheon at El Escorial. The royal pantheon was to serve as the final resting place for the future kings of Spain, and this was a virtual declaration of El Escorial as the new imperial temple. Indeed, Philip's decision to build the gigantic complex was partly motivated by the desire to create a symbol of the power, majesty, and religiosity of the Hapsburg empire, and to reflect the advent of a new world ruler near his center of power in Madrid, recently declared the capital of Spain. This purpose would not have been served by continuing to patronize the quintessentially Castilian Guadalupe.

The establishment of a permanent capital in Madrid in 1561 also had important consequences for Guadalupe. Until then, the kings of Castile had had an ambulatory court that regularly moved from place to place. The movement was organized around the key cities of the kingdom, which included Segovia, Burgos, Valladolid, Toledo, and Seville. Guadalupe, though distant from any major town, lay just off the main routes that led from northwestern Castile to the south and from central Castile to the west. Hence, when the court moved from Valladolid to Seville, for instance, it would often stop at Guadalupe. After Philip declared Madrid the sole and fixed capital of Spain, Guadalupe almost overnight became the remote and isolated place that it is today.

Thus, by 1600 Guadalupe was growing obscure in the shadow cast by Spain's vast empire. But pride in its past glories would not allow the monks to accept this turn of fate without a challenge. Around 1595, an ambitious program of renovation and new construction was launched, which may be interpreted as an attempt to reassert the importance of the monastery and recover its former glory. The first manifestation of the program is found in the construction of the Reliquary Chapel, which was to provide a splendid setting for the important collection of holy relics.[8] Initial discussions about the chapel were held on October 27, 1590, just four years after the inauguration of El Escorial. The construction, under the direction of Nicolás de Vergara the Younger, was begun and completed by October 1597, although the decoration was not finished until 1621.

[8] For the documents concerning the Reliquary Chapel, see Hermenegildo Zamora, "La Capilla de las Reliquias en el Monasterio de Guadalupe," *Archivo Español de Arte*, pp. 43-54.

No sooner had the chapel been completed than a second, and more important, project was launched, the renovation of the main altar (fig. 27).[9] In 1597, the monks commissioned El Greco to replace the existing late Gothic altarpiece with a new work that would include painted and sculptured elements.[10] On August 28 of the following year, Philip II agreed to donate twenty thousand ducats toward the cost of the altarpiece. Then, mysteriously, the project was halted until 1606, when it was tentatively renewed under the direction of the court architect, Juan Gómez de Mora. On June 15, 1606, Gómez de Mora wrote instructions on two drawings for the side elevations of the main chapel, which had been prepared by Pedro Freila de Guevara, a Cordoban architect and sculptor.[11] In the interim, El Greco had evidently either resigned or lost the commission. Three years later, the design stage had still not been completed. On June 2, 1609, Gómez de Mora approved a groundplan for the chapel and altarpiece (fig. 29) that substantially conforms to the work as executed.[12] But still no progress on construction was made until 1614, when at last the preliminary negotiations with artists and craftsmen began.

On June 14, 1614, a contract was signed by Gerolamo Lucente da Correggio, an Italian artist living in Seville.[13] According to its terms, the altarpiece was to be executed in Seville, with paintings by his hand or with the assistance of the court painters, Vicente Carducho and Eugenio Cajés. Curiously, the design had to be approved by Juan Bautista Monegro, a Toledan architect who had been an unsuccessful candidate for the job. The sculpture was separately contracted on January 18, 1615, with two Toledan artists, Giraldo de Merlo and Jorge Manuel Theotocopolos, El Greco's son.[14]

These carefully laid plans soon became unraveled, apparently because Gómez de Mora did not approve them. Philip III had agreed to honor his father's pledge of twenty thousand ducats, which, although no longer adequate to pay for the work, still gave him and his architect de facto power of veto. Hence, on December 20, 1614, Gómez de Mora sent a drawing for the elevation (fig. 30) on which he wrote lengthy and specific instructions.[15] The first sentence makes it clear who is in charge. "His Majesty orders that the main altarpiece be made according to this drawing." And the last sentence effectively annulled all existing arrangements. "This is what His Majesty ordered to be done, not withstanding any agreements and contracts that the monastery has executed."

[9] The most complete discussion of the rebuilding of the altarpiece is by Alvarez, *Guadalupe*, pp. 205-209. The following summary account is based on this study and the original documentation in the AHN.
[10] The contract is published by Francisco de Borja de San Román, *El Greco en Toledo* (Madrid, 1910), pp. 157-58.
[11] The drawings are published by Diego Angulo and A. E. Pérez Sánchez, *A Corpus of Spanish Drawings. Volume Two: Madrid 1600-1650*, p. 50, pl. 72.
[12] AHN, Dibujos y planos no. 25.
[13] AHN, Clero, leg. 1430-30. [14] AHN, Clero, leg. 1430-31.
[15] The drawing is in the Biblioteca Nacional, B. 365. The inscription is fully recorded by Angel Barcia, *Catálogo de la colección de dibujos originales de la Biblioteca Nacional*, pp. 77-78; the drawing is reproduced by Francisco Sánchez Cantón, *Dibujos españoles*, II, no. 155.

Hence, the contract with Lucente da Correggio was canceled and reassigned to Monegro, who in effect was acting as Gómez de Mora's executive assistant. On June 10, 1616, he submitted a groundplan (fig. 31) to Gómez de Mora, then in Seville, who approved it except for the floor pavement.[16] Meanwhile, agents for the monastery had been sent to Seville to sell some silver objects to finance the additional costs and to find wood for the architectural framework. On April 22, however, they communicated via a letter from the sculptor Juan Martínez Montañés that suitable wood could not be found.[17] Eventually, oak was sent from Sweden, arriving at Guadalupe in 1617. Also in June, the painter Cajés wrote to the monastery requesting the dimensions of the pictures he had been ordered to make.[18]

The work, then, finally began in June 1615, and was finished almost exactly two years later in July 1617.[19] The final construction was built according to the design of Gómez de Mora and executed by Monegro. The sculpture was the work of Merlo alone, Jorge Manuel having been dropped from the contract. The paintings were done by Carducho and Cajés as originally planned. The altarpiece was inaugurated on October 20, 1618, in the presence of Philip III and members of the court.

From a stylistic point of view, the altarpiece is a typical work of court art of the period and somewhat paradoxically imitates the monumental altarpiece of the Leoni. The imitation is pointedly confirmed by the figures in prayer which flank the altarpiece exactly as the statues of Charles V and Philip II do in the church at El Escorial. They represent Enrique IV on the left and his mother, María of Aragón, on the right and are funerary effigies of the two royal persons, whose remains are interred below (fig. 28). Each tomb is surmounted by large reliefs of the Castilian coat of arms. The inclusion of the effigies and the outsized heraldic shields was dictated by their special purpose—to call attention, like a billboard, to the royal presence in the shrine. In other words, the new altarpiece was meant not only to provide greater splendor to the shrine but also to remind visitors of the royal patronage that Guadalupe had traditionally enjoyed.

This propagandistic plan was continued in another decorative project that was carried out between 1621 and 1623 by a painter who had entered the order in 1615 and was known as Fray Juan de Santa María. His first major commission was a series of thirty-two paintings to decorate the lower storey of the mudéjar cloister.[20] These little-known paintings, which are competent

[16] AHN, Dibujos y planos no. 26.

Gómez de Mora's comments read in full as follows: "His Majesty [Philip III] has seen this plan of the church of Nuestra Señora de Guadalupe and thinks that the pavement should be made only of white marble and marble of Toledo, without other colored stone, because it is more solemn. The rest of the plan seemed satisfactory and should be done thus. Seville, June 10, 1616."

[17] This document is cited by Alvarez, *Guadalupe*, pp. 208-209.

[18] AHN, Clero, leg. 1424b-30.

[19] The date of completion is mentioned in an account of the inaugural ceremonies, published by Carlos de Villacampa, *Grandezas de Guadalupe. Estudios sobre la historia y las bellas artes del gran monasterio extremeño*, pp. 255-62.

[20] The artist is identified in documents published in ibid., pp. 151-52. The date is established in a *cuenta de gastos* of 1623 (AHN, Clero, leg. 1424b-45). Like Zurbarán's

examples of the late-sixteenth-century Italianate style then popular at court, depict events from the early history of the monastery and the most notable miracles of the Virgin of Guadalupe. The paintings, which are still in place, again seem to respond to the "public relations" campaign set in motion twenty years earlier. But more significant, they may be viewed as the immediate inspiration for the last component in the monastery's assertive program of self-glorification—the decoration of the newly constructed sacristy (fig. 32).

The history of the building and decoration of the sacristy and the adjacent chapel of Saint Jerome can be only partially reconstructed because many of the records of the relevant years have been lost. However, the researches of Arturo Alvarez have provided a fairly detailed outline of several aspects of the work, although not including Zurbarán's paintings.[21] The new sacristy was planned at three chapter meetings held in 1638 under the direction of the prior Diego de Montalvo. In that same year, an unnamed Carmelite monk was paid for the design of the new building, which was to be built on the southern flank of the huge monastic complex. The work began at once, as indicated by an inscription in the sacristy that gives the commencement date as August 5, 1638, and by substantial payments made to the *maestros de la obra*, Sebastián Prieto and a man named Pintiero. In 1639, the first of many payments that extend to 1645 was given to Manuel Ruiz, a painter and gilder who must have executed the elaborate fresco decorations in the sacristy and adjacent chapel. Work continued until 1647 when, according to an inscription on the wall, the sacristy was dedicated.

Zurbarán's contribution to the decoration of the sacristy—eight large paintings with scenes from the lives of Hieronymite monks—was the first to be completed.[22] The contract has never come to light, but the date of the commission is established by the signatures and dates on six of the paintings. One is dated 1638, five are dated 1639. Furthermore, Alvarez has discovered documents of 1638-1639 that record the arrival of unspecified paintings from Seville. These can only be the pictures by Zurbarán, who was then living there. It is thus a curious fact that the paintings were in hand well before the structure was finished. Apparently they were ordered almost as soon as the Carmelite monk had drawn the plans.

paintings for the sacristy, the commission by Fray Juan de Santa María is a valuable record for the history of monastic art. Monasteries frequently decorated the walls of cloisters with scenes from the history of the order. Owing to the exposed position, very few survive.

[21] Arturo Alvarez, "Madurez de un arte. Los lienzos de Guadalupe," *Mundo Hispánico*.

[22] In addition to the paintings by Zurbarán, there are five scenes in fresco on the ceiling that depict scenes from the life of Saint Jerome. These pictures do not relate to Zurbarán's canvases below them, but are connected to the paintings he executed for the adjacent chapel of Saint Jerome.

All the scenes from Saint Jerome's life, both those of Manuel Ruiz and Zurbarán, follow the common practice in monastic cycles of illustrating episodes from the life of the founder and are not directly related to the eight large paintings of Hieronymite brothers.

The theme of Zurbarán's paintings has never aroused much discussion, perhaps because the subjects have always been known due to the framed inscriptions that accompany the pictures.[23] On the surface, the meaning of the ensemble seems entirely obvious. As many writers have noted, all the monks are Hieronymites and all belonged to Guadalupe, not surprising, given the setting. Yet these obvious facts acquire considerable significance when viewed in the context of Spanish monastic painting. The paintings in the Guadalupe sacristy are possibly unique among seventeenth-century monastic series because they depict monks from a single monastery. Monastic cycles were almost always conceived in one of two ways: either as a "hall of fame" to which a brother from any branch of the order could be elected, or as a narrative representation of the important events of a single major figure, usually the founder of the order. But the paintings in the sacristy show only monks of Guadalupe—and, furthermore, monks who all lived in the fifteenth century. This important fact is explicitly stated in the inscriptions that identify the subjects. The texts contain elliptical Latin glosses on the scene pictured plus the name of the monk and the date of his death. The earliest date of death is 1408, the latest is 1479. The significance of this focus becomes clear when we recall the campaign to revive the fame of the shrine. The fifteenth century was the glorious century of Guadalupe, when the kings of Castile patronized the shrine and sought the religious and political counsel of the monks who tended it. Zurbarán's paintings must have been conceived by the prior, Diego de Montalvo, to serve as a record and reminder of those halcyon days.

This programmatic intention is expressed in the choice of the scenes in the eight Hieronymite portraits. But before we discuss their interrelationship, it may be helpful to describe the subjects, which, dealing as they do with episodes from a forgotten chapter of history, are now obscure. For the sake of convenience, they will be described in chronological order, according to the subject's date of death.

The first scene shows the *Vision of Fray Andrés Salmerón* (fig. 34). Salmerón, who died in 1408, was one of the original Hieronymites at Guadalupe. He became renowned for his trance-like periods of meditation. For hours on end he would stand or kneel without moving a muscle, completely lost in his prayers. On some occasions, he even had to be carried into the refectory in order to be fed. It was in the refectory that the miraculous vision seen in the painting occurred. The vision is described by the great Hieronymite scholar and biographer, José de Sigüenza, whose *Historia de la Orden de los Jerónimos* of 1600 is the primary textual source for all the paintings. "He was eating one day in the refectory when a celestial light covered him, and his face was transfixed by supernatural clarity—so much so that many persons around him thought that it shone as a second sun. It is not rare for Christ to appear to one of his followers in the refectory, which is as much a spiritual place as the church."[24]

The second scene (fig. 35) shows an episode from the life of Fray Fernando

[23] The inscriptions are transcribed by Tormo, "El Monasterio de Guadalupe," pp. 76-79.

[24] Sigüenza, *Historia*, I, p. 207.

Yáñez de Figueroa, who died in 1412.[25] Yáñez de Figueroa, the first Hieronymite prior of Guadalupe, was a man of great energy and authority and a founder of the order. He was also a close friend of the king, Enrique III, who, as Sigüenza noted, "discussed with him the great matters of state, and found his counsel wise and mature." Ultimately, the king decided to appoint Yáñez as the archbishop of Toledo and primate of Spain, a position of great temporal and spiritual power. Yáñez's reaction to the appointment was sorrowful, not joyful. He desired only to remain at Guadalupe, to retreat from the world and to tend to the salvation of his soul. At length, he became tormented by his dilemma, and took to wailing and moaning in his cell until his fellow monks came to understand his plight. They appointed a delegation to see the king, who was then in Guadalupe, and persuaded him to withdraw the offer, much to Yáñez's relief. Zurbarán's painting shows only the first part of the incident, as Enrique III places the archbishop's biretta on the prior's head.

Juan de Carrión, the subject of the third painting (fig. 36), who died in 1419, was another monk known for his single-minded devotion.[26] As he prayed, he forgot the world around him, and even came to forget the details of his life before entering the monastery. One day, as he was praying in the choir with his fellow monks, the Holy Spirit came to him and revealed that he was about to die. Immediately he arose and began to kiss the feet of his companions and to beg their forgiveness of his sins. Several thought he had lost his mind, but the few who believed him gathered around as he knelt and uttered his final prayers of forgiveness. Then he died. In Zurbarán's painting, Juan de Carrión kneels in the center, flanked by two believers, while the group of doubters looks on at the left.

In the fourth painting (fig. 37), we see Fray Martín de Vizcaya, who died in 1440.[27] Vizcaya served as the gatekeeper of the monastery, and was famous for his exceptional charity toward the poor. As Sigüenza relates, he "always kept these words of Our Lord in his heart: 'Whatsoever you do for the least of my brethren, you do it for me.' " Many of the poor whom he helped testified that even when he had nothing to give them, his mere presence would satisfy their want. Zurbarán wisely painted this saintly man on a day when the larder was full.

The subject of the fifth painting (fig. 38), Fray Pedro Cabañuelas, was a prior of Guadalupe who enjoyed a close relationship with the rulers of Castile, Juan II and María of Aragón.[28] However, the scene illustrates his religious, not his secular life. When he said mass, Cabañuelas was often tormented by a devil who would ask him how it was possible that the host could contain the blood as well as the body of Christ. This diabolical question kept repeating itself until one Saturday during the Mass of the Virgin when the answer was dramatically given. After Cabañuelas had consecrated the wine, a cloud covered the altar. When it had lifted, the host had vanished and the

[25] Ibid., pp. 174-78. [26] Ibid., pp. 183-85. [27] Ibid., p. 215.
[28] Ibid., pp. 419-22. As Rubio notes, Sigüenza's account seems to be based on Cabanuelas's own narration of the event, which is preserved in a manuscript in the monastery's archive.

chalice of consecrated wine was empty. Cabañuelas was struck with terror, and prayed to Christ and the Virgin to forgive his sins. Then he saw the host, which Zurbarán represents as a communion wafer, descend from above, alight upon the edge of the chalice and begin to drip blood until the chalice had been refilled with exactly the amount of liquid it had previously held. After the miracle was over, he heard a voice say, "Finish the mass and do not tell anyone what you have seen." These are the words that are written above his head in the picture. The acolyte who was assisting the mass saw and heard none of what transpired, and wondered only at the slowness of the mass.

The sixth painting (fig. 39) is the only non-narrative portrait in the series, and depicts Fray Gonzalo de Illescas, who succeeded Cabañuelas as prior when the latter died in 1441.[29] Illescas was destined for higher offices, which, unlike Yáñez de Figueroa, he decided to accept. In fact, no other Hieronymite from Guadalupe equaled the political and ecclesiastical status achieved by Gonzalo de Illescas. On July 5, 1453, he was nominated by Juan II as one of two King's councillors, and also as confessor to the King. Just before the king died on July 20, 1454, he appointed Illescas as bishop of Córdoba. Zurbarán's portrait lays stress on Illescas as bishop by showing him dressed in episcopal vestments.

The seventh painting is the *Temptation of Fray Diego de Orgaz* (fig. 40). From his childhood, Diego de Orgaz had been unsuccessfully tempted by the devil to abandon his devotion to the Virgin.[30] Finally, the devil addressed God and received permission to organize a Job-like ordeal. After a series of temptations and afflictions had failed to shake Orgaz's faith, came the final attempt. One night, a lion, a bear, and a beautiful woman visited his cell. Orgaz recognized this incongruous trio as devils and tried to dispel them by beating them with a stick. When they would not go, he realized that only prayer could accomplish what force could not, and he knelt and prayed to the Virgin, whereupon they vanished. For pictorial purposes, Zurbarán has divided the anecdote into a foreground and background scene, with demons in front and the praying monk behind.

The last painting (fig. 41) depicts the *Vision of Fray Pedro de Salamanca*, who died in 1479. Here again the story demonstrates the relationship of the Guadalupe Hieronymites to royalty, this time the king of Portugal.[31] One morning before sunrise, while saying matins, Pedro de Salamanca saw a light burning in the sky like a great fire. Doubting what he had seen, Salamanca asked a fellow friar to accompany him at the same time on the following morning. As the two stood in the cloister, the sky again turned red. Salamanca turned to his companion and spoke: "Brother, this fire signifies the great spilling of human blood that will soon occur." Later that year, 1458, the Christians, under the leadership of the Portuguese king, Alfonso V, defeated the Moors in North Africa. The Moorish casualties were extraordinarily high, thus fulfilling the prediction of the matutinal vision.

Today, these stories may seem only examples of devout and touching monastic piety. But given the intention to reassert the primacy of Guadalupe

[29] Ibid., pp. 426-32. [30] Ibid., pp. 433-35. [31] Ibid., pp. 204-205.

by recalling its glorious past, they can also be seen to have been carefully chosen for that specific purpose. The pictures illustrate the unique religious and secular status of Guadalupe by showing the brothers not only as servants of God but also as servants of kings. The pride in this special mission was still alive in 1743, when Fray Francisco de San Joseph wrote his history of the monastery. His preface to the lives of famous brothers aptly describes the program of the sacristy: "Some were called upon for great services by the kings of the earth, while others were called upon for sovereign enterprises by the King of Heaven. And all discharged their obligations with the great skill that will be seen in the following chapters."[32] Three rulers are referred to in the paintings—Enrique III, Juan II, Alfonso V of Portugal—and one of them is represented in person. These references must have been included to draw attention to Guadalupe's proud tradition of royal patronage and to its claim as the spiritual center of the kingdom of Castile.

The currency of these ideas in the 1630s is corroborated by a history of the monastery published just seven years before Zurbarán was asked to paint his pictures for the sacristy. The book, entitled *Venida de la Soberana Virgen de Guadalupe a España* and published in Lisbon in 1631, was written by a Hieronymite from Guadalupe named Diego de Montalvo, the same Montalvo who was prior when the construction of the sacristy was begun.[33] Montalvo's history is more than a simple chronological account of the shrine from its origins to the early seventeenth century. Throughout it runs an insistent strain of propaganda designed to remind and convince the reader of the glories of the Virgin of Guadalupe and her shrine. This advocative tone is strikingly similar to the spirit that informs the paintings by Zurbarán.

Most of the book's 312 folios are devoted to a series of miracles that occurred through the intervention of the Virgin of Guadalupe, the point being to demonstrate the efficacy and grandeur of the Virgin's power. But the six introductory chapters that sketch the history are equally partisan and return time and again to the favors bestowed on the shrine by the highborn. For example, chapter four is tendentiously entitled, "How the small, poor hermitage church became a temple and house of royalty." It concludes with a long account of how Alfonso XI became the patron of the shrine after the victory at Salado. Montalvo prefaces his narrative of this event by a typical sermon on the importance of the Virgin to the kingdom.

> Because this is the first miracle that the Virgin of Guadalupe worked in defending the crown of Spain and its kingdom, so that it would not again fall into savage hands, I will refer briefly to it, so that Spaniards will recognize the obligation they have to their Great Defender and show their gratitude for this miracle.[34]

In a later chapter, Montalvo stresses the "grandeurs of the House of the Mother of God," which include its educational programs, hospitals, and

[32] Francisco de San Joseph, *Historia universal de la primitiva y milagrosa imagen de Nra. Señora de Guadalupe*, p. 225.
[33] Diego de Montalvo, *Venida de la soberana Virgen de Guadalupe a España*.
[34] Ibid., fol. 6r.

charitable works. He concludes his account with a chapter that describes the wealth of costly presents bestowed on the blessed image by members of the royal family, noblemen, and high-ranking clergy. He also describes in some detail two works of architecture, the high altar and the reliquary chapel, both of which were recent constructions designed to enhance the splendor and image of Guadalupe.[35]

Montalvo's book confirms what Tormo suspected—that he inspired the construction of the sacristy and planned its decoration.[36] However, it is important to differentiate the objective of the book from the objective of Zurbarán's paintings. Montalvo's history primarily advances the claim of the Virgin of Guadalupe to preeminence among the Spanish cults of the Virgin. The sacristy extends the message in a logical way by pressing the claims of those who tended the Virgin's shrine. Like the *Venida de la Soberana Virgen de Guadalupe*, the decoration of the sacristy has a deliberate propagandistic ambition, whose expression was made even more lucid and effective by the original installation of the pictures.[37]

I say "original" advisedly because I believe that the paintings do not now hang in their intended places. As Paul Guinard and María Luisa Caturla observed some years ago, there is a lack of harmony in the present arrangement.[38] Caturla diagnosed the problem as a failure to integrate the compositions with each other in an harmonious scheme. But the problem may be more a matter of color than of composition. When the pictures are separated according to the richness, variety, and luminosity of the colors, they readily fall into two groups of unequal size. Five paintings employ a limited, somber palette in which the brown Hieronymite habit predominates; the remaining three use rich and brilliant colors. This division of the series into groups of five and three corresponds to the space available on the two walls for hanging

[35] Ibid., fols. 14v and 16r and 16v.

[36] Tormo, "El Monasterio de Guadalupe," p. 75, suggested the names of Montalvo or Fray Juan de Toledo as the possible inventors of the program.

[37] The dedicatory inscription, which is placed in a frame under one of the windows on the south wall, also seems to give voice to the main idea. However, its wording is ambiguous. The text reads as follows:

> Urbanum octavum dum cingit celsa Thiara,
> Hesperiae et quartus regna Philipus agit;
> Haec superis digna et mayori sacra Magistro
> enituit nostri gloria prima soli.

> (While the lofty tiara encircles Urban VIII
> and Philip IV rules the western world,
> this glory, worthy of the Higher Ones,
> and sacred to the greater Master, shines forth,
> [a glory] that was first ours alone.)

The antecedent of the word "glory" is unclear; it may be either the new sacristy or the shrine and its keepers.

I am grateful to Peter H. von Blanckenhagen for his help in translating this passage.

[38] Guinard, *Zurbarán*, p. 110, and María Luisa Caturla, "Sobre la ordenación de las pinturas de Zurbarán en la sacristía de Guadalupe," *Archivo Español de Arte*, pp. 185-86.

pictures. The architecture of the sacristy bears some resemblance to a corridor, of which one wall is continuous while the other is broken by two windows (fig. 33). The continuous wall is divided into five bays, leaving room for one picture per bay. On the opposite wall, the two windows occupy two of the bays, leaving room for only three pictures. The windows are also important because of the way they admit light and thus control the visibility of the paintings. The pictures on the continuous wall are always adequately illuminated by southern light. But the pictures on the window wall must be seen in indirect light and thus are difficult to see clearly, an observation supported by the virtual invisibility of the three darker paintings that now hang there. This fundamental and inherent problem would have been anticipated and communicated to Zurbarán, who solved it by making the three paintings on the window wall more luminous. If this was so, then the *Vision of Fray Andrés de Salmerón*, the *Mass of Fray Pedro de Cabañuelas*, and the *Portrait of Bishop Gonzalo de Illescas*, clearly the brightest paintings, were originally placed between the windows on the southern wall.[39] At some later date, the three "bright" pictures were transferred to the continuous wall and three of the dark paintings placed on the window wall.

Why and when was this exchange effected? I can think of only one reason why it happened; the three "bright" paintings are the most striking paintings of the series, and were placed in full light to show them off to best advantage. When the transfer occurred is also a matter of conjecture, but it could have happened even during the initial hanging. The work in the sacristy continued until 1647, and while it was in progress it would have been foolish to install the pictures. When the time came, neither the painter nor the prior who commissioned him were on hand. Diego de Montalvo, prior in 1638, had been twice succeeded, and Zurbarán, despite suggestions to the contrary, almost certainly never visited Guadalupe.[40] Hence, it would have been easy for the prior, then Fray Ambrosio del Castellar, to have ignored or disregarded the original intention. This is merely a suggestion, of course. The paintings can be taken down, as they were in 1964, when they were restored and exhibited in Madrid, and could have been moved around at any time. But it seems fairly certain that they were moved, and not only for aesthetic reasons. Because, by restoring the "bright" paintings to the window wall, and the "dark" paintings to the continuous wall, it becomes possible to place them all in a sequence that reinforces the program of ideas.

It has been mentioned that a separately framed inscription appears under each picture. The inscriptions contain the subject's name and the date of his death. The inclusion of the death date seems to offer a clue to the original placement. If we accept this clue as a basis for a working hypothesis and ar-

[39] This hypothesis was considered in passing and rejected by Guinard, *Zurbarán*, p. 110.

[40] The case against Zurbarán's visit to Guadalupe in 1638-1639 is convincingly made by Pemán, "Zurbaranistas gaditanos en Guadalupe," pp. 160-61. There is nothing extraordinary about painters executing commissions for sites they had never seen. The paintings for the high altarpiece at Guadalupe were painted in Madrid by Carducho and Cajés.

range the paintings in groups not only by color but also by chronology, the underlying theme and purpose of the paintings become clearer and more emphatic. As the paintings are now installed, the three "bright" pictures are placed in the center of the continuous wall, and three of the "dark" pictures are located on the window wall (fig. 42). In the proposed reordering, the paintings are arranged first into the "dark" and "bright" groups, and second according to the date of the subject's death (fig. 43). In this arrangement, there are independent chronological sequences for each wall. That is to say, on each wall the subject who died earliest is found near the entrance to the sacristy, the latest near the entrance to the chapel of St. Jerome. This somewhat loose sequence had to be adopted because the open, free-flowing space makes it impossible to direct the viewer through a tightly controlled, unvarying sequence of pictures that sends him back and forth across the room, walking first to the right for painting number one, then to the left for painting number two and then to the right again for painting number three and so on. Given the spectator's freedom to wander through the sacristy, a loosely structured arrangement guaranteed that legibility would not be sacrificed to accidents of perambulation. However, the symmetry of the walls, although interrupted by the windows on one side, did bring six of the paintings face to face, forming three pairs broken by two intervals of a single painting. The program seems to have taken advantage of the pairings to elaborate certain ideas in greater detail, but it does not matter whether one looks first to the left or to the right as one strolls through the sacristy.

Taking, then, the paintings in this order, the series opens with a pair comprising the *Vision of Fray Andrés de Salmerón* and *Fray Fernandez Yáñez de Figueroa* (figs. 34 and 35). These two works share a similar composition. The repetition might be considered fortuitous or simply the result of following the prescribed texts. But the story of Yáñez de Figueroa does not mention a moment when Enrique III actually placed the archbishop's biretta on the prior's head. Indeed, the point of the story is the refusal, not the acceptance, of high office, an intention that is virtually reversed in Zurbarán's painting. The reason for this distortion, however, becomes apparent when the painting is considered as one of a pair with the *Vision of Fray Andrés de Salmerón*. In both compositions, an act of bestowal is performed as a sign of favor for virtuous and faithful service. Yáñez receives recognition from the highest secular authority, and Salmerón, from the highest religious authority. It is curious, and perhaps significant, that the king of Castile, Enrique III, wears a seventeenth-century costume, although he lived in the fifteenth century. The anachronism may have been intentionally ordered to suggest the continuity of royal favor into a time when it was being sought, rather than conferred. Thus, there emerges a restatement of the reason for the creation and decoration of the sacristy, the assertion of Guadalupe's unique role in the secular and religious life of Castile, which was achieved by the piety and wisdom of its monks. As a matter of fact, Salmerón's miraculous visitation has also been distorted to fit the new purpose, because it occurred in the refectory, not in the indeterminate space shown by Zurbarán. By removing any suggestion of a physical setting, Zurbarán imparts a sense of timelessness to the scene that

helps to reinforce the notion of the continuity of the Hieronymite mission at Guadalupe.

Next in the chronological sequence is the *Death of Fray Juan de Carrión* (fig. 36), a dark painting that faces one of the two windows. This painting may be interpreted as demonstrating the virtue of penance as a necessary part of a good Christian death, the *buena muerte* in which a faithful believer prepares his soul for the passage into the next world through prayer and repentance. The subtheme of Counter-Reformation theology is repeated in the next two works, the *Charity of Fray Martín de Vizcaya* and the *Mass of Fray Pedro de Cabañuelas*, perhaps to illustrate that the monks of Guadalupe were in the forefront of Spanish Catholicism (figs. 37 and 38). Martín de Vizcaya illustrates the cardinal virtue of charity, while Cabañuelas vividly demonstrates Hieronymite devotion to the sacrament of the Eucharist. The unity between the paintings is further strengthened by the common symbol of bread, used in one instance as food for the body and in the second as food for the soul. Zurbarán calls attention to this symbol in the *Charity of Fray Martín de Vizcaya* by the conspicuous placement of the basket of loaves. Together, these three paintings develop the theme first stated in the *Vision of Fray Andrés de Salmerón*—Guadalupe's monks as the faithful servants of Christ.

The next painting, which faces the second window, is the *Temptation of Fray Diego de Orgaz* (fig. 40), an obvious symbol of the triumph of faith over sin and evil. Furthermore, Orgaz is shown to derive his spiritual strength from the patroness of the shrine, the Virgin of Guadalupe, before whose image he kneels in the small, window-like space in the background.

The correspondence of the final two paintings fulfills the initial theme and illustrates the quality that established the special place of Guadalupe in Spanish history. In the "bright" painting we see *Bishop Gonzalo de Illescas*, the monk who filled both high civil and ecclesiastical offices (fig. 39). His achievements in the world beyond Guadalupe are underscored in a number of ways. First, he wears ecclesiastical garb and not the Hieronymite habit. Second, he is represented in a formal Baroque portrait, complete with drapery swag, not as the actor in a dramatic episode. But lest we think him unaware of the ultimate realities, a number of details are included to stress his religiosity. A skull and hourglass on the desk remind him of the vanity of worldly endeavors, while the small background vignette shows him as a practitioner of the charity that will help to save his soul. And, last, the splendid, crisply painted motif of the apple on the book recalls the fatal temptation of placing knowledge above faith.

Opposite Gonzalo de Illesca's portrait is the *Vision of Fray Pedro de Salamanca* (fig. 41), which would have hung originally on the continuous wall. He, too, takes us beyond Guadalupe to the single most important event in medieval Spanish history, the battle against the Moslems, the *Reconquista*. In this struggle of seven hundred years, the Hieronymites played an active role as the redeemers of Christians held captive by the Moors. The Virgin of Guadalupe was regarded by these prisoners as a special protectress who would help them gain freedom. After their release, often obtained with ransom money from the Hieronymites, they made a votive pilgrimage to the

monastery, as Cervantes did in 1580 following his release from imprisonment in Algeria. Their redeemed vows are still vividly recalled by the chains and shackles that hang from the walls of the church where they were placed by grateful pilgrims.[41] The association of Guadalupe with this charitable mission is recalled in Pedro de Salamanca's vision and is further intensified because the victorious general in the predicted battle was Alfonso V of Portugal, who visited and patronized the monastery. Thus these two paintings restate the second part of the theme—Guadalupe as a force in the civil history of Spain—and thus close the cycle.

Even if this sequence of installation must remain hypothetical, I believe that the selection of the eight Hieronymite subjects is sufficient to reveal the meaning. They were meant to be seen and understood as a catalogue of the secular and divine qualities that had made Guadalupe the foremost center of Christianity in Castile during the fifteenth century. In that time and place, the peculiar union of church and state that is an enduring characteristic of early Spanish history found one of its ripest expressions. This is the transcendent meaning of the sacristy decoration. It affords, as few other works of art do, a view into the spirit and richness of Spanish religious life in the Golden Age. But we should not forget that the clarity and truth of this vision are ultimately the results of Zurbarán's artistic inspiration, which is uniquely illustrated at Guadalupe. For it is here, and here alone, that we can comprehend the full extent of Zurbarán's greatness as a painter of monastic subjects.

Paul Guinard has aptly called Zurbarán a "painter of monks and a monastic painter." This play on words is as revealing as it is clever because it suggests the profound interpenetration of subject matter and style that is essential to the artist. Perhaps this explains why the monks of Guadalupe turned to Zurbarán instead of to a more up-to-date painter from the court, as they had done twenty years before when redecorating the altarpiece. They must have perceived that Zurbarán's monumental, laconic means of expression were well-suited to convey the sober faith and deep pride in their historic mission. By placing clarity above complexity and simplicity above artifice, Zurbarán achieved a direct and unequivocal expression of his patrons' ideas. The use of plain, unidealized human types, the strong contrasts of light and dark, the uncanny realization of still-life details, and the placement of monumental figures on the front plane of the picture all clarify and dramatize the message. This emphatic, legible style was the perfect vehicle for recalling the past glories of Guadalupe and assuring their eternal remembrance.

[41] Another token of the Hieronymite's role in the struggle against the infidel is the large lamp that hangs in the chapel of St. Jerome. The lamp was captured from the ship of the Turkish admiral at the battle of Lepanto in 1570, and given to the monastery by Philip II. It was placed in the chapel around 1744.

6

Hieroglyphs of Death and Salvation: The Decoration of the Church of the Hermandad de la Caridad, Seville

The *Jeroglíficos de nuestras postrimerías* by Juan de Valdés Leal have held many a viewer in their grim thrall ever since they were painted for the Church of the Brotherhood of Charity in 1672. Rarely in the history of art have the spectacles of death and the grave been realized with such vividness. In the first painting, subtitled *In Ictu Oculi* (In the Twinkling of an Eye), the time-honored formula of a *memento mori* is observed with gruesome exactness (fig. 44). Death is a skeleton, carrying a coffin, a shroud, and a scythe, who disdainfully extinguishes the candle of life. The eyeless sockets seem to glower with satisfaction as the light goes out on the symbols of greatness and power. In the twinkling of an eye, the sum of life's achievement is obscured by dark death. The second painting, *Finis Gloriae Mundi* (The End of Worldly Glory; fig. 45), elaborates the theme of death by a chilling representation of sepulchral existence, where the fragile human substance is human no more, but merely decomposing matter. Worldly glory ends in rot and decay; bugs crawl over the human shell, nourishing their vile bodies with its mortal substance. Three open coffins reveal death's impartial destruction of life and fame. The power of these paintings is so considerable that it has been easy to forget a basic question about them: why were they commissioned for the church of a lay confraternity devoted to the practice of charity? The answer leads us to an unusual religious society and its leader, thence to the time when the society flourished and finally to the artistic decoration that characterized it.

The Hermandad de la Caridad was (and still is) a brotherhood that practiced a limited but unusual charitable program. According to legend, a prebendary of the Cathedral of Seville, Pedro Martínez, assumed the task in the late fifteenth century of burying executed criminals.[1] In those days, it was customary to leave men hanging on the gallows for a week prior to burying them. Frequently the bodies fell from the rope before the seven days were out and were left lying on the ground, providing fodder for predatory animals. To mitigate this horrible practice, Pedro Martínez is said to have built a wall

[1] Diego Ortiz de Zúñiga, *Anales . . . de Sevilla*, pp. 551-52. This study originally appeared, with additional documentation, in *Art Bulletin*, 52 (1970), pp. 265-77.

around the gallows and consecrated the enclosed ground as a cemetery. Then he arranged for proper funerals when the corpses had fulfilled their legal commitment. At his death, Martínez is supposed to have willed funds for the continuation of his work. The story of this bequest may have been invented because there are no records of the Caridad's activity until later in the sixteenth century. The documented record of the Caridad begins on August 19, 1565, when 120 members were admitted to the organization.[2] Its purpose, as set forth in the first *Rule of 1578*, reflected the aims of the legendary founder, which was to bury the dead. This activity answered an urgent social need, because the poor who died from starvation, exposure, and criminal assault were often left in the streets and fields unburied.

During its first twenty years, the Caridad flourished, but after 1588 enthusiasm seems to have waned. The *Libro de cabildos* covering the period 1588-1619 indicates long lapses of time between meetings of the governing board, and throughout the first half of the seventeenth century the association declined slowly. Only twenty-nine members were enrolled between 1613-1640, after which the brotherhood began to show signs of recovery. In 1640, the members decided to raze their chapel and build a new one. In 1645, the old structure came down and a twenty-five-year period of rebuilding began. A turning point seems to have occurred in 1650, when twenty-eight new members were admitted. During the next three years, 1651-1653, a total of nearly ninety men joined to help bury the dead of Seville. This sudden increase in enrollment occurred because the mortality rate rose dramatically in 1649, when an epidemic of bubonic plague brought death to the city on a terrifying scale.

In the spring of 1648, the disease had appeared on Spain's eastern coast, and by the year's end was breaking out near Seville in the ports of Cádiz, Sanlúcar, and Puerto de Santa María.[3] Before long, it had invaded the city and begun its deadly course. May and June were the worst months, during which the plague raged uncontrolled. On some days, up to twenty-five hundred people perished, leaving entire districts of the city unpopulated. When the plague finally ended in early June, it had taken an enormous toll of lives; careful estimates have set the number between fifty and sixty thousand inhabitants, or approximately half the pre-plague population of Seville.[4]

The end of the plague brought only a brief respite from suffering. In 1651, Seville was afflicted by a new disaster, famine, which was caused partly by fields left uncultivated during the epidemic and partly by the difficulty of

[2] Jesús Granero, *Don Miguel Mañara*, pp. 293-310. This work supersedes all previously written histories of the Caridad, which are listed in its bibliography. The following account is drawn from its pages.

[3] The principal source for the history of the plague of 1649 is a manuscript in the Biblioteca Colombina, Seville, entitled "Memorias de diferentes cosas sucedidas en esta muy noble y muy leal ciudad de Sevilla. Copiáronse en Sevilla año de 1696" (sig. 84-7-21). Authorship has been attributed to Diego Ignacio de Góngora. However, the "Memorias" is an anthology of several writers (mostly civic officials) on the plague. Another eyewitness account is Ortiz de Zúñiga, *Anales*, pp. 707-13. See also Granero, *Mañara*, pp. 213-25.

[4] Domínguez Ortiz, *Orto y ocaso de Sevilla*, p. 86, and Granero, *Mañara*, pp. 221-23.

finding farm labor after it had subsided. In 1652, the food shortage had become so acute that the populace launched a bread riot that almost won control of the city.[5] Normalcy was eventually restored, but the events of 1649-1652 provided the stimulus for the Caridad's resurgence. This was an ideal moment for an organization devoted to burying the dead, and henceforth the brotherhood started to grow in size and importance. By 1661, the members recognized that the *Rule of 1578* was inadequate to govern the expanding brotherhood, so a new one was drafted and submitted to the archbishop, who approved it on June 11. In the following year, the Caridad accepted as a member the extraordinary man who would inspire and lead it to its greatest accomplishments.

The biography of Miguel Mañara Vicentelo de Leca has often been told as a mixture of fact and legend. Because he was mistakenly identified first as the prototype of Tirso de Molina's Don Juan Tenorio, the *burlador de Sevilla*, and then as an imitator of Tenorio, his life has acquired an undeserved aura of adventure and notoriety. The legend, enriched by centuries of fanciful invention, is told this way. Mañara was born into the Sevillian nobility in 1627. As a young man, he embarked on an infamous career as a libertine and scoundrel. One after another of Seville's maidens were enticed to surrender their honor in exchange for worthless vows of marriage. One after another of the young ladies' relatives fell in duels as they unsuccessfully sought to avenge their family's disgrace. Then, Mañara met and married the girl whose goodness, purity, and quiet beauty inspired a complete reformation of his character. Henceforward he followed the path of righteousness that, after the shock of his wife's early death, finally led to a saintly life as leader of the Brotherhood of Charity.

The fiction of Mañara's life is stranger than the truth, as the judicious and well-documented biography by Jesús Granero, has shown.[6] He was born on March 3, 1627, to one of Seville's wealthiest families. Mañara's father, Tomás, had come as a young man from Corsica to Seville, and then gone on to the New World, where he spent ten years laying the foundations of his fortune as a *cargador de Indias*, or Indies trader. Miguel was his youngest surviving child and became heir, through the premature deaths of his two older brothers, to an immense fortune upon his father's death in 1648. His life in the twenty years before his father's death, the period to which the legend pertains, is almost impossible to reconstruct. He himself later viewed it with strong disapproval and thus suppressed the knowledge of it. In his final testament he characterized his early years this way: "I served Babylon and the devil, its

[5] The so-called Mutiny of the Plaza de la Feria began on May 22 and was put down on May 26. Its history is told by the contemporary eyewitness Joseph Maldonado Davilar y Saavedra, "Tratado verdadero del motín que hubo en esta ciudad de Seville este año de 1652," in "Memorias," fols. 110-153. See also Ortiz de Zúñiga, *Anales*, pp. 739-51.

[6] The source of Mañara's confusion with Tenorio was identified by Joaquín Hazanas y La Rua, "Tenorio y Mañara," *Bética*, pp. 4-6. He attributed the mistaken identification to the play by Dumas Père entitled *Don Juan de Marano ou la chute d'un ange* (1836). Granero, *Mañara*, pp. 3-18, discusses the legends and biographies that preceded his exhaustive work.

prince, with a thousand abominations, arrogance, adulteries, profanities, scandals and thefts, whose sins and crimes are beyond counting."[7] Mañara certainly was not a *buen caballero cristiano*, but there is little evidence to support this exaggeratedly negative self-description.

His life changed somewhat upon his father's death when he became head of the family. In the same year he married Jerónima Carillo de Mendoza, the daughter of a Granadan grandee, who was a calming influence. Although his father had secured membership for him in the aristocratic military order of Calatrava, and high civic office as *Provincial de la Santa Hermandad*, Mañara showed slight inclination to social or civic activity. He was content to live as a grand rentier, dedicated to improving his skill as a horseman and hunter, occasionally filling a ceremonial office as he did in 1657, when he went to Madrid as part of Seville's delegation to honor the birth of the royal heir, Felipe Próspero. Then, in September 1661, an event occurred that decisively affected his life—the death of his young and beloved wife at their summer residence near Ronda. At this point, truth and legend begin to coincide.

Mañara was inconsolably grieved and a morbid vein in his psychology, which had surfaced before, now took command of his personality. He immediately retired to a nearby Discalced Carmelite hermitage, Nuestra Señora de las Nieves, and made a complete confession of his sins. In April 1662, he returned to Seville where, according to his contemporary biographer, "he lived in his house as if he were in the most cloistered religious order, full of holy thoughts and strong desires to work in the service of the Lord, who had already captured his heart."[8] Finally Mañara decided to resolve his spiritual crisis by devoting himself to God's work, and to this end he applied for membership in the Hermandad de la Santa Caridad on September 8, 1662. The brotherhood at first opposed his application for fear that he would either disrupt or dominate it. The second of these fears proved justified, although entirely without the negative consequences that were imagined. Mañara was reluctantly granted membership on December 10, 1662; one year later, on December 27, 1663, he was unanimously elected *hermano mayor* and maintained leadership until his death in 1679. His rapid ascendancy in the brotherhood is the first indication of Mañara's compelling personality, which still pervades the organization. With the unwavering dedication and inexhaustible energy of a zealot, but also with the acumen of a shrewd businessman, he made the Caridad synonymous with Christian charity and himself a saint in the eyes of his fellow men.[9] Under his inspired leadership the Caridad became a center of Seville's religious life in the third quarter of the seventeenth century.

With Mañara's election to *hermano mayor*, the Caridad started the most dynamic episode of its history. In addition to the brotherhood's original charity, that of burying the dead, four new charities were installed aimed at re-

[7] The testament is reproduced in Juan de Cárdenas, *Breve relación de la muerte, vida y virtudes del venerable caballero D. Miguel Mañara Vicentelo de Leca, caballero del Orden de Calatrava, Hermano Mayor de la Santa Caridad*, p. 377.

[8] Ibid., p. 8.

[9] Although two attempts have been made (one began in 1680, the other in 1735) to canonize Mañara, he still awaits sainthood.

ducing the number of burials by keeping the needy alive. In 1663, before he had become *hermano mayor*, Mañara had suggested the foundation of a hospice, which opened its doors in 1664 to shelter and feed the homeless and hungry. The second and third supplemental charities involved caring for the sick. An ambulance service was organized, with the brothers serving as attendants, whose purpose was to convey the sick and abandoned to an appropriate hospital. A little later, the brotherhood established its own infirmary to care for the incurable and the aged who were refused admission elsewhere. Finally, the Christian education of the inmates of the hospice and hospital was established as a major goal.

This ambitious plan required an enlargement of the Caridad's facilities. Therefore, Mañara initiated a major building campaign, which continued throughout his life. A warehouse from the adjacent Royal Arsenal was rented from the crown and converted into the hospice. The hospital, which began as part of the hospice, was moved into a separate building finished in June 1674. Over the next six years, the hospital was twice expanded so that it ultimately was able to accommodate 100 patients. But the first task on Mañara's list of building projects was to finish the brotherhood's chapel and spiritual center.[10] The church of San Jorge, as it was officially known, had been rented to the brotherhood in 1578 by the crown, on whose Royal Arsenal it was located. During the Caridad's lean years the church had fallen into bad repair, principally because its situation near the river made it susceptible to damage by flooding. On April 30, 1640, the brotherhood finally decided to renovate the church by tearing it down and building a new structure that would be raised well above ground level.[11] In June a committee was formed to petition the king's permission to destroy the old church and to use some additional land for expansion.[12] Three years later the royal *Junta de obras y bosques* agreed to cede the church and land for what was considered the exorbitant annual rent of five hundred *reales*. Rather than to assume such a heavy debt in perpetuity, the *cabildo* (board of directors) decided to raise the money for outright purchase.[13] When the fund-raising campaign failed, the *cabildo* agreed on November 6, 1644, to pay the rent for a site four *varas* long by eight *varas* wide (about twelve by twenty-four feet).[14]

The building was quickly leveled, as can be inferred from the fact that the *cabildo* of February 5, 1645, took place not in San Jorge, its usual site, but in the warehouse at Cristóbal de la Peña, which had been rented until the new

[10] The documentary history of the church and its decoration was partially written by Granero, *Mañara*, pp. 301-303, 403-23. My reading of the Caridad's archive was undertaken to supplement his biographical viewpoint with an art historical one.

[11] "Cabildo" of April 30, 1640, "Libro I de Cabildos" (January 1, 1619-December 28, 1671), "Copia literal de 1899," p. 63. The literal copy of the "libros de actos" was made in 1899 to save the originals from wear and tear. It is exact (except for some orthographical modernization) and possesses the advantage of numbered pages.

[12] "Cabildo" of June 3, 1640, "Libro I de Cabildos," p. 65.

[13] "Cabildo" of January 25, 1643, "Libro I de Cabildos," pp. 80-81. "Cabildo" has two meanings: one is "board of directors," the second is a "meeting of the board of directors."

[14] "Cabildo" of November 6, 1644, "Libro I de Cabildos," pp. 94-97.

church could be erected.[15] At this meeting, the board enthusiastically decided to begin the project on the following day, although in fact the contract with the architect, Pedro Sánchez Falconete, was not signed until March 18.[16] By May, the funds were exhausted, and from that point forward the work proceeded on a brick-by-brick basis, largely under the direction of the master mason, Juan González.[17] On December 31, 1659, González, evidently convinced that the church would not be immediately finished, asked the *cabildo* to make a final accounting of his labors.[18] His pessimism was based not only on the lack of money but also on the lack of space for expansion. The *cabildo* of February 8, 1660, discussed the need for acquiring additional land to build the *capilla mayor*, indicating that approximately two-thirds of the fabric had been constructed.[19] Once again the brotherhood began the difficult negotiations with the crown, whose urgent need for money made the bargaining hard. At the meeting of April 9, 1662, it was announced that acceptable terms could not be made and that the construction of the *capilla mayor* would be postponed indefinitely.[20]

This negative decision was reversed in December 1663, when Mañara became *hermano mayor*. One of his first actions was to assess the condition of the church, and what he saw was not cheering. As his biographer describes the situation, Mañara found that, besides lacking the *capilla mayor*, the church was "in very bad condition. The floor was earthen, the roof untiled and open to the sky in places. Through these openings a flock of pigeons came and went, continually flying through the beams . . . so that the floor was indecent and hardly clean."[21] On May 18, 1664, he gave the order to put a floor in the church, which was done by February 9, 1665, when Juan González presented his bill for the labor. Another year passed and then work began in earnest.[22] On March 15, 1666, the *cabildo* agreed in principle to finish the church.[23] Two weeks later, April 3, a works committee was formed, headed by Mañara, who seems to have directed the project single-handedly.[24]

The first stage of operations had two goals: first, to consolidate and finish what was already standing and, second, to obtain additional land for the *capilla mayor*. The construction proved to be easier than the negotiation, for the nave of the church had been completed by June 12, 1667, while the dis-

[15] "Cabildo" of February 5, 1645, "Libro I de Cabildos," pp. 98-100.

[16] Celestino López Martínez, "La Hermandad de la Santa Caridad y el venerable Mañara," *Archivo Hispalense*, p. 6.

[17] Gestoso y Pérez, *Sevilla monumental y artística*, III, p. 324, footnote 1, cites a receipt in the Biblioteca Colombina, Seville, given by González in payment for his work as *maestro mayor* of the church between Jan. 5, 1652 and August 3, 1653, when the receipt was issued.

[18] "Cabildo" of December 31, 1659, "Libro I de Cabildos, p. 252.

[19] "Cabildo" of February 8, 1660, "Libro I de Cabildos," pp. 256-57.

[20] "Cabildo" of April 9, 1662, "Libro I de Cabildos," pp. 313-14.

[21] Cárdenas, *Breve relación*, p. 42.

[22] "Cabildo" of May 18, 1664, and "Cabildo" of February 9, 1665, "Libro I de Cabildos," pp. 451-52 and p. 501.

[23] "Cabildo" of March 15, 1666, "Libro I de Cabildos," p. 563.

[24] "Cabildo" of April 3, 1666, "Libro I de Cabildos," pp. 566-67.

cussions with the royal wardens were still in progress.[25] However, on August 21, Mañara reported the results of his talks with the officials.[26] As usual, the wardens were unreasonable, and were demanding three hundred *reales* annual rent for a small piece of property. This rate sparked a lengthy debate in the *cabildo*, most of whose members believed that the rental fee plus the costs of construction would overtax the brotherhood's slender financial resources. Mañara at length convinced the brothers that money would be delivered by Providence, and, rather incredibly, it was.[27] Thus on February 12, 1668, possession was taken of the site and the decision to dig the foundations was made. Juan González, the master mason, was given full responsibility for the plan and its execution, which, because the *capilla* was not large, was speedily accomplished.[28] In the *cabildo* of July 13, 1670, the termination of the *capilla mayor*, and thus of the church, was announced.[29]

As he saw the church taking shape, Mañara began to consider its decoration. The earliest mention of the adornment may have occurred on April 3, 1666, when the works committee was formed, although perhaps a more logical moment for the commission would have been after the nave had been completed on June 12, 1667.[30] In any case, one stage of the scheme was over by July 12, 1670, as Mañara reported in a summary of progress to the board of directors. In his statement, he noted that the architecture had been finished and that there had been "placed in it, with the grandeur and beauty that can be seen, six hieroglyphs that explain six works of charity."[31] The "hieroglyphs" illustrating six works of mercy are identifiable with an important series of paintings by Bartolomé Esteban Murillo, himself a brother of the Caridad. Only two of these pictures remain in the church—*Moses Sweetening*

[25] "It was agreed that our secretary, Francisco de Noriega, should inform the members of the tanners and woodworkers guild that the church of la Santa Caridad is finished." "Cabildo" of June 12, 1667, "Libro I de Cabildos," p. 632.

[26] "Cabildo" of August 21, 1667, "Libro I de Cabildos," pp. 646-47.

[27] The story of how money was raised for the church is picturesque, and perhaps true. A beggar called Luis came one morning in March 1666 to see Mañara. His purpose was to offer the Brotherhood the pittance his wife had left upon her death a few days before. He was so insistent that Mañara finally accepted the money. At the next meeting, Mañara shrewdly based an appeal for funds on this incident and was able to raise 30,000 *reales* to resume the construction of the church. As time progressed, the Brotherhood became a favorite beneficiary of Seville's wealthy class. Mañara's fortune was also a dependable source of funds.

[28] "When the time comes the foundations should be laid and the work constructed according to the plans left by Juan González, master mason." "Cabildo" of February 12, 1668, "Libro I de Cabildos," p. 710.

[29] "Cabildo" of July 13, 1670, "Libro I de Cabildos," pp. 891-92. The minutes of this important meeting, including notice of the church's architectural completion, are transcribed in Brown, "Hieroglyphs," p. 276.

[30] "It was agreed to name deputies and special assistants for the work that has to be done in the church of la Santa Caridad. Jacinto Cosme and Jorge Silvera were nominated for the purpose of acting with the *hermano mayor* to assist and arrange for such materials and workmen as are necessary for the service of God and the good of our church." "Cabildo" of April 3, 1666, "Libro I de Cabildos," pp. 566-67. Although the "works" were probably architectural, they may imply the decoration of the church as well.

[31] "Cabildo" of July 13, 1670, "Libro I de Cabildos," pp. 891-92; see Brown, "Hieroglyphs," p. 276.

the Waters of Mara and the *Feeding of the Five Thousand* (figs. 46 and 47)—while the remaining four are in foreign collections: the *Return of the Prodigal Son* (National Gallery, Washington; fig. 48), *Christ Healing the Paralytic* (National Gallery, London; fig. 49), the *Liberation of St. Peter* (The Hermitage, Leningrad; fig. 50), and *Abraham and the Three Angels* (National Gallery of Canada, Ottawa; fig. 51). The first painting was paid for in the year it was completed, 1670, but Murillo was not compensated for the other five pictures until later, probably because sufficient funds were lacking. The *Feeding of the Five Thousand* was paid for in 1671; the remaining four pictures, in 1674. Although the date of payment has usually been accepted as the date of completion, in fact the entire group of six was probably begun in 1667 and was surely completed by July 1670.[32]

At the same meeting in 1670, Mañara proposed that the seventh work of mercy, burying the dead, be represented by the *Entombment of Christ* in the altarpiece of the new *capilla mayor* (fig. 54). Prior to this meeting, plans for the altarpiece had been submitted by Francisco de Rivas and Bernardo Simón de Pineda, who, the document notes parenthetically, were deemed to be Seville's best architects. A committee of eleven was chosen, with Mañara as chairman and Murillo among its members, to select the best project. After a day's deliberation it decided to contract with Pineda. On July 19 the agreement was signed by Mañara for the Caridad, by Pineda as designer and architect, and by Pedro Roldán as sculptor. Juan de Valdés Leal served as guarantor.[33] The artists were given two years to finish the work in return for 12,000 *reales*, although the altarpiece was not finished until June 15, 1674.[34]

Besides these seven works, four more paintings were commissioned, although when this occurred is not clear; all were paid for in 1672.[35] They in-

[32] The records of the Caridad contain the information about the payments for Murillo's six acts of mercy. The references from the "Libro I de Cabildos" are drawn from the year-end meetings when the annual budget was summarized. Hence the days mentioned are not the ones on which Murillo actually was paid.
 a. "Cabildo" of December 28, 1670, "Libro I de Cabildos," p. 976: "más del lienço grande de la Historia de Moyses de mano de Bartolome Murillo con su marco, costó trece mil trescientos reales de vellón."
 b. "Cabildo" of December 28, 1671, "Libro I de Cabildos," p. 1139: "Yten del lienço y moldura del quadro, del milagro de los Panes y Peces: quince mil novecientos y setenta y çinco reales de vellón."
 c. The four remaining pictures, costing 8,000 *reales* apiece, were paid for in 1674; see "Libro general de inventarios de esta Hermandad de la Santa Caridad de Nuestro Señor Jesu-cristo Año de 1674," folio 14-14v.
 This documentation was partially published by Neil Maclaren, *National Gallery Catalogues. The Spanish School*, p. 89.
[33] For the contract, see López Martínez, *Retablos y esculturas de traza sevillana*, pp. 99-102.
[34] See Brown, "Hieroglyphs," pp. 276-77, for the documentary history of the altarpiece.
[35] This documentation is found in the "Libro II de Cabildos," which covers the period from January 10, 1672 to December 28, 1676. Page numbers refer to the "Copia literal de 1899." Once again the pictures are mentioned in the year-end financial summary made on Dec. 28, 1672.
 a. p. 156: "Yten del lienço y moldura de San Juan de Dios; ocho mil y quatrocientos y viente reales de vellón."
 b. p. 157: "Yten del lienço de Santa Isabel Reina de Ungría, otros ocho mil quat-

clude two more pictures by Murillo—*St. John of God* and *St. Elizabeth of Hungary* (figs. 52 and 53)—and the *Hieroglyphs* by Valdés Leal. Because they are not mentioned at the meeting of July 13, 1670, they may represent an amplification of Mañara's program for the decoration of the church. Or perhaps he simply excluded their mention because they were not part of the seven acts of mercy. In either case, together they represent a line of thought that Mañara began to crystallize in his writings around 1667. These ideas achieved visual form in the program that expresses the aims of the brotherhood as formulated by its *hermano mayor*. It speaks directly of the man and his organization, and indirectly of the events that shaped them both.

The key to the program is found in the content of Valdés Leal's two paintings, the *Hieroglyphs of the Four Last Things* and their role in the church's decoration (figs. 44 and 45). It has long been known that the paintings were inspired by Mañara and that, to some extent, they reflect his personal obsession with death. During the first thirty-five years of his life, he had witnessed the untimely passing of almost his entire immediate family. In 1633, when he was only three, his sister María Jerónima, aged eleven, suddenly died. Seven years later, his two older brothers, Francisco and Juan Antonio, died within months of each other. His father's death in 1648 and his mother's four years later left him the sole survivor of a large family. These tragic events altered Mañara's character; just beneath the surface of his youthful ebullience lay a streak of profound morbidness that often surfaced, occasionally in dramatic form. His nephew reported that the sight of a coffin during the day prevented him from sleeping at night. On one occasion, according to his page who was present at the time, he fainted upon hearing a voice call out, "Bring the coffin; he is already dead."[36] When his wife died in 1661, Mañara's secret fear of death came into the open. The theme dominated his action and thought thereafter, reaching its most dramatic and explicit form in his book called *Discurso de la verdad*, first published in 1671, the year before Valdés received payment for his canvases.

Mañara's "truth" as expressed in his book is identical with the theme of the paintings; the fugacity of life, the inevitability of death, and hence the futility of worldly aims and achievements. The book's twenty-seven chapters are divided into two parts. In the first part (chapters 1-16), Mañara warns against an earthly directed existence. He reiterates the omnipresent threat of death, which, striking suddenly and unexpectedly, vitiates all human endeavor.

> What does it matter, brother, that you are great in the world if death
> will make you the equal of the smallest? Go to a bone heap that is
> full of the bones of the dead: distinguish among them the rich from
> the poor, the wise from the ignorant, the humble from the mighty.
> They are all bones, all skulls, they all look alike.[37]

rocientos y viente reales vellón." This document settles the doubt occasionally expressed about the queen's identity by those who call her St. Elizabeth of Portugal.

c. p. 157: "Yten dos lienços con molduras doradas de Geroglíficos de nras. postrimerías; cinco mil setecientos y quarenta reales vellón."

[36] These incidents are documented by Granero, *Mañara*, pp. 155-56.

[37] Miguel Mañara Vicentelo de Leca, *Discurso de la verdad*, p. 35.

Certain passages are even closer to the pictures themselves and have been used to establish firmly Mañara's authorship of the iconography.[38] The source of *In Ictu Oculi* (fig. 44) has been identified with part of chapter eighteen. Here Mañara contrasts sinful and saintly lives by an allegory of two mountains, one of good, the other of evil. In giving instructions on how to ascend the mountain of good, he writes,

> Regard the saints who occupy the slopes of this holy mountain, and how, to reach its peak with greater speed, they strip themselves of all that impedes them from climbing higher. Look at the king throwing away his crown, the merchant his wealth, the scholar his books, the soldier his arms. Everything that blocks the road is detested by its owner.[39]

Similarly, *Finis Gloriae Mundi* (fig. 45) corresponds partially to one paragraph in chapter four:

> If we have the truth before us, it is this, there is no other: the shroud we will wear must daily be before our eyes. If you remember that you will be covered with earth and stepped on by all, you will easily forget the honors and status of this life. Remember also the vile worms that will eat your body, and how ugly and abominable you will be in the grave, and how those eyes that are reading these words will be eaten by the earth, and how those hands will be devoured and left dry, and how the silks and finery that you had today will be converted into a rotten shroud, your amber into a stench, your beauty and grace into worms, your family and greatness into the greatest loneliness imaginable.
>
> Look into a tomb, enter it thoughtfully and look at your parents or your wife, the friends you once knew. Listen to the silence; not a sound can be heard, only the gnawing of termites and worms. And the clatter of pages and lackeys, where is it now? All of that is left behind; cobwebs are the jewels in the palace of the dead. . . . And the mitre and the crown? They are also left behind. Remember, my brother, that this will surely happen to you and all your being will disintegrate into dry bones, horrible and frightening. So much so that the person who loves you most today, be it your wife, your son or your husband, will be shocked to see you the moment after you expire, and whoever knew you will be shocked to see you.[40]

Although these quotations correspond with the general tenor of the *Hieroglyphs*, the *Discurso* is in many ways less explicit than the paintings. The paintings contain details not mentioned in the book, details that are not only

[38] The connection between the *Hieroglyphs* and the *Discurso de la verdad* was noticed by Celestino López Martínez, *Valdés Leal y sus discipulos*, p. 39, footnote 3 (repeated in his *Valdés Leal*, pp. 43-44). The literature on these paintings is considerable, although largely repetitious. Works of particular interest are cited below.

[39] Mañara, *Discurso*, pp. 48-49. [40] Ibid., pp. 7-9.

more pictorial but also impart a different significance to the works. For instance, the skeleton extinguishing the candle of life in *In Ictu Oculi* is a motif that unifies the painting and intensifies its drama. In the same way, the painstaking attention to the worldly attributes sharpens the focus of the text. The scholar's books are clearly titled, the trappings of kingship are increased in number, and the ecclesiastical hierarchy, signified by the papal tiara and staff, is added to the category of futile worldly endeavors.[41] These additional details must correspond to specific instructions from Mañara. He kept close watch over all aspects of the Caridad's activities, and it seems unlikely that he would have relaxed his vigil in so important a matter as the church's decoration. The *Discurso de la verdad* and the *Hieroglyphs* are separate manifestations of an aspect of Mañara's thought. But whereas the book is a self-sufficient work, the paintings are part of the synthesis of ideas that became the theme of the decorative cycle.

Finis Gloriae Mundi is the link in this chain of thought. The section from the *Discurso* that has been associated with the picture explains only the lower register with its decaying corpses. However, in the upper part is a motif that not only amplifies the meaning, but also connects the *Hieroglyphs* to the other works in the church, thus revealing the expressive intent of the whole cycle. There a stigmatized hand holds a balance that symbolizes the judgment of the soul. On the left side the seven deadly sins are represented by animal symbols; on the right, prayer books and penitential instruments (a scourge and hair shirt among them) suggests that prayer and repentance offset sin.[42] The meaning is explicitly conveyed by the mottoes inscribed on each plate: nothing more (*NI MAS*) is needed for damnation than sin, and nothing less (*NI MENOS*) for salvation than prayer and penance.[43] The *Hieroglyphs*, then, present the two aspects of death as an end and as a beginning. Death (*In Ictu Oculi*) makes earthly existence futile and meaningless as it simultaneously releases the soul for judgment based on how it directed earthly life (*Finis Gloriae Mundi*). The self-devoted, it is implied, will be damned, while those who worshipped and suffered for Christ may be saved. But are prayers and penance sufficient to insure salvation? The scale is in balance and judgment occurs only when one side outweighs the other. Furthermore, the motto tells us explicitly that the right side only contains the bare minimum; "nothing less" is needed to balance the seven deadly sins, something more is implicitly required to tip the scale in favor of salvation.

[41] Trapier, *Valdés Leal*, pp. 57-58, identifies the book titles and other objects in the painting.
[42] The left-hand plate of the scale contains the following animal symbols: a peacock (pride), a bat perched on a heart (envy), a dog (wrath), a pig (gluttony), a goat (avarice), a monkey (luxury), and a sloth (laziness). The right-hand plate contains these objects symbolizing prayer and penance: prayer books, including one inscribed *SALT. de David*; a cat o' nine tails; a whip and a chain; a hair shirt and bristled girdle; a nail-studded cross; loaves of bread; and, on top, a flaming heart with the Jesuit monogram.
[43] Alejandro Guichot y Sierra, *Los Jeroglíficos de la Muerte de Valdés Leal*, p. 36, points out that the idea for the image of the scale weighing the seven deadly sins against prayer and mortification derives from Padre Juan Nieremberg's *Práctica del catecismo romano y doctrina cristiana* (Madrid, 1640).

The "something more" is represented on the walls of the church by Murillo's six biblical paintings and the sculptural group in the center of the altarpiece, the "Hieroglyphs of mercy," as Mañara called them on July 13, 1670.

> At the same time our *hermano mayor* Don Miguel Mañara mentioned that the work on our church is finished, and that the six hieroglyphs that explain the six works of mercy have been placed in it with the grandeur and beauty that can be seen. This leaves only the act of burying the dead, the principal charity of our institution, for the main altarpiece.[44]

With this guide, it is simple to identify each work with an act of mercy. Feeding the hungry is symbolized by the *Feeding of the Five Thousand* (fig. 47); giving drink to the thirsty, by *Moses Sweetening the Waters of Mara* (fig. 46); clothing the naked, by the *Return of the Prodigal Son* (fig. 48); harboring the stranger, by *Abraham and the Three Angels* (fig. 51); visiting the sick, by *Christ Healing the Paralytic* (fig. 49); ministering to prisoners, by the *Liberation of St. Peter* (fig. 50); and, as the document states, burying the dead, by the *Entombment of Christ* in the altarpiece (fig. 54). The *Entombment of Christ* (fig. 55), with its implication of resurrection, emphasizes the full meaning of the cycle: salvation through the performance of charitable acts.[45]

Mañara defined charity as the road to salvation in another of his writings. In 1675, the brotherhood assembled to hear the reading of the new rule which Mañara had devised for its conduct. The expansion of charitable activities that followed Mañara's election to *hermano mayor* required a new organization. As early as 1665, he had begun revising the *Rule* that had been written only four years before.[46] A first draft was written in 1667, but the final form was not achieved until eight years later. Essentially the *Regla de la muy humilde hermandad de la Santa Caridad* is a description of the brotherhood's purpose and program. It contains, for instance, detailed instructions for the pursuit of the Caridad's charitable deeds, such as the procedure for the annual banquet for the poor of Seville, including the menu and manner of service. It also states the theological premise of the association. Mañara ordained that the brotherhood would assemble once a month to hear the virtues of charity expounded in a series of four sermons.[47] Here is the most forthright and lucid

[44] "Cabildo" of July 13, 1671, "Libro I de Cabildos." See Brown, "Hieroglyphs," p. 276.

[45] Mâle, *L'Art religieux après le Concile de Trente*, pp. 93-96, associated Murillo's paintings with the seven corporal acts of mercy through a process of reasoning that is incorrect in two important points. Because Mâle did not realize that the altarpiece represented the act of burying the dead, he invented a picture by Murillo called "Tobias Gathering the Bones" to illustrate it. Then he mistakenly included the *Charity of St. John of God* and *St. Elizabeth of Hungary Healing the Sick* (discussed below) among the acts of mercy, so that the act of visiting the sick was illogically represented by three pictures.

The seven acts of mercy are derived from the description in Matthew 25: 34-39.

[46] For the history of the *Regla*'s composition, see Granero, *Mañara*, pp. 529-30.

[47] Miguel Mañara Vicentelo de Leca, *Regla de la muy humilde hermandad de la Santa Caridad*, pp. 117-18.

explanation of his idea that charity was not solely a humanitarian exercise but also a means to insure the soul's salvation. The lectures were to discuss specifically the role played by charity in the process of death and afterlife, the so-called "Four Last Things" or *postrimerías*. The speaker was to insist on how charity could assure a good death, prepare the soul for judgment, save it from hell, and deliver it to heaven. The outline for the sermon on death describes the intent of the church's decoration.

> Ponder the brevity of life and the certainty of death, and that it ends everything: paint the rigorous agony of death and how the greatest grandeur ends in worms. Comfort us by holy alms and by exercises of charity [with which] we achieve a happy death.[48]

The *Hieroglyphs* by Valdés Leal presented the spectacle of death and raised the question of salvation. The term *postrimerías*, as the paintings were called by the brotherhood, reveals their subject, the "Four Last Things": death, judgment, heaven, and hell.[49] Death and judgment were depicted in Valdés's two paintings while heaven and hell awaited the outcome of the weighing. With the soul hanging in the balance, charitable acts were needed to complete its salvation, and thus they became the subjects of the works in the body of the church. The idea of charity as death's antidote and the way to salvation connects Murillo's paintings and the altarpiece to the *Hieroglyphs*, and unifies their disparate subject matter. Together they proclaimed the Christian virtue to which the Caridad was dedicated, by expressing its ability to conquer death.

The message was heightened by the disposition of the scenes in the church. Mañara's awareness of the importance of placement is made clear in the *cabildo* of July 13, 1670, when he suggested the Entombment of Christ as the subject for the altarpiece. The Caridad's foundation charity was to be the most conspicuous subject. The paintings of Murillo and Valdés seem to have been placed with similar care. Although the ensemble is no longer intact, having been dispersed in 1810 when Marshal Soult removed five of Murillo's paintings, its original disposition can be reconstructed through a study of the present arrangement assisted by the writings of Ceán Bermúdez and Antonio Ponz.[50] From these descriptions we learn that Valdés's *Hieroglyphs* occupy their original location. If one were able to enter the church from the front (it is now entered from the patio to the south), *In Ictu Oculi* would be found at the left and *Finis Gloriae Mundi* at the right, both shut off from light by the choir balcony above. Murillo's six paintings were hung three to a wall, just below the cornice. On the left wall, from entrance to altar, were *Abraham and the Three Angels*, the *Return of the Prodigal Son*, and *Moses Sweetening the Waters of Mara*. On the right wall the arrangement consisted of the *Liberation of St. Peter*,

[48] Ibid., p. 117.

[49] The entry in the "Libro II de Cabildos" (see above, note 35) calls the picture *"Geroglíficos de nras. Postrimerías."* *Postrimerías* is a theological term that means the "Four Last Things" (death, judgment, heaven, and hell).

[50] Ceán Bermúdez, *Diccionario histórico*, II, pp. 52-53, and Ponz, *Viaje de España*, IX, pp. 147-51.

Christ Healing the Paralytic, and the *Feeding of the Five Thousand*. Finally, at the head of the church was the impressive altarpiece of the *Entombment of Christ*, still *in situ*.

The arrangement emphasized the didactic intent of the pictures. Upon entering, the brother saw death all around; in front was the *Entombment of Christ* in the glittering altarpiece; on either side, the morbid *Hieroglyphs* spoke pessimistically of life, death, and salvation. Life is as futile as death is certain; salvation still hangs in the balance in spite of prayer and penance. In the altarpiece, however, a "good" death was shown, a death that, like Christ's, would lead to salvation. In the well-lighted nave, six acts of charity appeared like steps on a ladder, culminating in the seventh act that was Christ and salvation. And, on the crown of the altarpiece, above the *Entombment*, stood a sculpted personification of Charity in a mandorla, surrounded by putti and flanked by two angels holding the instruments of the Passion. Charity, then, literally overcame death; it was the saving grace, a promise extended to the brotherhood on the walls of its church.

In spite of its unity and clarity, the program was not yet complete. In 1672, Murillo was paid for two more paintings that were destined for the church, the *Charity of St. John of God* (fig. 52) and *St. Elizabeth of Hungary Healing the Sick* (fig. 53).[51] They remain in their original locations, set into altars in the first bay of the nave, *St. Elizabeth* on the right and *St. John* on the left underneath the places where the *Liberation of St. Peter* and *Abraham and the Three Angels*, respectively, once hung. Although the pictures of St. Elizabeth and St. John represent charitable acts, they differ from the acts of mercy by their shape, composition, and content as well as location. Whereas the six painted acts of mercy are rectilinear, these two pictures are arched at the top. Their common compositional scheme is distinct because they contain a secondary background scene that complements the foreground narrative; the acts of mercy, on the other hand, are represented by only a single episode. And, finally, the protagonists are not drawn from the Bible, but rather from the lives of saints. In a figurative sense, the lower hanging explains these differences and their purpose, namely to bring the acts of mercy "down to earth." More specifically, St. Elizabeth and St. John were offered as precedents for the brotherhood's particular charitable program as described in Mañara's *Rule*, and as fulfillments of the promise of salvation that it made.

Although the *Rule* is essentially an administrative text, it is unified by a single principle, that charity must be effected through personal participation. Mañara was preoccupied with this idea because the brotherhood's membership was largely drawn from Seville's upper class and aristocracy. To a certain extent, it had become an exclusive social organization and belonging to it was a mark of class and privilege. The requirements for admission presupposed wealth and pure Christian blood.

> The man who wishes to be a member of this holy brotherhood has to be an old Christian of clean and honorable ancestry, without Moorish, Negro or Jewish blood. He cannot have been sentenced by

[51] See above, note 38.

the Inquisition, nor be one of those recently converted to our Holy Faith, nor a descendant of such, and he must not have a vile or low occupation. . . . And he must be able and ready to exercise the duties of this holy brotherhood, and be at least twenty-five years old, and have sufficient wealth to sustain himself according to the quality of his person.[52]

These requirements were stringently enforced by an investigating committee that made admission difficult, as in the case of Murillo's application in 1660. Murillo would have seemed a qualified candidate, although he was not wealthy. However, he had to wait five years for acceptance, which did not occur until June 14, 1665. The reason for the delay is nowhere stated, but surely his occupation of painter would have been a serious obstacle to fulfilling the condition implied by the phrase, "quality of person." As has been shown in Chapter 4, the social status of the artist was still a matter of debate in Spain at this time, and to some people a painter and a carpenter were socially indistinguishable. Murillo ultimately was accepted because the brotherhood was swayed by the practical reasons implied in the document that records the event.

The deputies named in this petition for the inquiry of the *moribus et vita* [sic] of D. Bartholomé Esteban Murillo say that we have tried to make all the investigations that conform to the chapter of our Holy Rule, and that we have not found anything that might prevent his admittance into our holy brotherhood. On the contrary, it seems to us that he will be of great service to God Our Father and to the poor, as much for his kindness as for his art for the decoration [of our chapel].[53]

Obviously the brothers realized at length how advantageous it would be to have Seville's foremost painter in their number, thus guaranteeing a claim on his services. (Under the circumstances, it is strange that Murillo was not only paid but very well paid for his eight paintings.) The process of Murillo's application reveals the extent of the brotherhood's social prejudice and thus posed what Mañara recognized as a basic problem: how to convince his membership to accept the ideal and practice of personal performance of charitable acts on behalf of the poor. The temptation to engage in long-distance philanthropy by gifts of money had to be exposed as unworthy and useless. Mañara stresses this point time and again in the *Rule*, as in this passage: "Let us serve God with our persons. The same difference exists between us and our goods as between works done by ourselves and those which proceed only from our wealth."[54]

This desire to impress the need for personal charity also explains the inclusion of *St. Elizabeth* and *St. John*. These two saints, unlike the exemplars

[52] Mañara, *Regla*, p. 81.
[53] The documents pertaining to Murillo's application are found in Luis León Domínguez, *La Caridad de Sevilla: Mañara, Murillo y Valdés Leal*, pp. 108-10.
[54] Mañara, *Regla*, pp. 10-11.

shown in the seven acts of mercy, were drawn from post-Biblical history and thus were more realistic precedents for the brothers. St. John of God, in fact, had died in nearby Granada only one hundred years before, while St. Elizabeth of Hungary was a royal princess, as well-born as the most aristocratic of the Caridad. In their examples, the brotherhood could see how honorable, saintly, and efficacious it was to practice personal charity. They unequivocally proved that charity led to sainthood and salvation. To drive the point home, Mañara chose two saints whose charities were identical to those described in the brotherhood's *Rule*.

During Mañara's term of leadership, the brotherhood began to divert its energies toward pre-mortem charities, caring for the poor and distressed instead of simply burying them. The ambulance service that was organized to help those in need of medical attention was manned by the brothers in monthly turns. However, the *Rule* obliged every member to arrange the transportation of a sick person whenever and wherever one was found lying neglected in the city.

> And whereas the poor and destitute, falling ill, often get so weak that they frequently die in the streets, we order that whenever any of our brothers comes upon such an occurrence, he will attempt to find out what is wrong and, although the poor man may not ask it, to help him with the compassion of a father to ease his affliction, and then to seek some way to carry him to our house. And if nothing can be found, remember that Christ is under those rags and, putting him on your shoulder, bring him to this holy house. Blessed is he to whom it happens.[55]

Mañara, who believed that the distasteful charities counted for more than the pleasanter ones, especially esteemed carrying a sick man ashoulders. He even made the brothers swear to do it in the membership oath: "And I pledge to this Holy Brotherhood that I come disposed to serve in public and in private my beloved brothers, the poor; so that if it is necessary to carry them on my shoulders, I will do so willingly in order to serve and respect in their persons my Lord Jesus Christ."[56]

Once the patient had been brought to the Caridad, the brother on duty in the hospital was instructed as follows: "And if they bring some poor, sick man from the city, . . . go to meet him with love and lower him in your arms from the conveyance and carry him to the infirmary. And before putting him to bed, wash his feet and kiss them."[57] This act is illustrated in the small scene at the right of the picture, where St. John sits at his patient's feet and washes them. By emulating these actions, then, the brothers would fulfill the *Rule* and improve their chance for salvation. Mañara expressed his belief in St. John's charities in a letter he wrote to a charitable organization in Antequera on May 21, 1676, exhorting its members to follow the example of Seville's Caridad. "And once you have put your hand to the plow, do not turn back, because you will not be worthy of the Kingdom of God. And if you persist in

[55] Ibid., p. 40. [56] Ibid., p. 85. [57] Ibid., p. 60.

the work begun, God from heaven will bless you, and the holy angels will be among you, as they were in the hospital of St. John of God."[58]

The companion painting, *St. Elizabeth of Hungary Healing the Sick*, illustrates another sequence in the brotherhood's charitable routine: the medical treatment that was offered in the hospital. Like the lepers' hospital founded by St. Elizabeth, the Caridad's infirmary specialized in incurable diseases. The section of the *Rule* that describes the medical policy helps to explain the painting. "Formal cures are not permitted in this house, because if they were the hospitals would not want to admit the poor we bring to them in our chairs. Our cure must be palliative, such as cleaning incurable sores or the like."[59] More directly related is the prescription for the treatment of the afflicted. "On the arrival of the doctor, a box of unguents, bandages and cloths will be provided, carried by the attendants [members of the brotherhood], and when they arrive at the poor man, they will fall on their knees. . . . And however wounded or disgusting he may be they will not turn their faces, but with fortitude will offer that mortification to God."[60]

Although this passage does not literally describe the action in the picture, there is a coincidence of spirit, especially in the way that St. Elizabeth seems to struggle not to avert her glance from the sore she cleans. In the background, a small scene shows the saint serving a meal to her patients, just as the brothers were instructed to do in the continuation of this routine. "Dinner will be served when the hospice bell strikes six o'clock, [the brothers] serving them with all love and reverence."[61]

The paintings of St. John and St. Elizabeth complete the message on the church walls. The abstract acts of mercy are shown as they were daily performed by members of the Caridad who hoped that their deeds would be received by God with no less favor than were those of the two saints. Together, the ensemble told the brothers that, by foreswearing the vanities of life and dedicating themselves to charity and the Caridad, they need not fear death, for in this way salvation would surely be won.

The Caridad's statement of purpose in painting and sculpture owes its effectiveness above all to Mañara's sympathetic choice of artists. His first requirement was quality, and the selection of Murillo and Valdés Leal as Seville's best available painters still seems correct three centuries later. More important, however, was his perception of their styles, as shown by the way he distributed the subjects between them. It may be obvious now that, had he reversed the assignments and given the *Hieroglyphs* to Murillo and the acts of mercy to Valdés, few would have been convinced to lead a good life. But Mañara clearly understood where each artist's strength lay and, by dividing the cycle as he did, gave both the opportunity to paint the subjects that best suited them. As a result, the Caridad's decoration became a paradigmatic exposition of the contrasting styles of Seville's most important late seventeenth-century painters.

The *Hieroglyphs of the Four Last Things* look at first like unreliable indicators

[58] Ibid., p. 235.
[60] Ibid., p. 60.

[59] Ibid., p. 123.
[61] Ibid., p. 60.

of Valdés's style and temperament. Presumably any painter would have been obliged to adapt his style to their gruesome subject matter, which would initially dominate first impressions of the pictures. However, the works are morbidly fascinating not because of their theme, which is after all common in the seventeenth century, but because Valdés attacks it with such skill and gusto. The skeleton in *In Ictu Oculi* (fig. 44), slightly hunched over with his burden, is a pure malevolent force. He stands in the flickering half-light, defiantly snuffing out life's flame, looking outward as if he expected to hear the futile complaint of the living. *Finis Gloriae Mundi* (fig. 45) conjures up the dank, fetid atmosphere of the tomb. In the strongly lit foreground, insects feast on a sallow head that is rendered by short, nervous strokes that impart repulsive actuality to the decay. The brilliant red cross of Calatrava vibrates against a white background as a symbol of useless earthly glory. In the background, the luminosity suddenly diminishes. A flash of yellow light from the left falls on an owl's head whose dark eyes stare out. Then in the nearly faded light a bone-pile and coffin appear, representing the final stage of death's indignity. From above, an arm sleeved in red appears amid gray clouds, dangling a scale that balances an animal picture against a still life. The seven deadly sins are led by a snarling black-and-white dog. A peacock provides the background with its tail of dark blues and greens. On the other side, the instruments of prayer and penance form a moody Spanish still life in browns and yellows, in which surface textures are keenly observed and rendered. In these ways, Valdés contrives an atmosphere that is not only terrifying, but sinister. By bringing death to life, his world beyond the grave exudes the tension that characterized his treatment of more conventional subjects.

Murillo's acts of mercy provide the perfect counterfoil to Valdés Leal's agitated style. Calm, benevolence, and warm humanity flow through the pictures like a broad, peaceful river. The pace of life is slower in Murillo's world; human beings perform their good works in a deliberate, measured pace. Colors are deeper and purer, seldom stirred by high-lights that roil the surface. Murillo's pictorial mastery is complete, but he always plays it down. In the *Charity of St. John of God*, the yellow-robed angel emits just enough light to separate the saint's gray robe from darkness. Hardly noticeable is the murky cityscape in the background, lit only by a sliver of the moon and populated by two boys whose heads appear through a window at the upper left. The figures in *St. Elizabeth of Hungary* are casually but effectively composed. Using a favorite device of Sevillian painters, Murillo constructs a dark architectural background as a setting for the group at the left. The bluish tonality of the costumes is accented here and there by touches of red, such as on the platebearer's sash or the cloth on the old woman's lap. To the right, Murillo shows an airy, open porch against the blue-gray sky. The miniature figures are sketches but perfectly legible because of the contrasts between lighter and darker figures. Murillo's inspiration falters only in the two large pictures, the *Feeding of the Five Thousand* and *Moses Sweetening the Waters of Mara*. *Moses* is the better of the two, although marred by a lack of unity that results from the attempt to depict too many individual reactions of the event. But the *Feeding of the Five Thousand* wanders aimlessly off into the background at the right

while the apostles try unconvincingly to busy themselves around Christ. The other six paintings, however, display Murillo's unerring ability to emphasize the rare human qualities of unselfish love and sympathy that he found perfected in Christian deities.

The striking contrast between Valdés and Murillo that emerges from the Caridad cycle distinguished the artists throughout their careers. Valdés is nervous, dramatic, at times eccentric and ambiguous. He is also markedly uneven; frequently his compositions are overcrowded with figures and overloaded with extreme emotions. But when in control, his jittery brush creates strange and fascinating works of art. Thin, strident colors are boldly juxtaposed; oddly made figures, sometimes daintily unreal, other times overly coarse, move in a realm of eerie, shimmering lights. Murillo, on the other hand, is normal, peaceful, warm, and direct. His style develops consistently, directed by the aim of capturing the ideal of reciprocal love between man and God. In the cloud-filled world where this encounter takes place, soft, misty colors dissolve into one another.

The artistic decoration of the Caridad thus offers an opportunity to study Seville's best late seventeenth-century painters through the eyes of their contemporaries. And these works of art in turn illuminate the special nature of the Brotherhood of Charity and the time in which it flourished. For, in the final analysis, one question about the brotherhood must be answered—how did the fear of death become its principal motivation to charitable works? A faithful Catholic of the time would, of course, have pondered the end of his life in this world and its beginning in the next. But the Brotherhood of Charity seems to have had an exaggerated sense of life's transience. Mañara nourished this feeling, but he was not the cause. Perhaps the origins can be found in the events that led to the Caridad's resurgence at mid-century. The plague of 1649 must have altered the psychology of Seville's population by emphasizing the fragility of human life. Even after the worst was over, the city continued to be assailed by the after-effects. The general level of health remained weak, and the city was struck by a lesser plague and famine in 1677-1678. It is difficult, centuries after the event, to calculate and describe the mood of a populace in the wake of universal catastrophe. But it is equally difficult to assume that life went on as before, at least during the short term. The decoration of the Caridad's church may be interpreted as an indication of how mass mortality affected the attitudes of Sevillians who survived. One detail invites us to make the connection: on either side of the *Entombment of Christ* are statues of male saints (fig. 54). At the left stands St. George, the titular saint of the church, and on the right stands St. Roch, patron of the plague-stricken. His presence may help to explain why death was so much in the minds of the Brotherhood of Charity and on the walls of its church.

EPILOGUE

It is difficult to summarize a book that comprises four discrete studies that vary in length and focus, however desirable a summary might be. Circumstances of time and place impart a certain unity to these essays, especially because all of them are concerned with painters who worked in Seville at least for part of their lives. Hence, this book may in the long run be of greatest interest to those who study the history of painting in that important cultural center. Yet, as I have stated more than once, I hope that the book will also heighten the awareness of the diversity and variety of Spanish Baroque painting, especially as a vehicle for the expression of prevailing ideas and beliefs. It is a truism that form and content are organically related in a work of art. For reasons that I have outlined in the Introduction, this truism needs to be made more of a reality in the study of seventeenth-century painting in Spain. If these essays have an underlying unity and purpose, it is to reveal some of the ways in which this goal might be accomplished.

BIBLIOGRAPHY

Alberti, Leon Battista. *On Painting*. Trans. John R. Spencer. New Haven and London, 1966.

Alberto de la Barrera, Cayetano. *Francisco de Rioja*. Madrid, 1867.

Alcahalí, Baron of. *Diccionario biográfico de artistas valencianos*. Valencia, 1897.

Alciati, Andrea. *Emblemata*. Augsburg, 1531.

Alpers, Svetlana. *The Decoration of the Torre de la Parada*. Corpus Rubenianum Ludwig Burchard, vol. 9. London and New York, 1971.

Alvarez, Arturo. *Guadalupe. Arte, historia y devoción mariana*. Madrid, 1964.

———. "Madurez de un arte. Los lienzos de Guadalupe," *Mundo Hispánico*, no. 197 (August 1964), pp. 51-57.

Angulo Iñiguez, Diego. *Velázquez, como compuso sus cuadros principales*. Seville, 1947.

———. *La mitología y el arte español del renacimiento*. Madrid, 1952.

———. " 'Las Hilanderas,' " *Archivo Español de Arte*, 25 (1952), pp. 67-84.

———. *Pintura del Renacimiento*. Ars Hispaniae, vol. 12. Madrid, 1954.

———. "Francisco Rizi. Su vida. Cuadros religiosos anteriores a 1670," *Archivo Español de Arte*, 31 (1958), pp. 89-115.

———. "Francisco Camilo," *Archivo Español de Arte*, 32 (1959), pp. 89-107.

———. "La fábula de Vulcano, Venus y Marte y 'La Fragua' de Velázquez," *Archivo Español de Arte*, 33 (1960), pp. 149-81.

———. "Francisco Rizi. Cuadros religiosos posteriores a 1670 y sin fechar," *Archivo Español de Arte*, 35 (1962), pp. 95-122.

———. "Los frescoes de Céspedes en la iglesia de la Trinidad de los montes," *Archivo Español de Arte*, 42 (1969), pp. 305-307.

———. "Francisco Rizi. Cuadros de tema profano," *Archivo Español de Arte*, 44 (1971), pp. 357-87.

———. "Francisco Rizi. Pinturas murales," *Archivo Español de Arte*, 47 (1974), pp. 361-382.

Angulo Iñiguez, Diego, and Pérez Sánchez, Alfonso E. *A Corpus of Spanish Drawings. Volume Two: Madrid 1600-1650*. London, 1977.

———. *Historia de la pintura española. Escuela madrileña del primer tercio del siglo XVII*. Madrid, 1969.

———. *Historia de la pintura española. Escuela toledana de la primera mitad del siglo XVII*. Madrid, 1972.

Antonio, Nicolás. *Biblioteca Hispana*. Rome, 1692.

Arana de Varflora, Fermín. *Hijos de Sevilla ilustres en santidad, letras, armas, artes o dignidad*. Seville, 1791.

Arfe y Villafañe, Juan de. *Descripción de la traza y ornato de la custodia de plata de la Santa Iglesia de Sevilla*. Seville, 1587.

Arguijo, Juan de. *Obras poéticas*. Ed. Stanko B. Vranich. Madrid, 1971.

Asensio, José M. *Don Juan de Arguijo, estudio biográfico*. Madrid, 1883.

———. *Francisco Pacheco. Sus obras artísticas y literarias*. Seville, 1886.

Azcárate, José M. de. "Noticias sobre Velázquez en la corte," *Archivo Español de Arte*, 33 (1960), pp. 357-85.

Baglione, Giovanni. *Le Vite de pittori, scultori et architetti dal Pontificato di Gregorio XIII del 1572 in fine a tempi di Papa Urbano ottavo nel 1642*. Ed. Valerio Mariani. Rome, 1935.

Barbadilla, Manuel. *Pacheco, su tierra y su tiempo*. Jerez de la Frontera, 1964.

Barcia Pavón, Angel. *Catálogo de la colección de dibujos originales de la Biblioteca Nacional*. Madrid, 1906.

Bataillon, Marcel. *Erasmo y España, estudios sobre la historia espiritual del siglo XVI*. Trans. Antonio Alatorre. Mexico City, 1966.

Beach, Robert M. *Was Fernando de Herrera a Greek Scholar?* Philadelphia, 1908.

Beruete, Aureliano de. *Velázquez*. Paris, 1898.

Blunt, Anthony. "El Greco's 'Dream of Philip II': An Allegory of the Holy League," *Journal of the Warburg and Courtauld Institutes*, 3 (1939-40), pp. 58-69.

———. *Artistic Theory in Italy 1450-1600*. Oxford, 1940.

Bonet Correa, Antonio. "Velázquez, arquitecto y decorador," *Archivo Español de Arte*, 33 (1960), pp. 215-49.

Bottineau, Yves. "A Portrait of Queen Mariana in the National Gallery," *Burlington Magazine*, 97 (1955), pp. 114-16.

———. "L'Alcázar de Madrid et l'inventaire de 1686," *Bulletin Hispanique*, 58 (1956), pp. 421-52; 60 (1958), pp. 30-61, 145-79, 289-326, 450-83.

Brown, Jonathan. "La teoría del arte de Pablo de Céspedes," *Revista de Ideas Estéticas*, 23 (1965), pp. 99-105.

———. "Hieroglyphs of Death and Salvation: The Decoration of the Church of the Hermandad de la Caridad, Seville," *Art Bulletin*, 52 (1970), pp. 265-77.

———. *Jusepe de Ribera: Prints and Drawings*. Princeton, 1973.

———. *Zurbarán*. New York, 1973

———. "Pen Drawings by Herrera the Younger." In *Hortus Imaginum. Essays in Western Art*. Ed. Marilyn Stokstad and Robert Enggass. U. of Kansas, 1974.

———. "Drawings by Herrera the Younger and a Follower," *Master Drawings*, 13 (1975), pp. 235-40.

———. *Murillo and His Drawings*. Princeton, 1976.

Buendía, José R. "Sobre Escalante," *Archivo Español de Arte*, 43 (1970), pp. 33-50.

Buero Vallejo, Antonio. "El espejo de Las Meninas," *Revista de Occidente*, 31 (1970), pp. 136-66.

Cámara, Porrás de la. *Elogio del Licenciado Francisco Pacheco, canónigo de Sevilla*. Ed. B. José Gallardo. In *El Criticón*. Madrid, 1835.

Camón Aznar, José. *Los Ribaltas*. Madrid, 1958.

Campo, Angel del. "Ocios literarios y vida retirada en Rodrigo Caro." In *Studia Philológica. Homenaje ofrecido a Dámaso Alonso*. Madrid, 1960.

———. "El Alcázar de *Las Meninas*," *Villa de Madrid*, 12 (1974), pp. 55-61.

Canons and Decrees of the Council of Trent. Trans. Theodore W. A. Buckley. London, 1851.

Cárdenas, Juan de. *Breve relación de la muerte, vida y virtudes del venerable caballero D. Miguel Mañara Vicentelo de Leca, caballero del Orden de Calatrava, Hermano Mayor de la Santa Caridad.* Seville, 1903.

Carducho, Vicente. *Diálogos de la pintura.* Ed. Gregorio Cruzada Villaamil. Madrid, 1865.

Caro, Rodrigo. *Flavii Lucii Dextri Omnimodae Historiae quae extant Fragmenta.* Seville, 1627.

———. *Antigüedad y principado de la ilustrísima ciudad de Sevilla.* Seville, 1634.

———. *Memorial de la Villa de Utrera.* Ed. Marcelino Menéndez y Pelayo. Seville, 1883.

———. *Días geniales o lúdicros.* Seville, 1884.

———. *Varones insignes en letras.* Ed. Santiago Montoto. Seville, 1915.

Carriazo, José M. "Correspondencia de Don Antonio Ponz con el Conde del Aguila," *Archivo Español de Arte y Arqueología,* 5 (1929), pp. 157-83.

Cascales y Muñoz, José. *Francisco de Zurbarán: su época, su vida y sus obras.* Madrid, 1911.

———. *Las bellas artes plásticas en Sevilla.* Toledo, 1929.

Castro, Américo. "Juan de Mal Lara y su Filosofía Vulgar." In *Homenaje a Menéndez Pidal,* vol. 3. Madrid, 1925.

Caturla, María L. "Cartas de pago de los doce cuadros de batalla para el Salón de Reinos del Buen Retiro," *Archivo Español de Arte,* 33 (1960), pp. 333-55.

———. "Sobre la ordenación de las pinturas de Zurbarán en la sacristía de Guadalupe," *Archivo Español de Arte,* 37 (1964), pp. 185-86.

Ceán Bermúdez, Juan Agustín. *Diccionario histórico de los más ilustres profesores de las bellas artes en España.* 6 vols. Madrid, 1800.

Céspedes, Pablo de. "Collected Writings." In Juan A. Ceán Bermúdez, *Diccionario histórico de las bellas artes en España,* vol. V. Madrid, 1800.

———. *Poema de la pintura.* In Guillermo Díaz-Plaja, *Antología mayor de la literatura española,* vol. II. Barcelona, 1958.

Chastel, André. *Marsile Ficin et l'art.* Geneva-Lille, 1954.

Cobo Sampedro, Ramón. *Pablo de Céspedes, apuntes biográficos.* Cordoba, 1881.

"Conmemoración del nacimiento de Pablo de Céspedes—MDXXXVIII—y de la muerte de Vicente Carducho," *Anales de la Real Academia de Bellas Artes de San Fernando,* series III, no. 1 (1939), pp. 56-77.

Corominas, Juan. *Diccionario crítico etimológico de la lengua castellana.* Madrid, 1954.

Cossío, Manuel B. *El Greco.* Madrid, 1908.

Coste, Jean. *Francisco de Rioja, racionero entero de la Santa Iglesia de Sevilla.* Madrid, 1965.

Coster, Adolphe. *Fernando de Herrera (el Divino).* Paris, 1908.

Cruzada Villaamil, Gregorio. *Rubens, diplomático español.* Madrid, 1874.

———. *Anales de la vida y obras de Diego de Silva Velázquez.* Madrid, 1885.

Cuadra, Luis de la. *Catálogo-inventario de los documentos del Monasterio de Guadalupe.* Madrid, 1973.

Curtis, Charles B. *Velázquez and Murillo: A Descriptive and Historical Catalogue.* London and New York, 1883.

Darby, Delphine F. *Francisco Ribalta and His School.* Cambridge, 1938.

Darby, Delphine F. "In the Train of the Vagrant Silenus," *Art in America*, 31 (1943), pp. 140-48.

———. "Ribera and the Blind Men," *Art Bulletin*, 39 (1957), pp. 195-217.

———. "Ribera and the Wise Men," *Art Bulletin*, 44 (1962), pp. 279-307.

Delgado, Feliciano. "El Padre Jerónimo Nadal y la pintura sevillana del siglo XVII," *Archivium Historium Societatis Iesu*, 28 (1959), pp. 354-63.

Díaz Padrón, Matías. "Un nuevo 'Cristo crucificado' de Pacheco," *Archivo Español de Arte*, 38 (1965), pp. 128-30.

Documentos de la Catedral de Toledo coleccionados por Don Manuel R. Zarco del Valle. Datos documentales inéditos para la historia del arte español, vol. 2. Madrid, 1916.

Documentos para la historia del arte en Andalucía. 10 vols. Seville, 1927-46.

Dolce, Lodovico. *Dialogo della pittura intitolato l'Aretino*. Florence, 1735.

Domínguez Ortiz, Antonio. *Orto y ocaso de Sevilla. Estudio sobre la decadencia de la ciudad durante los siglos XVI y XVII*. Seville, 1946.

———. *The Golden Age of Spain, 1516-1659*. London, 1971.

Emmens, J. A. "Les Menines de Velasquez. Miroir des Princes pour Philippe IV," *Nederlands Kunsthistorisch Jaarboek*, 12 (1961), pp. 51-79.

Espinosa, Pedro. *Flores de poetas ilustres de España*. Valladolid, 1605.

"Etiquetas generales de la Casa Real del Rey Nuestro Señor para el uso y exercicio de los ofizios de sus criados." Madrid, Biblioteca Nacional, sig. 10.666.

Felton, Craig M. "Jusepe de Ribera: A Catalogue Raisonné." Ph.D. Diss., U. of Pittsburgh, 1971.

Fernández, José M. "El pintor Antonio Mohedano de la Gutierra," *Archivo Español de Arte*, 21 (1948), pp. 113-19.

Fiorillo, J. D. *Geschichte der Mahlerey in Spanien*. Geschichte der zeichenden Künste, vol. IV. Gottingen, 1806.

Galindo San Miguel, Natividad. "Alonso del Arco," *Archivo Español de Arte*, 45 (1972), pp. 347-85.

Gállego, Julián. *Vision et symboles dans la peinture espagnole du siècle d'or*. Paris, 1968.

———. "Datos sobre la calificación profesional de Velázquez." In *Ponencias y comunicaciones. XXIII Congreso Internacional de Historia de Arte*. Granada, 1973.

———. *Velázquez en Sevilla*. Seville, 1974.

Gallego Morell, Antonio. *El mito de Faetón en la literatura española*. Madrid, 1961.

García Chico, Estéban. *Documentos para el estudio del arte en Castilla*. 3 vols. Valladolid, 1940-46.

García y Bellido, Antonio. "Rodrigo Caro, semblanza de un arqueólogo renacentista." *Archivo Español de Arqueología*, 24 (1951), pp. 7-21.

Gaya Nuño, Juan A. *La pintura española fuera de España*. Madrid, 1958.

Gerstenberg, Kurt. *Diego Velázquez*. Munich and Berlin, 1957.

———. "Velázquez als Humanist." In *Varia Velazqueña*. Madrid, 1960.

Gestoso y Pérez, José. *Ensayo de un diccionario de los artífices que florecieron en Sevilla desde el siglo XIII a XVII inclusive*. Seville, 1899-1900.

———. *Curiosidades antiguas sevillanas*. Seville, 1910.

———. "La casa de Juan de Arguijo," *Bética*, 2, no. 20 (Nov. 20, 1914) and no. 21 (Dec. 5, 1914), pp. unnumbered.

———. *Biografía del pintor sevillano Juan de Valdés Leal*. Seville, 1916.

Gilio, Giovanni A. *Due dialogi*. Camerino, 1564.

Godoy Alcántara, José. *Historia crítica de los falsos cronicones*. Madrid, 1868.

Gómez-Menor, José. "En torno a algunos retratos del Greco," *Boletín de Arte Toledano*, 1 (1966), pp. 85-88.

Góngora, Ignacio. "Claros varones en letras." Seville, Biblioteca Colombina.

González Moreno, Joaquín. *Don Fernando Enríquez de Ribera tercer Duque de Alcalá de los Gazules (1583-1637)*. Seville, 1969.

González Novalín, José L. *El inquisidor general Fernando de Valdés (1483-1568). Su vida y obra*. Oviedo, 1968.

Granero, Jesús. *Don Miguel Mañara*. Seville, 1963.

Gronau, Georg. *Titian*. London and New York, 1904.

Guerrero Lovillo, José. *Sevilla*. Guías artísticas de España. 2nd ed., Barcelona, 1962.

Guichot y Sierra, Alejandro. *Los Jeroglíficos de la muerte de Valdés Leal. Análisis de las alegorías de los dos famosos lienzos de Juan de Valdés Leal, de 1672*. Seville, 1932.

Guinard, Paul. *Zurbarán et les peintres espagnols de la vie monastique*. Paris, 1960.

———. *Dauzats et Blanchards, peintres de l'Espagne romantique*. Paris, 1967.

Gutíerrez de los Rios, Gaspar. *Noticia general para la estimación de las artes y de la manera en que conocen las liberales de las que son mecánicas y serviles*. Madrid, 1600.

Harris, Enriqueta. "A Decorative Scheme by El Greco," *Burlington Magazine*, 72 (1938), pp. 154-64.

———. "La misión de Velázquez en Italia," *Archivo Español de Arte*, 33 (1960), pp. 109-36.

———. "Velázquez en Roma," *Archivo Español de Arte*, 31 (1958), pp. 185-92.

———. "Sir William Stirling-Maxwell and the History of Spanish Art," *Apollo*, 79 (1964), pp. 73-77.

Haskell, Francis. *Patrons and Painters. A Study in the Relations between Italian Art and Society in the Age of the Baroque*. London, 1963.

Hazañas y La Rua, Joaquín. *Noticia de las academias literarias, artísticas y científicas de los siglos XVII y XVIII*. Seville, 1888.

———. "Tenorio y Mañara," *Bética*, Nov. 20, 1913, pp. 4-6.

Heikamp, Detlev. "Vicende de Federico Zuccaro," *Rivista d'arte*, 32 (1957), pp. 175-232.

Hernández Díaz, José. *Documentos para la historia del arte en Andalucía*, vol. II. Seville, 1928 and 1930.

Herrera, Fernando de. *Obras de Garcilaso de la Vega con anotaciones*. Seville, 1580.

Herrero, Miguel. "Jáuregui como dibujante," *Arte Español*, 13 (1941), pp. 7-12.

Hoyo, Arturo del. "El conceptismo de Velázquez (ante *Las Meninas*)," *Insula* (May 15, 1960), pp. 4 and 13.

Iñiguez Almech, Francisco. *Casas reales y jardines de Felipe II*. Madrid, 1952.

———. "La Casa del Tesoro, Velázquez y las obras reales." In *Varia Velazqueña*. Madrid, 1960.

Inza, Carlos de. "Prosiguen las pesquisas," *Arquitectura*, 3 (1961), pp. 44-48.

Jáuregui, Juan de. "Diálogo entre la naturaleza y las dos artes pintura y escultura, de cuya preeminencia se disputa y juzga." *Rimas*. Seville, 1618.

———. *Obras*. Ed. Inmaculada Ferrer de Alba. Clásicos castellanos 182-83. Madrid, 1973.

Jordán de Urries y Azara, José. *Biografía y estudio crítico de Jáuregui*. Madrid, 1899.

Jovellanos, Gaspar M. de. *Elogio de las bellas artes*. Madrid, 1781.

Justi, Karl. *Velázquez und sein Jahrhundert*. Bonn, 1888.

———. *Velázquez and His Times*. Trans. A. H. Keane. London, 1889.

Kahr, Madlyn. "Velázquez and *Las Meninas*," *Art Bulletin*, 57 (1975), pp. 225-46.

———. *Velázquez: The Art of Painting*. New York, 1976.

Kamen, Henry. *The Spanish Inquisition*. London, 1965.

King, Willard. *Prosa novelística y academias literarias en el siglo XVII*. Madrid, 1963.

Kinkead, Duncan T. "Juan de Valdés Leal (1622-1690): His Life and Works." Ph.D. diss., University of Michigan, 1976.

Kris, Ernst, and Kurz, Otto. *Die Legende von Kunstler. Ein Geschichtliche Versuch*. Vienna, 1924.

Kubler, George. "El 'San Felipe de Heraclea' de Murillo y los cuadros del claustro chico," *Archivo Español de Arte*, 43 (1970), pp. 11-31.

———. "Three Remarks on the *Meninas*," *Art Bulletin*, 48 (1966), pp. 212-14.

Kubler, George, and Soria, Martin. *Art and Architecture in Spain and Portugal and Their American Dominions*. Harmondsworth, 1951.

Kunoth, George. "Francisco Pacheco's *Apotheosis of Hercules*," *Journal of the Warburg and Courtauld Institutes*, 27 (1964), pp. 335-37.

Kunstlé, Gustav. "Uber 'Las Meninas' und Velázquez." In *Festschrift Karl M. Swoboda zum 28 Januar 1959*. Vienna, 1959.

Lafuente Ferrari, Enrique. "Escalante en Navarra y otras notas sobre el pintor," *Príncipe de Viana*, 2 (1941), pp. 1-16.

———. "Borrascas de la pintura y triunfo de su excelencia. Nuevos datos para la historia del pleito de la ingenuidad del arte de la pintura," *Archivo Español de Arte*, 17 (1944), pp. 77-103.

Lafuente Ferrari, Enrique, and Friedlander, Max J. *El realismo en la pintura del siglo XVII. Paises bajos y España*. Historia del Arte Labor, vol. 12. Barcelona, 1935.

Lasso de la Vega y Argüelles, Angel. *Historia y juicio crítico de la escuela poética sevillana en los siglos XVI y XVII*. Madrid, 1871.

Ledda, Giuseppina. *Contributo allo studio della letteratura emblematica in Spagna (1549-1613)*. Pisa, 1970.

Lee, Rensselaer W. "Ut Pictura Poesis: The Humanistic Theory of Painting," *Art Bulletin*, 22 (1940), pp. 197-269.

Léon Domínguez, Luis. *La Caridad de Sevilla: Mañara, Murillo y Valdés Leal*. Madrid, 1930.

Levey, Michael. *Painters at Court*. London, 1971.

Lipschutz, Ilse H. *Spanish Paintings and the French Romantics*. Cambridge, 1972.

Llaguno y Amirola, Eugenio. *Noticias de los arquitectos y arquitectura desde su restauración, por D. Eugenio Llaguno y Amirola, illustradas y acrecentadas con notas, adiciones y documentos, por D. Juan Agustín Ceán Bermúdez*. Madrid, 1829.

López Martínez, Celestino. *Valdés Leal y sus discipulos*. Seville, 1907.

———. *Valdés Leal*. Seville, 1922.

———. *Arquitectos, escultores y pintores vecinos de Sevilla*. Seville, 1928.

———. *Retablos y esculturas de traza sevillana*. Seville, 1928.

———. *Desde Jerónimo Hernández hasta Martínez Montañés*. Seville, 1929.

———. *Desde Martínez Montañés hasta Pedro Roldán*. Seville, 1932.

———. "El licenciado Francisco Pacheco," *El Liberal* (Seville), Nov. 23, 1934, p. 1.

———. "La Hermandad de la Santa Caridad y el venerable Mañara," *Archivo Hispalense*, 1, no. 1 (1943), pp. 25-48; no. 2, pp. 5-26.

López Navío, José. "Velázquez tasa los cuadros de su protector D. Juan de Fonseca," *Archivo Español de Arte*, 34 (1961), pp. 53-84.

López-Rey, José. "Nombres y nombradía de Velázquez," *Goya*, 37 (1960), pp. 4-5.

———. *Velázquez. A Catalogue Raisonné of His Oeuvre*. London, 1963.

———. *Velázquez' Work and World*. London, 1968.

Maclaren, Neil. *National Gallery Catalogues. The Spanish School*. London, 1952.

Madrazo, Pedro de. "Necrología de Valentín Carderera y Solano," *Boletín de la Real Academia de la Historia*, 2 (1882), pp. 1-12; 103-26.

Mâle, Emile. *L'Art religieux après le Concile de Trente*. Paris, 1932.

Mal Lara, Juan de. *La philosophía vulgar*. Seville, 1568.

———. *Descripción de la Galera Real del Sermo. Sr. Don Juan de Austria*. Seville, 1876.

———. *Filosofía vulgar*. Ed. Antonio Vilanova. Barcelona, 1958.

Mañara Vicentelo de Leca, Miguel. *Discurso de la verdad*. Seville, 1679.

———. *Regla de la muy humilde hermandad de la Santa Caridad*. Seville, 1868.

Martí y Monsó, Jose. "Dos cartas de Francisco Pacheco," *Estudios históricos-artísticos relativos principalmente a Valladolid*. Valladolid, 1898-1901.

———. *Estudios históricos-artisticos relativos principalmente a Valladolid*. Valladolid, 1898-1901.

Matute y Gaviria, Justino. *Adiciones y correcciones a los hijos de Sevilla . . . de I. Fermín Arana de Varflora*. Seville, 1886.

Mayer, August L. *Jusepe de Ribera (Lo Spagnoletto)*. Leipzig, 1908.

Meiss, Millard. *Painting in Florence and Siena after the Black Death*. Princeton, 1951.

"Memorias de diferentes cosas sucedidas en esta muy noble y mui leal ciudad de Sevilla. Copiaronse en Sevilla ano de 1696." Seville, Biblioteca Colombina, sig. 84-7-21.

Méndez Bejarano, Mario. *Diccionario de escritores, maestros y oradores naturáles de Sevilla y su actual provincia*. Seville, 1923.

Menéndez Pelayo, Marcelino. *Historia de las ideas estéticas en España*. Madrid, 1901.

Mestas, Alberto de. "Descendencia regia de un pintor de reyes," *Hidalguía*, 8 (1960), pp. 661-68.

Mestre Fiol, Bartolomé. "El 'espejo referencial' en la pintura de Velázquez," *Traza y Baza*, no. 2 (1973), pp. 15-36.

Miró, Aurora. "Francisco Solís," *Archivo Español de Arte*, 46 (1973), pp. 401-22.

Montalvo, Diego de. *Venida de la soberana Virgen de Guadalupe a España*. Lisbon, 1631.

Montoto y Sedas, Santiago. "Las capellanías del poeta Francisco de Rioja," *Boletín de la Real Academia Española*, 31 (1951), pp. 455-60.

Morales, M. *Rodrigo Caro, bosquejo de una biografía íntima*. Seville, 1947.

Moya, Ramiro de. "El trazado regulador y la perspectiva en *Las Meninas*," *Arquitectura*, 3 (1961), pp. 3-12.

Muller, Priscilla E. "Francisco Pacheco as a Painter," *Marsyas*, 10 (1961), pp. 39-44.

Nieremberg, Juan E. *Varones ilustres de la Compañía de Jesús*. Bilbao, 1891.

Notas del Archivo de la Catedral de Toledo, redactadas sistemáticamente en el siglo XVIII, por el canónigo-obrero Don Francisco Pérez Sedano. Datos documentales inéditos para la historia del arte español, vol. 1. Madrid, 1914.

Ortiz de Zúñiga, Diego. *Anales eclesiásticos y seculares de la muy noble y muy leal ciudad de Sevilla*. Madrid, 1795-96.

Pacheco, Francisco, the Elder. *Officia propia Sanctorum hispalensis ecclesiae et diocesis*. Seville, 1590.

Pacheco, Francisco. "Tratados de erudición de varios autores. Año 1631." Madrid, Biblioteca Nacional, sig. 1713.

————. *Libro de descripción de verdaderos retratos de ilustres y memorables varones*. Ed. José M. Asensio. Seville, 1881-85.

————. *A los profesores de arte de la pintura*. Ed. Francisco J. Sánchez Cantón. *Fuentes literarias para la historia del arte español*, vol. V. Madrid, 1941.

————. *El arte de la pintura*. Ed. Francisco J. Sánchez Cantón. Madrid, 1956.

Pacheco de Navaez, Luis. *Compendio de la filosofía y destreza de las armas de Gerónimo Carranza*. Madrid, 1612.

Palomino de Castro y Velasco, Acisclo Antonio. *El museo pictórico y escala óptica*, 2 vols., 1st ed. Madrid, 1715-24; ed. cited Madrid, 1947.

Panofsky, Dora and Erwin. *Pandora's Box. The Changing Aspects of a Mythical Symbol*. London, 1956.

Panofsky, Erwin. "The Neoplatonic Movement and Michelangelo," *Studies in Iconology*. New York, 1962.

————. *Idea. A Concept in Art Theory*. Trans. Joseph J. S. Peake. Columbia, S.C., 1968.

Passavant, J. D. *Die christliche Kunst in Spanien*. Leipzig, 1853.

Passeri, Giovanni. *Vite de Pittori*. Ed. Jacob Hess. Rome, 1934.

Pastor, Ludwig von. *Geschichte der Päpste seit dem ausgang des mittelalters*. Freiburg im Breisgau, 1895-1933.

Pemán, César. "Zurbaranistas gaditanos en Guadalupe," *Boletín de la Sociedad Española de Excursiones*, 55 (1951), pp. 155-87.

Pérez de Moya, Juan. *Philosophía secreta*. Madrid, 1585.

Pérez Pastor, Cristóbal. *Noticias y documentos relativos a la historia y literatura española*. Memorias de la Real Academia Española, vol. 11. Madrid, 1914.

Pérez Sánchez, Alfonso E. "Don Matías de Torres," *Archivo Español de Arte*, 38 (1965), pp. 31-42.

———. *Pintura italiana del s. XVII en España*. Madrid, 1965.

———. "La crisis de la pintura española en torno a 1600." In *España en las crisis del arte europeo* Madrid, 1968.

———. "Diego Polo," *Archivo Español de Arte*, 42 (1969), pp. 43-54.

———. "Carlo Saraceni á la Cathédrale de Toledo." In *Actes du XXII^{eme} Congrès International d'Histoire de l'Art*, vol. 2. Budapest, 1970.

———. "Céspedes en Guadalupe," *Archivo Español de Arte*, 44 (1971), pp. 338-41.

———. *Jerónimo Jacinto de Espinosa*. Madrid, 1972.

———. *Caravaggio y el naturalismo español*. Seville, 1973.

Pineda, Juan de. *Comentarios Salomon praevivus, id est, de rebus Salomonis Regis, libri octi*. Lyon, 1609.

Pineda Novo, Daniel. "Juan de Mal Lara, poeta, historiador y humanista del siglo XVI," *Archivo Hispalense*, 46-47 (1967), pp. 9-99.

Ponz, Antonio. *Viaje de España*. 18 vols. Madrid, 1772-94.

Proske, Beatrice. *Juan Martínez Montañés, Sevillian Sculptor*. New York, 1967.

Quilliet, Frédéric. *Dictionnaire des peintres espagnols*. Paris, 1816.

Ramírez de Arellano, Rafael. *Diccionario biográfico de artistas de la provincia de Córdoba*. Colección de documentos inéditos para la historia de España, vol. 107. Madrid, 1893.

———. "Artistas exhumados: Pablo de Céspedes, pintor, escultor, arquitecto, literato insigne y ¿músico?" *Boletín de la Sociedad Española de Excursiones*, 11 (1903), pp. 204-14; 232-36; 12 (1904), pp. 34-41.

Reglas y establecimientos de la Orden y Cavallería del Glorioso Apostol Santiago, Patrón de Las Spañas, con la historia del origen y principio della. Madrid, 1655.

Rekers, B. *Benito Arias Montano*. London, 1972.

Richter, J. P. *The Literary Work of Leonardo da Vinci*. London, 1883.

Ripa, Cesare. *Iconologia*. Siena, 1613.

Robles, Juan de. *Diálogo entre dos sacerdotes en razón del uso de la barba de los eclesiásticos*. Seville, 1642.

———. *Primera parte de culto sevillano*, Seville, 1631, ed. Sociedad de Bibliófilos Andaluces. Seville, 1883.

Rodríguez G. de Ceballos, Alfonso, "Alonso Matías, precursor de Cano." In *Centenario de Alonso Cano en Granada. Estudios*. Granada, 1969, pp. 165-201.

Rodríguez Marín, Francisco. *Luis Barahona de Soto, estudio biográfico, bibliográfico y crítico*. Madrid, 1907.

———. *Pedro Espinosa*. Madrid, 1907.

———. "Una sátira sevillana del licenciado Francisco Pacheco," *Revista de Archivos, Bibliotecas y Museos*, 17 (1907), pp. 1-25; 433-54.

———. *Francisco Pacheco, maestro de Velázquez*. Madrid, 1923.

———. *Nuevos datos para la biografía de cien escritores de los siglos XVI y XVII*. Madrid, 1923.

Rodríguez Villa, Antonio. *Etiquetas de la Casa Real de Austria*. Madrid, n.d. (1875).

Rooses, Max, and Ruelens, Charles. *Correspondance de Rubens et documents épistolaires*. Antwerp, 1904.

Rosenthal, Earl. "The Invention of the Columnar Device of Emperor Charles V at the Court of Burgundy in Flanders in 1516," *Journal of the Warburg and Courtauld Institutes*, 36 (1973), pp. 198-230.

―――. "*Plus Oultre*: The *Idea Imperial* of Charles V in his Columnar Device on The Alhambra." In *Hortus Imaginum*. Essays in Western Art. Eds. Marilyn Stokstad and Robert Enggass. University of Kansas, 1974.

Rubio, Germán. *Historia de Nuestra Señora de Guadalupe*. Barcelona, 1926.

Rumeu de Armas, Antonio. *Itinerario de los Reyes Católicos 1474-1516*. Madrid, 1974.

Saltillo, Marquis del. *Mr. Frédéric Quilliet, comisario de Bellas Artes del gobierno intruso en Sevilla el año 1810*. Madrid, 1933.

―――. "Efemérides artísticas madrileñas del siglo XVII," *Boletín de la Academia de la Historia*, 120 (1947), pp. 605-85.

―――. *Artistas y artífices sorianos de los siglos XVI y XVII (1509-1699)*. Madrid, 1948.

―――. "Efemérides artísticas madrileñas (1603-1811)," *Boletín de la Sociedad Española de Excursiones*, 52 (1948), pp. 5-41, 81-120.

―――. "Artístas madrileños (1592-1850)," *Boletín de la Sociedad Española de Excursiones*, 57 (1953), pp. 137-243.

Sánchez, José. *Academias literarias en el siglo XVII*. Madrid, 1961.

Sánchez Cantón, Francisco J. *Los Arfe*. Madrid, 1920.

―――. "La librería de Velázquez." In *Homenaje a Menéndez Pidal*, vol. III. Madrid, 1924.

―――. *Las Meninas y sus personajes*. Barcelona, 1943.

―――. "Necrología de Elías Tormo y Monzó," *Boletín de la Academia de la Historia*, 142 (1958), pp. vii-xxv.

―――. "Los libros españoles que poseyó Velázquez." In *Varia Velazqueña*. Madrid, 1960.

Sánchez y Escribano, Federico. *Juan de Mal Lara*. New York, 1941.

Sancho Corbacho, Antonio. "Francisco Pacheco, tratadista de arte," *Archivo Hispalense*, 23 (1955), pp. 9-65.

San Joseph, Francisco de. *Historia universal de la primitiva y milagrosa imagen de Nra. Señora de Guadalupe*. Madrid, 1743.

San Román, Francisco de Borja de. *El Greco en Toledo*. Madrid, 1910.

Saxl, Fritz. "Velázquez and Philip IV," *Lectures*. London, 1957.

Selig, Karl L. "The Commentary of Juan de Mal Lara to Alciato's *Emblemata*," *Hispanic Review*, 14 (1956), pp. 26-41.

Seznec, Jean. *The Survival of the Pagan Gods*. New York, 1961.

Sigüenza, José de. *Historia de la Orden de los Jerónimos*. Nueva Biblioteca de Autores Españoles. Madrid, 1907-1909.

Simonde de Sismondi, Jean C. L. *Historia de la literatura española*. Trans. José L. Figueroa and José Amador de los Rios. Seville, 1842.

Soehner, Halldor. "Die Geschichte der Spanischen Malerei im Spiegel der Forschung," *Zeitschrift für Kunstgeschichte*, 19 (1956), pp. 278-302.

———. "Las Meninas," Münchner Jahrbuch der Bildenden Kunst, 16 (1965), pp. 149-69.

Somoza, Julio. Manuscritos de Jovellanos, inéditos, raros o dispersos. Madrid, 1913.

Soria, Martin S. "Some Flemish Sources of Baroque Painting in Spain," Art Bulletin, 30 (1948), pp. 249-59.

———. Zurbarán. 2nd ed., London, 1955.

———. "Una carta poca conocida sobre Velázquez," Archivo Español de Arte, 30 (1957), pp. 135-36.

Stirling-Maxwell, William. Annals of the Artists of Spain. 4 vols. London, 1847-48.

———. Velázquez and His Works. London, 1855.

Suárez Fernández, Luis, and Carriazo Arroquia, Juan de Mata. La España de los Reyes Católicos (1474-1516). Historía de España, vol. XVII, tome 1. Ed. Ramón Menéndez Pidal. Madrid, 1964.

Tanner, Marie. "Titian: the 'Poesie' for Philip II." Ph.D. diss., New York University, 1976.

Taylor, René. "Architecture and Magic: Considerations of the Idea of the Escorial." In Essays in the History of Architecture Presented to Rudolf Wittkower. Eds. Douglas Fraser, Howard Hibbard, and Milton J. Lewine. London, 1967.

Tellechea Idigoras, José I. Fray Bartolomé Carranza. Documentos históricos I. Recusación del Inquisidor General Valdés (Tomo XII del Proceso). Archivo Documental Español publicado por la Real Academia de la Historia, vol. XVIII. Madrid, 1962.

Tervarent, Guy de. Attributs et symboles dans l'art profane 1450-1600. Geneva, 1958.

Tolnay, Charles de. "Velázquez' Las Hilanderas and Las Meninas (An Interpretation)," Gazette des Beaux-Arts, 35 (1949), pp. 21-38.

Tormo y Monzó, Elías. El monasterio de Guadalupe y los cuadros de Zurbarán. Madrid, 1905.

———. "Un gran pintor vallisoletano: Antonio Pereda," Boletín de la Sociedad Castellana de Excursiones, 4 (1910), pp. 469-75, 507-11; 6 (1914), pp. 505-10, 532-38; 7 (1915), pp. 89-94, 103-105, 129-32, 162-65, 173-79.

———. "Más de Cabezalero, pintor de la escuela de Madrid," Boletín de la Sociedad Española de Excursiones, 23 (1915), pp. 41-50; 109-23.

———. "La educación artística de Ribalta, padre, fué en Castilla," Revista Crítica Hispanoamericana, 2 (1916), pp. 19-83.

———. "Mateo Cerezo," Archivo Español de Arte y Arqueología, 3 (1927), pp. 113-28; 245-75.

———. "El Monasterio de Guadalupe y los cuadros de Zurbarán," Pintura, escultura y arquitectura en España. Estudios dispersos de Elías Tormo y Monzó. Madrid, 1949.

Tormo y Monzó, Elías; Gusi, Celestino; and Lafuente Ferrari, Enrique. La vida y obra de Fray Juan Ricci. Madrid, 1930.

Trapier, Elizabeth Du Gué. Ribera. New York, 1952.

———. Valdés Leal. New York, 1960.

Trens, Manuel. María, iconografía de la Virgen en el arte español. Madrid, 1947.

Trens, Manuel. *La eucaristía en el arte español*. Barcelona, 1952.

Tubino, Francisco. *Pablo de Céspedes*. Madrid, 1868.

Urmeneta, Fermín de. "Directrices teológicas ante el arte sagrado y las teorías de Pacheco," *Revista de Ideas Estéticas*, 18 (1960), pp. 237-49.

Valbuena Prat, Angel. "Velázquez y la evasión del espejo mágico." In *Varia Velazqueña*. Madrid, 1960.

Valeriano, Pietro. *Hieroglyphica*. Basel, 1556.

Valgoma y Díaz-Varela, Damilo de la. *Norma y ceremonia de las reinas de la Casa de Austria*. Madrid, 1958.

————. "Un injusticia con Velázquez. Sus probanzas de ingreso en la orden de Santiago," *Archivo Español de Arte*, 33 (1960), pp. 191-214.

Varey, J. E. "Calderón, Cosme Lotti, Velázquez and the Madrid Festivities of 1636-37," *Renaissance Drama*, 1 (1968), pp. 253-82.

————. "L'Auditoire du Salón Dorado de l'Alcázar de Madrid au XVIIᵉ siècle." In *Dramaturgie et Société. Rapports entre l'oeuvre théâtrale, son interprétation et son public aux XVIᵉ et XVIIᵉ siècles*. Paris, 1968.

————. "Motifs artistiques dans l'entrée de Marianne d'Autriche à Madrid en 1649." In *La fête théâtrale et les sources de l'opéra. Actes de la 4ᵉ session des Journées Internationales d'Etudes du Baroque*. Montauban, 1972.

————. "Velázquez y Heliche en los festejos madrileños de 1657-58," *Boletín de la Real Academia de la Historia*, 169 (1972), pp. 407-22.

Varia Velazqueña. Madrid, 1960.

Vega, Lope de. *El Laurel de Apolo*. Madrid, 1630.

Viardot, Louis. *Notices sur les principaux peintres de l'Espagne*. Paris, 1839.

Vilanova, Antonio. "Preceptistas españoles de los siglos XVI y XVII." In *Historia General de la Literaturas Hispánicas*, vol. 3. Barcelona, 1953.

Villacampa, Carlos de. *Grandezas de Guadalupe. Estudios sobre la historia y las bellas artes del gran monasterio extremeño*. Madrid, 1924.

Viñaza, Count of la. *Adiciones al Diccionario histórico de los más ilustres profesores de las bellas artes en España de D. Juan Agustín Ceán Bermúdez*. 4 vols. Madrid, 1889.

Volk, Mary C. *Vicencio Carducho and Seventeenth-Century Castilian Painting*. New York, 1976.

Wethey, Harold E. *Alonso Cano. Painter, Sculptor, Architect*. Princeton, 1955.

————. "Sebastián de Herrera Barnuevo," *Anales del Instituto de Arte Americano e Investigaciones Estéticas*, 2 (1958), pp. 13-41.

————. *El Greco and His School*. Princeton, 1962.

Winner, Matthias. "Gemälte Kunstheorie. Zu Gustave Courbets 'Allégorie réélle' und der Tradition." *Jahrbuch der Berliner Museen*, N.F. 4 (1962), pp. 151-85.

Zamora, Hermenegildo. "La Capilla de las Reliquias en el Monasterio de Guadalupe," *Archivo Español de Arte*, 45 (1972), p. 43-54.

Zarco del Valle, Manuel. *Documentos inéditos para la historia de las bellas artes en España*. Colección de documentos inéditos para la historia de España, vol. 55. Madrid, 1870.

INDEX

LIBRARY OF CONGRESS CATALOGING IN PUBLICATION DATA

Brown, Jonathan.
 Images and ideas in seventeenth-century Spanish
painting.

 (Princeton essays on the arts ; 6)
 Based on the author's thesis, Princeton University,
1964.
 Bibliography: p.
 Includes index.
 1. Painting, Spanish. 2. Painting, Baroque—Spain.
3. Art and society—Spain. 4. Catholic Church and art.
I. Title.
ND806.B76 759.6 78-52485
ISBN 0-691-03941-0
ISBN 0-691-00315-7 pbk.

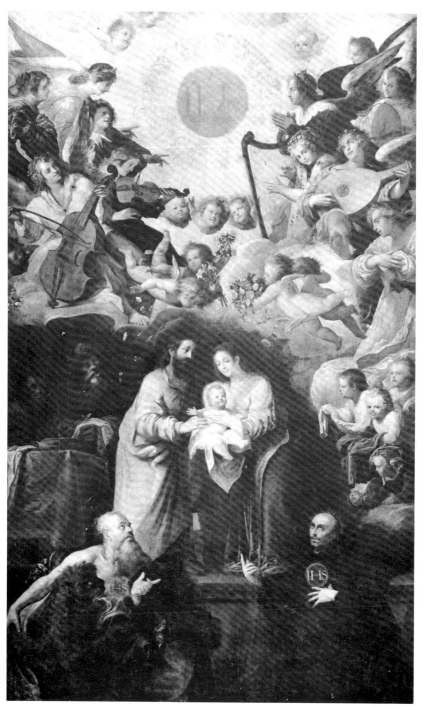

1. Juan de las Roelas, *Circumcision*. Seville, University Chapel

2. Antonio Mohedano, *Annunciation*.
Seville, University Chapel

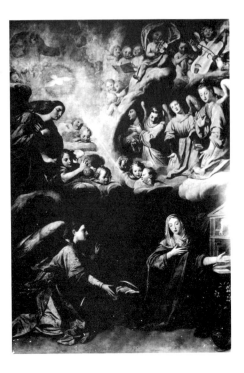

3. Juan de las Roelas, *Annunciation*.
Marchena, Santa Isabel

4. Francisco de Zurbarán, *Annunciation*. Musée de Grenoble, Grenoble

5. Alonso Cano, *Annunciation*. Getafe, Church of la Magdalena

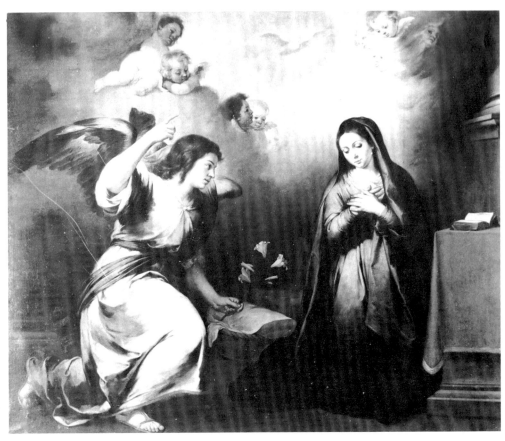

6. Bartolomé Murillo, *Annunciation*. Seville, Museo de Bellas Artes

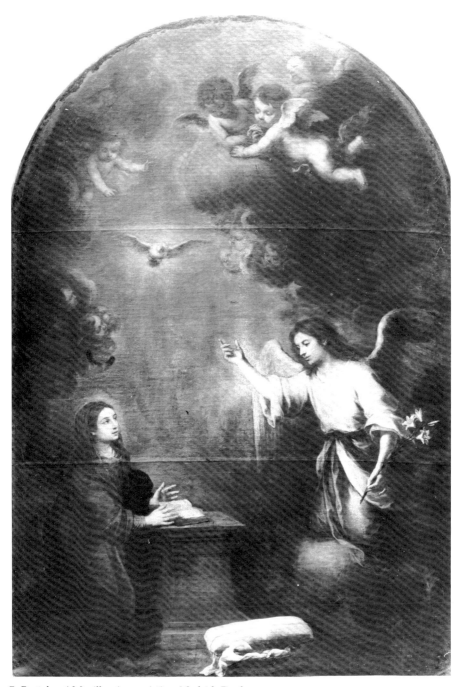

7. Bartolomé Murillo, *Annunciation*. Madrid, Prado

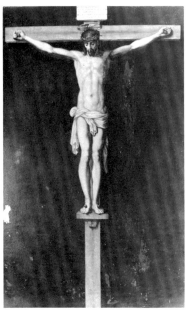

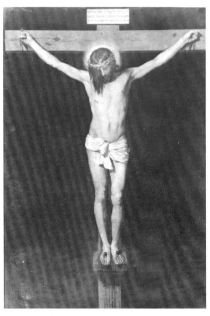

8. Francisco Pacheco, *Crucifixion*. Madrid, Collection Gómez-Moreno

9. Diego de Velázquez, *Crucifixion*. Madrid, Prado

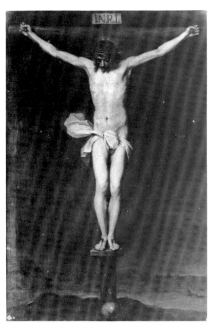

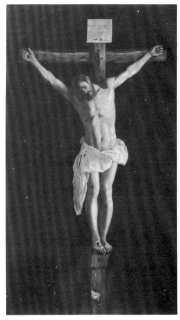

10. Alonso Cano, *Crucifixion*. Madrid, Academia de Bellas Artes de San Fernando

11. Francisco de Zurbarán, *Crucifixion*. Chicago, Art Institute

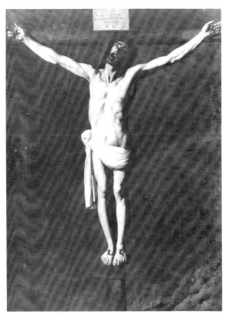

12. Francisco de Zurbarán, *Crucifixion*. Seville,
Museo de Bellas Artes

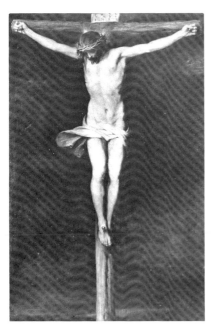

13. Alonso Cano, *Crucifixion*. Madrid,
Collection Gregorio Curto

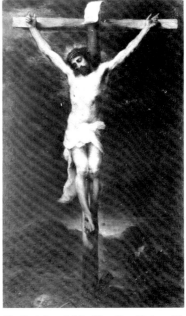

14. Bartolomé Murillo, *Crucifixion*. Ma-
drid, Prado

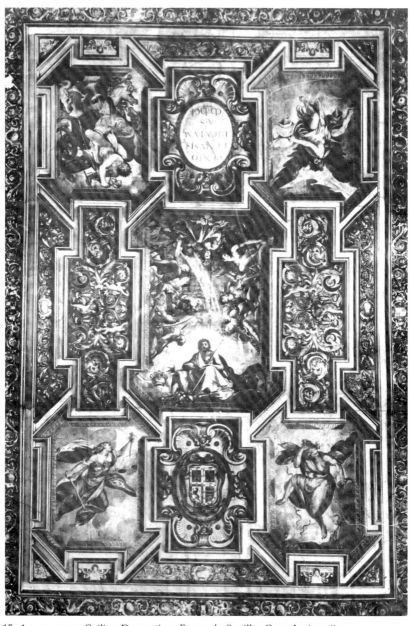

15. Anonymous, Ceiling Decoration. Formerly Seville, Casa de Arguijo

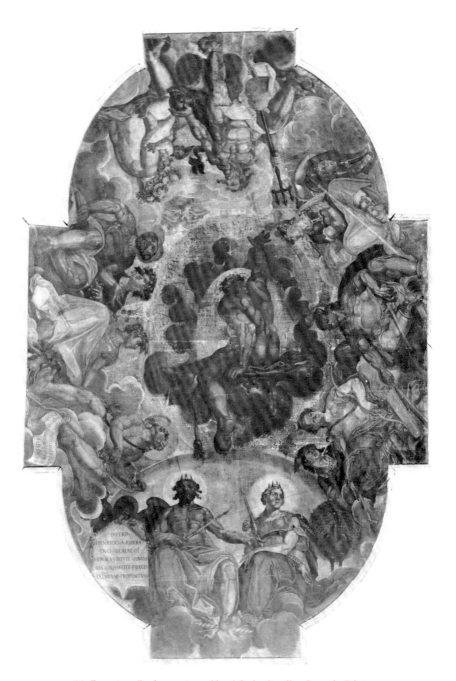

16. Francisco Pacheco, *Assembly of Gods*. Seville, Casa de Pilatos

17. Francisco Pacheco, *Fall of Phaëton*. Seville, Casa de Pilatos

18. Francisco Pacheco, *Fall of Icarus*. Seville, Casa de Pilatos

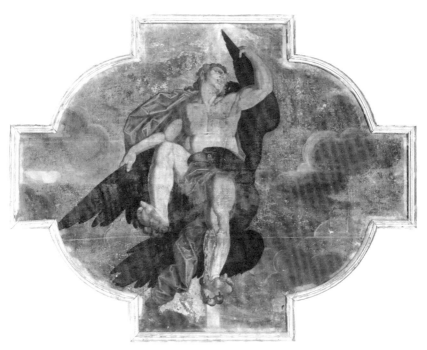

19. Francisco Pacheco, *Rape of Ganymede*. Seville, Casa de Pilatos

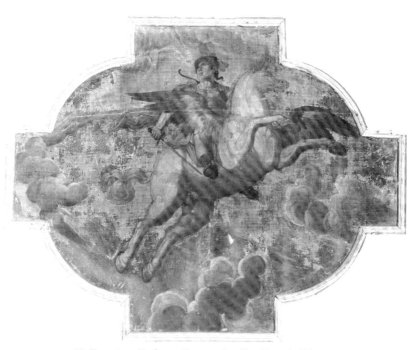

20. Francisco Pacheco, *Perseus*. Seville, Casa de Pilatos

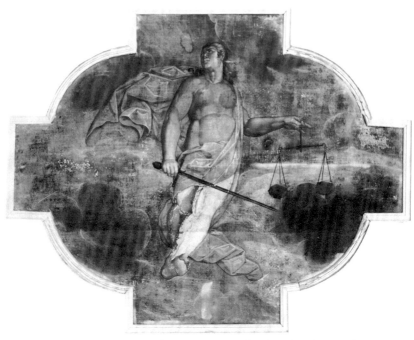

21. Francisco Pacheco, *Justice*. Seville, Casa de Pilatos

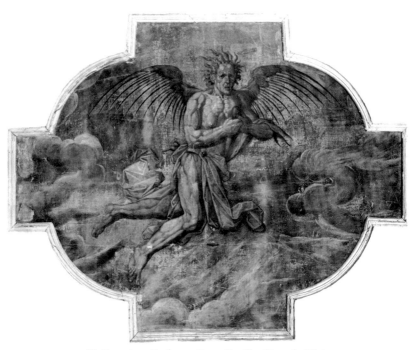

22. Francisco Pacheco, *Envy*. Seville, Casa de Pilatos

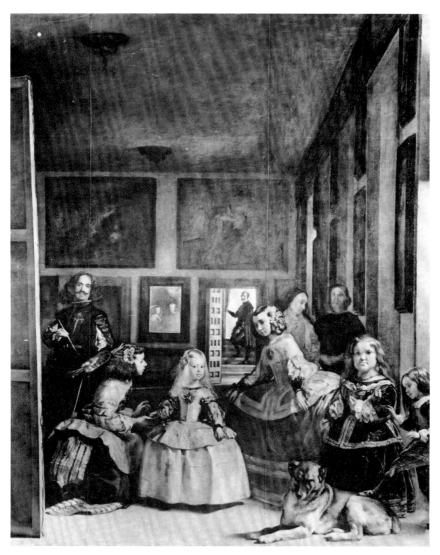

23. Diego de Velázquez, *Las Meninas*. Madrid, Prado

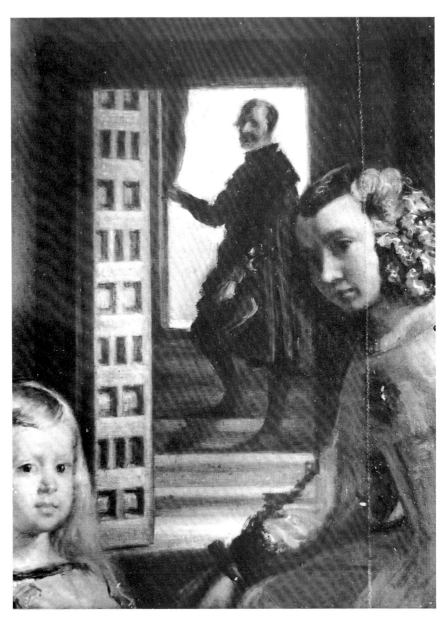

24. Diego de Velázquez, detail of *Las Meninas*

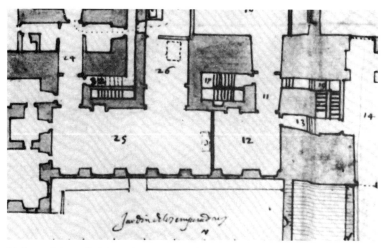

25. Juan Gómez de Mora, Pieza principal, cuarto bajo del Príncipe, from plan
of second floor, Alcázar, Madrid. Vatican, Biblioteca Apostolica

26. View of Monastery, Guadalupe

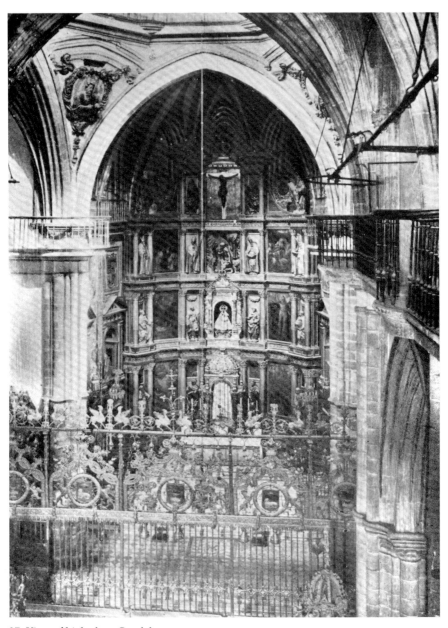

27. View of high altar, Guadalupe

28. Giraldo de Merlo, *Tomb of Enrique IV*. Guadalupe

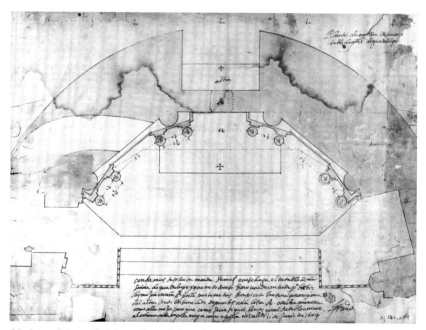

29. Juan Gómez de Mora, *Groundplan of sanctuary*, Guadalupe. Madrid, Archivo Histórico Nacional

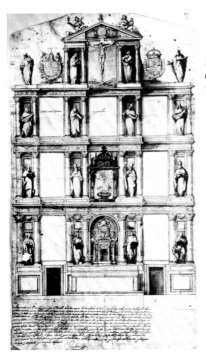

30. Juan Gómez de Mora, *Project for high altar*, Guadalupe Madrid, Biblioteca Nacional

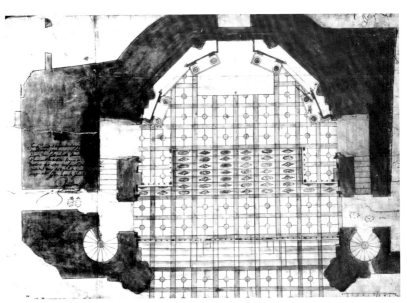

31. Juan Bautista de Monegro, *Groundplan of sanctuary*, Guadalupe Madrid, Archivo Histórico Nacional

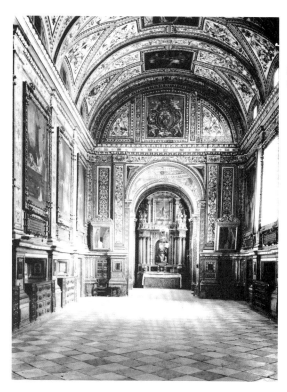

32. View of sacristy, Gua-
dalupe

33. Groundplan of sac-
risty, Guadalupe (after
Guinard)

34. Francisco de Zurbarán, *Vision of Fray Andrés Salmerón*. Guadalupe, sacristy

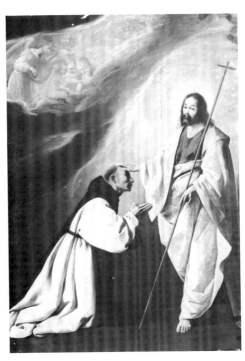

35. Francisco de Zurbarán, *Fray Fernando Yañez de Figueroa Refuses the Archbishopric of Toledo*. Guadalupe, sacristy

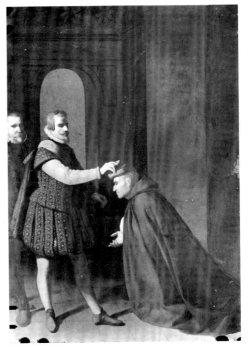

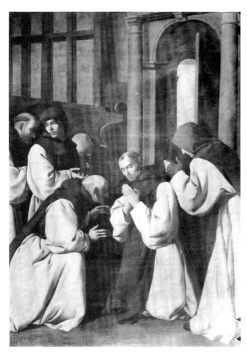

36. Francisco de Zurbarán, *Death of Fray Juan de Carrión*. Guadalupe, sacristy

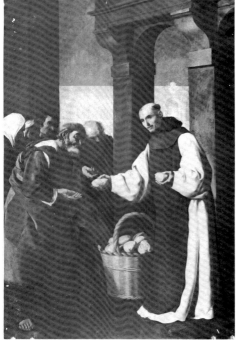

37. Francisco de Zurbarán, *Charity of Fray Martín de Vizcaya*. Guadalupe, sacristy

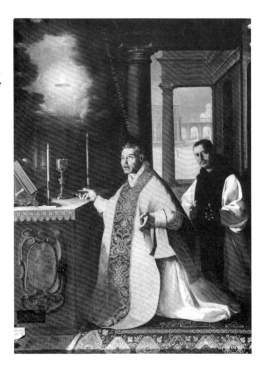

38. Francisco de Zurbarán, *Miraculous Mass of Fray Pedro de Cabañuelas*. Guadalupe, sacristy

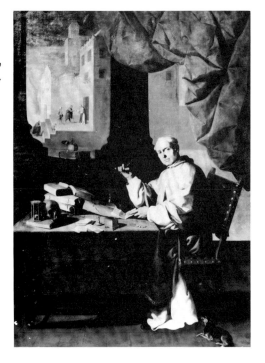

39. Francisco de Zurbarán, *Bishop Gonzalo de Illescas*. Guadalupe, sacristy

40. Francisco de Zurbarán, *Temptation of Fray Diego de Orgaz*. Guadalupe, sacristy

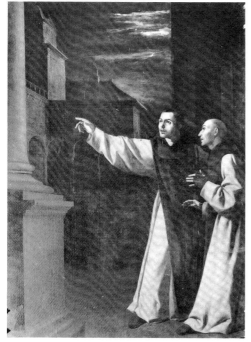

41. Francisco de Zurbarán, *Vision of Fray Pedro de Salamanca*. Guadalupe, sacristy

42. Composite view of present arrangement of paintings in the sacristy, Guadalupe

43. Composite view of proposed re-arrangement of paintings in the sacristy, Guadalupe

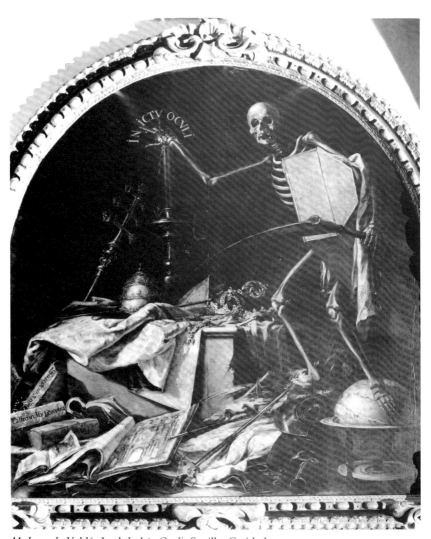

44. Juan de Valdés Leal, *In Ictu Oculi*. Seville, Caridad

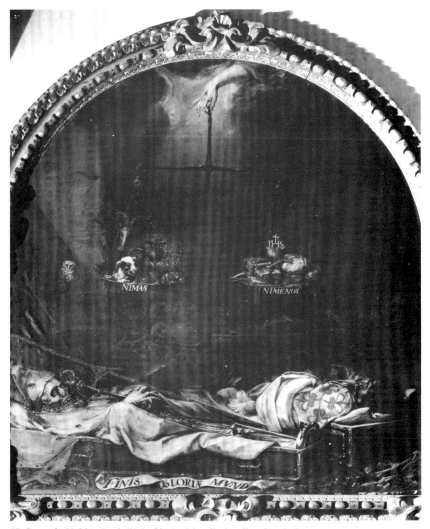

45. Juan de Valdés Leal, *Finis Gloriae Mundi*. Seville, Caridad

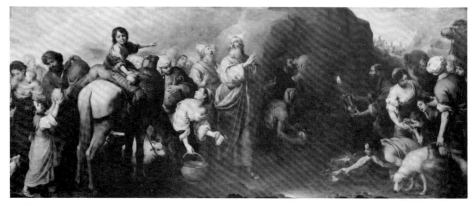

46. Bartolomé Murillo, *Moses Sweetening the Waters of Mara*. Seville, Caridad

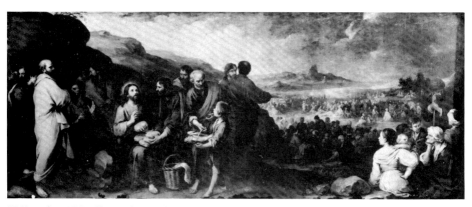

47. Bartolomé Murillo, *Feeding of the Five Thousand*. Seville, Caridad

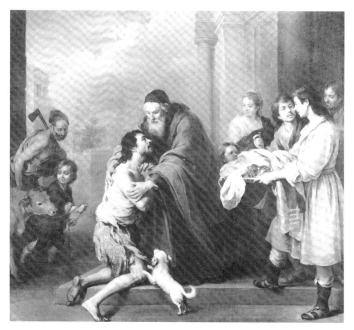

48. Bartolomé Murillo, *Return of the Prodigal Son*. Washington, National Gallery of Art

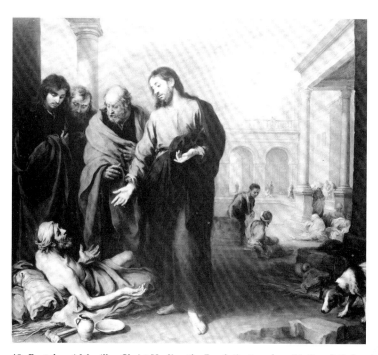

49. Bartolomé Murillo, *Christ Healing the Paralytic*. London, National Gallery

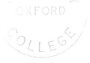

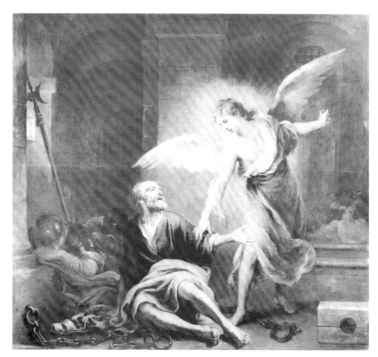

50. Bartolomé Murillo, *Liberation of St. Peter*. Leningrad, Hermitage

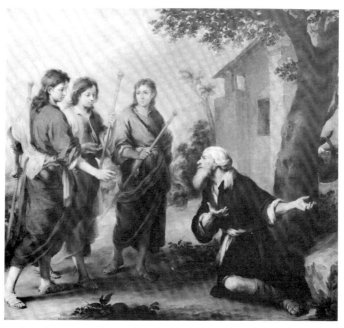

51. Bartolomé Murillo, *Abraham and the Three Angels*. Ottawa, National Gallery of Canada

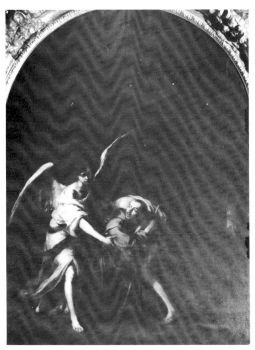

52. Bartolomé Murillo, *Charity of St. John of God*. Seville, Caridad

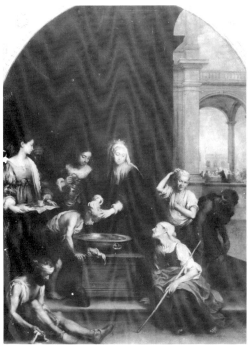

53. Bartolomé Murillo, *Saint Elizabeth of Hungary Healing the Sick*. Seville, Caridad

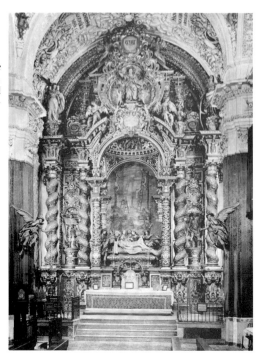

54. Bernardo Simon de Pineda, Pedro Roldán, Juan de Valdés Leal and Bartolomé Murillo, altarpiece. Seville, Caridad

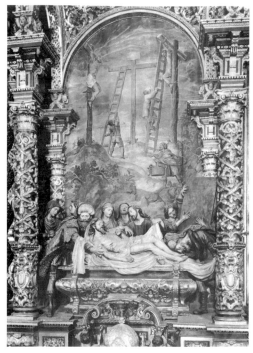

55. Pedro Roldán and Bartolomé Murillo, *Entombment, of Christ.* Seville, Caridad